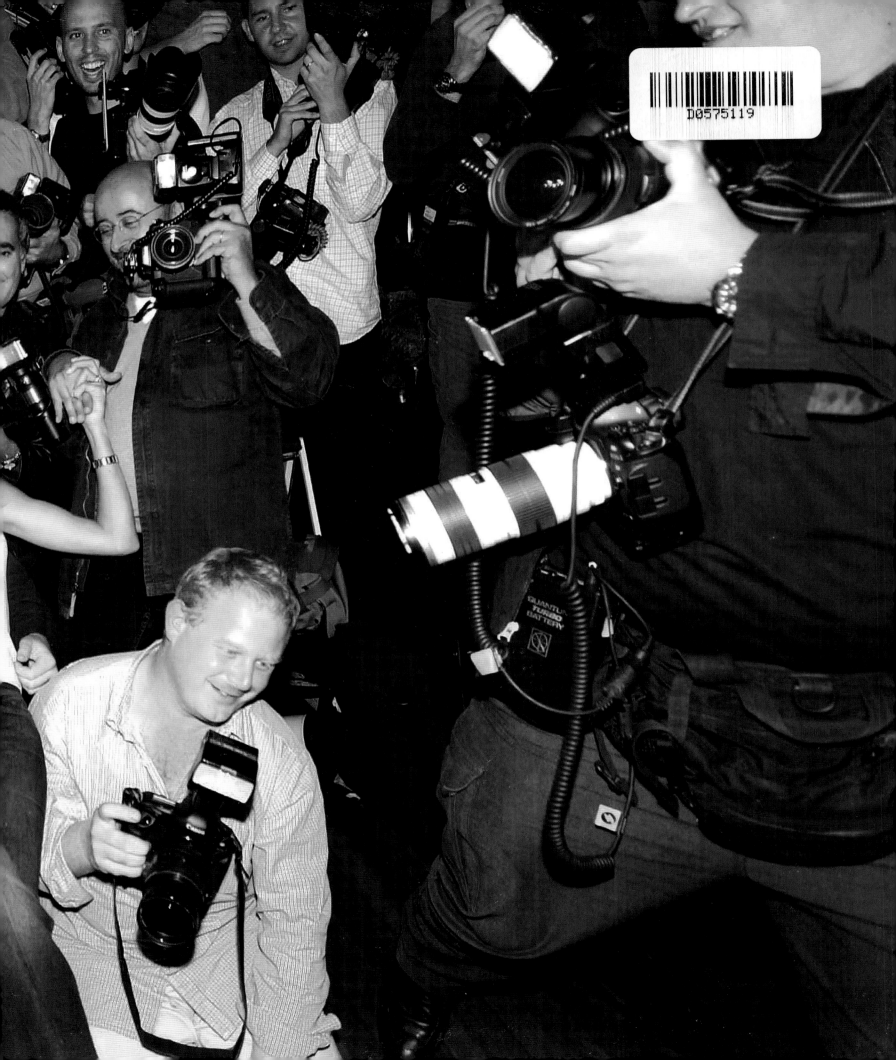

INSIDE HOLLYWOOD

The Greatest Celebrity Photos From *Us Weekly*

WENNER BOOKS · NEW YORK

PRECEDING SPREAD: Uma Thurman was adrift in a sea of flashbulbs
at an October 2, 2003, *Kill Bill Vol. 1* press conference in London.
OPPOSITE: (clockwise from top left) Tara Reid, Kelly Ripa, Leonardo DiCaprio,
Lara Flynn Boyle, Ben Affleck & Jennifer Lopez, Ashanti, Angelina Jolie read *Us*!

Please turn to page 254 for photo credits.
Library of Congress Cataloging-in-Publication Data
Inside Hollywood.
p. cm.
ISBN 1-932958-05-3
1. Portrait photography--United States. 2. Celebrities--United States--Portraits. I. Title: Us weekly.
TR681.F3U88 2005
779'.2--dc22
2005042345

Wenner books are available for special promotions and premiums.
For details contact Michael Rentas, Manager,
Inventory and Premium Sales,
Hyperion, 77 West 66th Street, 11th floor,
New York, NY 10023, or call 212-456-0133.

10 9 8 7 6 5 4 3 2 1

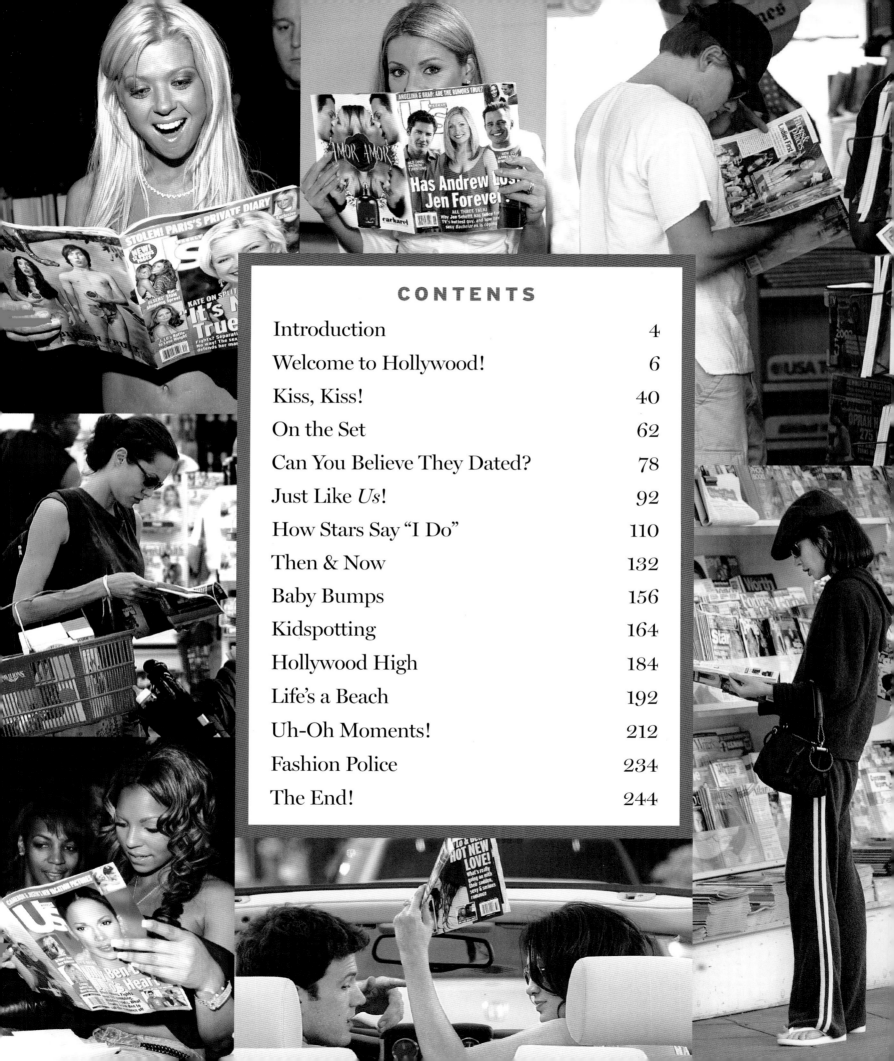

CONTENTS

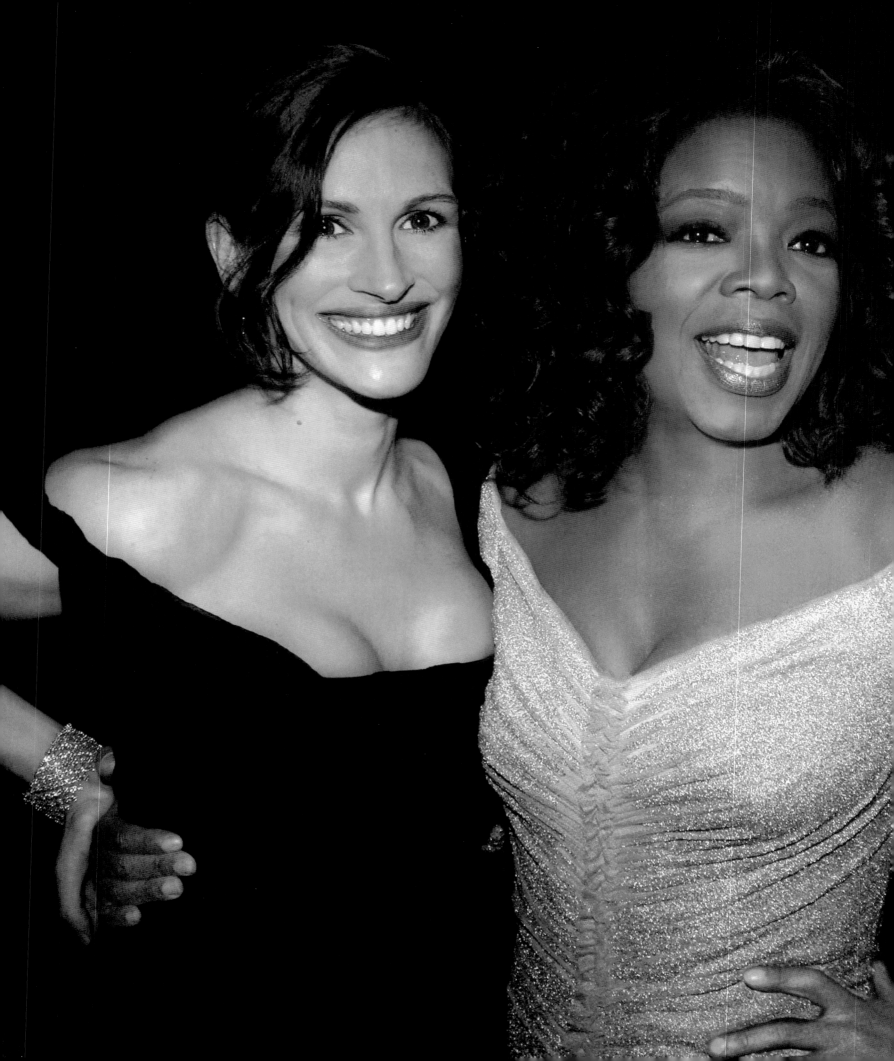

INTRODUCTION

ONE OF THE THINGS I LOVE most about being editor in chief of *Us* is getting the first look at photos I just know everyone will be talking about. There have been many favorites over the years: Brad Pitt and Jennifer Aniston's first public kiss as a couple at a Tibetan Freedom Concert in 1998, and their last, on the shores of Anguilla in 2005; the beautiful family portrait of Catherine Zeta-Jones, Michael Douglas and their new baby boy, Dylan; and the moment Jessica Simpson and Nick Lachey wed in a candlelit, fairy-tale ceremony. Then there are the pictures stars might want to forget: Britney Spears going barefoot in a gas-station restroom; Janet Jackson's Super Bowl "wardrobe malfunction"; Cameron Diaz grabbing a photographer's camera! These are the shots that give all of *Us* something to talk about.

EVEN THE CELEBRITIES THEMSELVES get a kick out of our photos. *Live With Regis and Kelly*'s Kelly Ripa has admitted, "I get sucked into my *Us Weekly* world; we all sit there at production meetings holding the magazine." They even joke with *Us* on their shows. When Lindsay Lohan hosted *Saturday Night Live* in May 2004, *Us* got a spot in her opening monologue: "You might know me from *Us Weekly* as the girl who's always fighting with Hilary Duff." And they all keep reading!

WE HAD SO MUCH FUN DIGGING through old issues to find the most amazing gems for this book. We smiled over those "Can You Believe They Dated?" couples: Jennifer Aniston and Tate Donovan; George Clooney and Kelly Preston; Pamela Anderson — and *Scott Baio*? And laughed out loud at the high-school photos of stars like Julia Roberts and Meg Ryan — actresses who went from big hair to the big screen! We rediscovered some great photos we know you'll want to see again, and we found some surprising ones you might have missed. So here are the most glamorous, cute, funny and outrageous photos of Hollywood at work and play. We hope you'll enjoy looking at them as much as we enjoyed finding them for you.

— Janice Min, Editor in Chief, *Us Weekly*

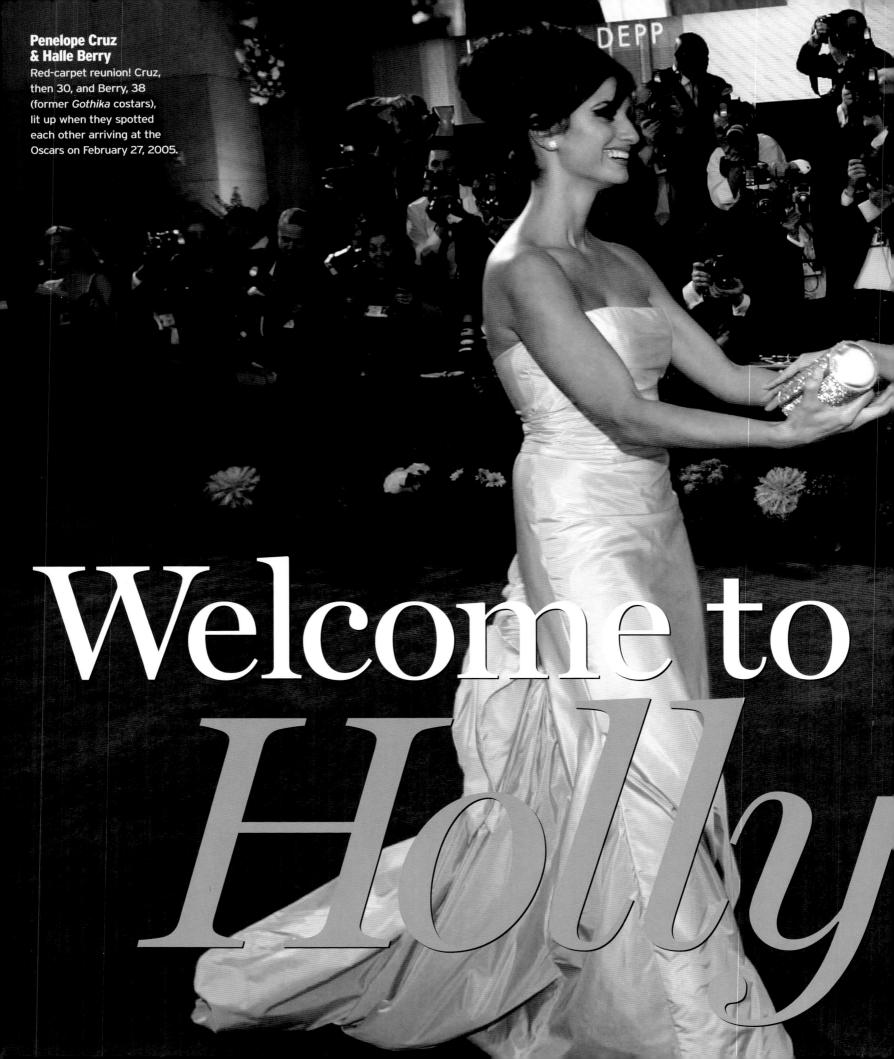

Penelope Cruz & Halle Berry
Red-carpet reunion! Cruz, then 30, and Berry, 38 (former *Gothika* costars), lit up when they spotted each other arriving at the Oscars on February 27, 2005.

Welcome to
Holly

wood!

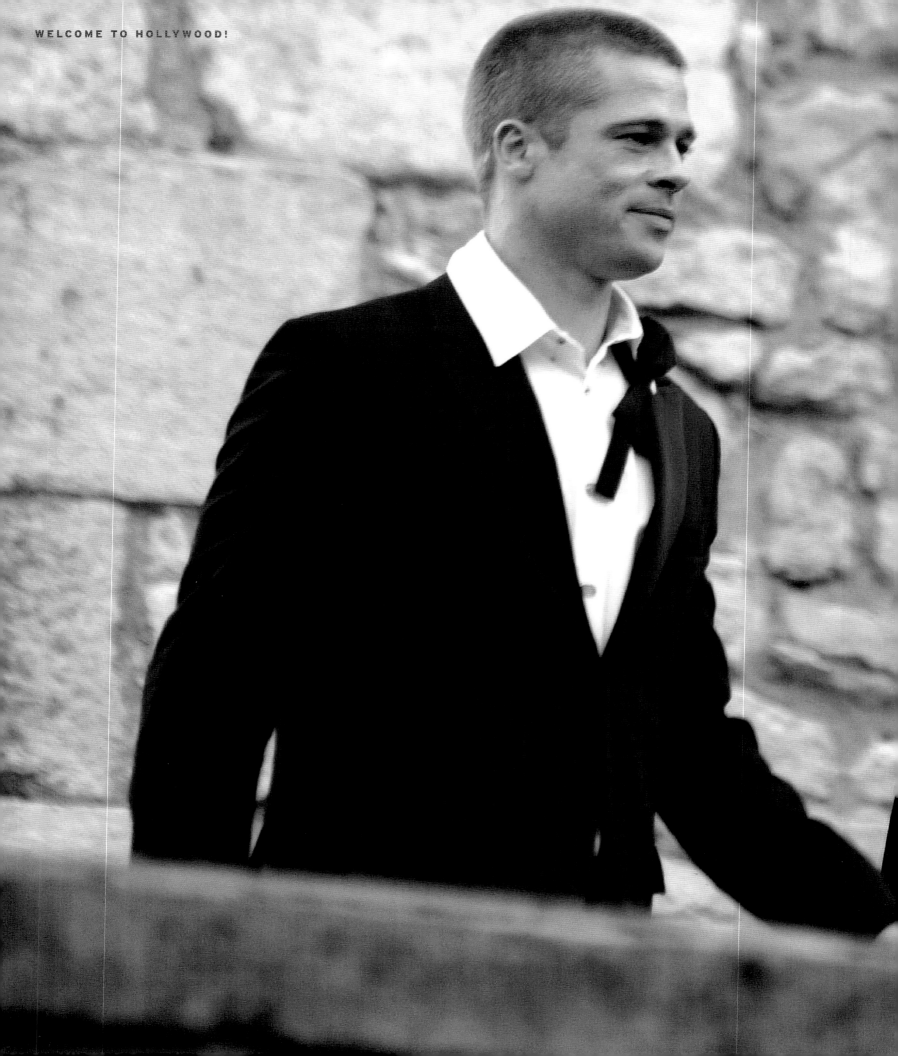

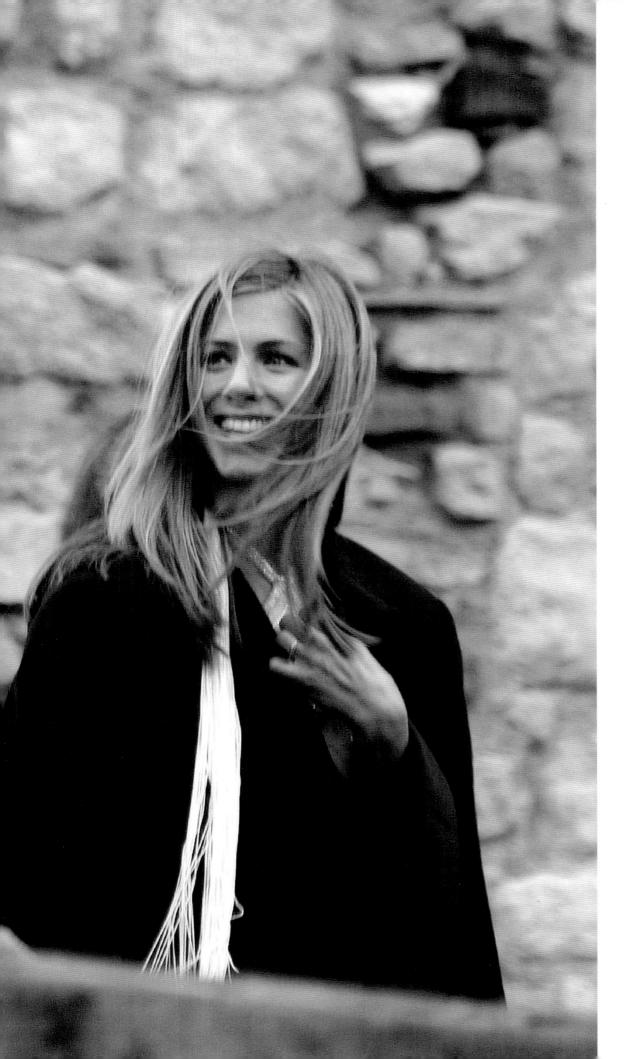

Brad Pitt & Jennifer Aniston

After his epic *Troy* premiered at the Cannes Film Festival, Pitt, then 40, and wife Aniston, 35, enjoyed a romantic stroll through the French Riviera town of Antibes on May 13, 2004. Only eight months later, the couple announced their separation.

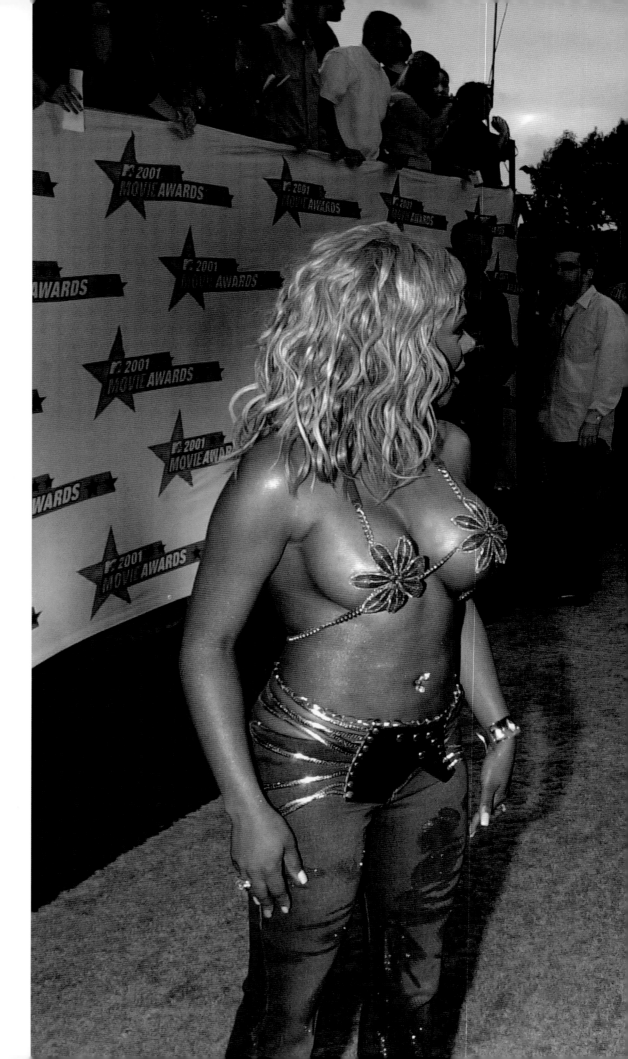

**Lil' Kim, Gwen Stefani
& Gavin Rossdale**
Don't look, Gavin! Stefani, then 31, shielded
husband-to-be Rossdale, 33, from 25-
year-old Lil' Kim's peep show at the MTV
Movie Awards in L.A. on June 2, 2001.

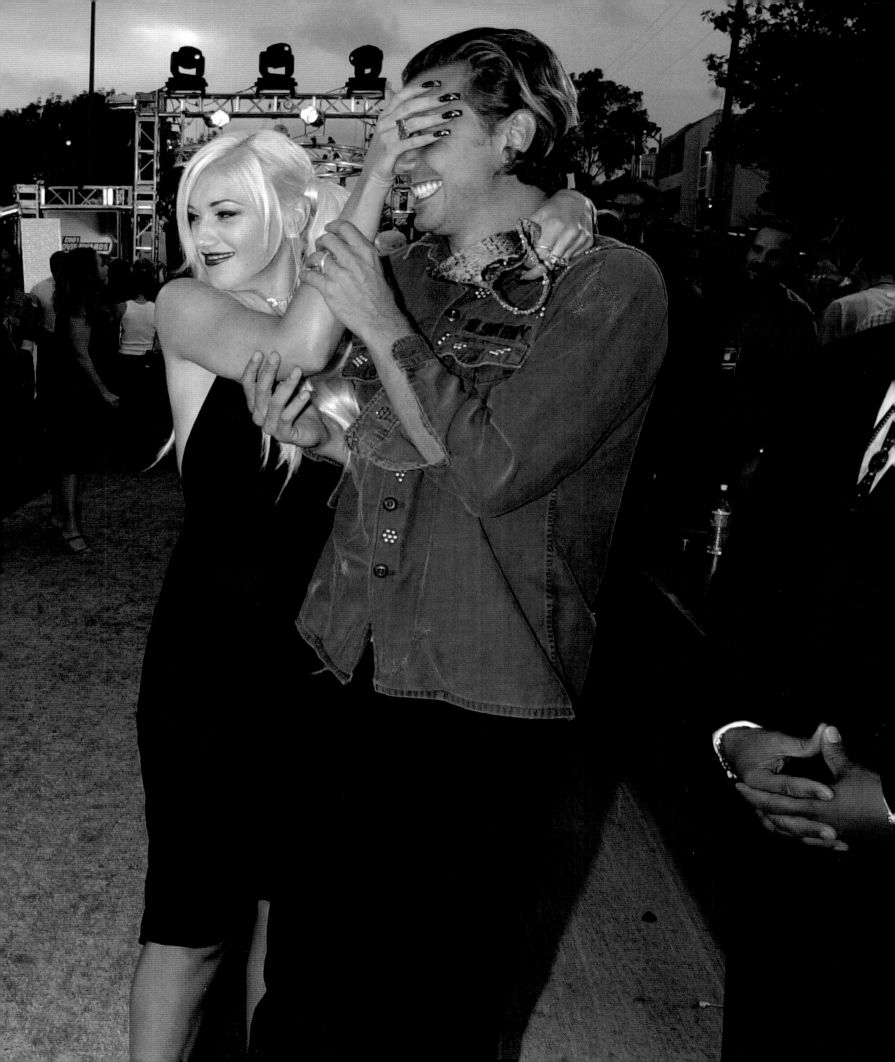

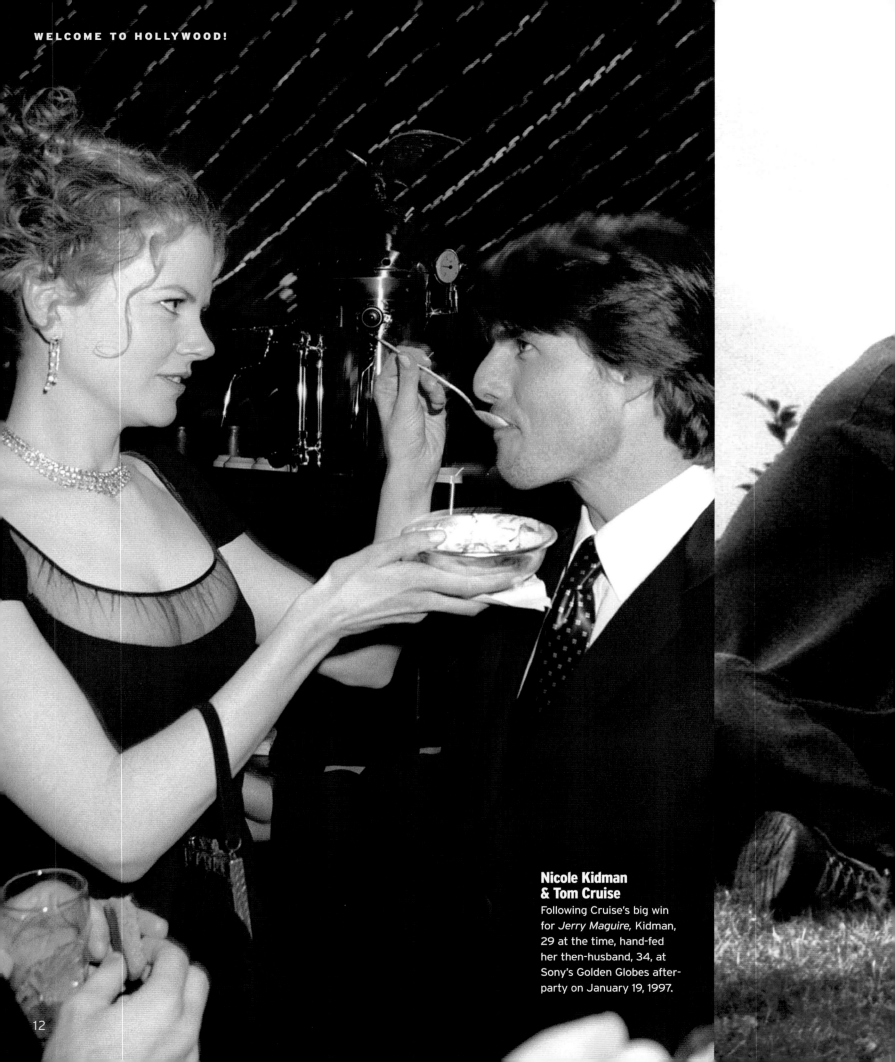

Nicole Kidman & Tom Cruise
Following Cruise's big win for *Jerry Maguire*, Kidman, 29 at the time, hand-fed her then-husband, 34, at Sony's Golden Globes after-party on January 19, 1997.

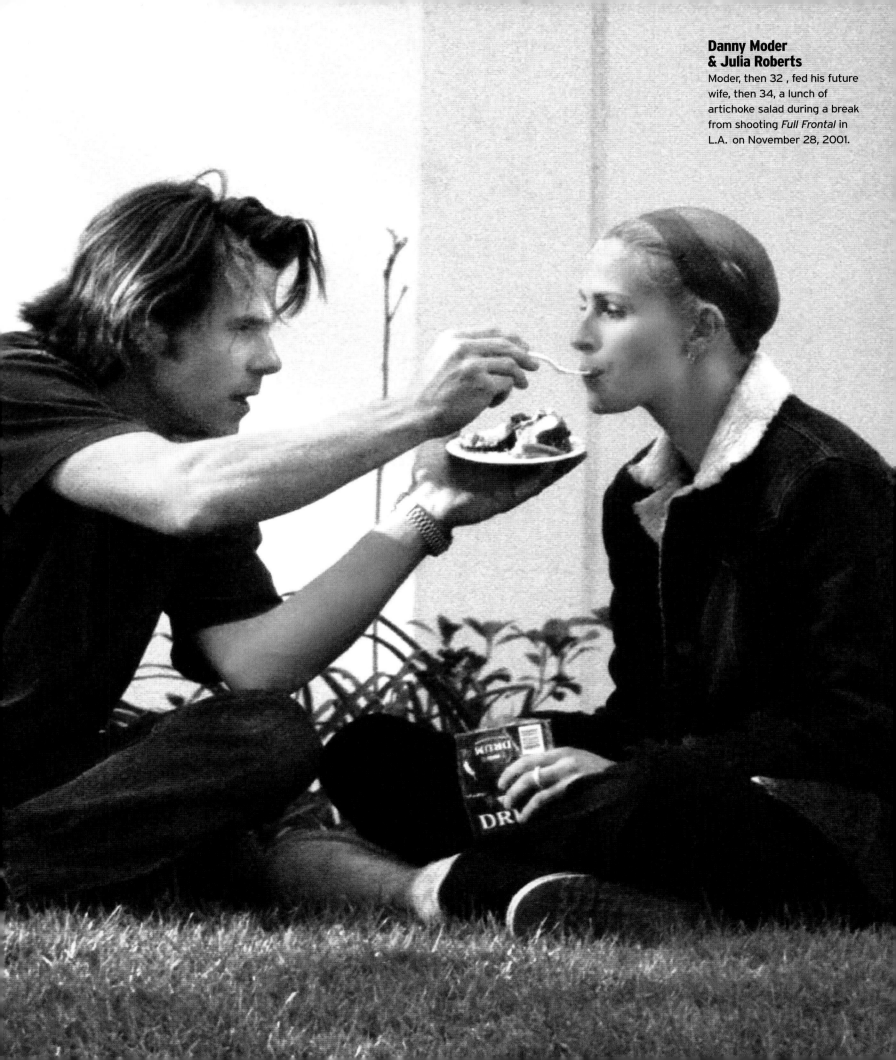

Danny Moder & Julia Roberts
Moder, then 32 , fed his future wife, then 34, a lunch of artichoke salad during a break from shooting *Full Frontal* in L.A. on November 28, 2001.

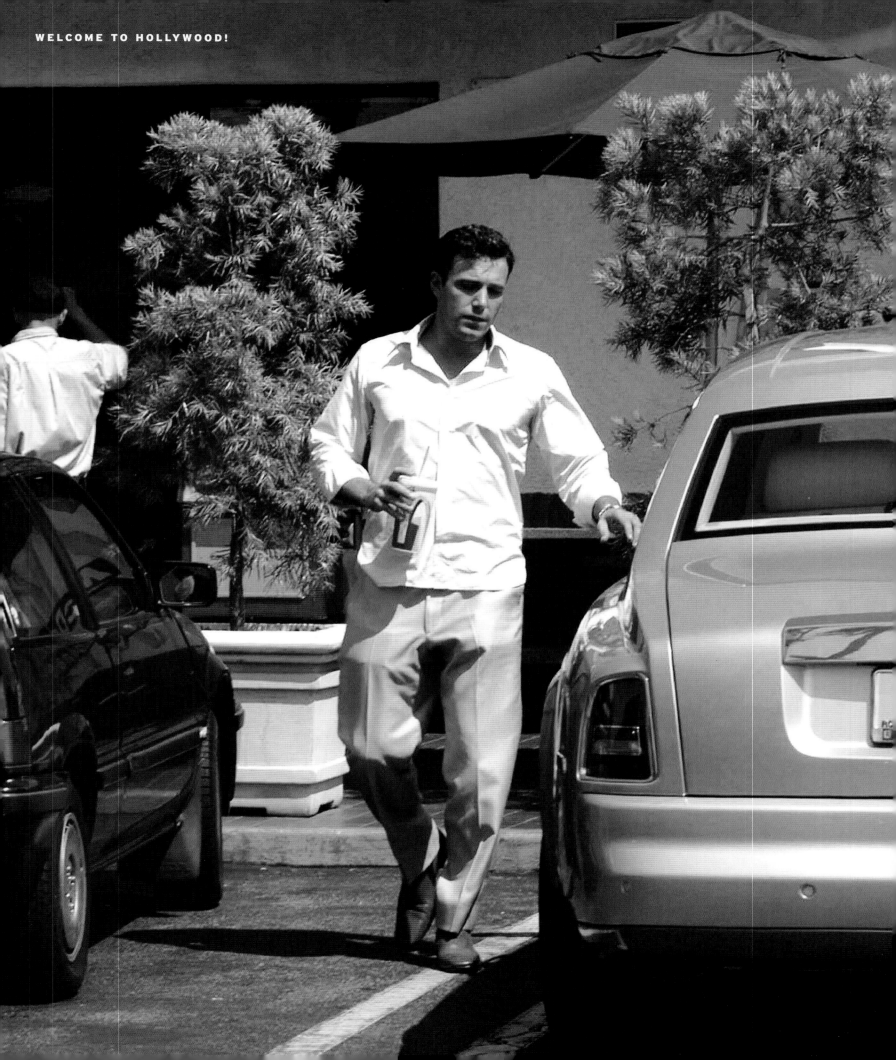

Ben Affleck

Stars go to McDonald's, too – just in nicer cars! Affleck, then 30, treated fiancée Jennifer Lopez (in the car) to a fast-food fix on July 26, 2003, in a $320,000 Rolls-Royce. Later, he drove her home to Hollywood Hills for her surprise 34th-birthday bash.

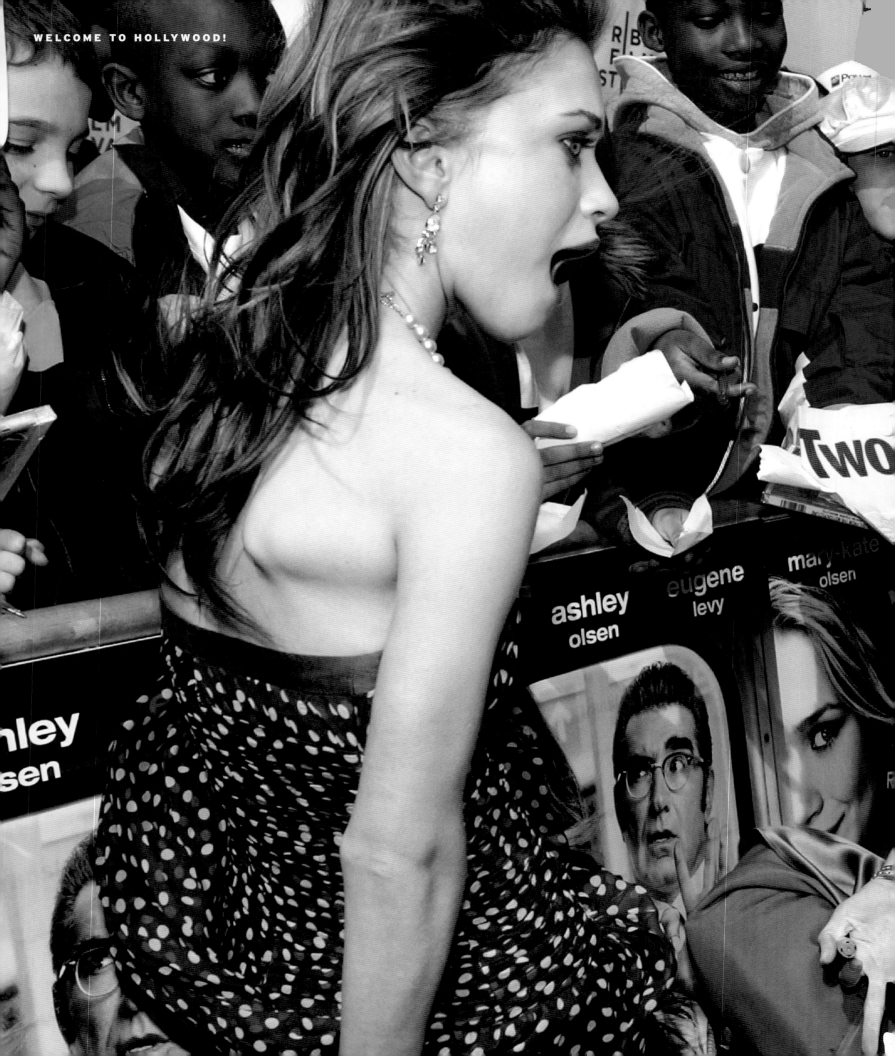

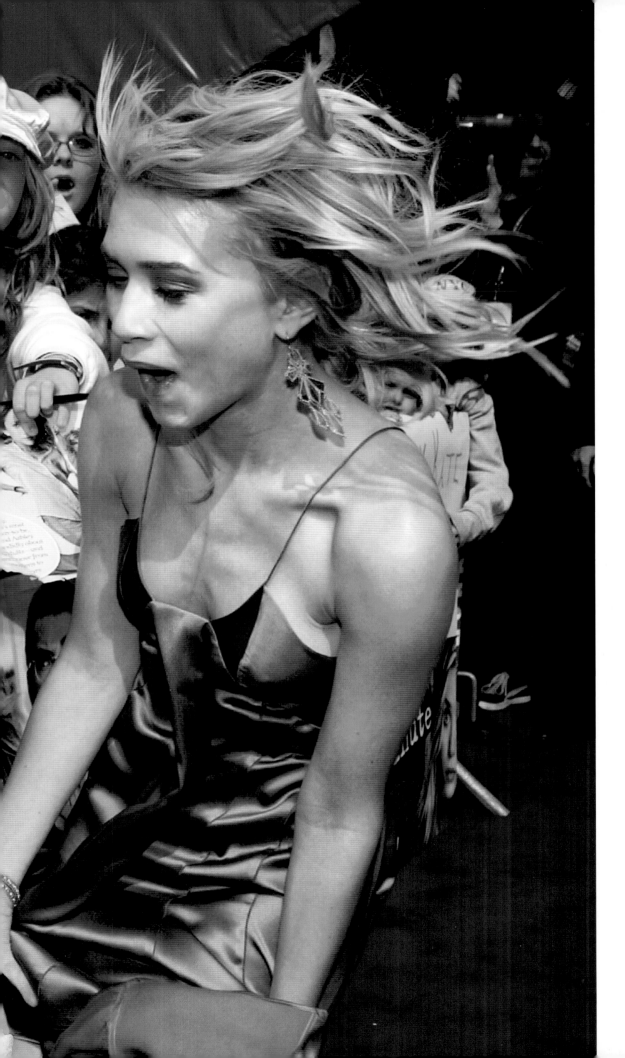

Mary-Kate & Ashley Olsen

Double trouble! The Olsen twins, then 17, got blown away by the excitement (and the breeze!) at the May 4, 2004, New York City premiere of their first big-screen release, the comedy *New York Minute*.

17

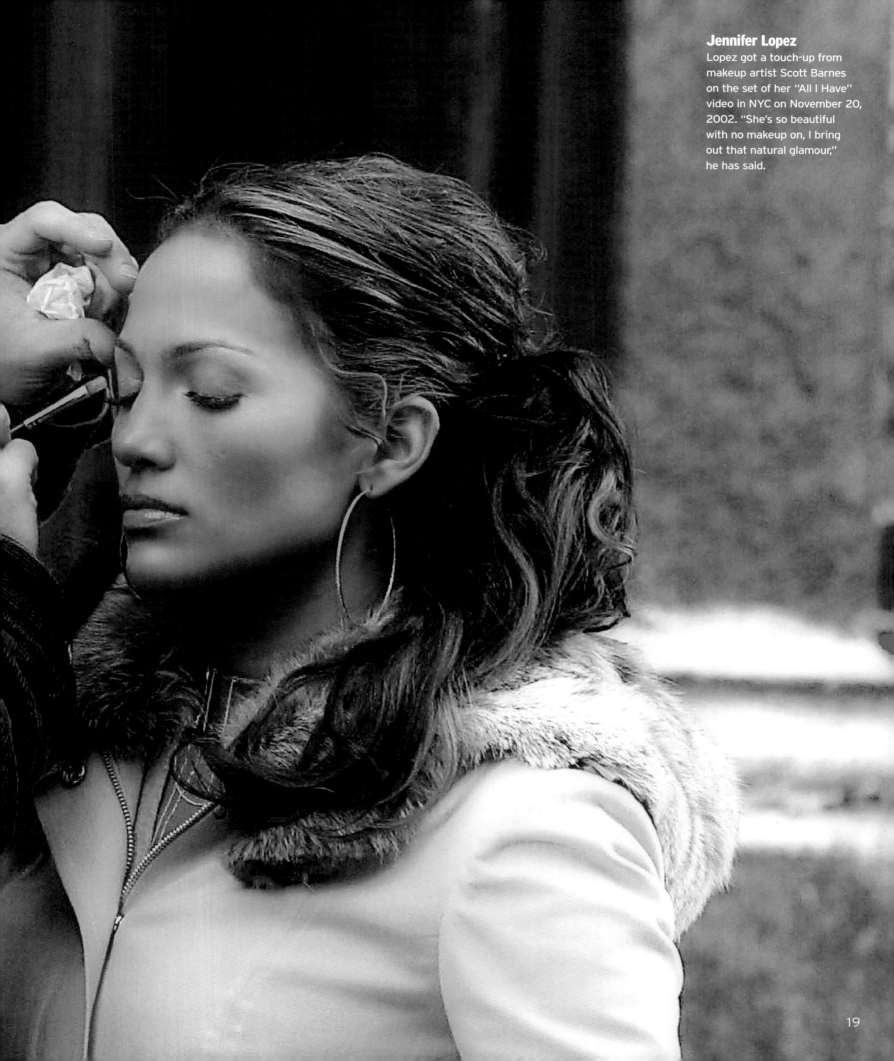

Jennifer Lopez
Lopez got a touch-up from makeup artist Scott Barnes on the set of her "All I Have" video in NYC on November 20, 2002. "She's so beautiful with no makeup on, I bring out that natural glamour," he has said.

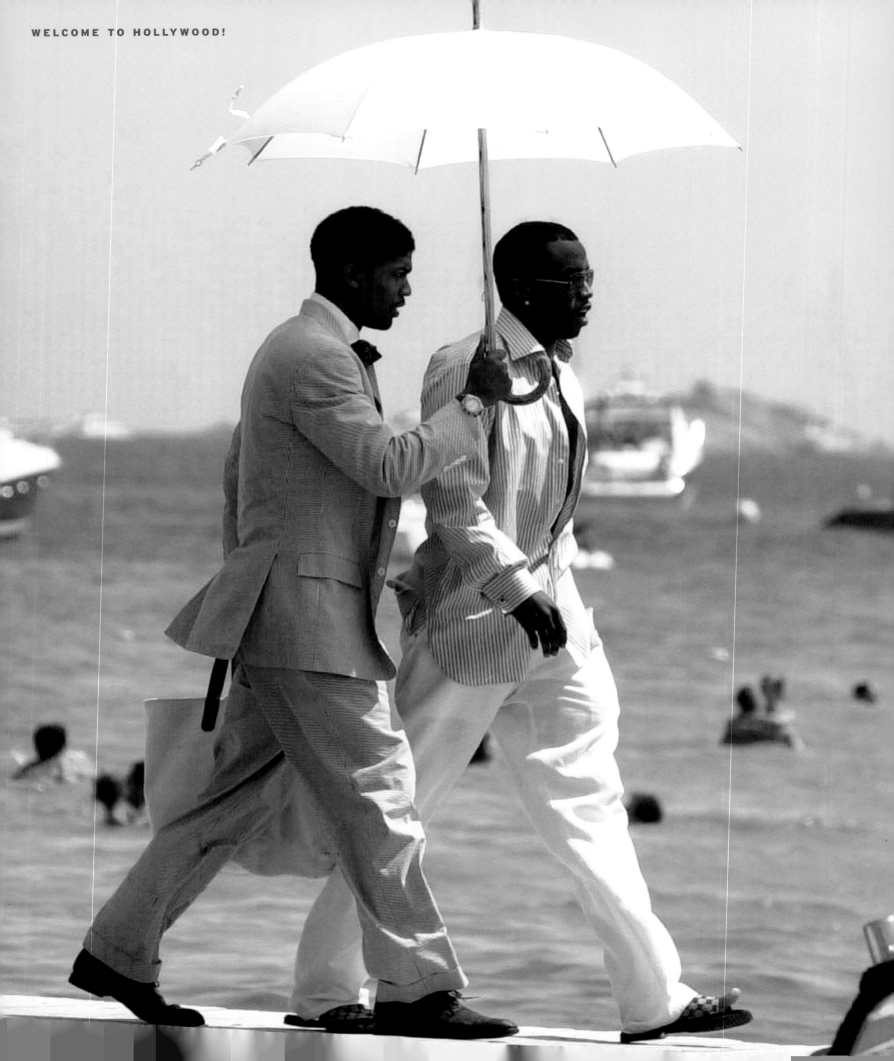

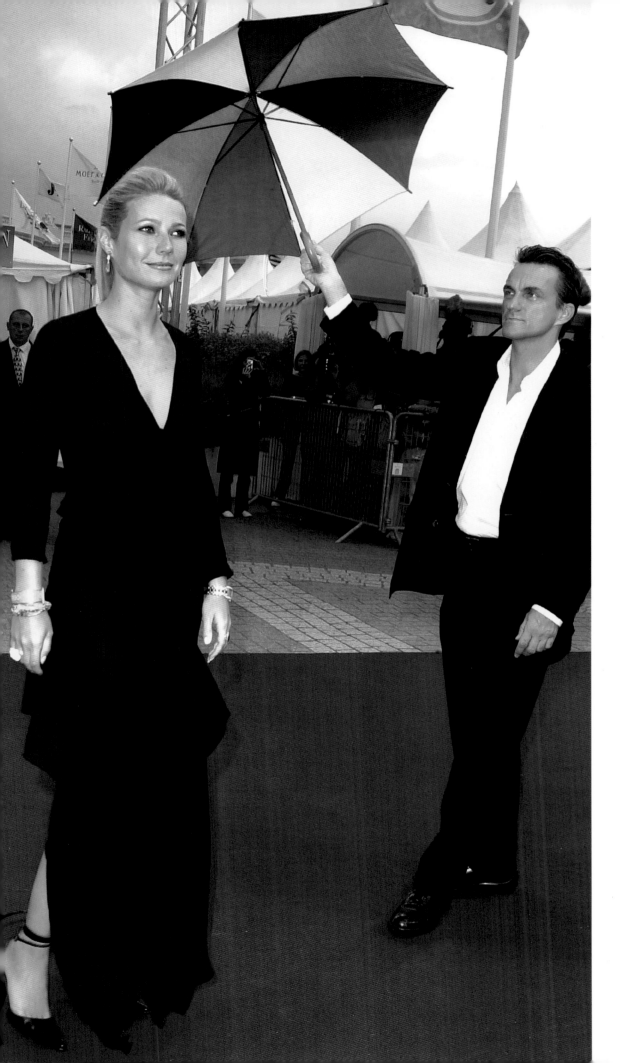

P. Diddy

OPPOSITE: Personal Umbrella Handlers (PUH)! Diddy, then 31, showed up in St-Tropez in July 2001 with dapperly dressed, umbrella-toting personal assistant Fonzworth Bentley, 27.

Gwyneth Paltrow

THIS PAGE: Paltrow, then 29, stayed dry at the September 2002 premiere of *Possession* at the Deauville Festival of American Film in France, thanks to her publicist, Stephen Huvane.

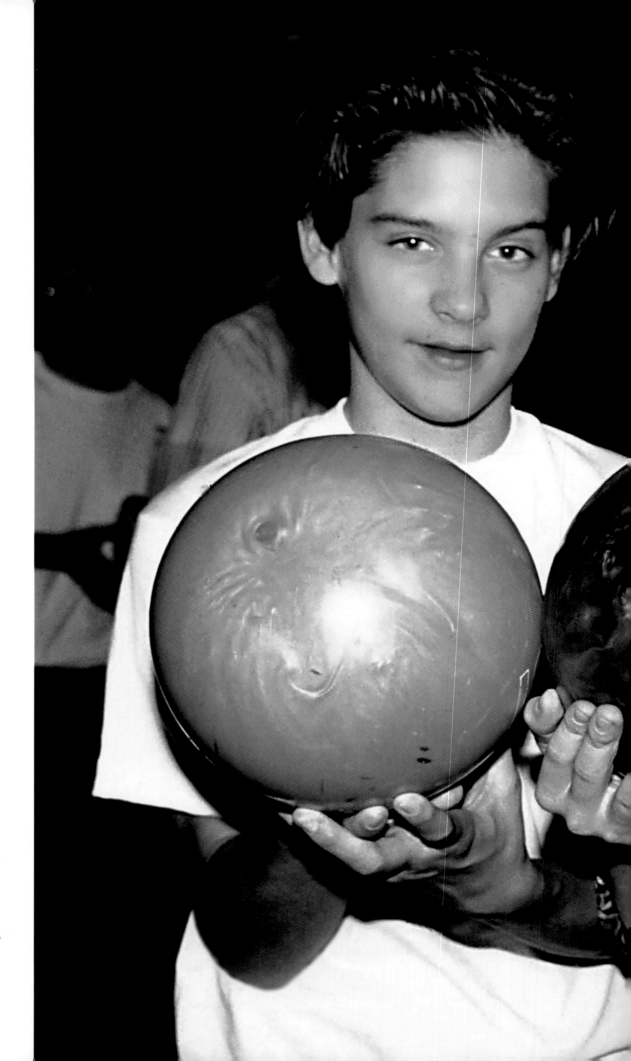

Tobey Maguire & Leonardo DiCaprio
Who would have guessed these scrawny 15-year-olds (here at the American Youth Awards' bowling tournament in L.A. on October 15, 1990) would one day strike it big as the stars of *Spider-Man* and *Titanic* and make women around the world swoon?

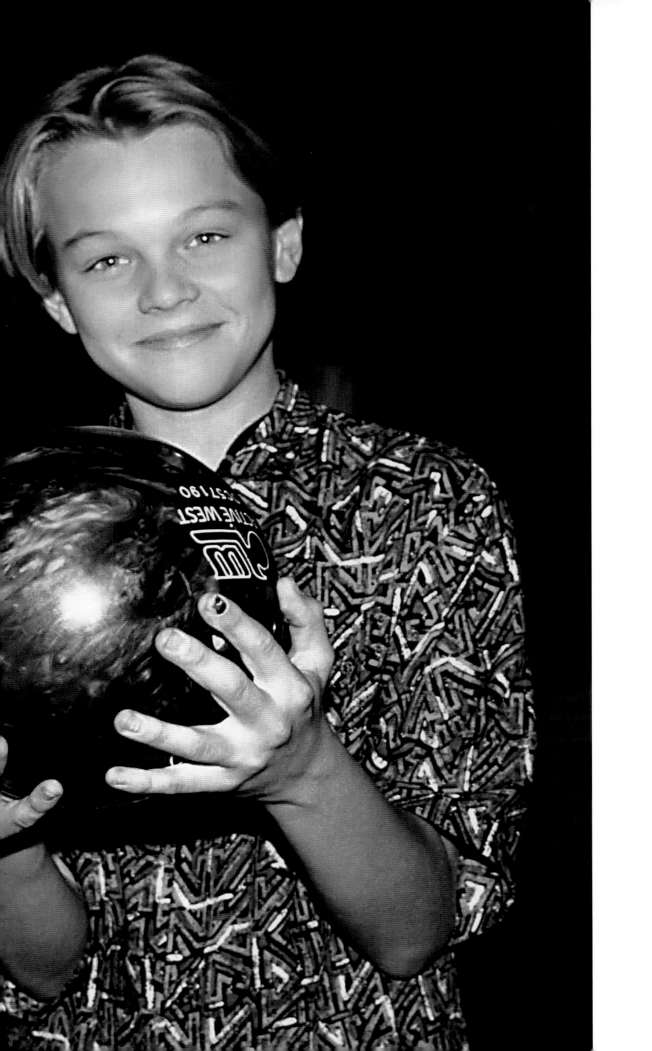

Courteney Cox & Helen Hunt
Under the gaze of their respective husbands, David Arquette, then 28, and Hank Azaria, 35, newlyweds Cox, 35, and Hunt, 36, checked out each other's rings when they met up at the premiere of *Three to Tango* on October 19, 1999.

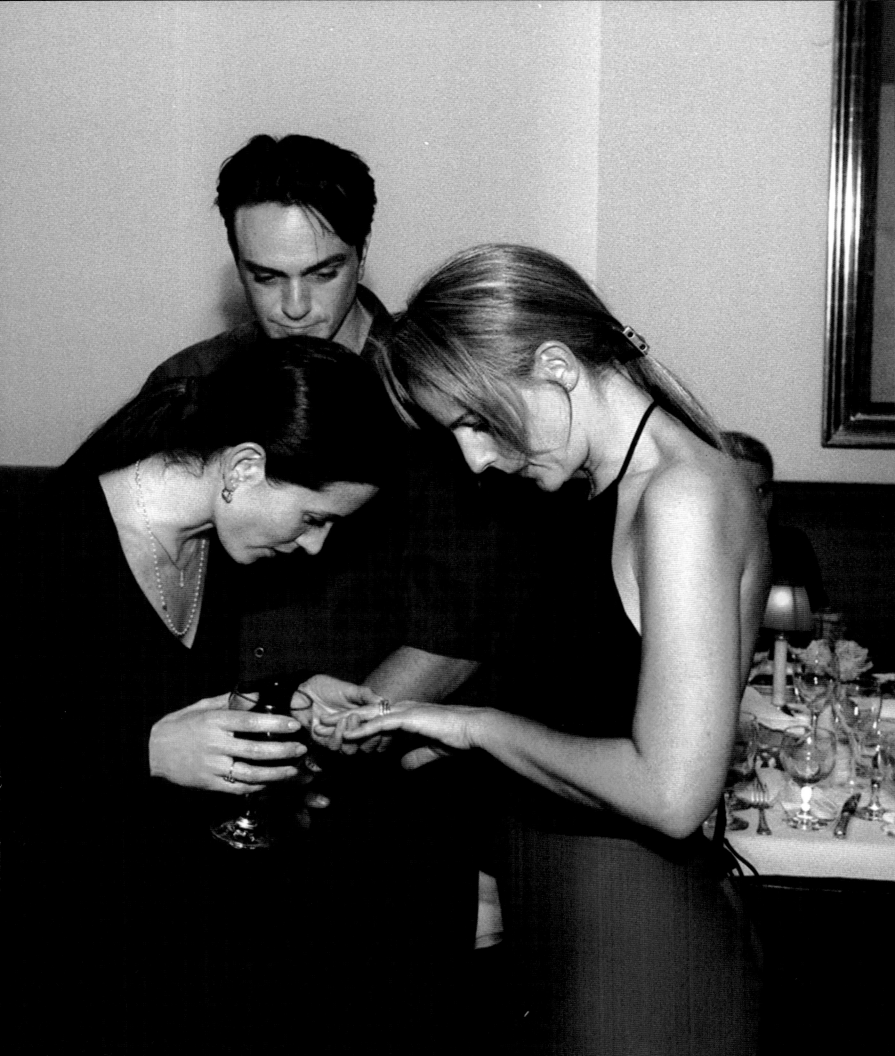

Jessica Simpson & Nick Lachey

The Newlyweds met some four-legged fans after they performed at the Houston Livestock Show and Rodeo on March 16, 2004. Lachey told a nervous Simpson, "Don't worry, they won't bite!"

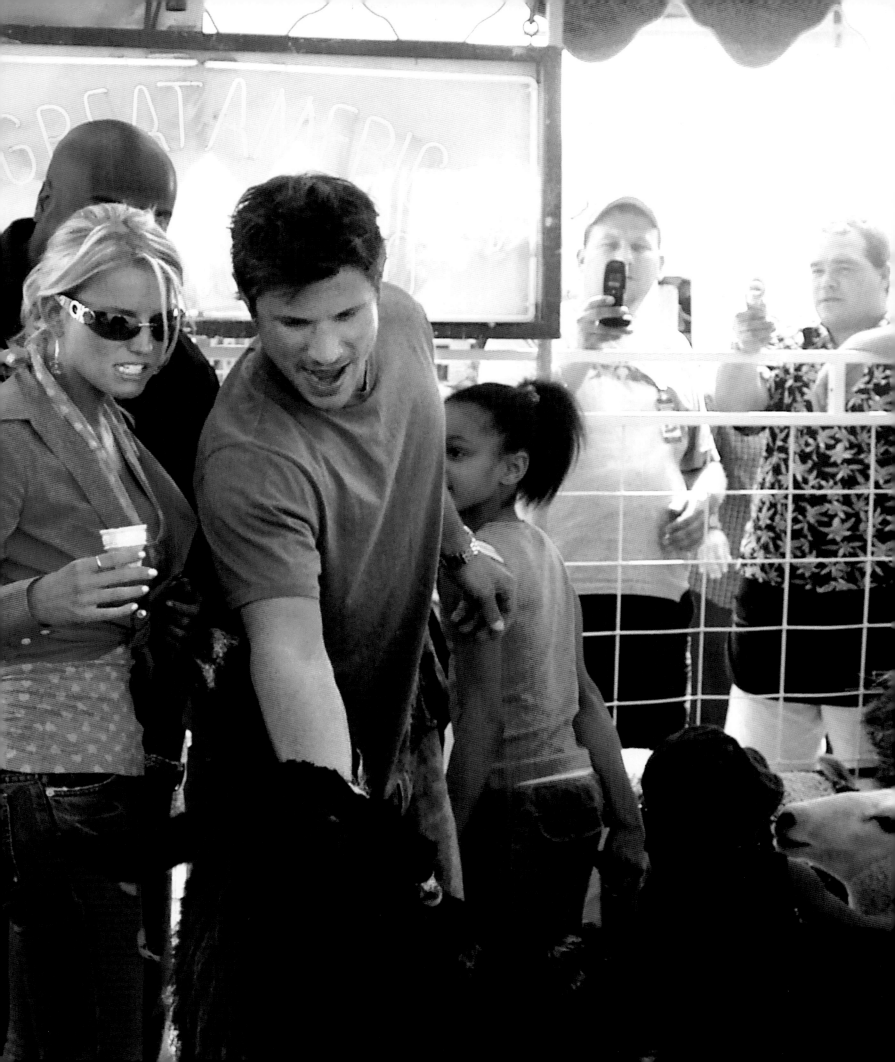

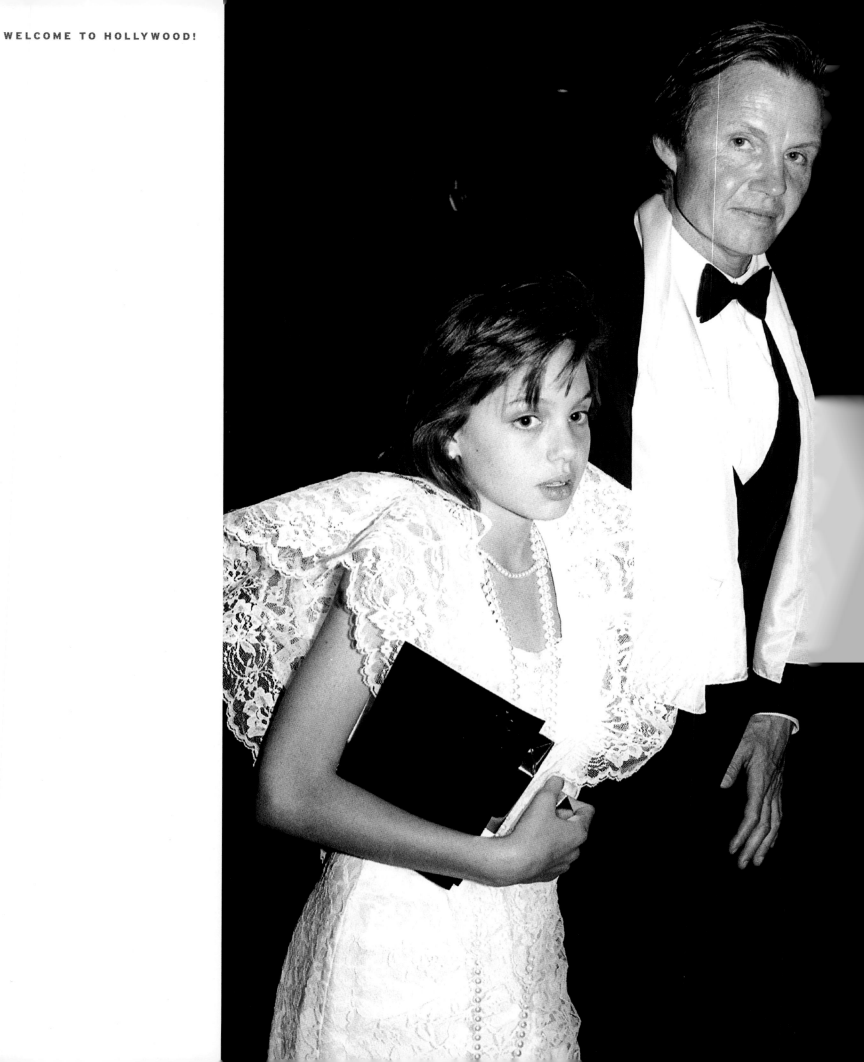

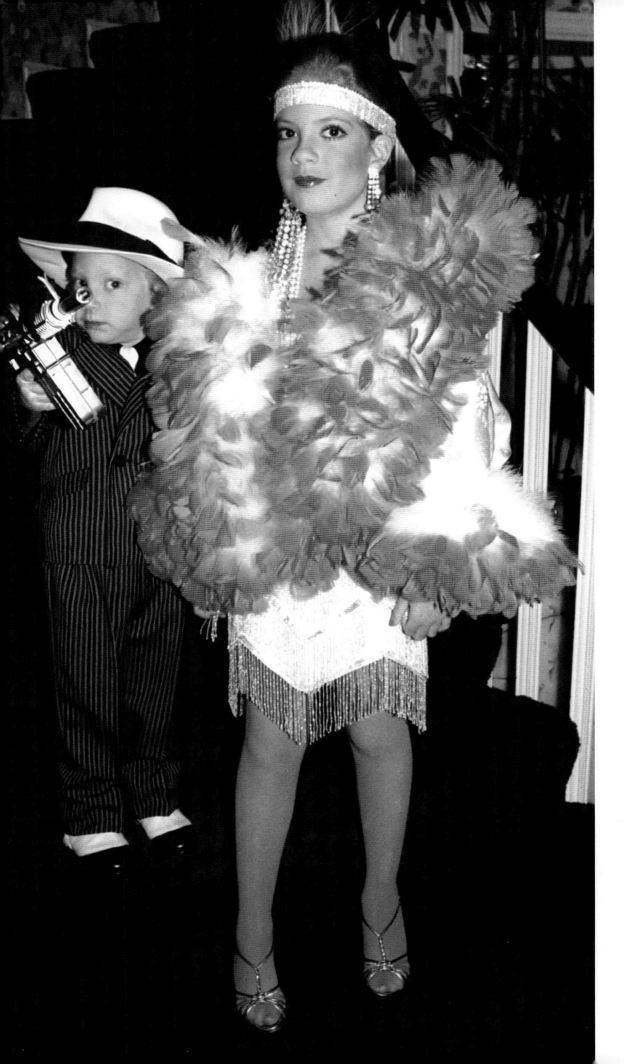

Angelina Jolie & Jon Voight

OPPOSITE: At the March 1986 Academy Awards' Governors Ball, daddy and daughter, then 10, stepped out in style together. The pair are now estranged.

Randy & Tori Spelling

THIS PAGE: In 1982, when father Aaron Spelling was producing *Dynasty*, his gangster son, Randy, then 4, and flapper daughter, Tori, 9, packed heat for a Roaring '20s Halloween bash.

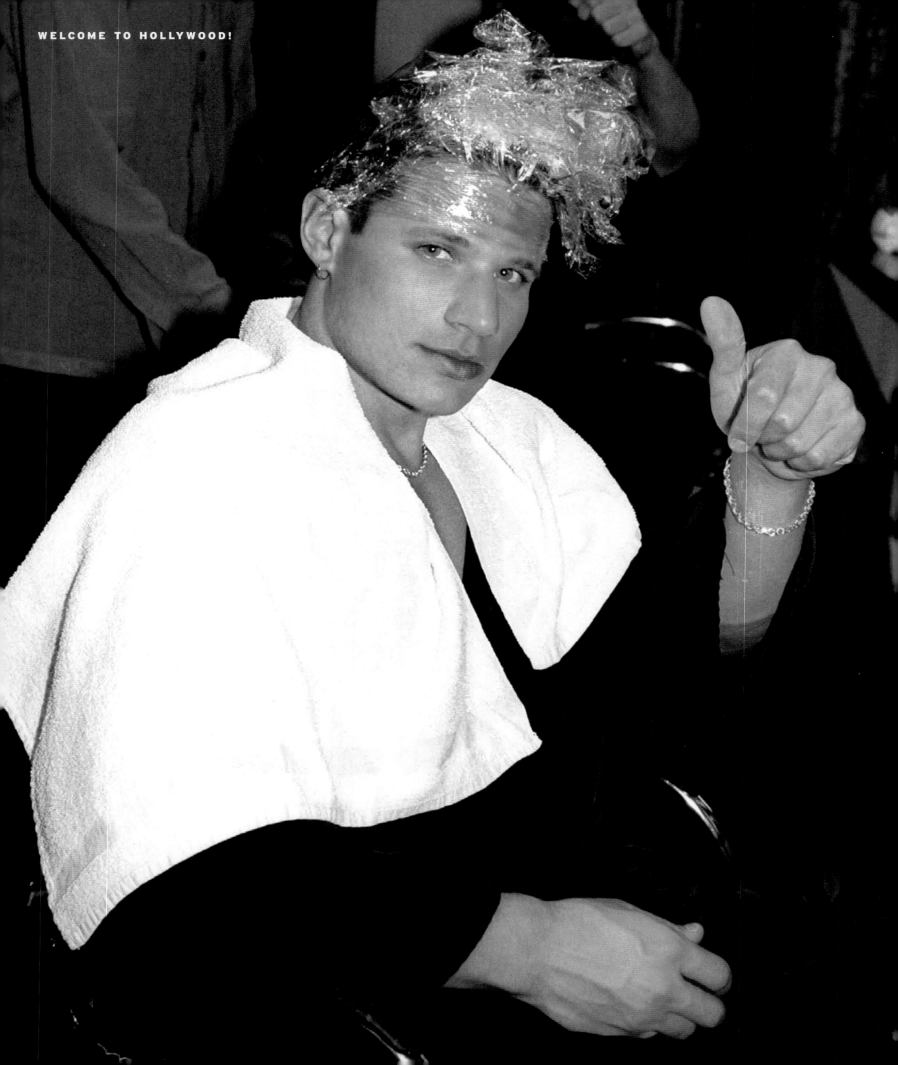

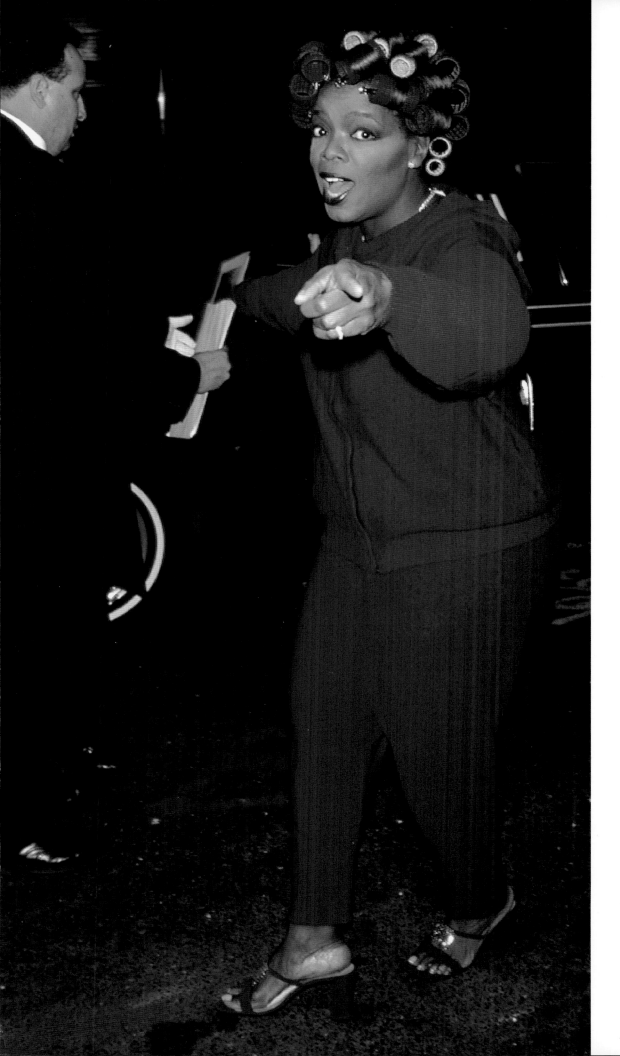

Nick Lachey

OPPOSITE: 98 Degrees singer Lachey, then 24, lit up his locks with a trip to a NYC salon in August 1998, just a few months before meeting future wife Jessica Simpson.

Oprah Winfrey

THIS PAGE: The curler-covered talk-show hostess, then 46, sure wasn't red-carpet ready when she rolled into NYC's Radio City Music Hall on April 14, 2000, to host the Essence Awards.

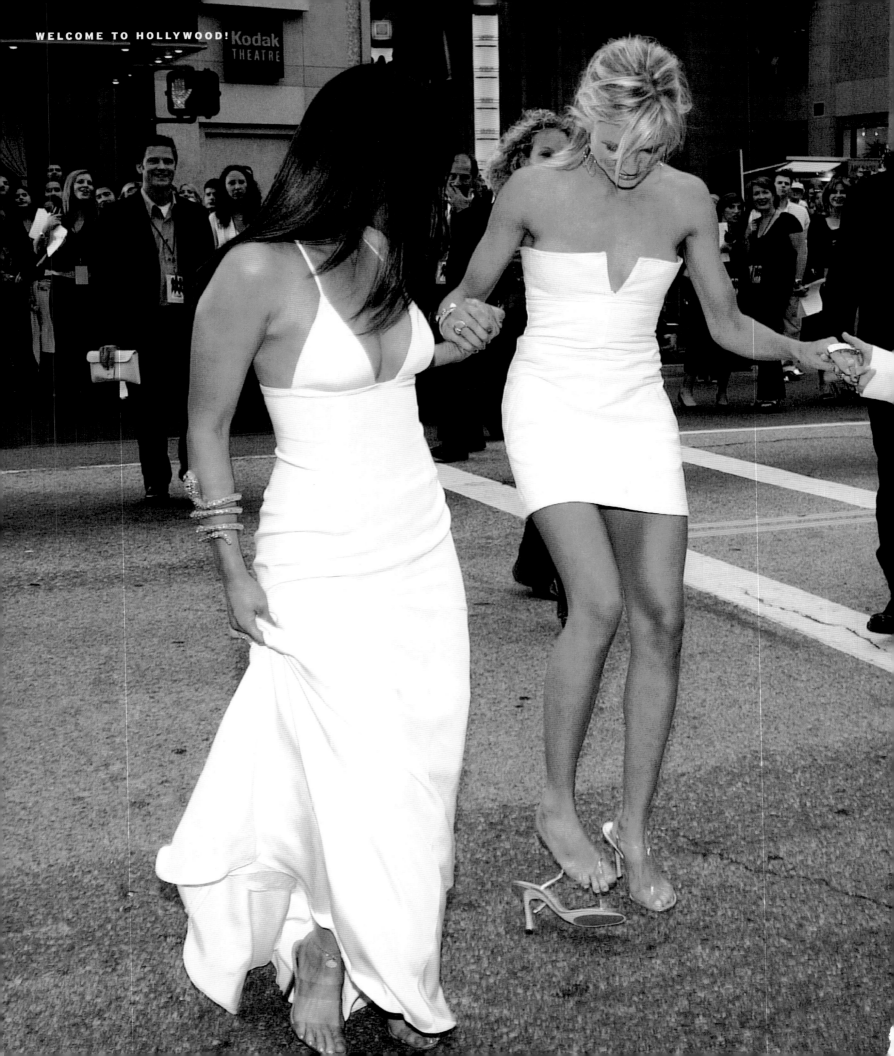

Lucy Liu, Cameron Diaz & Drew Barrymore

Diaz, then 30, had best friends Barrymore, 28, and Liu, 35, to help when her Manolo Blahnik snapped at the June 18, 2003, premiere of *Charlie's Angels: Full Throttle* in Hollywood. "We all lean on each other," Diaz has said of the trio.

33

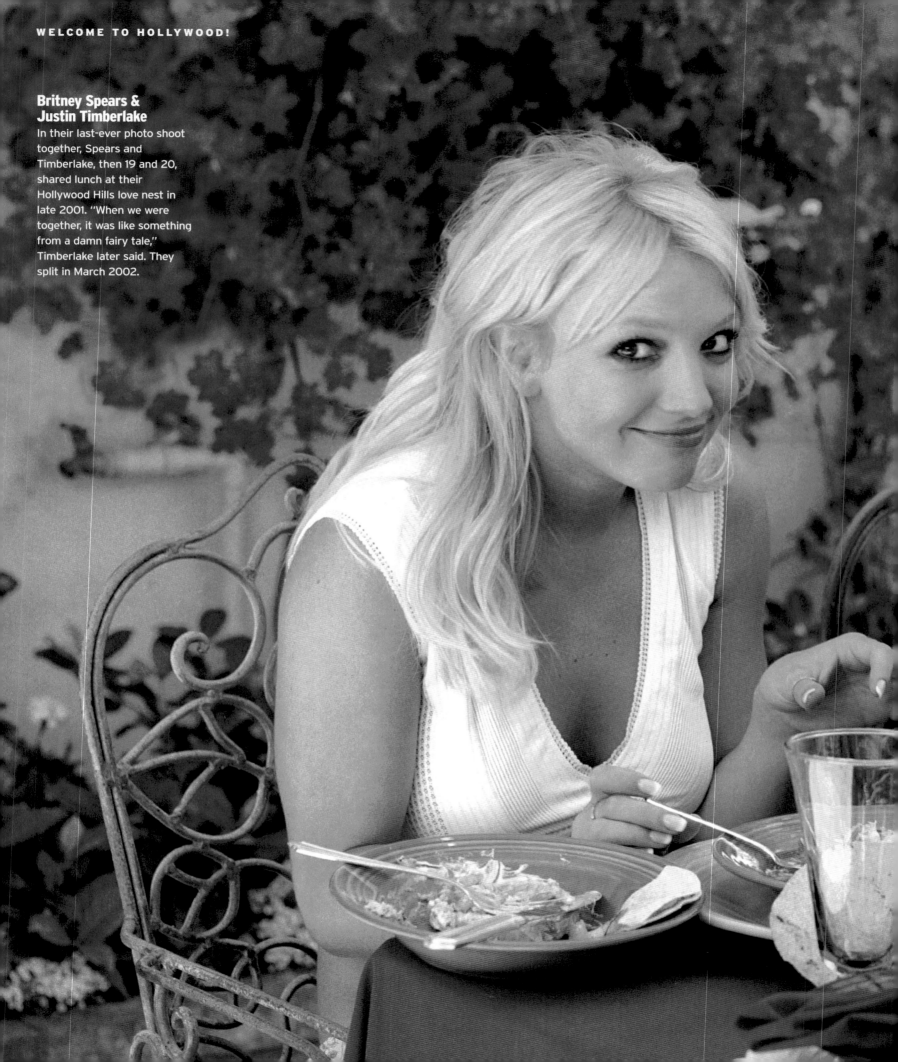

**Britney Spears &
Justin Timberlake**
In their last-ever photo shoot
together, Spears and
Timberlake, then 19 and 20,
shared lunch at their
Hollywood Hills love nest in
late 2001. "When we were
together, it was like something
from a damn fairy tale,"
Timberlake later said. They
split in March 2002.

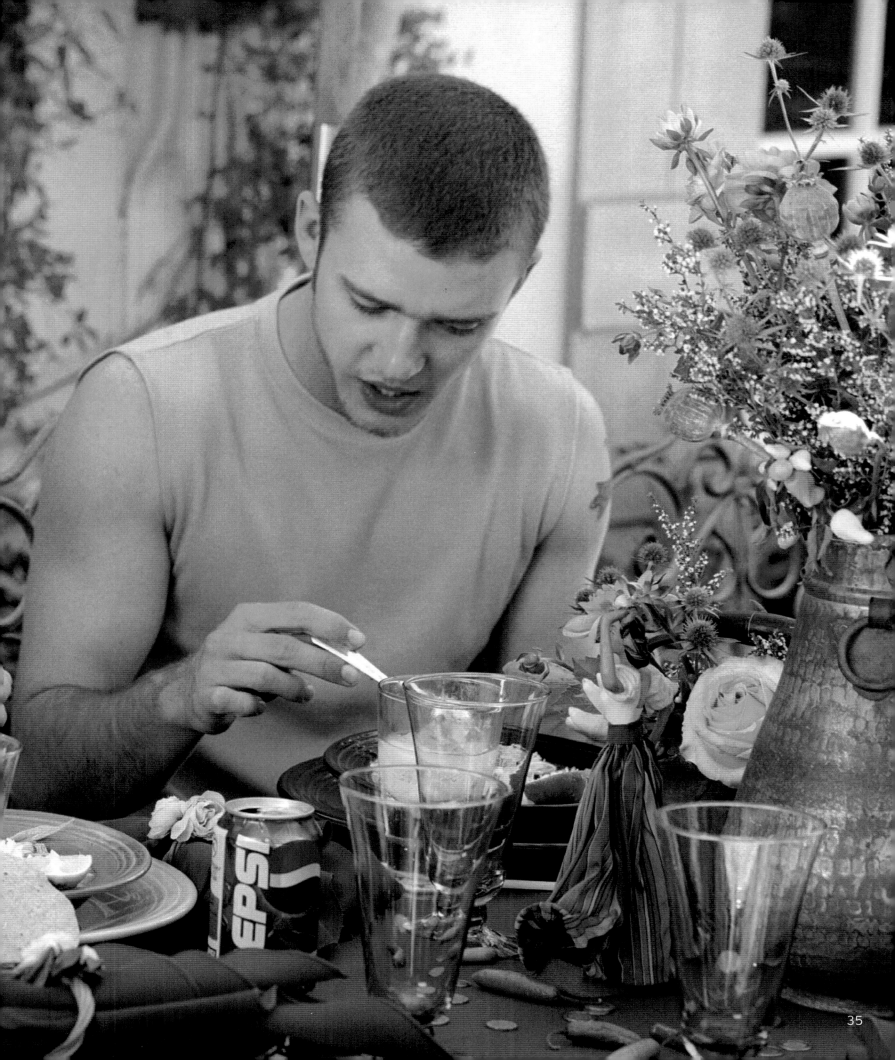

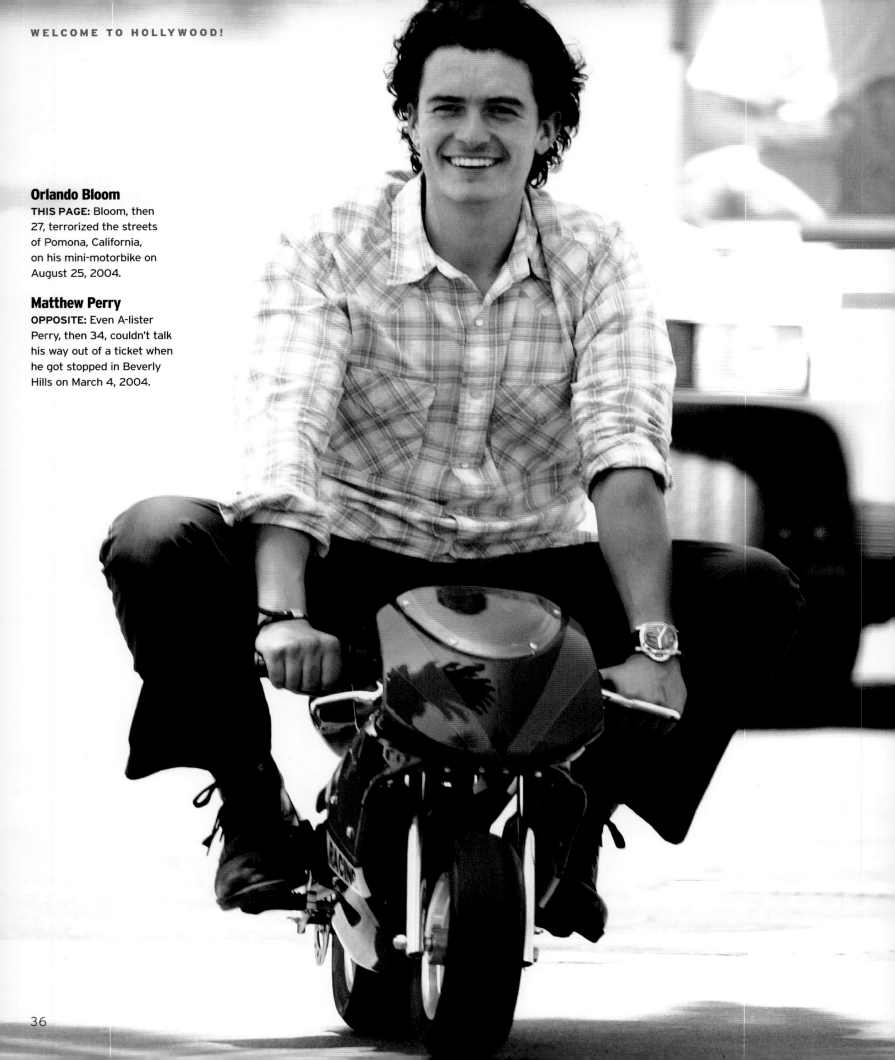

Orlando Bloom
THIS PAGE: Bloom, then 27, terrorized the streets of Pomona, California, on his mini-motorbike on August 25, 2004.

Matthew Perry
OPPOSITE: Even A-lister Perry, then 34, couldn't talk his way out of a ticket when he got stopped in Beverly Hills on March 4, 2004.

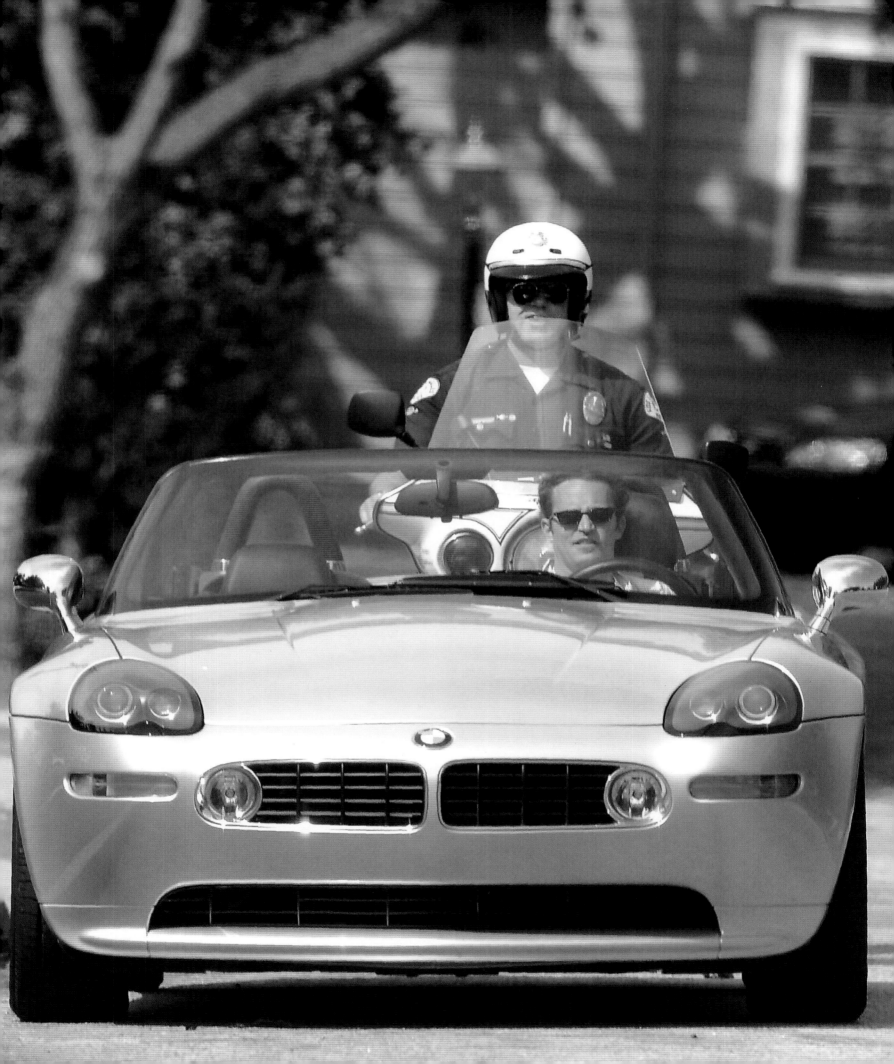

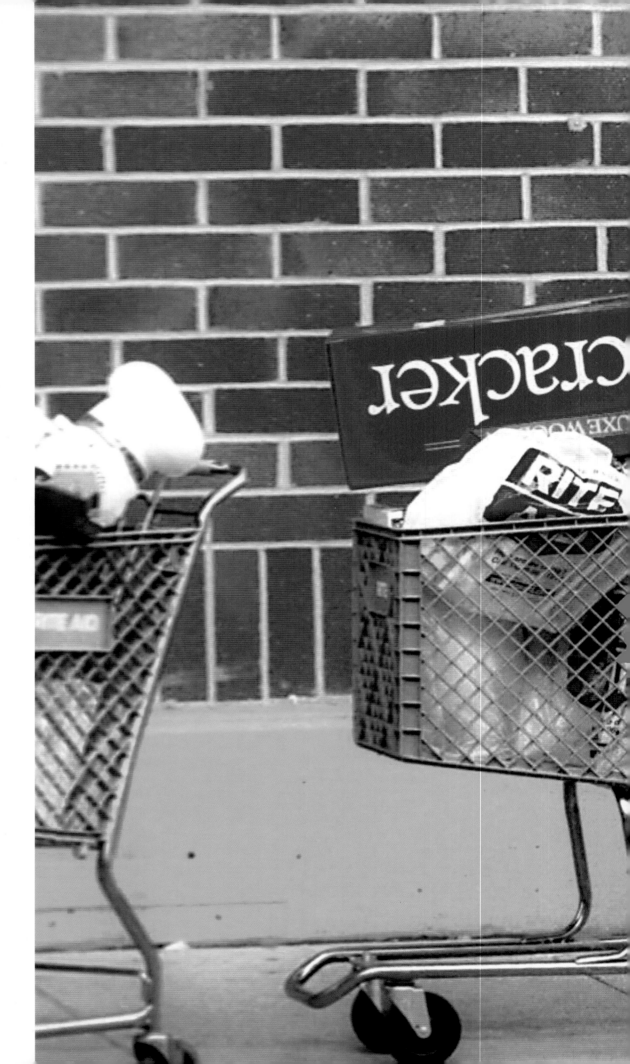

Johnny Depp

On December 7, 2002, the expat actor, then 39, stocked up on festive basics at a Hollywood Rite-Aid before heading home to France to celebrate the holidays with girlfriend Vanessa Paradis, daughter Lily-Rose, 3, and son Jack, nearly 8 months.

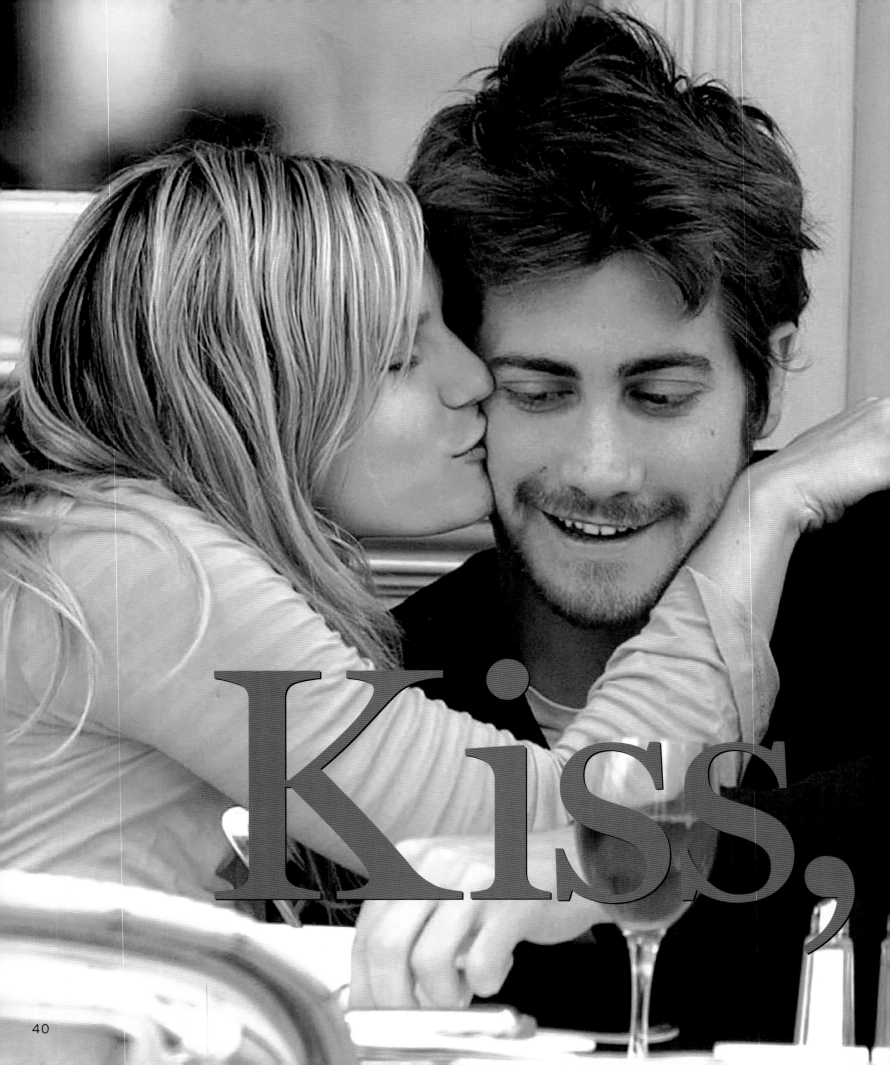

Kiss,

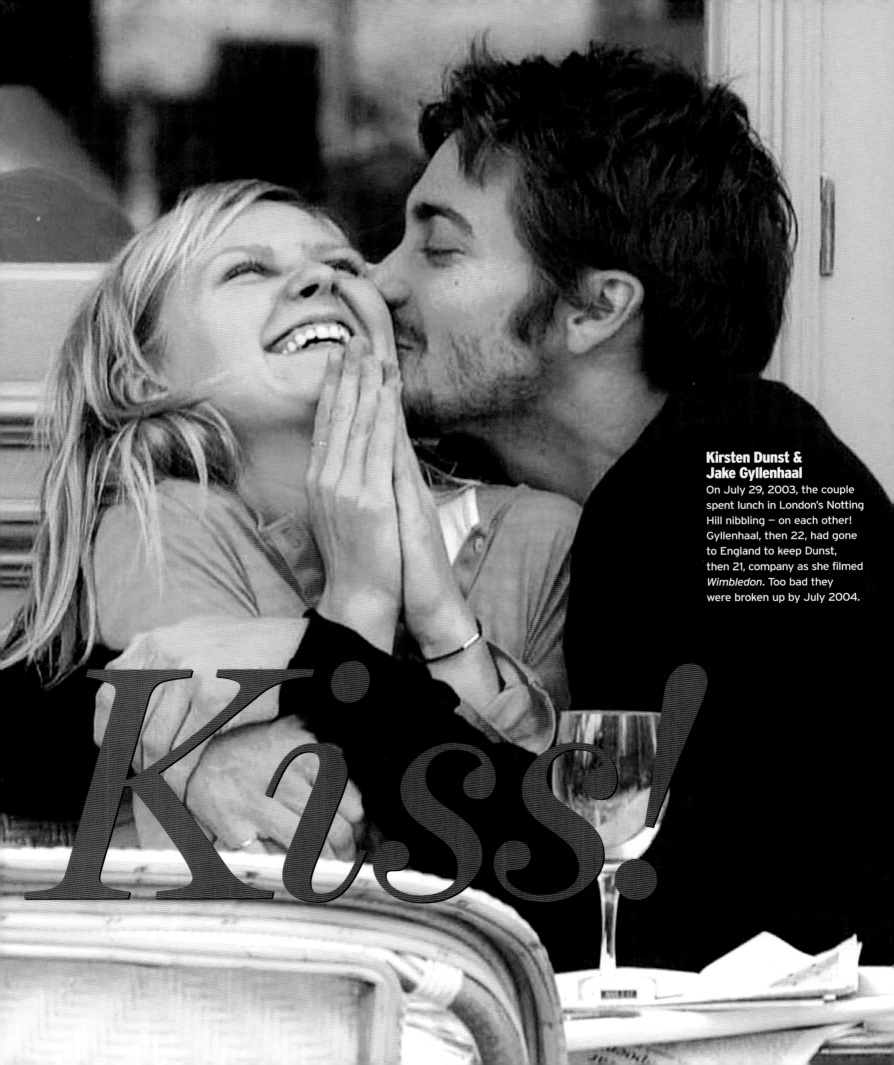

Kirsten Dunst & Jake Gyllenhaal
On July 29, 2003, the couple spent lunch in London's Notting Hill nibbling – on each other! Gyllenhaal, then 22, had gone to England to keep Dunst, then 21, company as she filmed *Wimbledon*. Too bad they were broken up by July 2004.

Kiss!

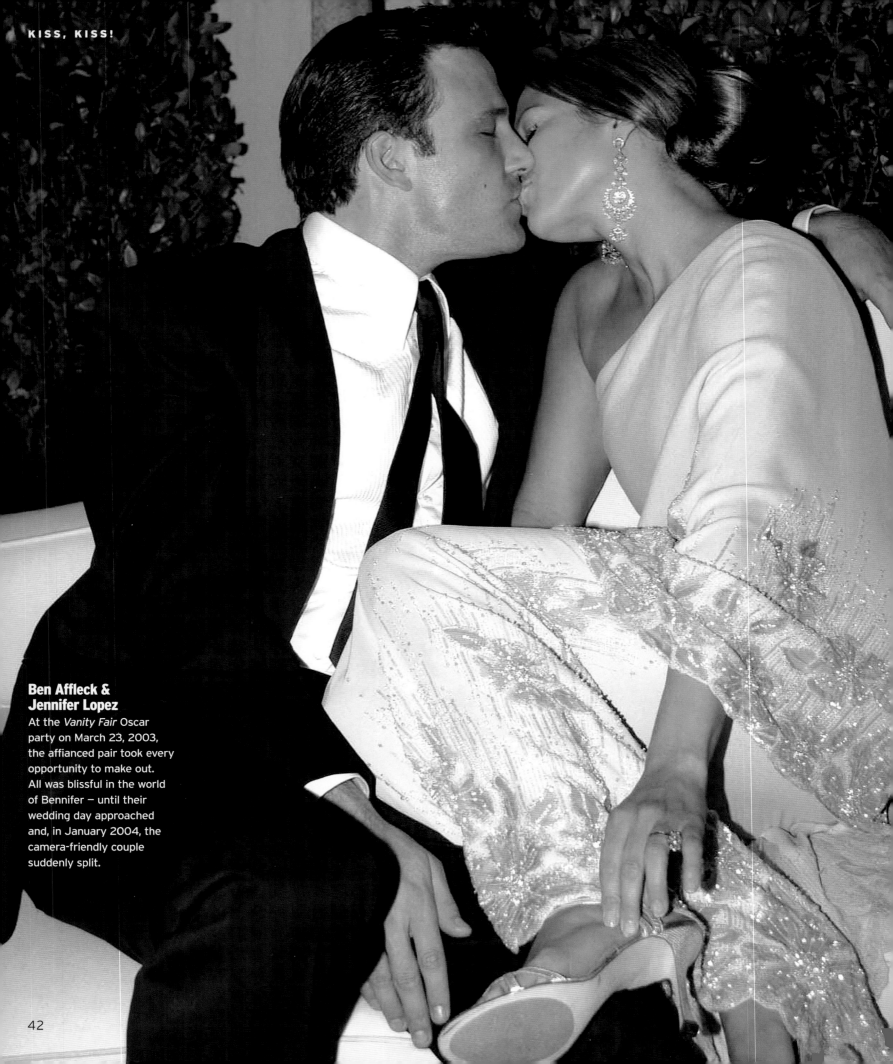

Ben Affleck & Jennifer Lopez
At the *Vanity Fair* Oscar party on March 23, 2003, the affianced pair took every opportunity to make out. All was blissful in the world of Bennifer — until their wedding day approached and, in January 2004, the camera-friendly couple suddenly split.

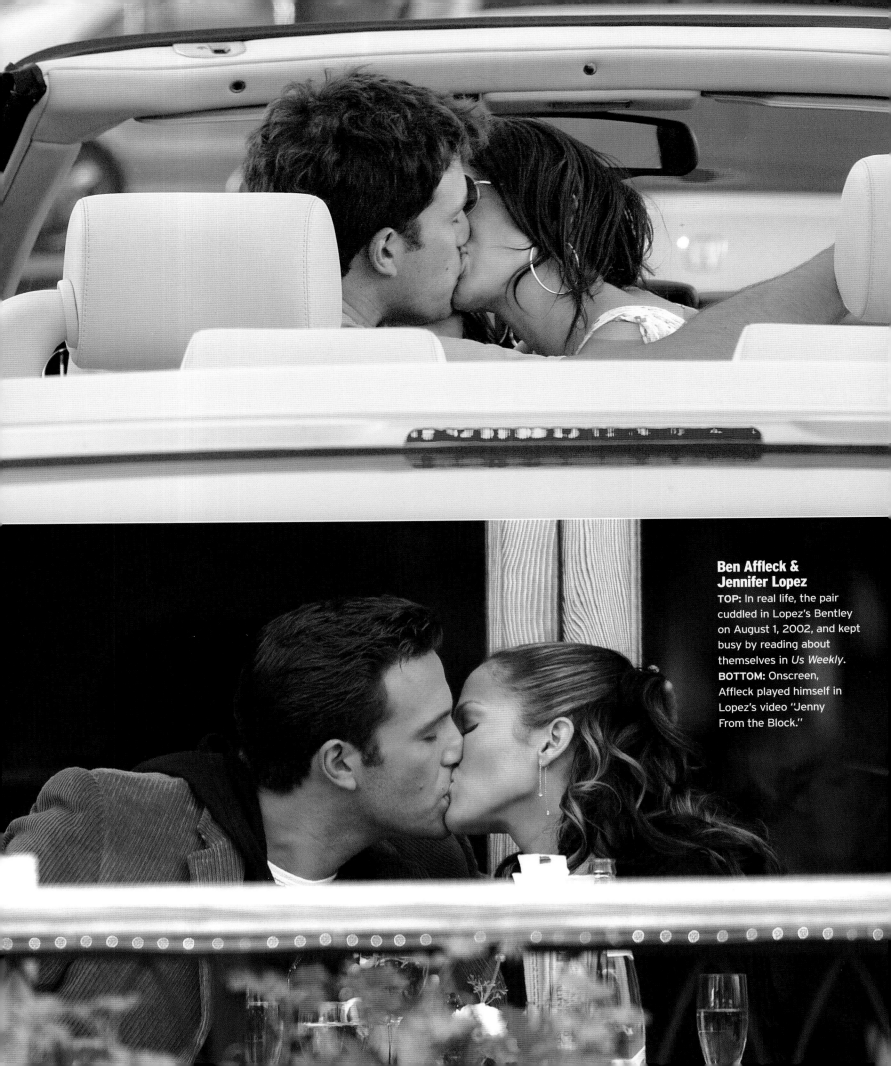

**Ben Affleck &
Jennifer Lopez**
TOP: In real life, the pair
cuddled in Lopez's Bentley
on August 1, 2002, and kept
busy by reading about
themselves in *Us Weekly*.
BOTTOM: Onscreen,
Affleck played himself in
Lopez's video "Jenny
From the Block."

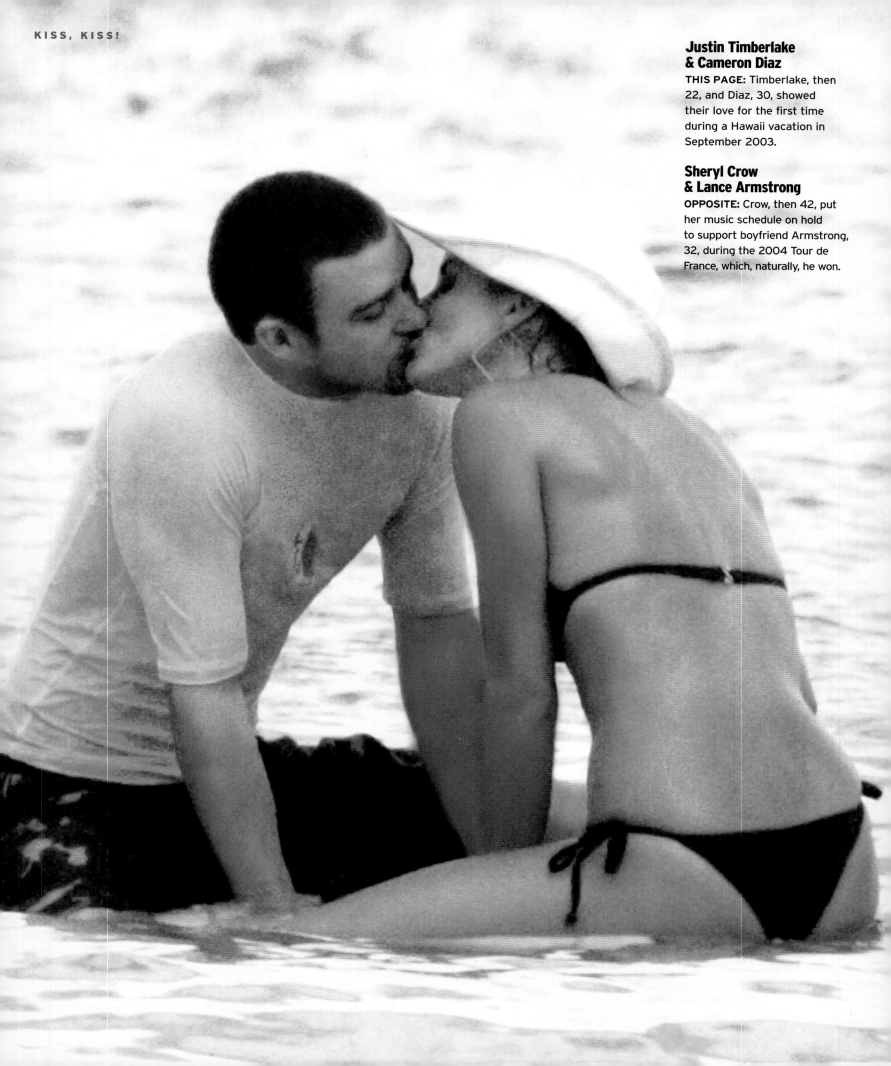

Justin Timberlake & Cameron Diaz
THIS PAGE: Timberlake, then 22, and Diaz, 30, showed their love for the first time during a Hawaii vacation in September 2003.

Sheryl Crow & Lance Armstrong
OPPOSITE: Crow, then 42, put her music schedule on hold to support boyfriend Armstrong, 32, during the 2004 Tour de France, which, naturally, he won.

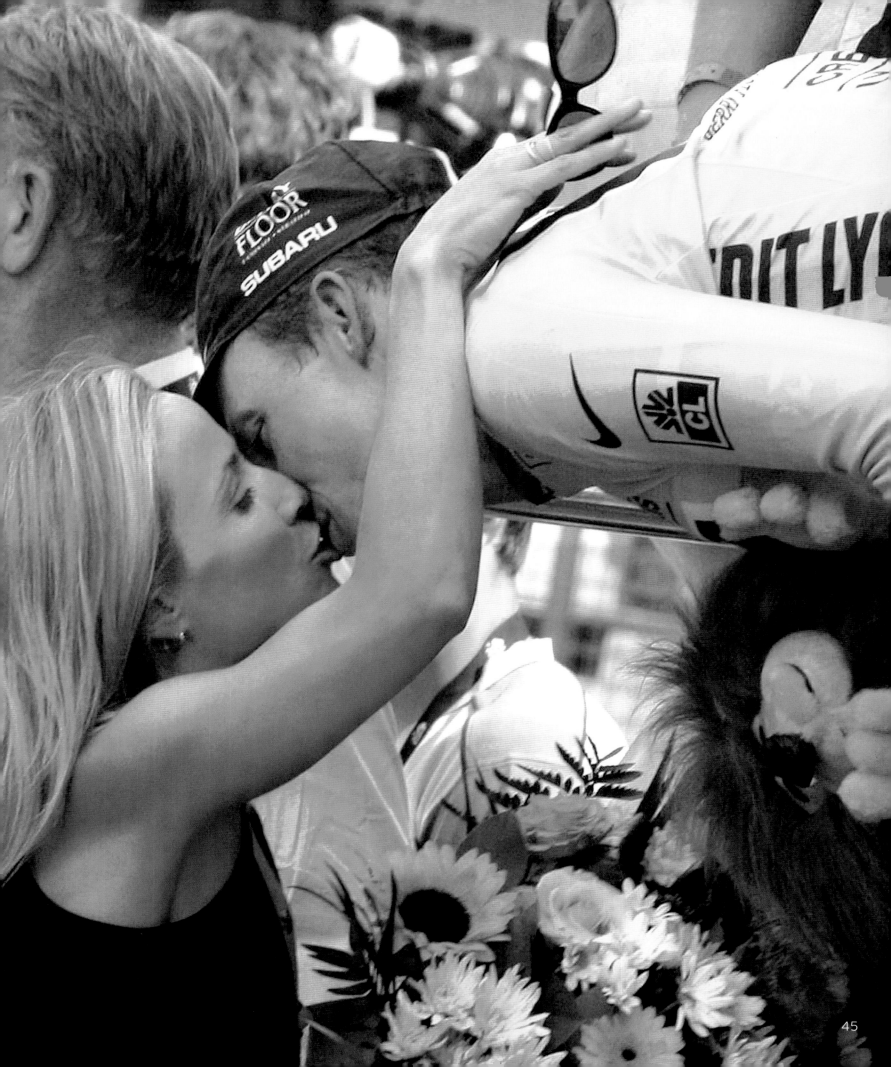

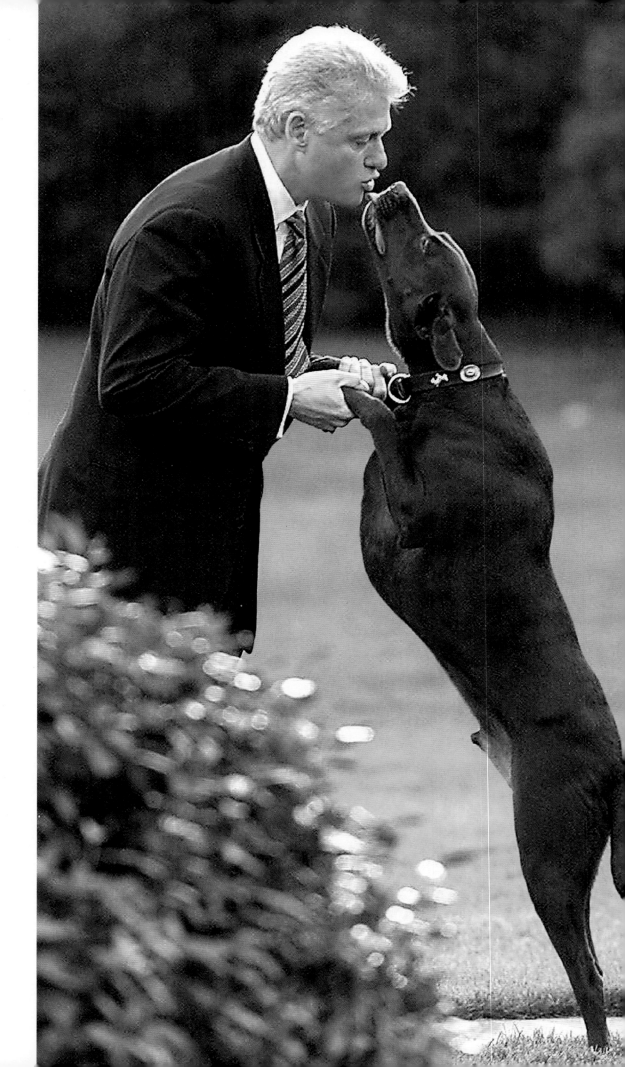

Bill Clinton & Buddy

THIS PAGE: President Clinton, then 53, still in the doghouse with wife Hillary two years after the Monica Lewinsky scandal, shared a wet-nose moment with his chocolate Lab, Buddy, on December 8, 1999.

Al & Tipper Gore

OPPOSITE: Who knew he had it in him? Vice President Gore shocked everyone at the Democratic National Convention in L.A. on August 17, 2000, by planting a nice big one on wife Tipper, who looked plenty surprised herself!

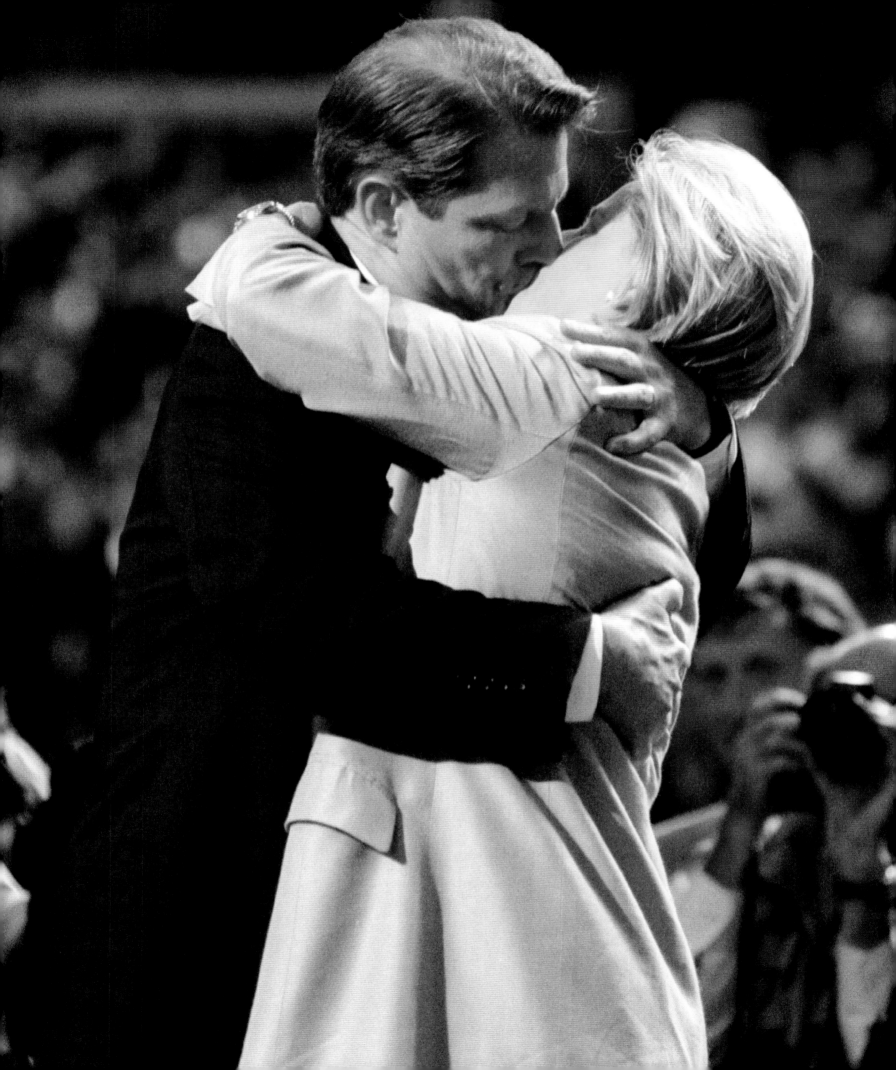

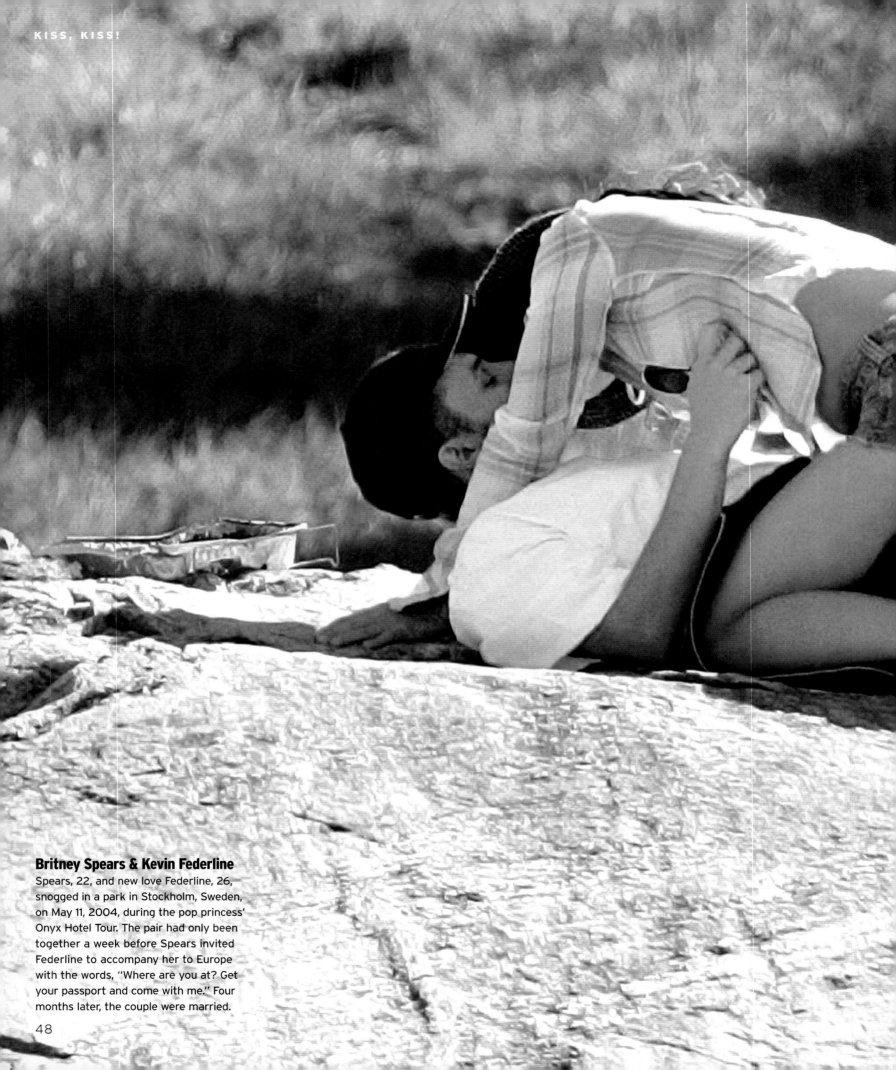

Britney Spears & Kevin Federline
Spears, 22, and new love Federline, 26, snogged in a park in Stockholm, Sweden, on May 11, 2004, during the pop princess' Onyx Hotel Tour. The pair had only been together a week before Spears invited Federline to accompany her to Europe with the words, "Where are you at? Get your passport and come with me." Four months later, the couple were married.

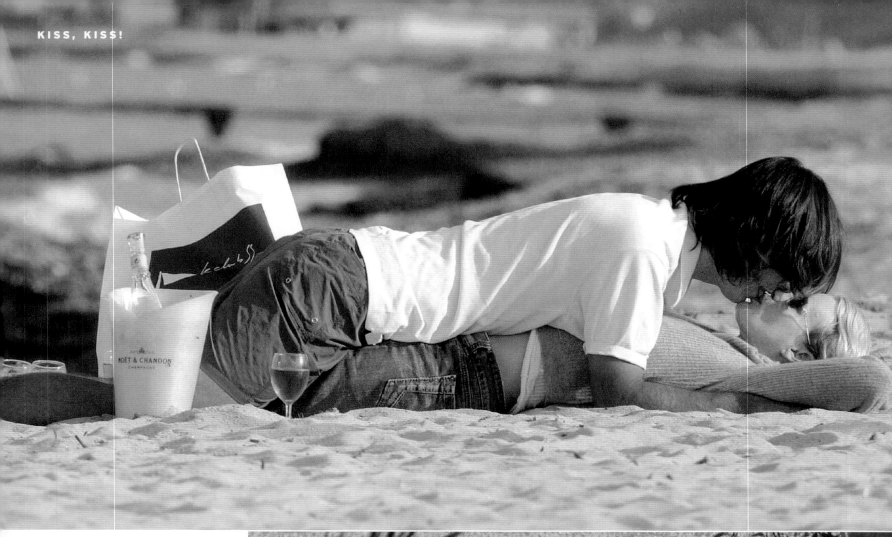

**Daryl Hannah &
Sean McPherson**

TOP: Hannah, then 43, and new boyfriend McPherson enjoyed wine, sunshine and the beach at St-Tropez on May 17, 2004.

**Heather Graham
& Heath Ledger**

RIGHT: A nine-year age gap didn't stop the *Four Feathers* star, then 21, from enjoying some poolside petting with Graham, 30, at the Berbere Palace Hotel in Ouarzazate, Morocco, on November 10, 2000.

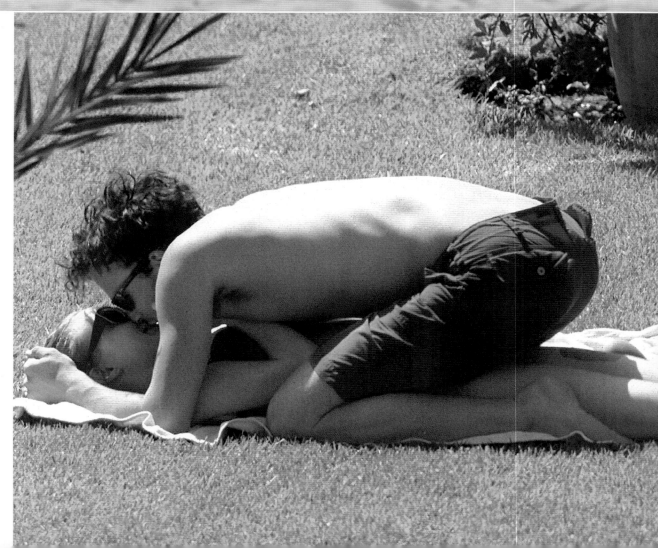

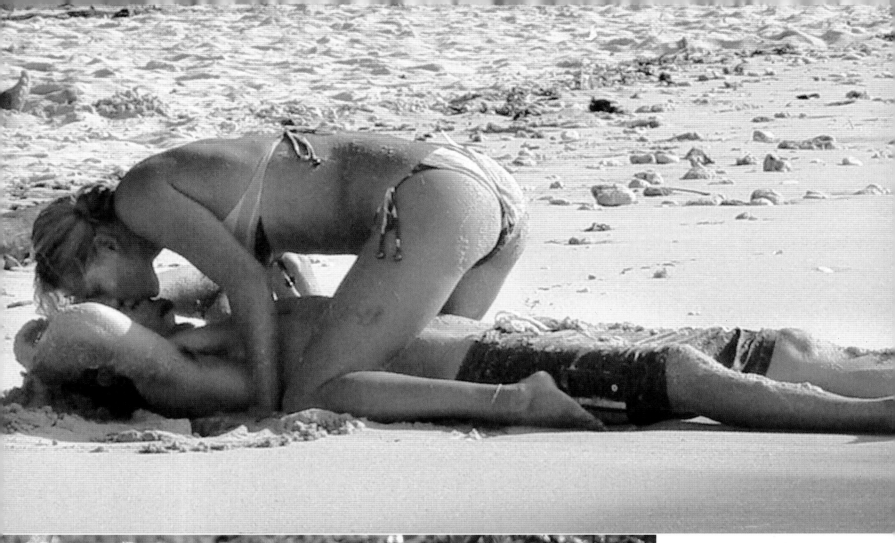

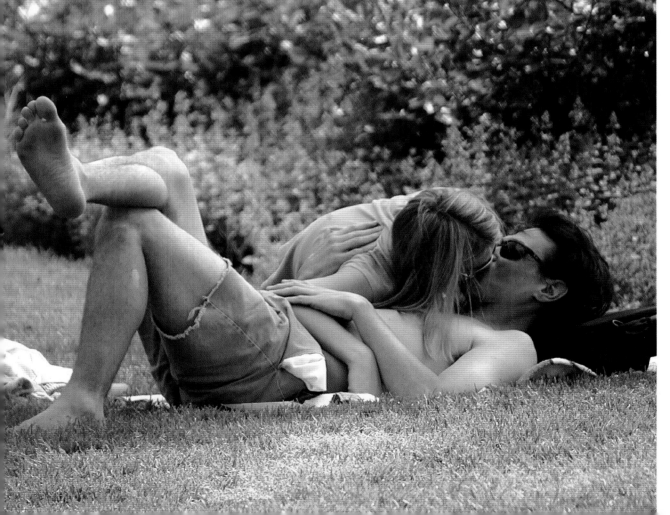

Anna Kournikova & Enrique Iglesias

TOP: The couple indulged in a sandy smooch in Indonesia on March 30, 2004. "She's one of the sexiest women in the world," said Iglesias, then 29, of the tennis pro, 22.

Claire Danes & Billy Crudup

LEFT: Danes, then 25, and Crudup, 36, got comfortable on the set of *Stage Beauty*. Months later in May 2004, the couple spent a lazy afternoon K-I-S-S-I-N-G in NYC's Battery Park.

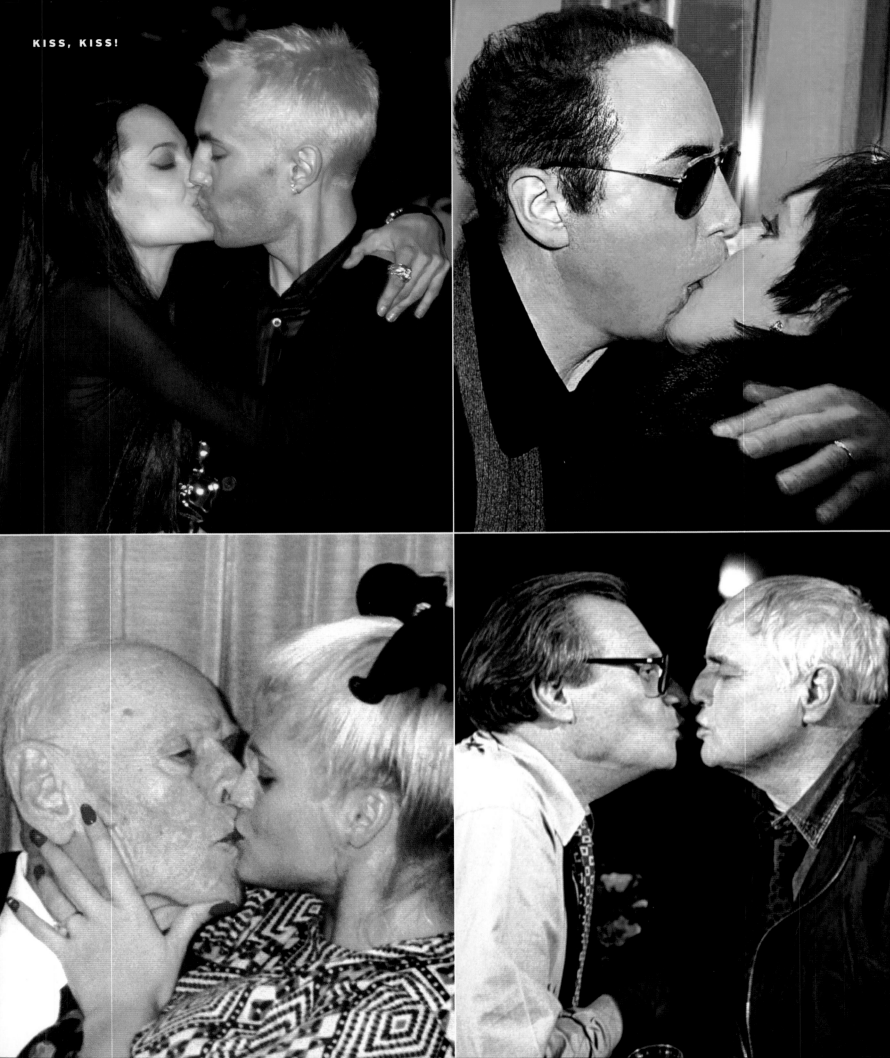

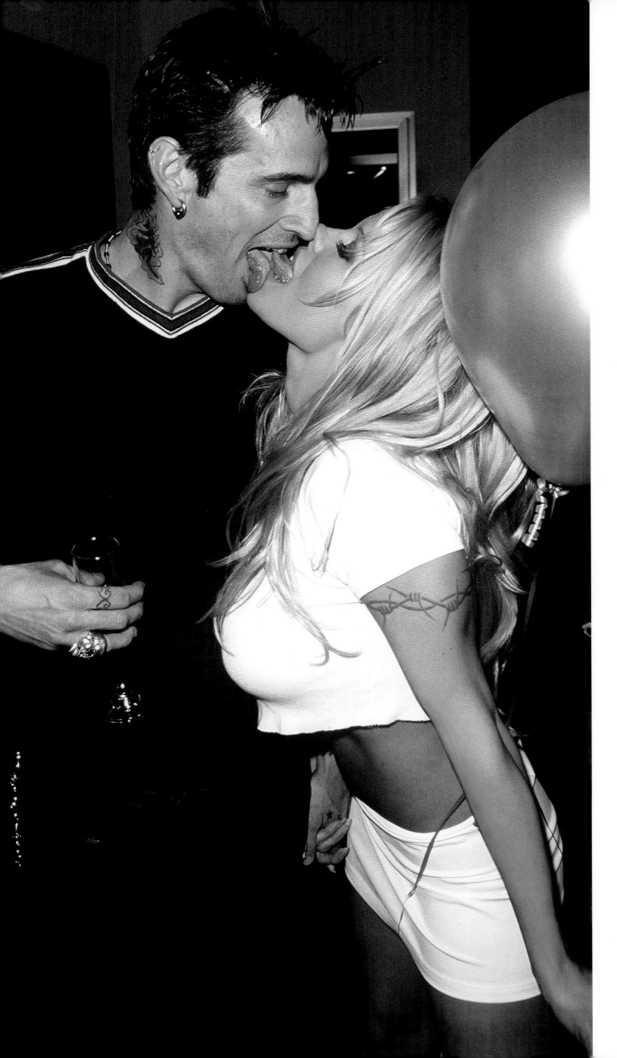

THIS PAGE:

Pamela Anderson & Tommy Lee

"I picture Tommy and me old, toothless, on a bench somewhere with our tattoos," Anderson once said. Indeed, she and Lee (then 30 and 35) looked happy at a Rolling Stones concert in Las Vegas on February 15, 1998, but they filed for divorce weeks later.

OPPOSITE, CLOCKWISE FROM TOP LEFT:

Angelina Jolie & James Haven

Jolie, then 24, shocked at the Oscars in 2000 when she sucked some unsisterly face with her date, brother Haven, 26.

Liza Minnelli & David Gest

In Rome in April 2002, the romantic Gest, then 48, gave his new wife, 56, a very public smooch.

Larry King & Marlon Brando

Guest Brando gave King a peck he couldn't refuse while taping *Larry King Live* in 1994.

Anna Nicole Smith & J. Howard Marshall II

Model Smith, then 26, wed 89-year-old oil tycoon Marshall — worth more than $400 million — in 1994, only to have him die the very next year and leave her nothing!

53

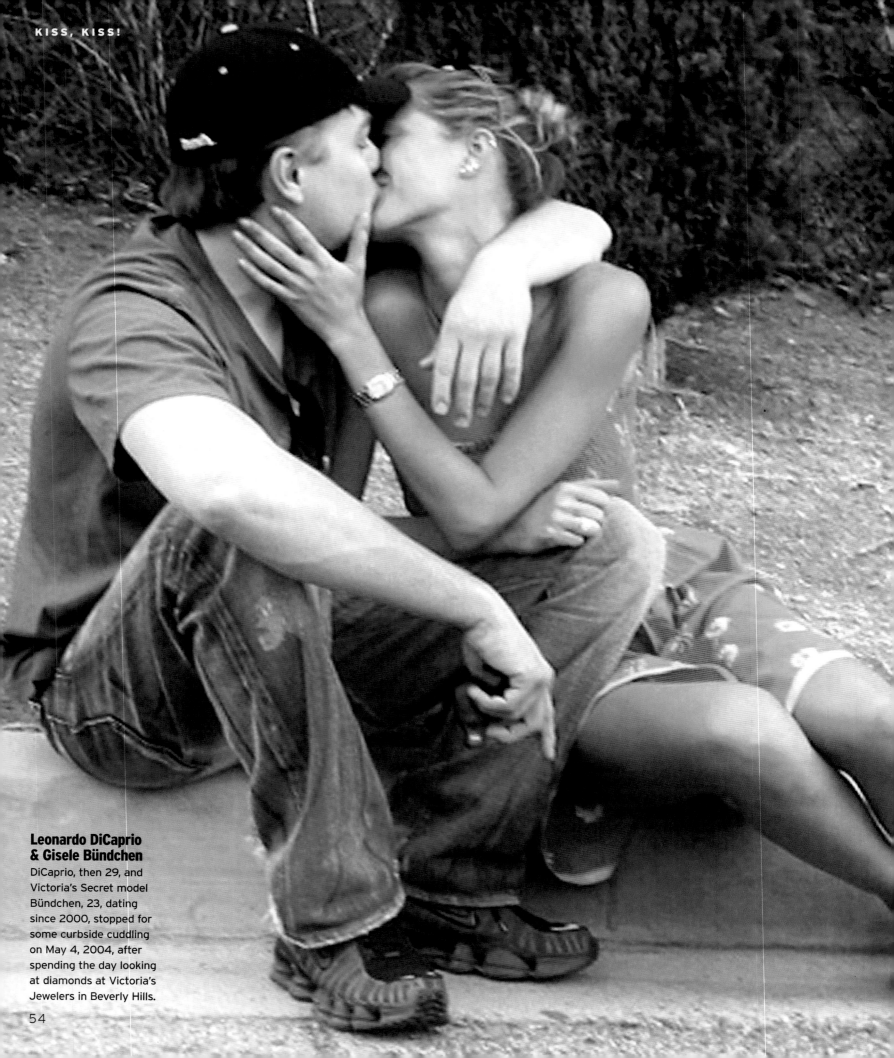

**Leonardo DiCaprio
& Gisele Bündchen**
DiCaprio, then 29, and
Victoria's Secret model
Bündchen, 23, dating
since 2000, stopped for
some curbside cuddling
on May 4, 2004, after
spending the day looking
at diamonds at Victoria's
Jewelers in Beverly Hills.

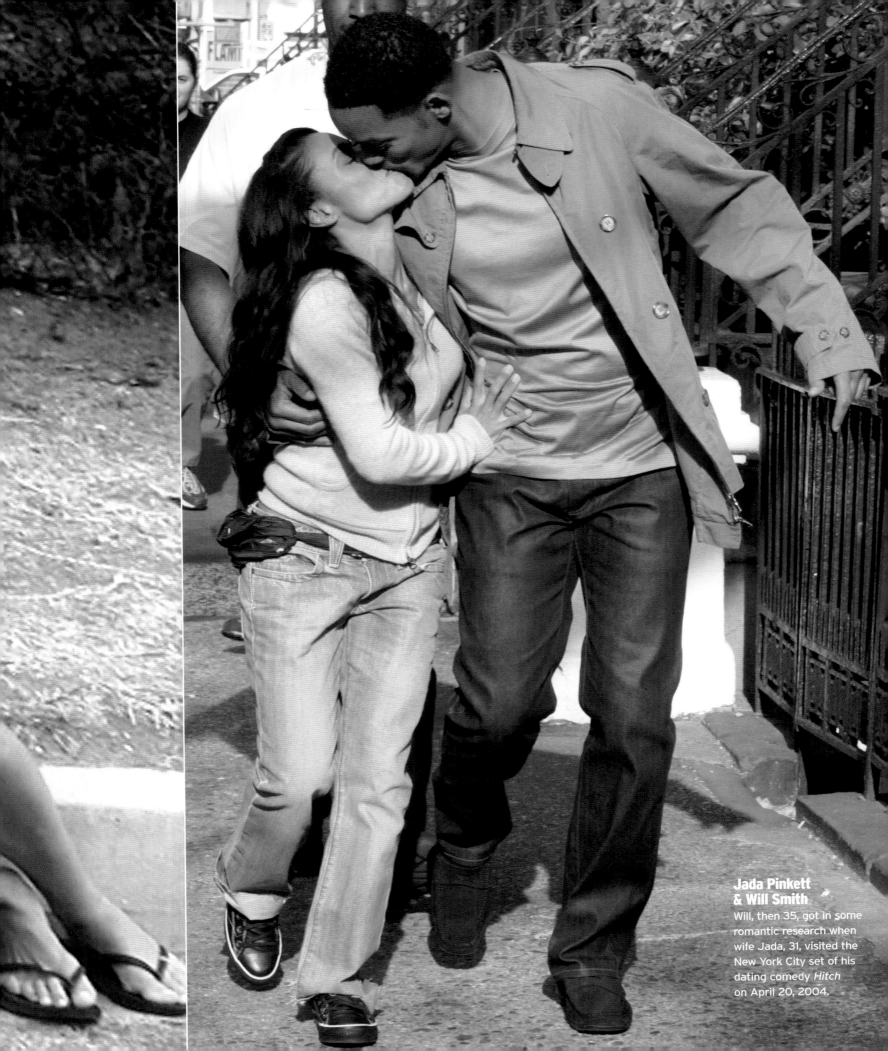

Jada Pinkett & Will Smith
Will, then 35, got in some romantic research when wife Jada, 31, visited the New York City set of his dating comedy *Hitch* on April 20, 2004.

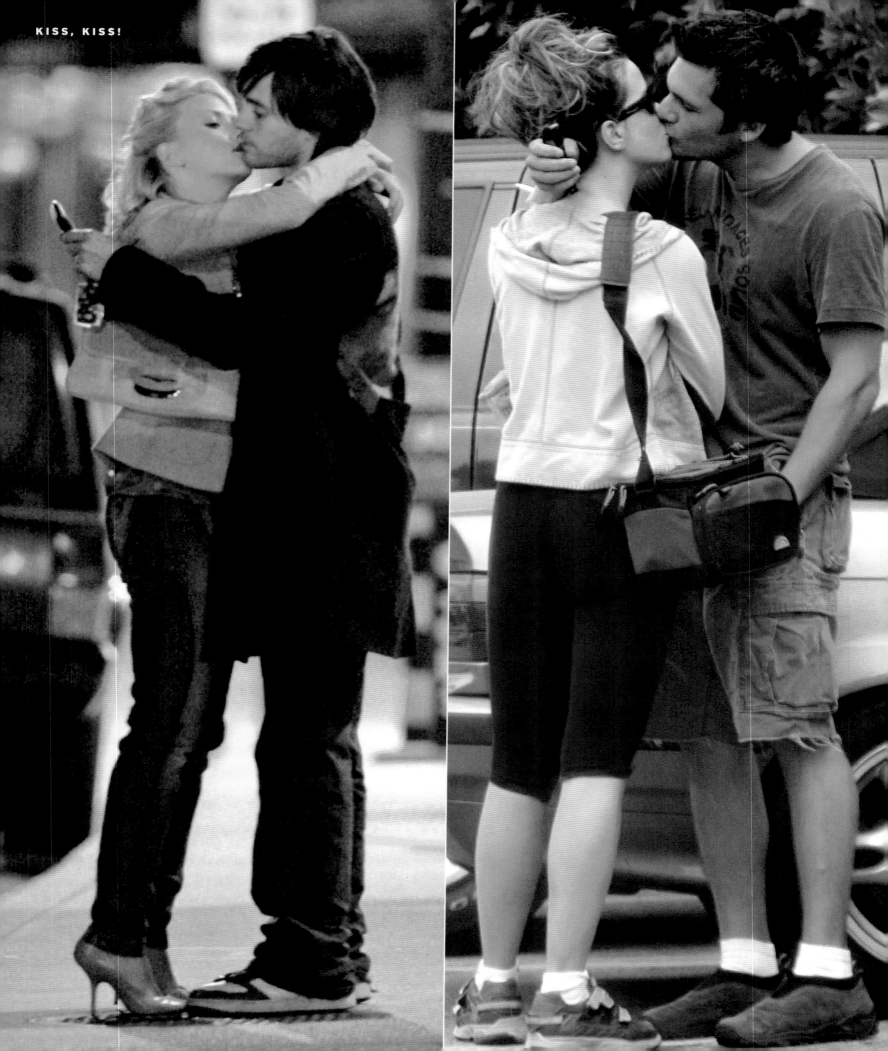

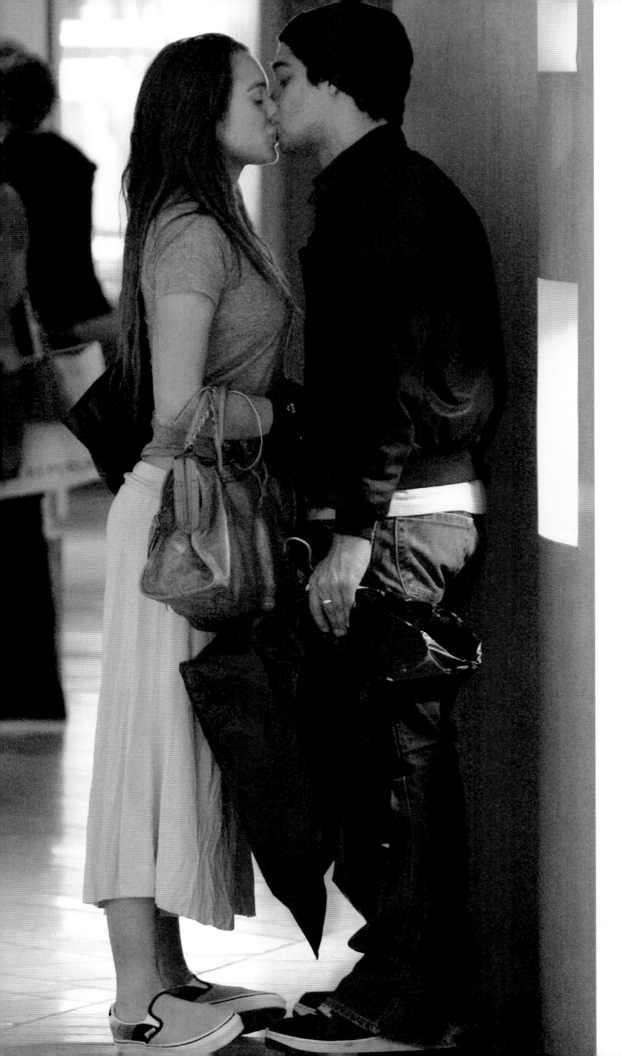

Scarlett Johansson & Jared Leto
OPPOSITE, LEFT: Leto, then 32, got busted checking his phone mid-buss with new love Johansson, 19, in West Hollywood in November 2004.

Kate Beckinsale & Len Wiseman
OPPOSITE, RIGHT: Newlyweds Beckinsale and director Wiseman, both 30 at the time, found another way to burn calories after a gym trip in Beverly Hills in May 2004.

Lindsay Lohan & Wilmer Valderrama
THIS PAGE: The *Mean Girls* star, 18 at the time, made nice with her boyfriend, *That '70s Show*'s Valderrama, 24, while shopping at L.A.'s Beverly Center in August 2004.

57

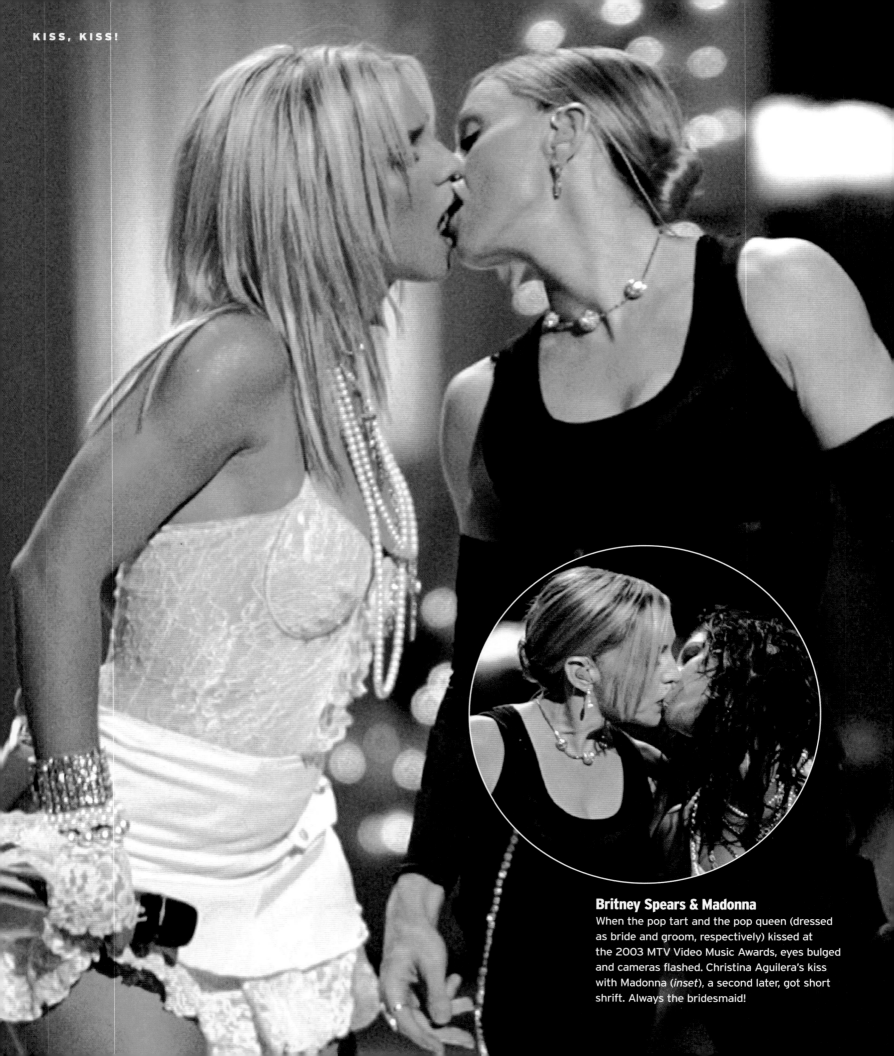

Britney Spears & Madonna

When the pop tart and the pop queen (dressed as bride and groom, respectively) kissed at the 2003 MTV Video Music Awards, eyes bulged and cameras flashed. Christina Aguilera's kiss with Madonna (*inset*), a second later, got short shrift. Always the bridesmaid!

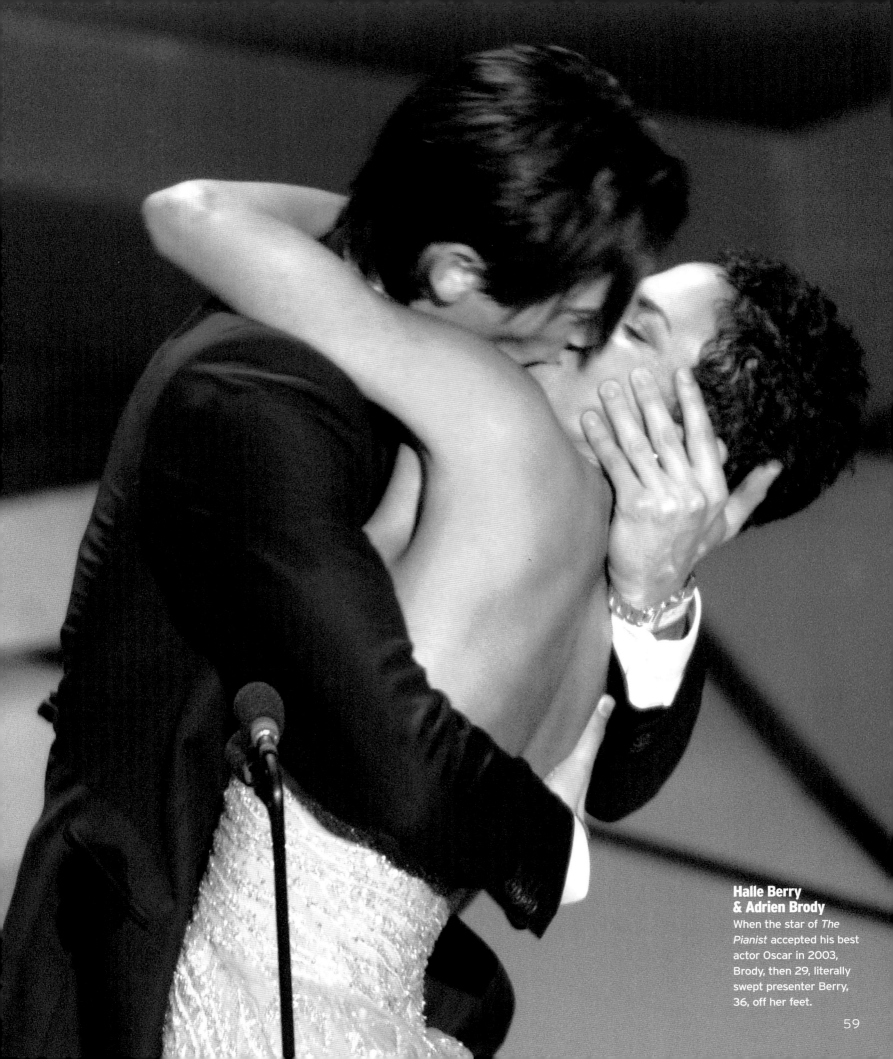

Halle Berry & Adrien Brody
When the star of *The Pianist* accepted his best actor Oscar in 2003, Brody, then 29, literally swept presenter Berry, 36, off her feet.

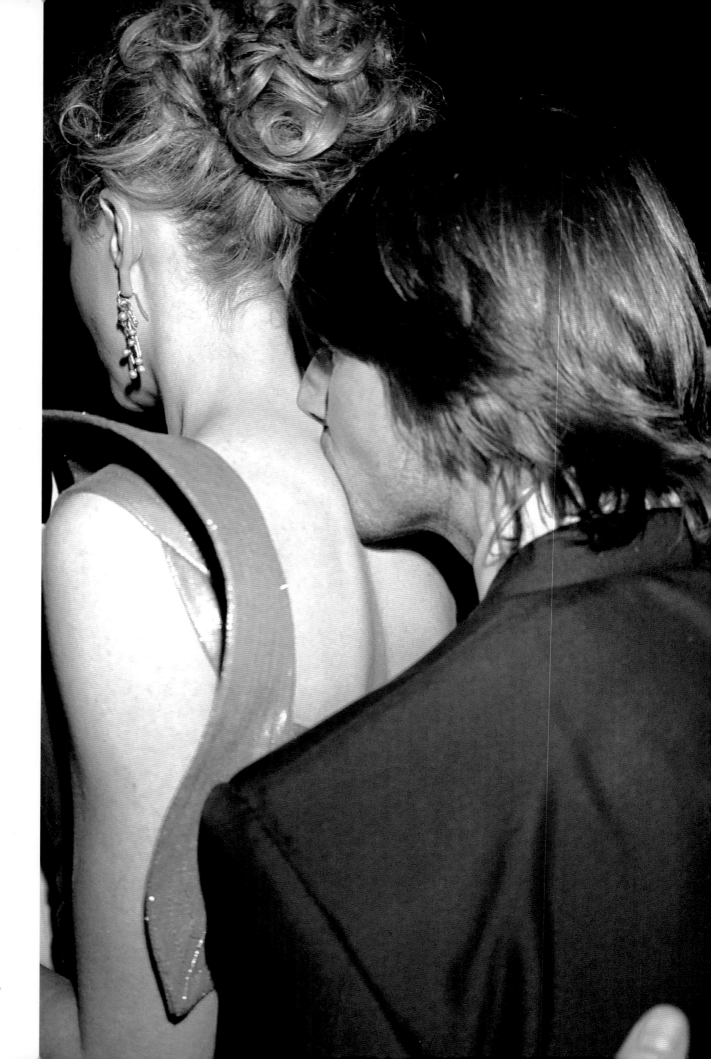

KISS, KISS!

**Tom Cruise
& Nicole Kidman**

At *Vanity Fair*'s 2000 Oscar party on March 26, Cruise, 37, nuzzled his then-wife's back.

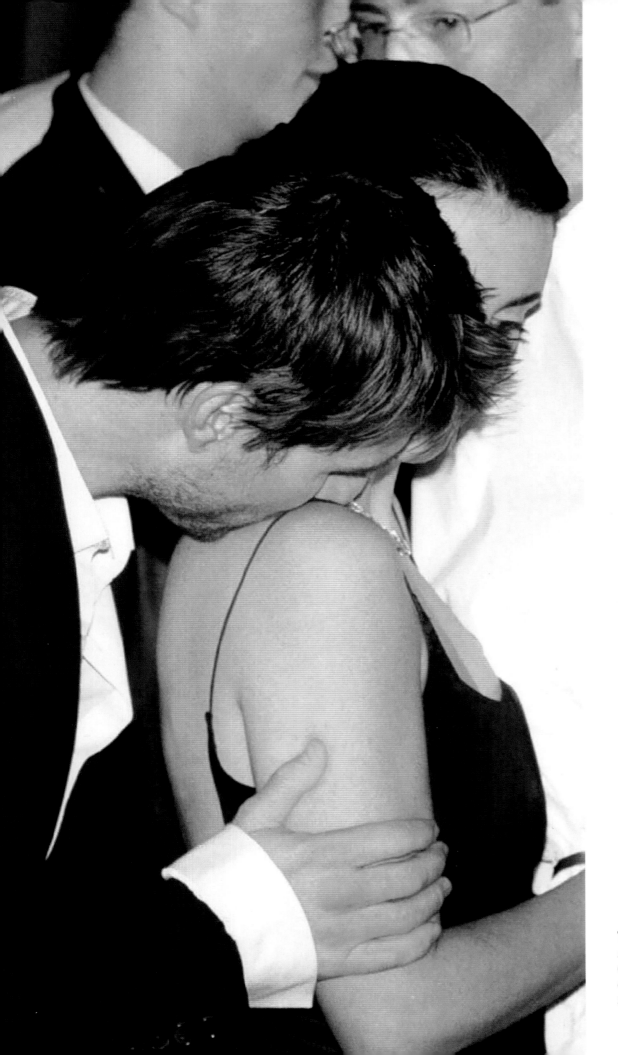

Tom Cruise & Penelope Cruz

After splitting with wife Nicole Kidman in 2001, Cruise performed a familiar romantic gesture on new love Cruz, then 27, at the January 22, 2002, Paris premiere of *Vanilla Sky*.

61

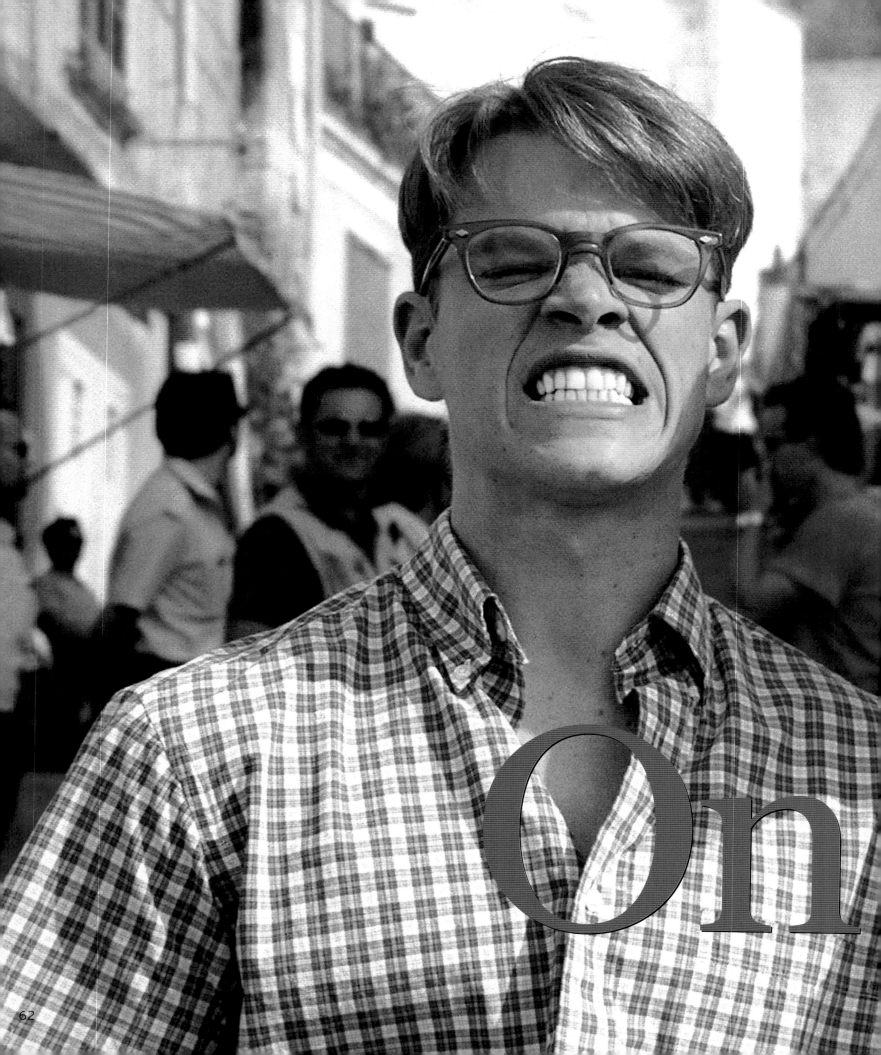

On

the Set

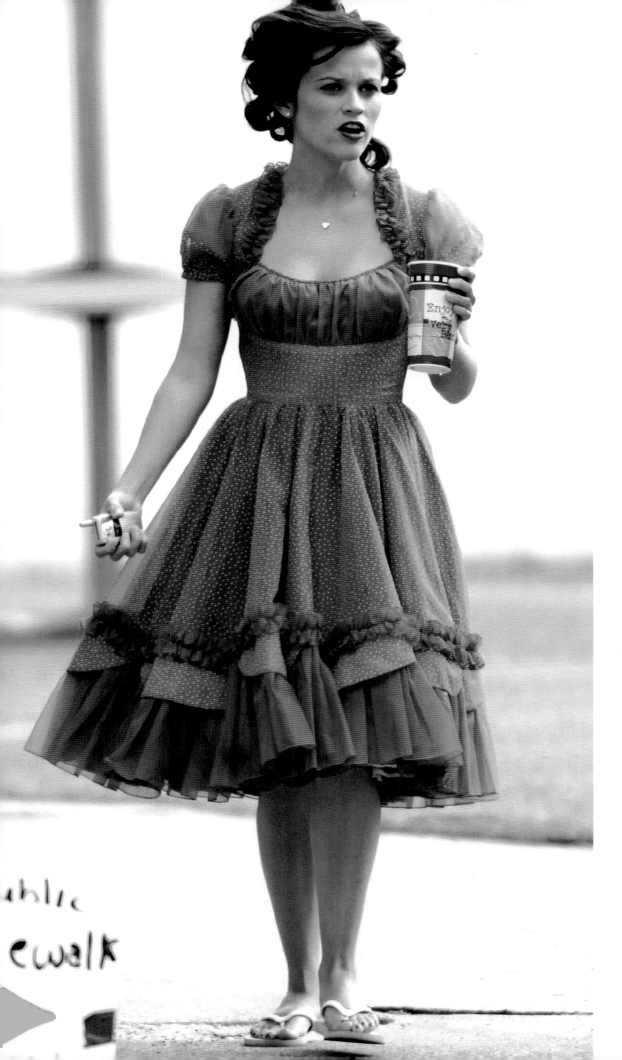

Brad Pitt

OPPOSITE: The *Troy* star, then 39, traded his sword for a cell on the film's Malta set on May 30, 2003. There was plenty to talk about during the rigorous shoot: from his Achilles tendon injury to braving the summer heat.

Reese Witherspoon

THIS PAGE: She may have dyed those famous (and legally!) blonde locks and donned '50s-style duds to play Johnny Cash's wife, June, in *Walk the Line* (here filming in Tennessee in July 2004), but Witherspoon, then 28, wasn't about to give up her coffee or cellphone!

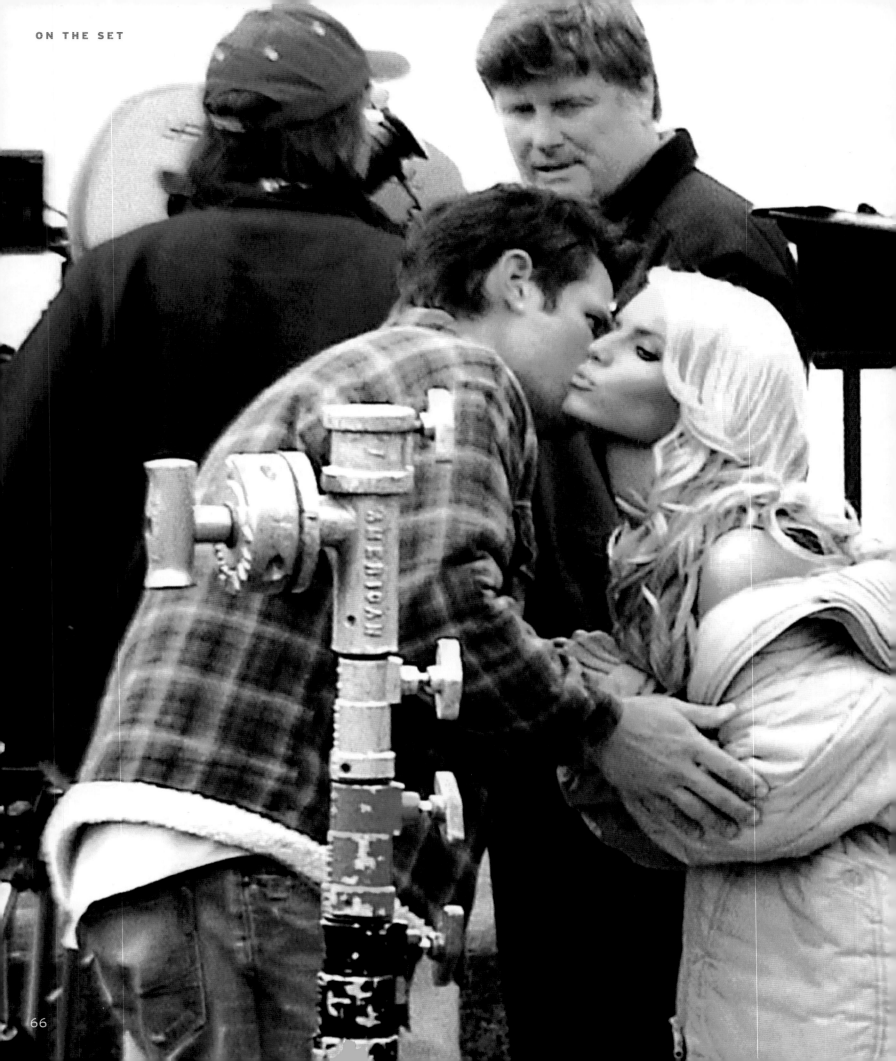

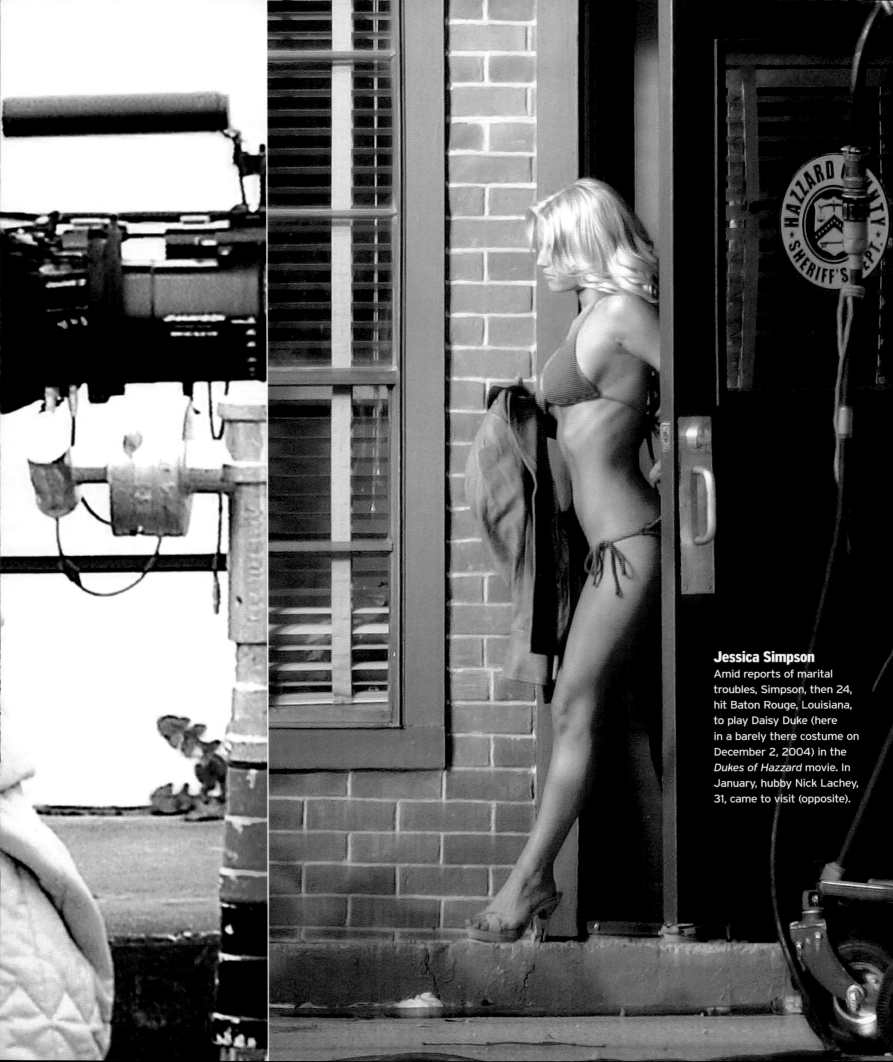

Jessica Simpson
Amid reports of marital troubles, Simpson, then 24, hit Baton Rouge, Louisiana, to play Daisy Duke (here in a barely there costume on December 2, 2004) in the *Dukes of Hazzard* movie. In January, hubby Nick Lachey, 31, came to visit (opposite).

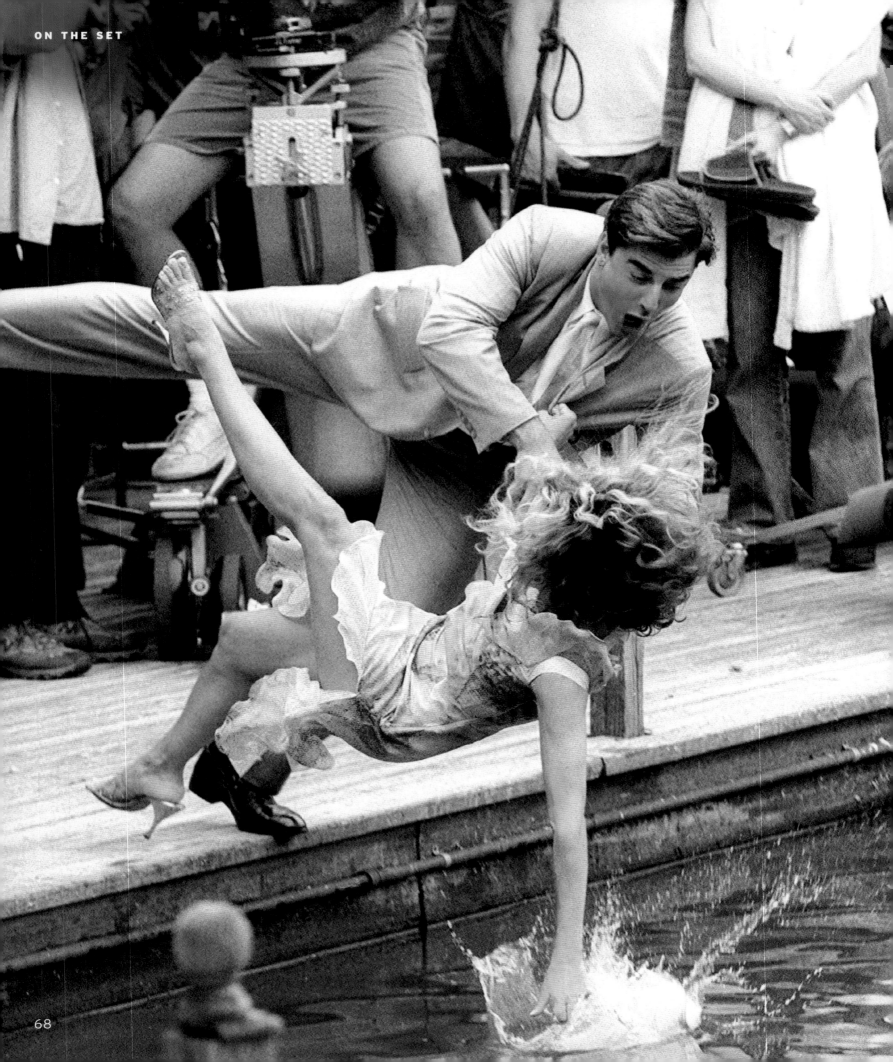

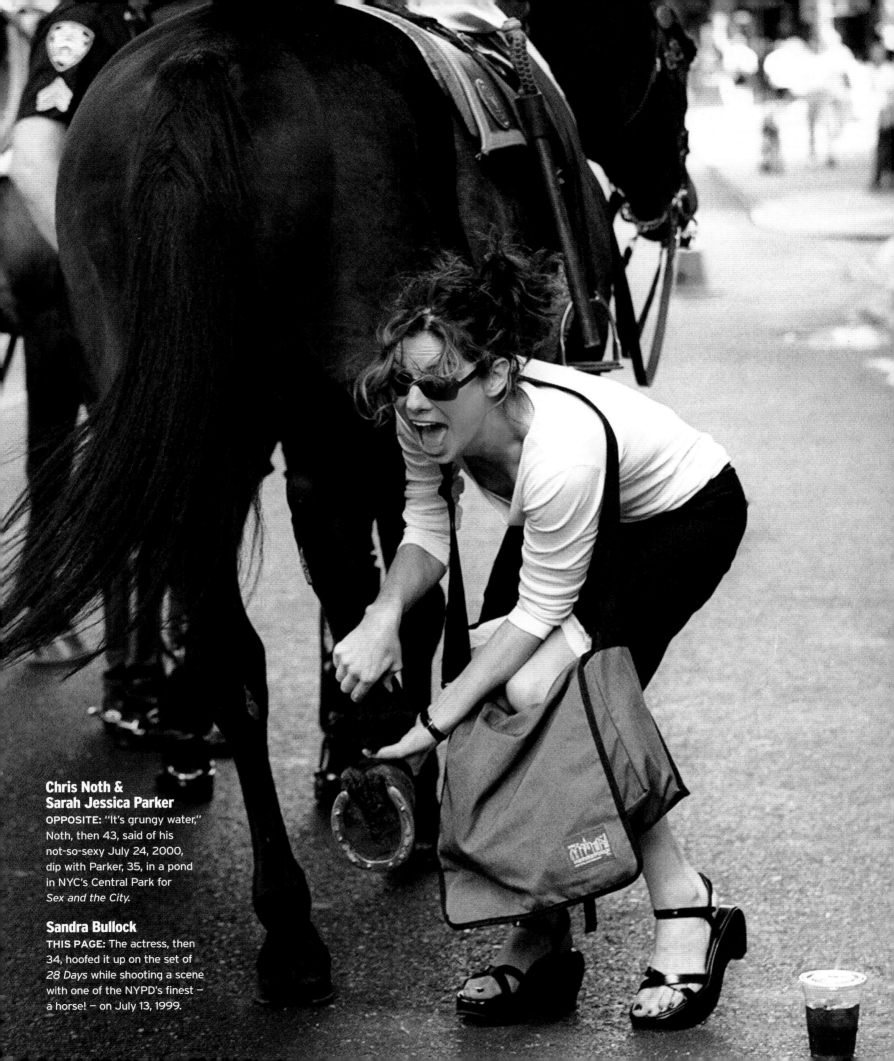

**Chris Noth &
Sarah Jessica Parker**
OPPOSITE: "It's grungy water," Noth, then 43, said of his not-so-sexy July 24, 2000, dip with Parker, 35, in a pond in NYC's Central Park for *Sex and the City*.

Sandra Bullock
THIS PAGE: The actress, then 34, hoofed it up on the set of *28 Days* while shooting a scene with one of the NYPD's finest — a horse! — on July 13, 1999.

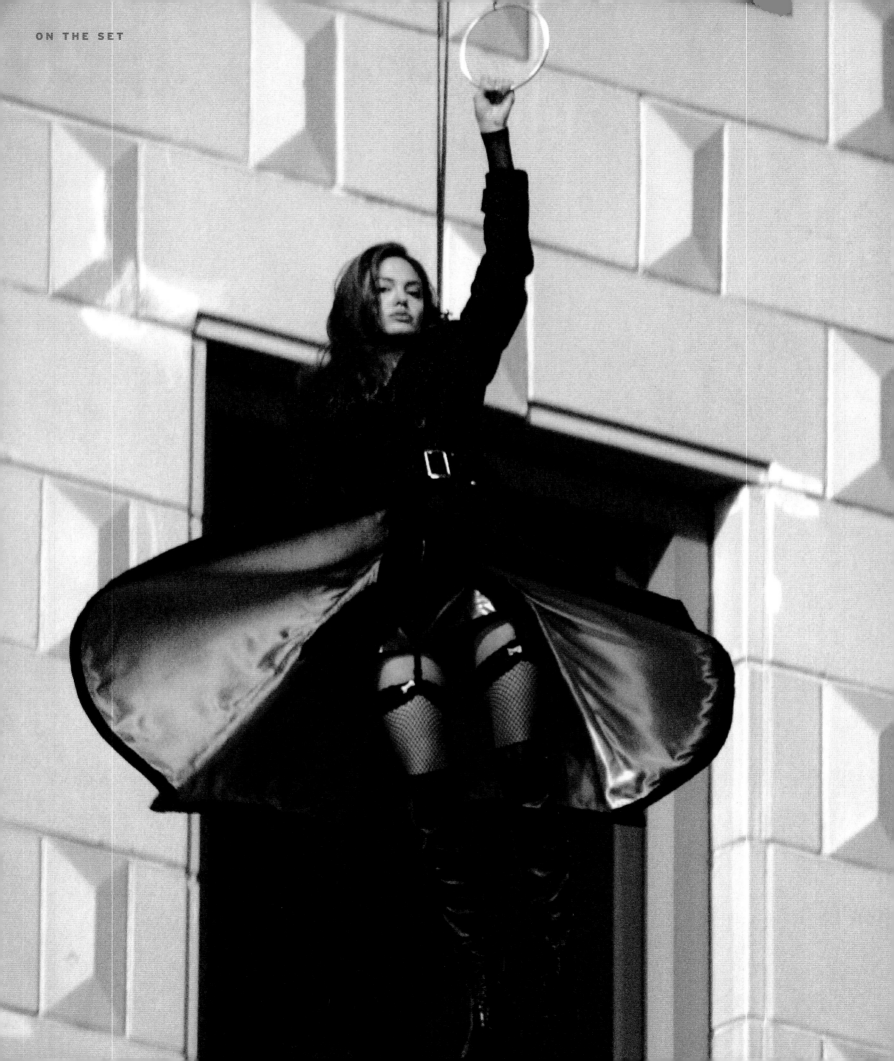

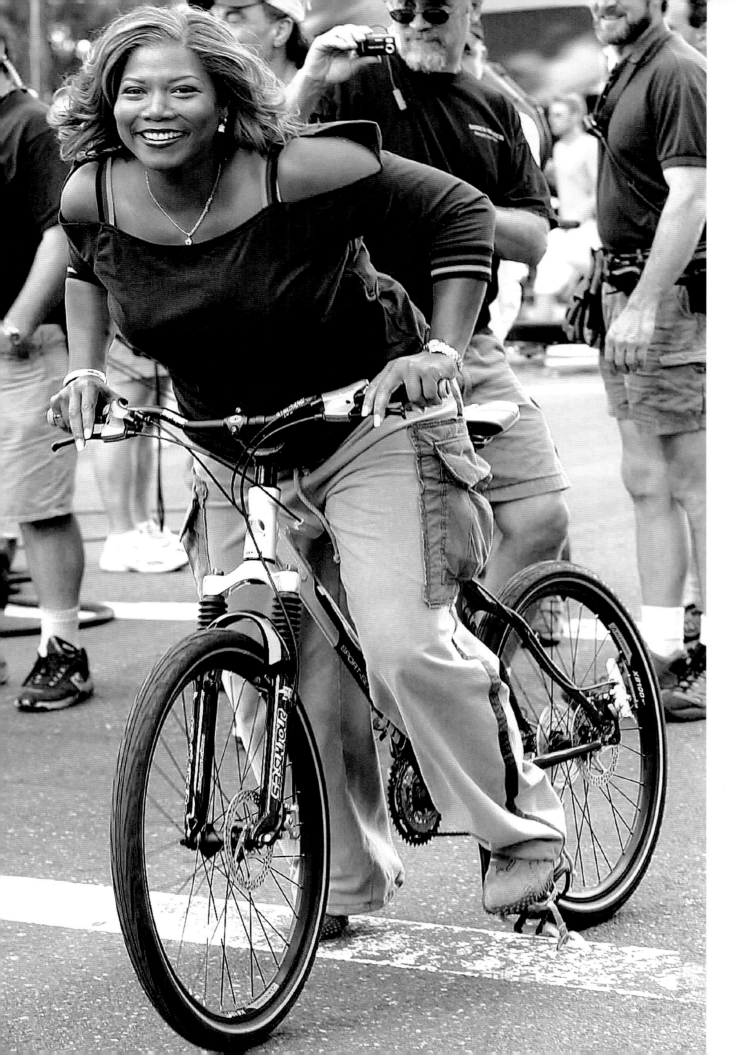

Angelina Jolie

OPPOSITE: Jolie, then 29, hung around the set of *Mr. and Mrs. Smith* in August 2004. Offscreen, sparks flew between her and costar Brad Pitt.

Queen Latifah

THIS PAGE: The actress, then 33, took a break from cabs on the New York City set of *Taxi* on September 23, 2003.

71

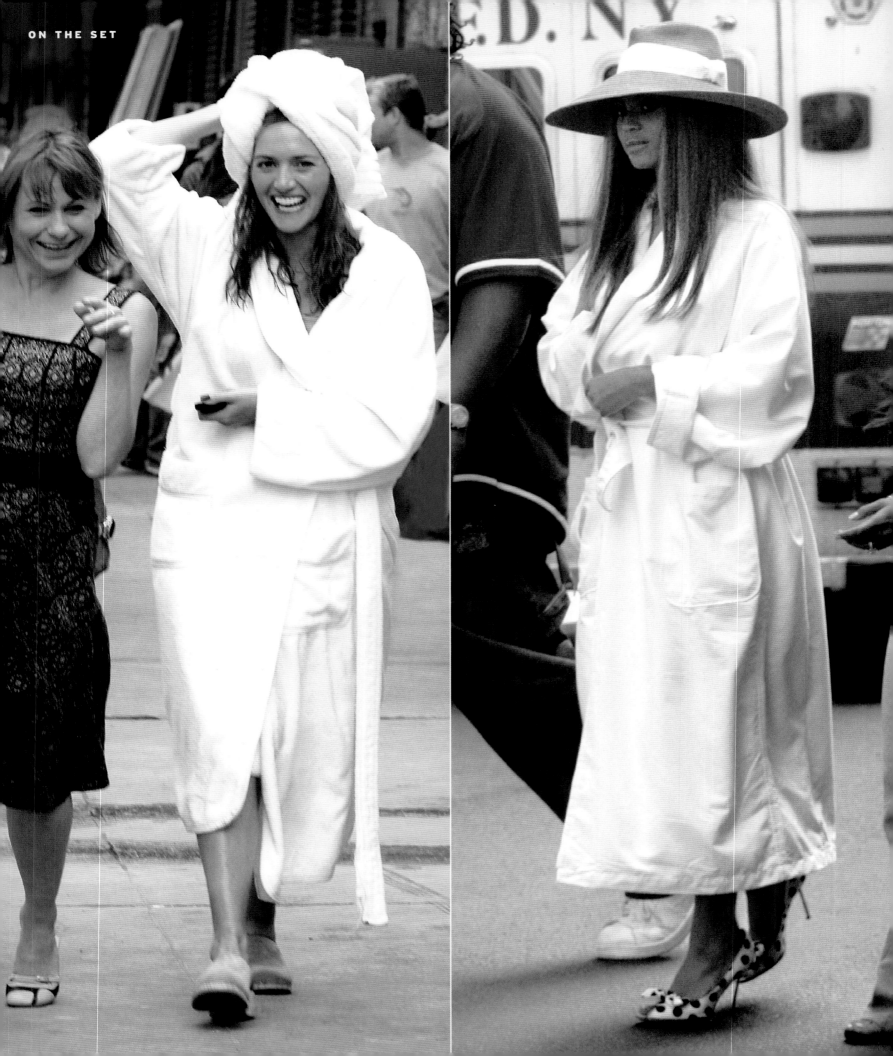

Kate Winslet

OPPOSITE, LEFT: Winslet, then 28, dried off in NYC on August 6, 2004, after filming a scene for the musical *Romance and Cigarettes* that had her swimming – and singing! – in a giant fishbowl.

Beyoncé

OPPOSITE, RIGHT: The singer, then 22, waited on the NYC set of *The Pink Panther* on May 10, 2004. Of her acting career, she admitted, "I need to [make] a couple movies to be sure I know what I'm doing!"

Nicole Kidman

THIS PAGE: A scene from *Cold Mountain*? Nah – just another freezing day for Kidman, then 35, in New York City's Central Park during the filming of *Birth* on March 11, 2003.

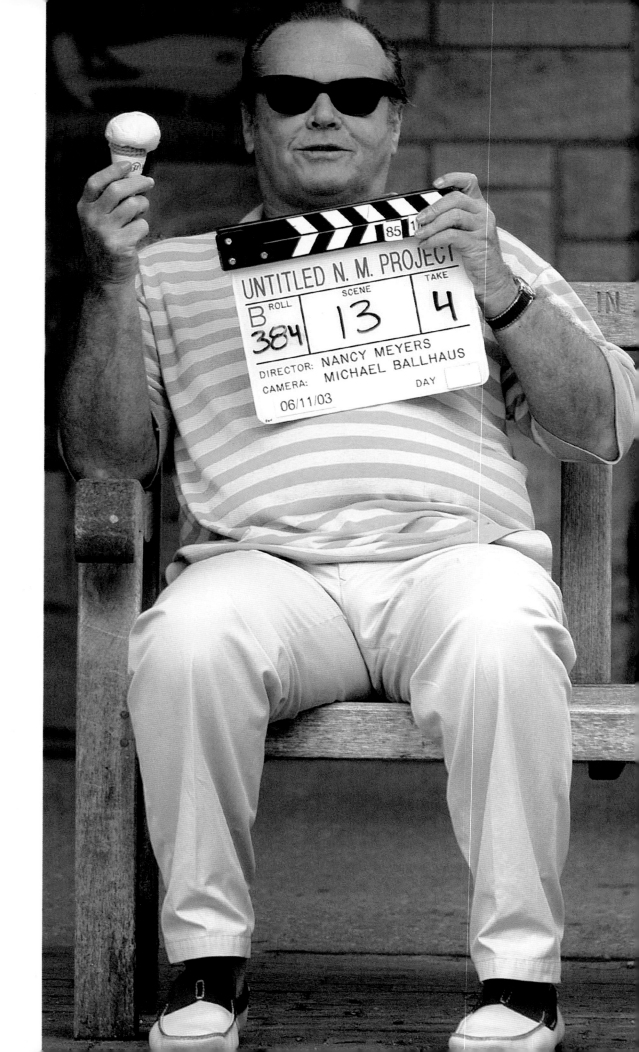

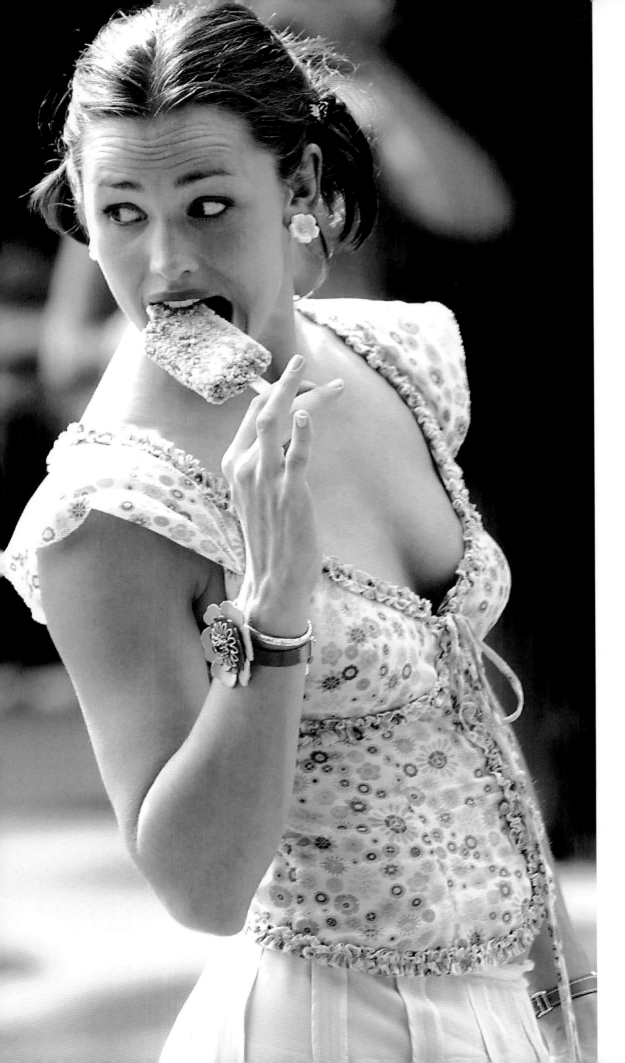

Jack Nicholson

OPPOSITE: On the set of *Something's Gotta Give* in New York's Hamptons in June 2003, Nicholson, then 66, led the cast and crew on frequent jaunts to a nearby ice-cream parlor.

Jennifer Garner

THIS PAGE: Filming *13 Going on 30* gave Garner, then 31 (here in NYC's Central Park on July 16, 2003), the chance to indulge her sweet tooth. She threw a slumber party in the name of research, too!

75

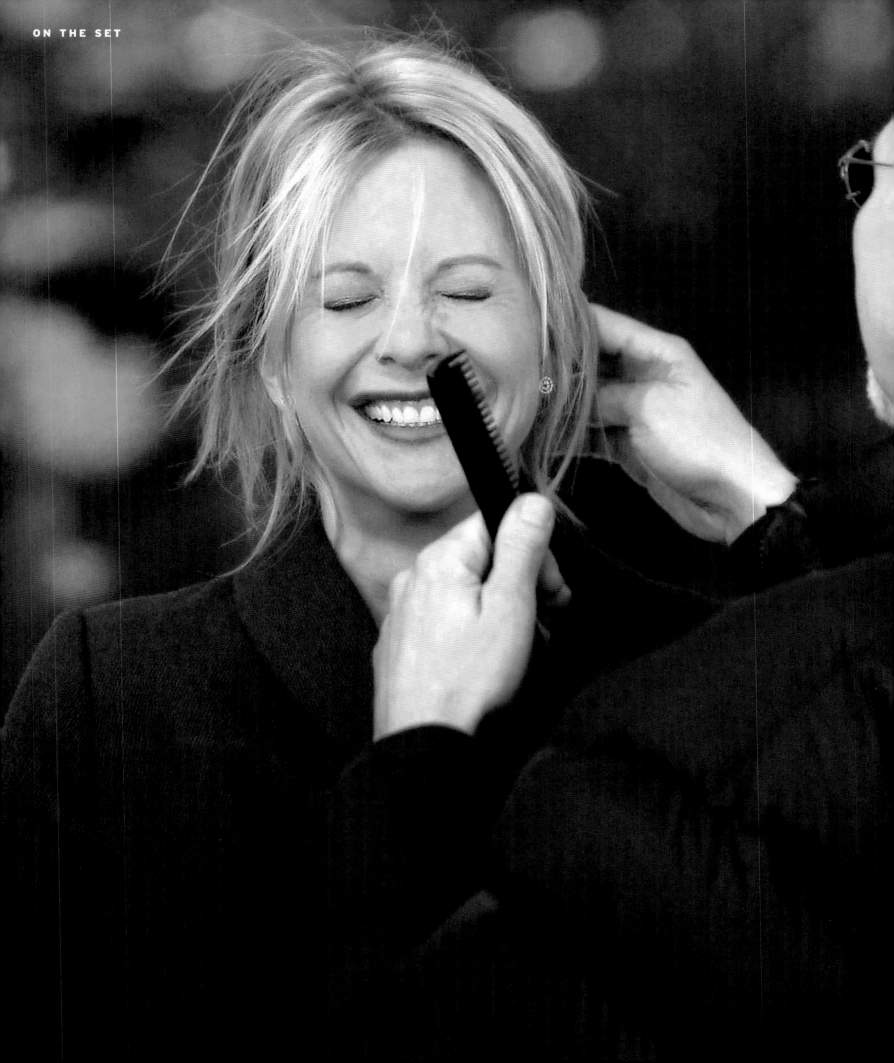

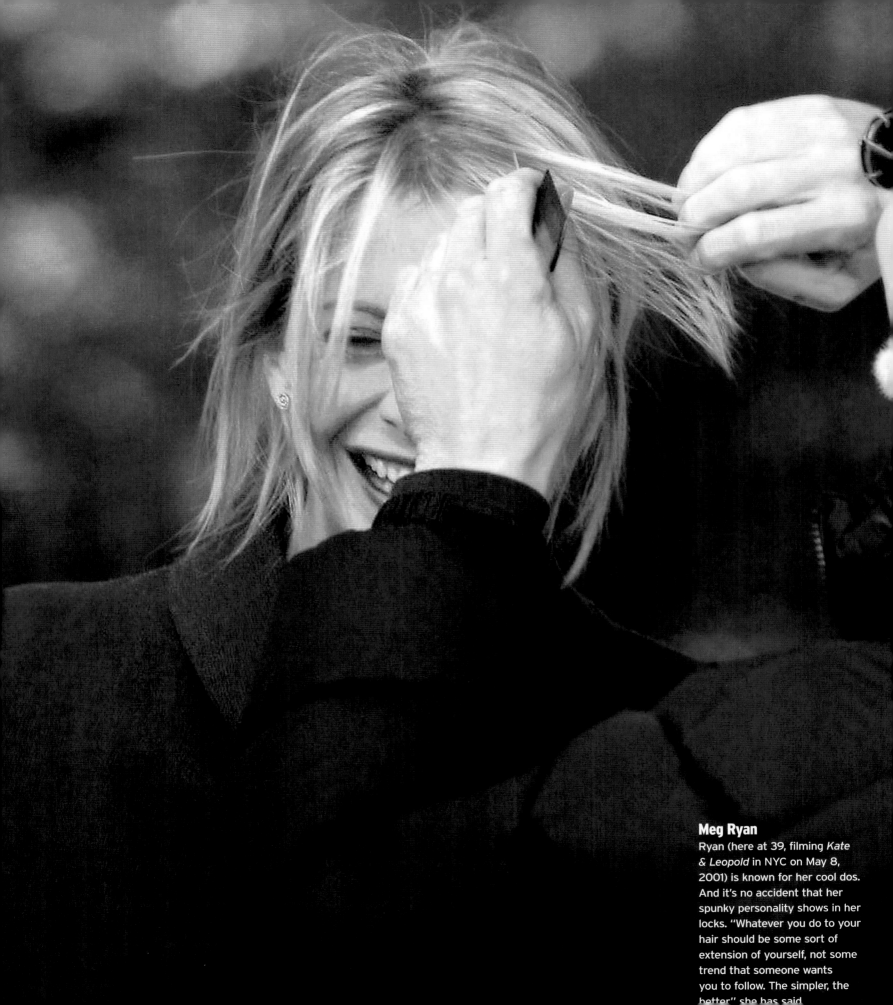

Meg Ryan
Ryan (here at 39, filming *Kate & Leopold* in NYC on May 8, 2001) is known for her cool dos. And it's no accident that her spunky personality shows in her locks. "Whatever you do to your hair should be some sort of extension of yourself, not some trend that someone wants you to follow. The simpler, the better," she has said.

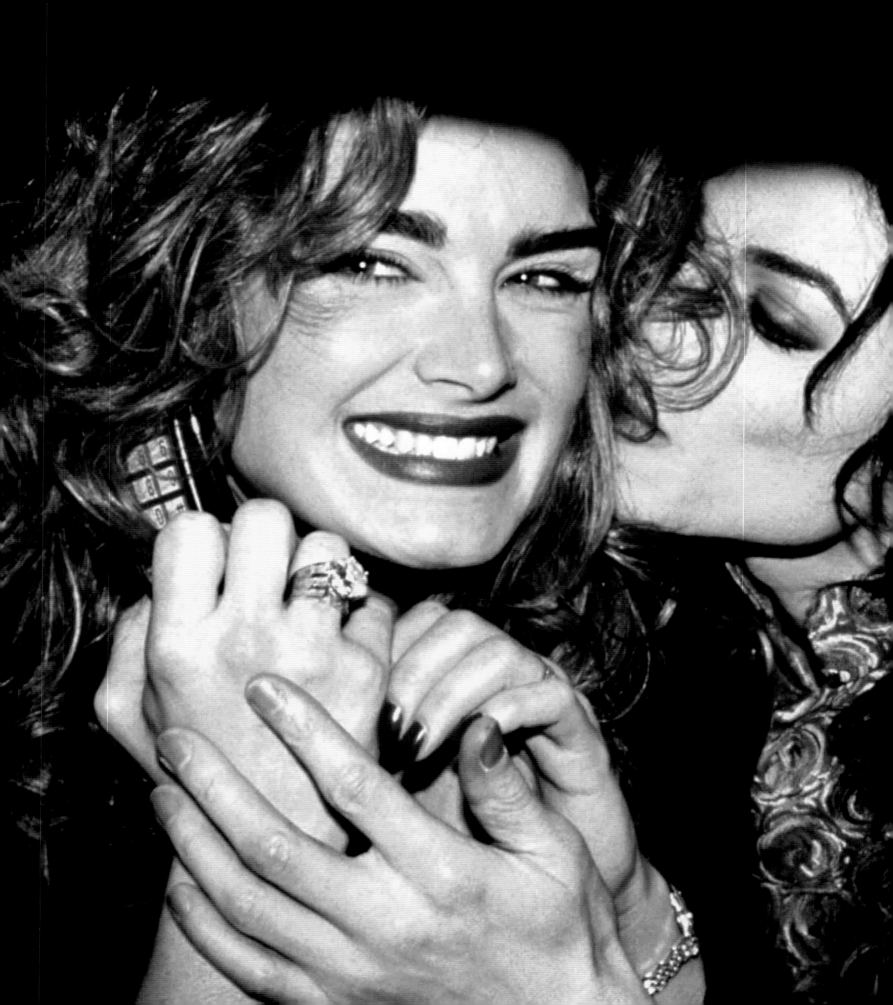

Can You Believe They *Dated?*

Brooke Shields & Michael Jackson

The couple (here in 1993) were surrounded by rumors of romance. They had first met when she was an 18-year-old Calvin Klein model and he was the 25-year-old pop sensation behind *Thriller*. In 1984, the shy actress would only say, "I love Michael dearly. I talk to him a lot." But when asked about him in 2002, she said, "Don't even get me started!"

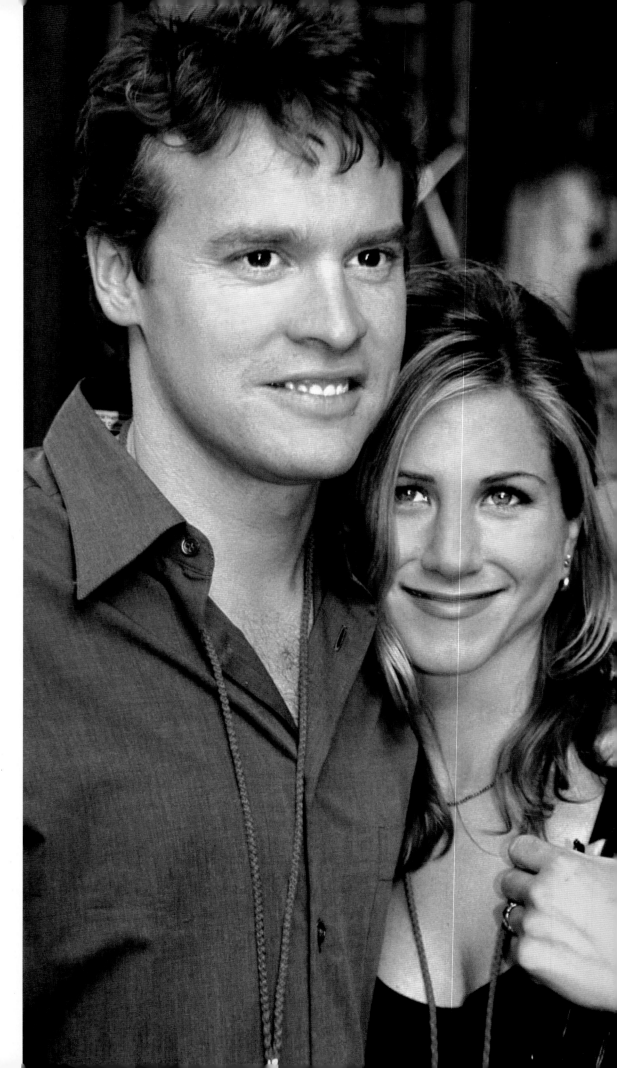

Jennifer Aniston & Tate Donovan

THIS PAGE: After meeting in 1995 (he was 32; she was 26) on the short-lived sitcom *Partners,* they began dating. Donovan (here in 1997) even played Aniston's onscreen crush in *Friends.* Although Aniston said, "When we met it was this instant click" and the pair exchanged commitment rings, they split after two and a half years together.

Brad Pitt & Christina Applegate

OPPOSITE: They didn't make it far enough to be *Married . . . With Children,* but Pitt and Applegate (here in 1989) had fun together. Applegate, a hit at 17 as bad girl Kelly Bundy, even brought a then-unknown Pitt, 25, as her date to the 1989 MTV Video Music Awards.

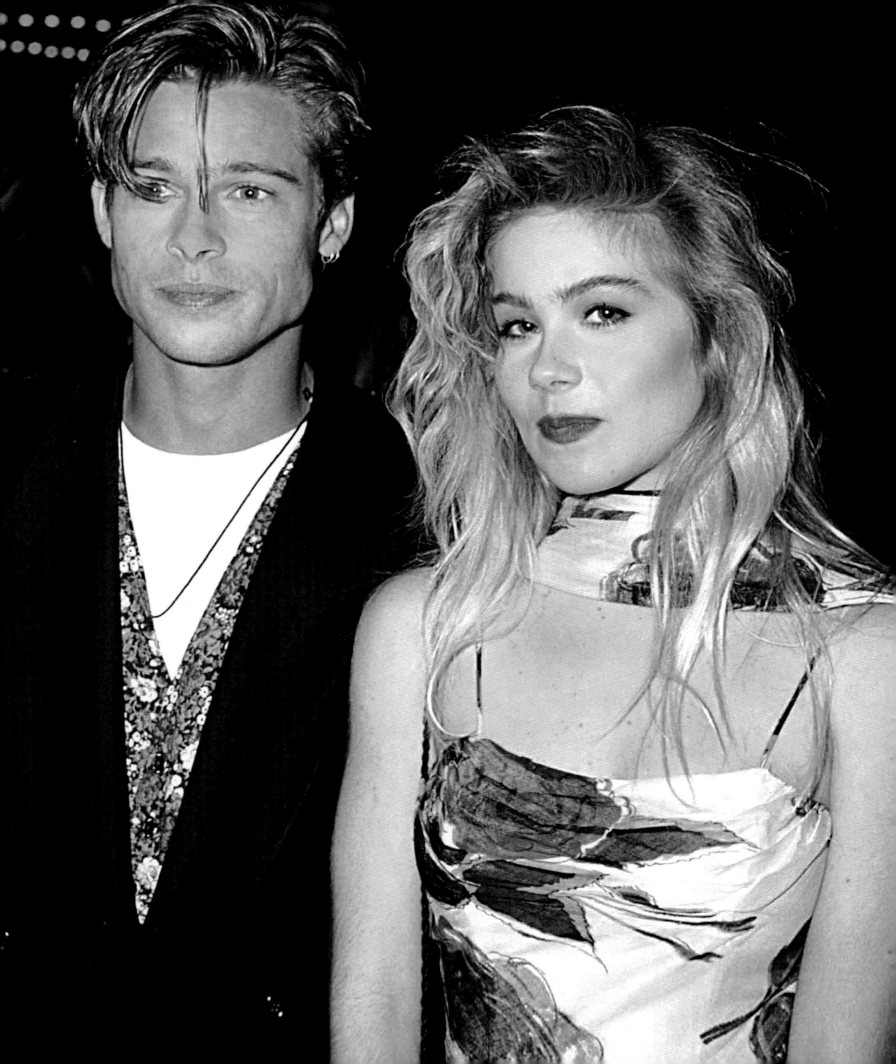

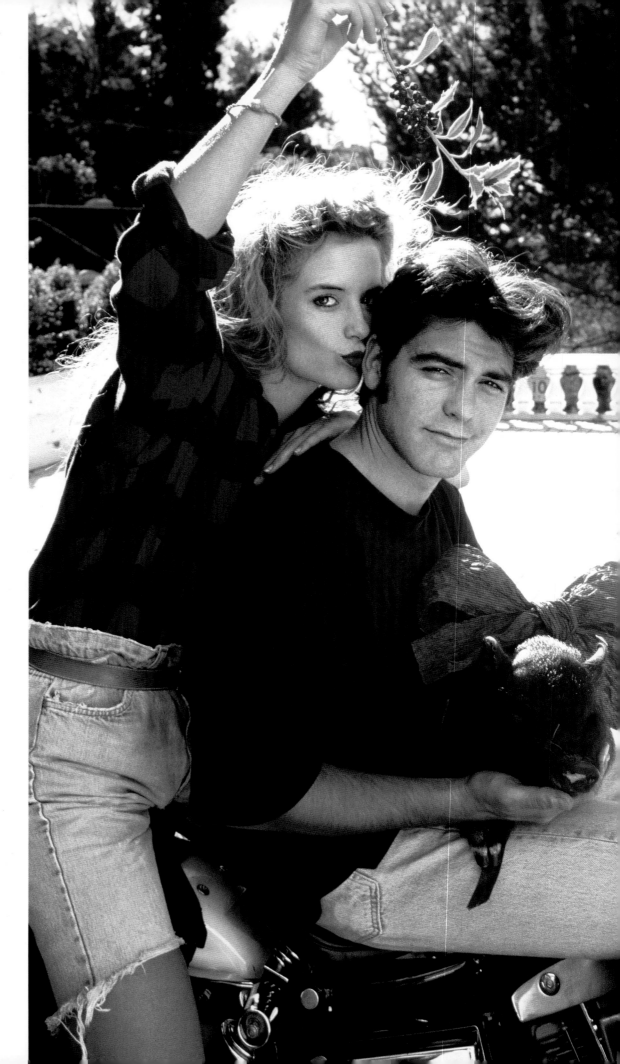

George Clooney & Kelly Preston

THIS PAGE: They met in 1987, when he was 27 and she was a 26-year-old starlet. A month later, she moved into Clooney's bachelor pad, which she had to share with his pet potbellied pig, Max. Two years later, the pair parted. She married John Travolta in 1991; Clooney still lives with Max.

Madonna & Warren Beatty

OPPOSITE: In 1989, the Material Girl, then 31, shocked the world by dating legendary womanizer Beatty, 52, after he cast her as bombshell Breathless Mahoney in *Dick Tracy*. But Madonna's love of the spotlight overshadowed the relationship. "She doesn't want to live off camera," he famously complained in 1991's *Truth or Dare*.

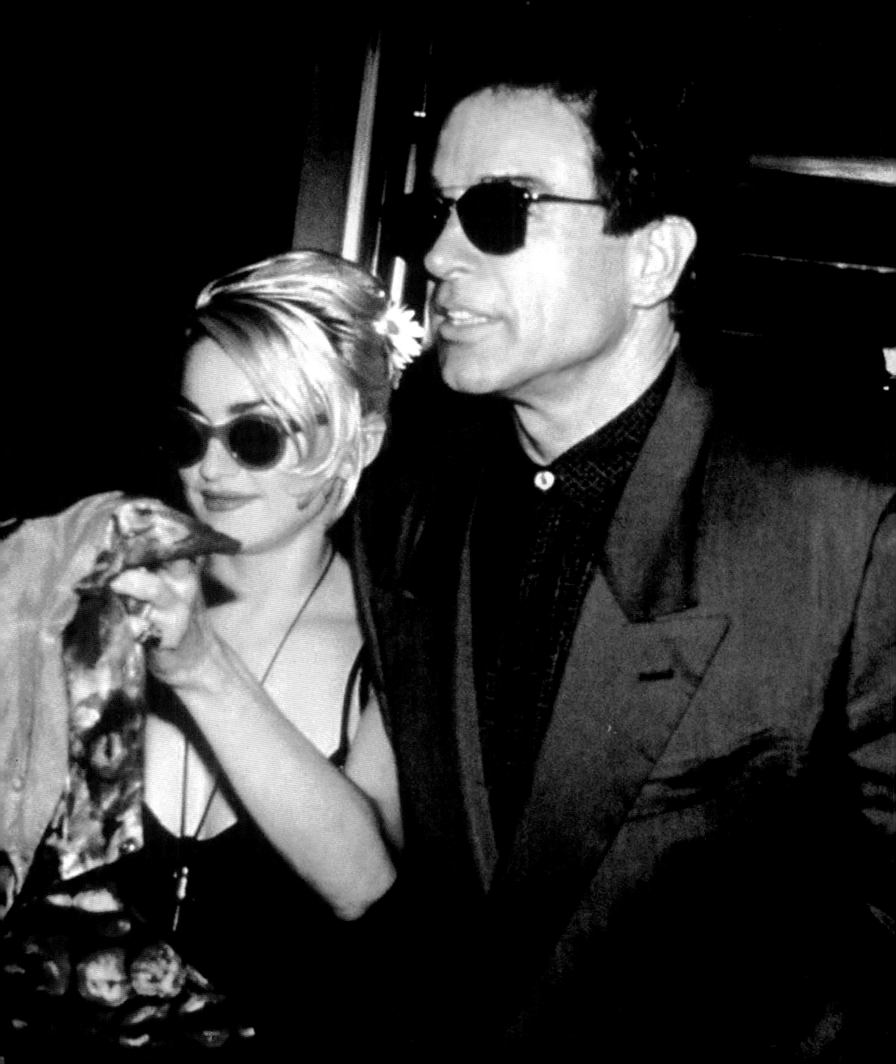

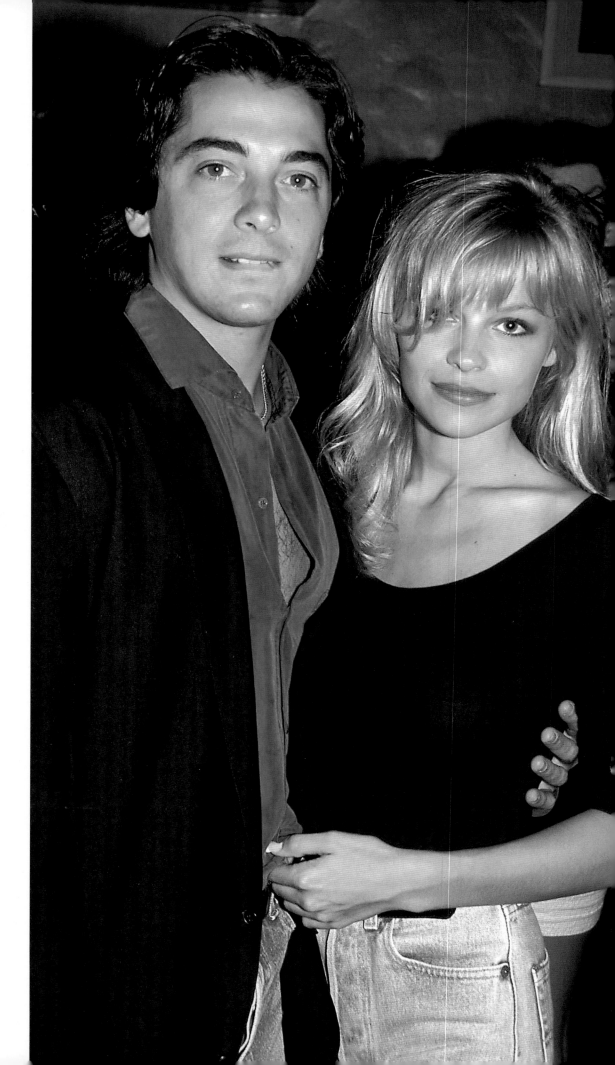

Scott Baio & Pamela Anderson

THIS PAGE: Baio, here at 29 in 1991, and Playmate Anderson, 23, met in 1989 at the Playboy Mansion. The indecisive pair dated on and off until 1993, when they finally got engaged — only to rapidly break up for good. "We just didn't get along," Anderson has said.

Scott Baio & Heather Locklear

OPPOSITE: When the pair, both then 20, got together (here in 1982), she was a *Dynasty* vixen, while he was — and would forever be — Chachi. But their romance didn't last: She later wed rocker Tommy Lee, while Baio dated Pamela Anderson (who later married Lee!).

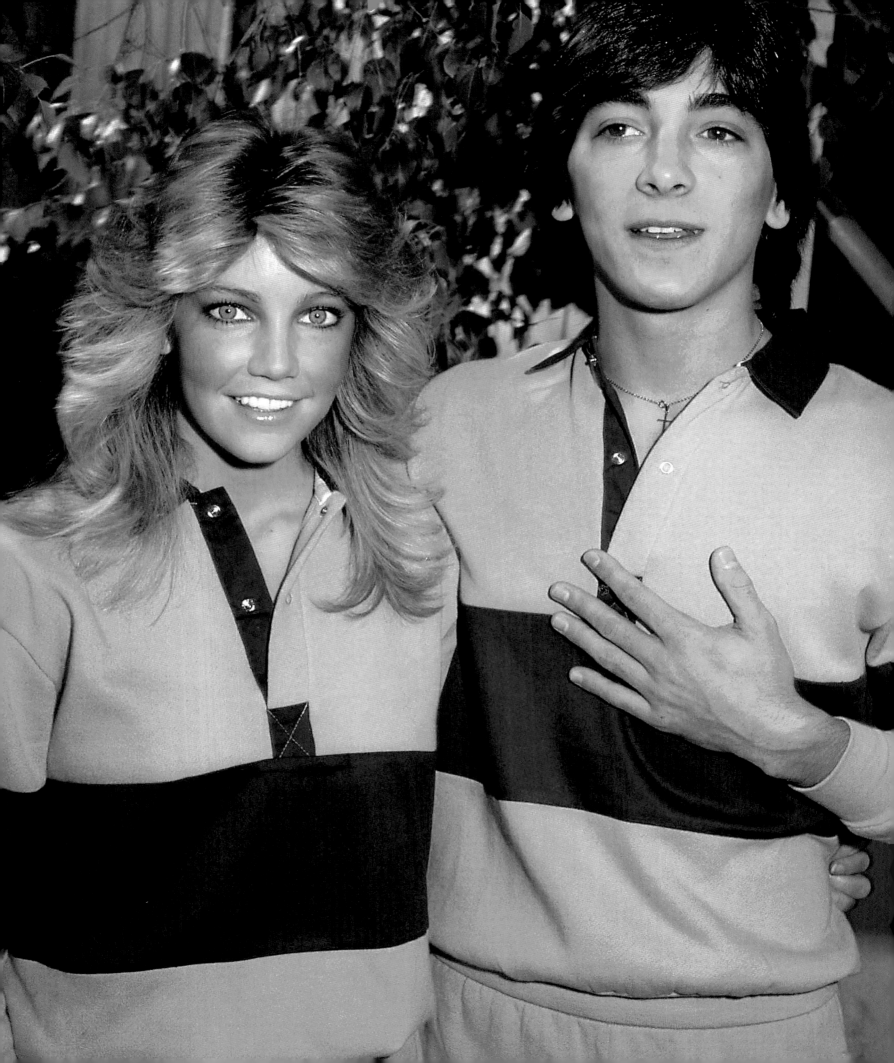

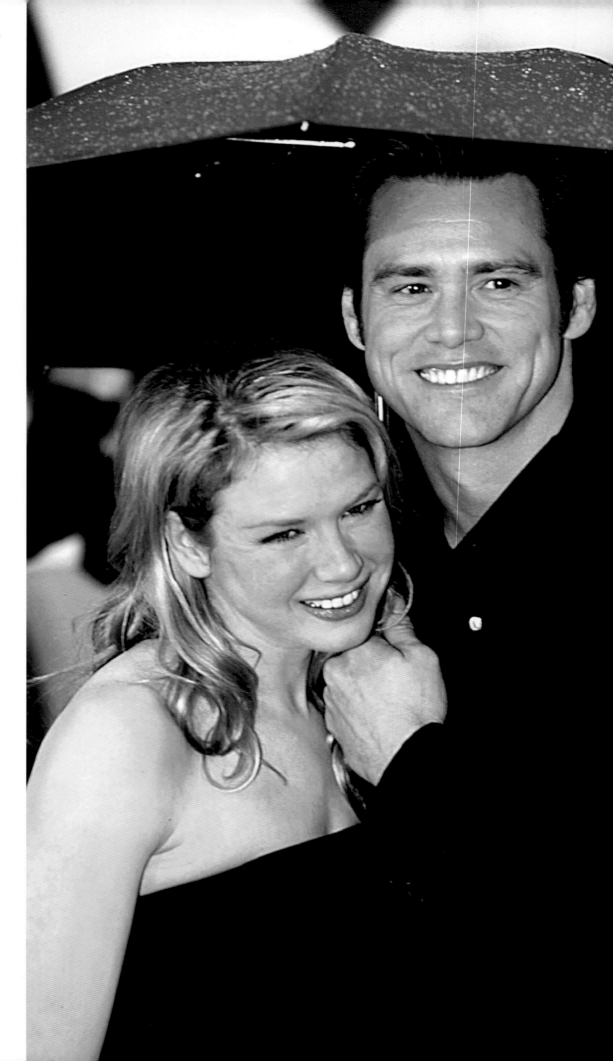

Renée Zellweger & Jim Carrey

It seemed as if the *Bridget Jones's Diary* star, then 31, had found her own Mr. Darcy in funnyman Carrey, 38. "It was an unexpected, wonderful thing," Zellweger said of the relationship. The pair fended off rumors of engagement at January 2000's Golden Globes (pictured), and by December, they had parted.

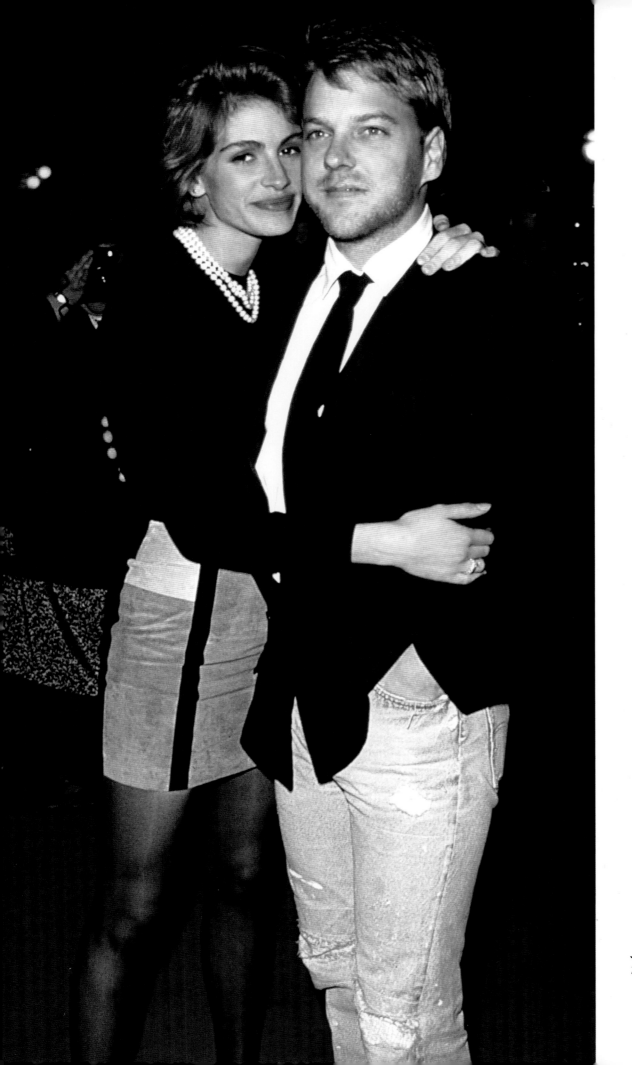

Julia Roberts & Kiefer Sutherland

Runaway Bride! Roberts left fiancé Dylan McDermott for her *Flatliners* costar in 1990. Just a year later – in June 1991, when he was 24 and she was 23 – they were set to marry; she called it off just days before, reportedly suspecting Sutherland of cheating on her.

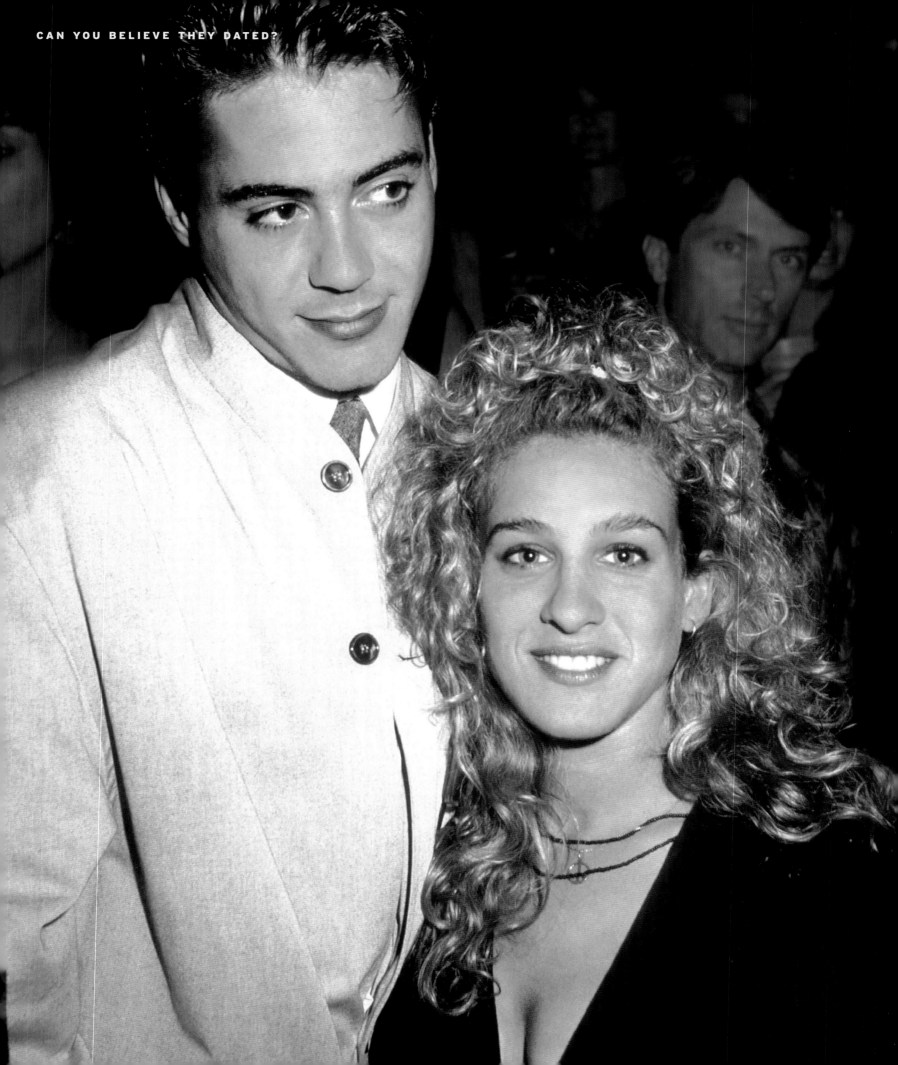

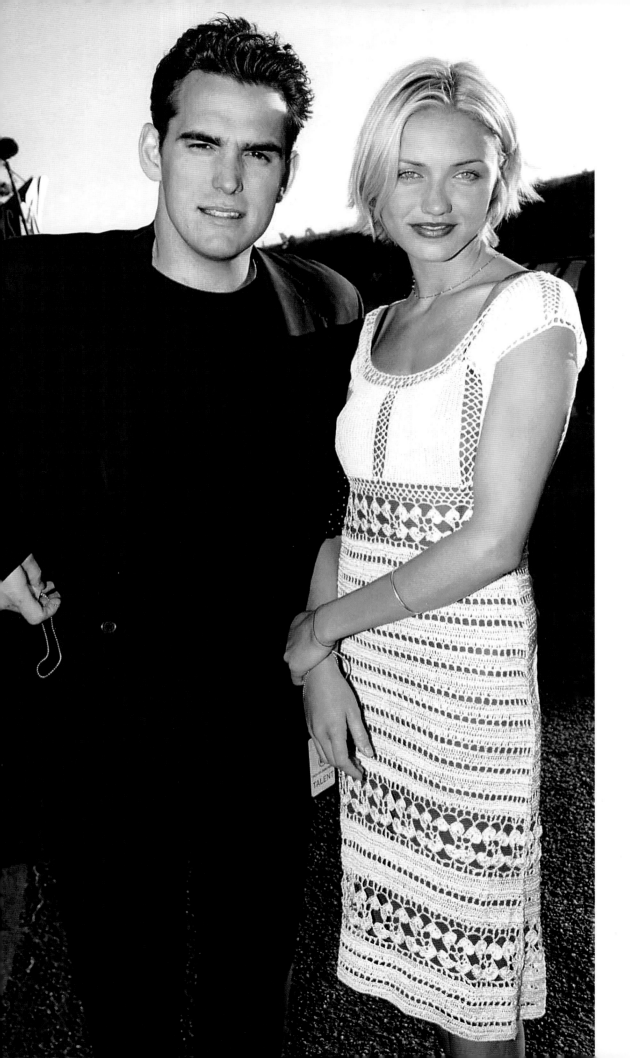

Sarah Jessica Parker & Robert Downey Jr.

OPPOSITE: The couple (here, both 22 in 1987) met while filming the 1984 drama *Firstborn* and stayed together for seven years. "He's one of those tortured souls," Parker later said of Downey.

Cameron Diaz & Matt Dillon

THIS PAGE: Diaz, then 25, and Dillon, 34, lovers in real life, also starred together in 1998's *There's Something About Mary*. "They were madly in love," *Mary* director Bobby Farrelly has said.

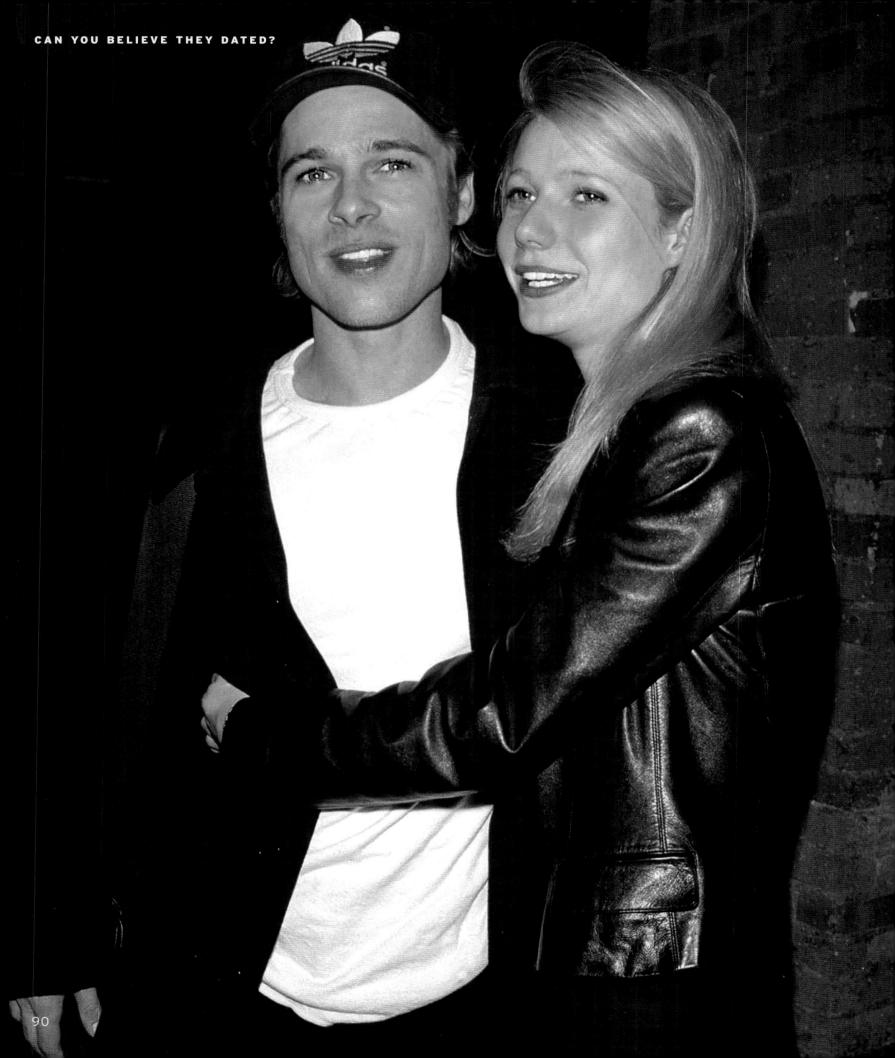

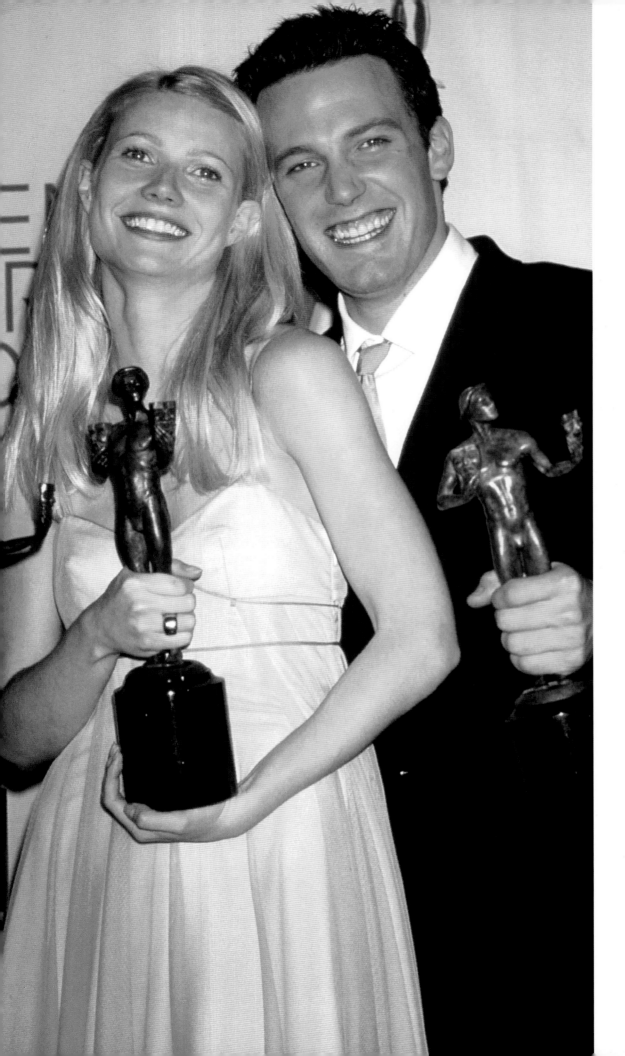

Gwyneth Paltrow & Brad Pitt

OPPOSITE: They fell in love on the set of *Seven* in 1994 and were engaged by November 1996. "I knew immediately," Pitt, then 32, said. "I got within 10 feet of her, and I got goofy. She's sunshine." Eventually though, the clouds rolled in, and in June 1997, he and Paltrow, 23, separated.

Gwyneth Paltrow & Ben Affleck

THIS PAGE: Paltrow and Affleck, both then 26, hooked up after she and Brad Pitt broke off their engagement. The couple won Screen Actors Guild awards (here in 1999) after both starred in *Shakespeare in Love*. But by the time they appeared together again in the box-office flop *Bounce* in 2000, their relationship had fallen flat.

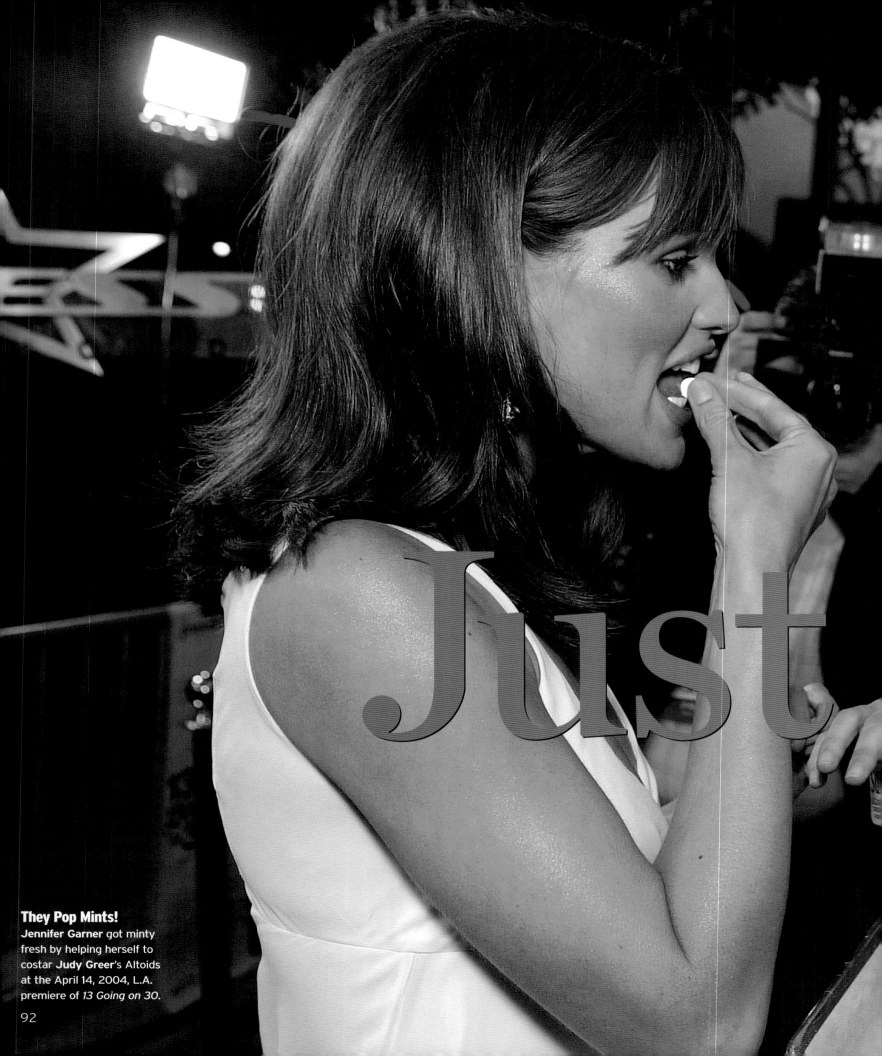

Just

They Pop Mints!
Jennifer Garner got minty
fresh by helping herself to
costar Judy Greer's Altoids
at the April 14, 2004, L.A.
premiere of *13 Going on 30*.

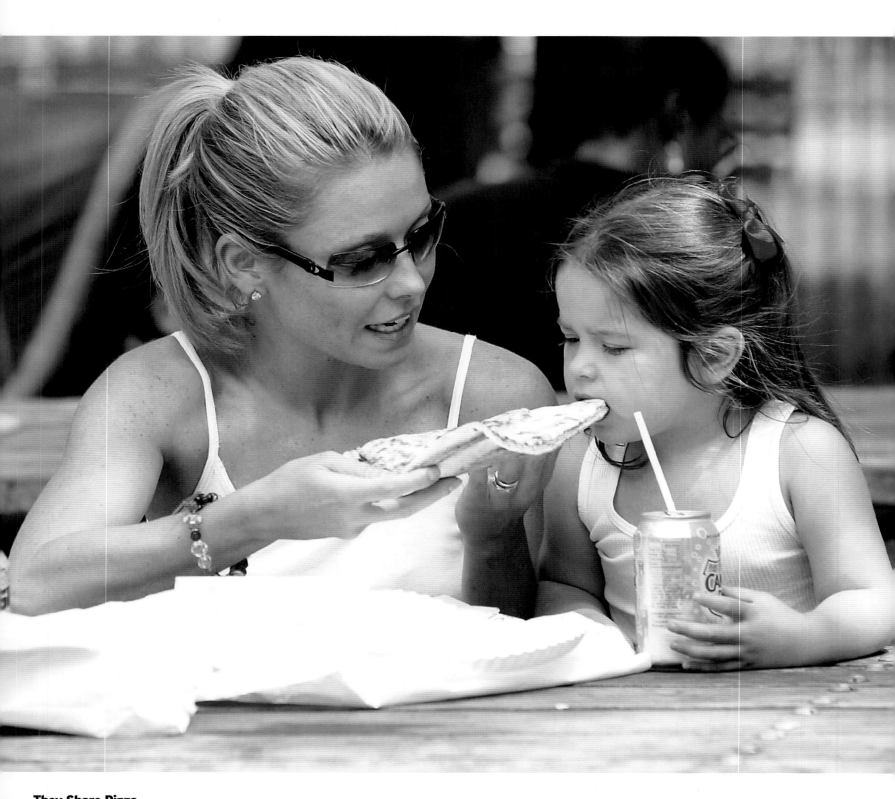

They Share Pizza . . .
Kelly Ripa treated daughter Lola, then nearly 3, to a slice during a May 7, 2004, visit to a NYC playground.

. . . And Take Home Leftovers!

After dinner at L.A.'s Orso – one of her favorite haunts – on September 29, 2004, **Jennifer Aniston** got the rest to go.

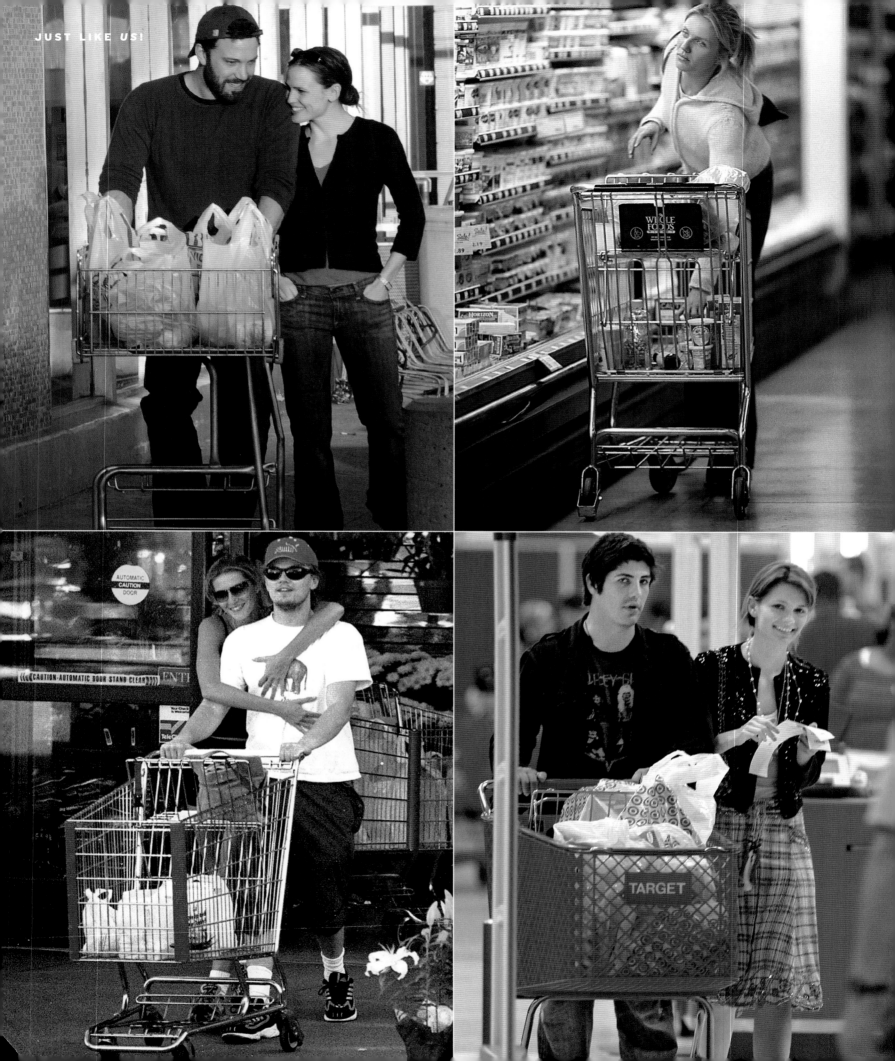

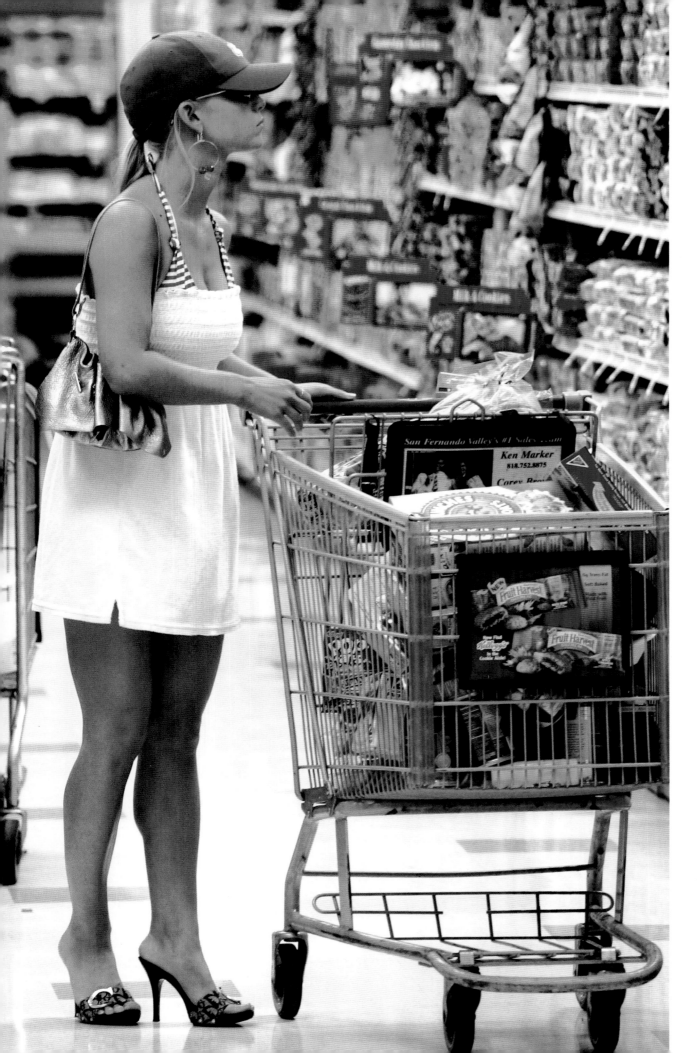

They Shop Till They Drop

OPPOSITE, TOP LEFT:
Ben Affleck and **Jennifer Garner** picked up groceries and Amstel Light beer at Vincente Foods in L.A. on January 22, 2005.

OPPOSITE, TOP RIGHT:
Cameron Diaz went for nutritious fare like yogurt on a December 27, 2000, shopping spree in Hollywood.

OPPOSITE, BOTTOM LEFT:
On April 25, 2001, **Leonardo DiCaprio** and **Gisele Bündchen** got touchy-feely at a market in West Hollywood.

OPPOSITE, BOTTOM RIGHT:
Mischa Barton and boyfriend **Brandon Davis** hit a Target in L.A. on November 8, 2004, after lunch at Johnny Rockets.

THIS PAGE:
On August 15, 2004, **Jessica Simpson**'s supermarket sweep near Calabasas, California, included Pop-Tarts, Kraft Easy Mac and stacks of Red Bull — but no Chicken of the Sea!

97

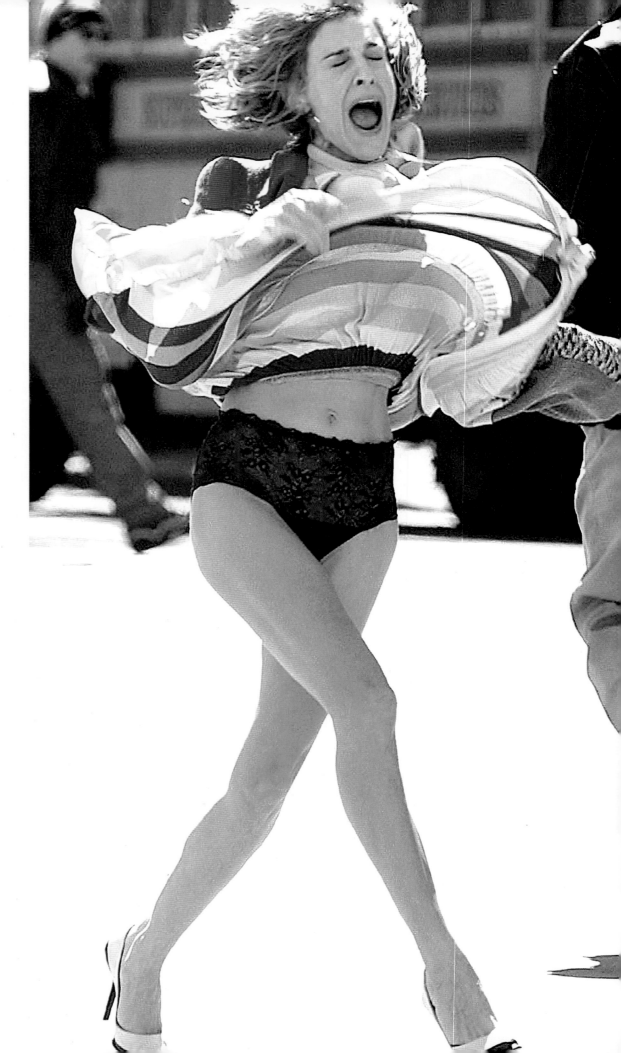

They Get Their Skirts Blown By the Wind . . .

THIS PAGE: Sarah Jessica Parker gave a peep show while filming a scene for *Sex and the City*'s fifth season outside NYC's Guggenheim Museum on April 4, 2002.

. . . And Their Hair Too!

OPPOSITE: Paris Hilton had a hair-raising experience with the wild Beverly Hills wind on July 12, 2004.

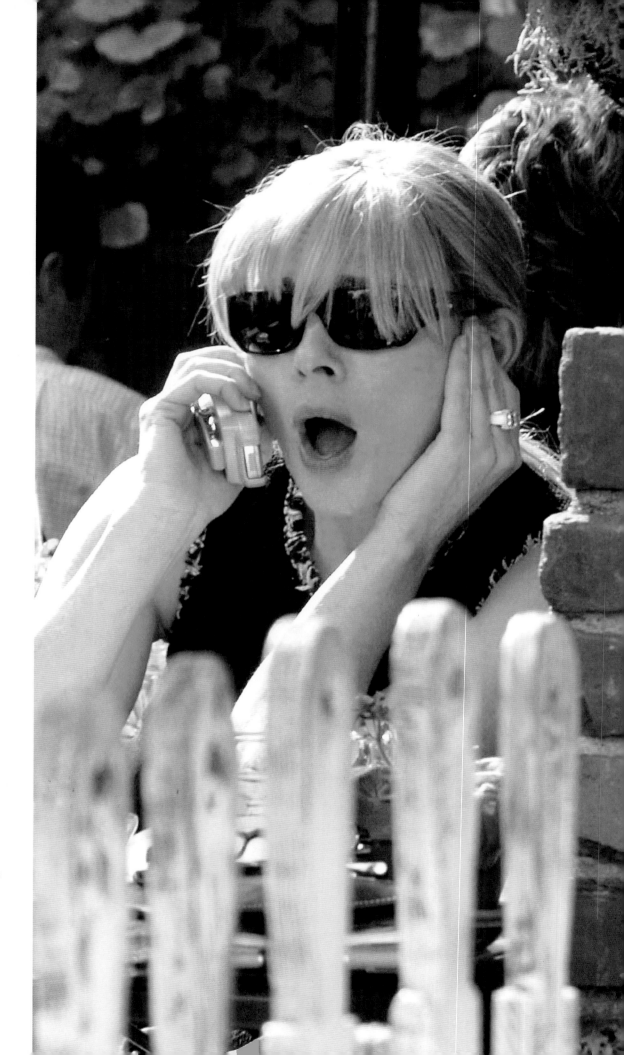

They Love Their Cellphones...
THIS PAGE: While lunching at the Ivy in L.A. on February 26, 2004, something sure surprised 47-year-old *Sex and the City* star **Kim Cattrall**!

...And Their Gadgets!
OPPOSITE: Heartthrob **Ashton Kutcher**, then 26, caught up on his text messages between takes of *A Lot Like Love* in Los Angeles on May 24, 2004.

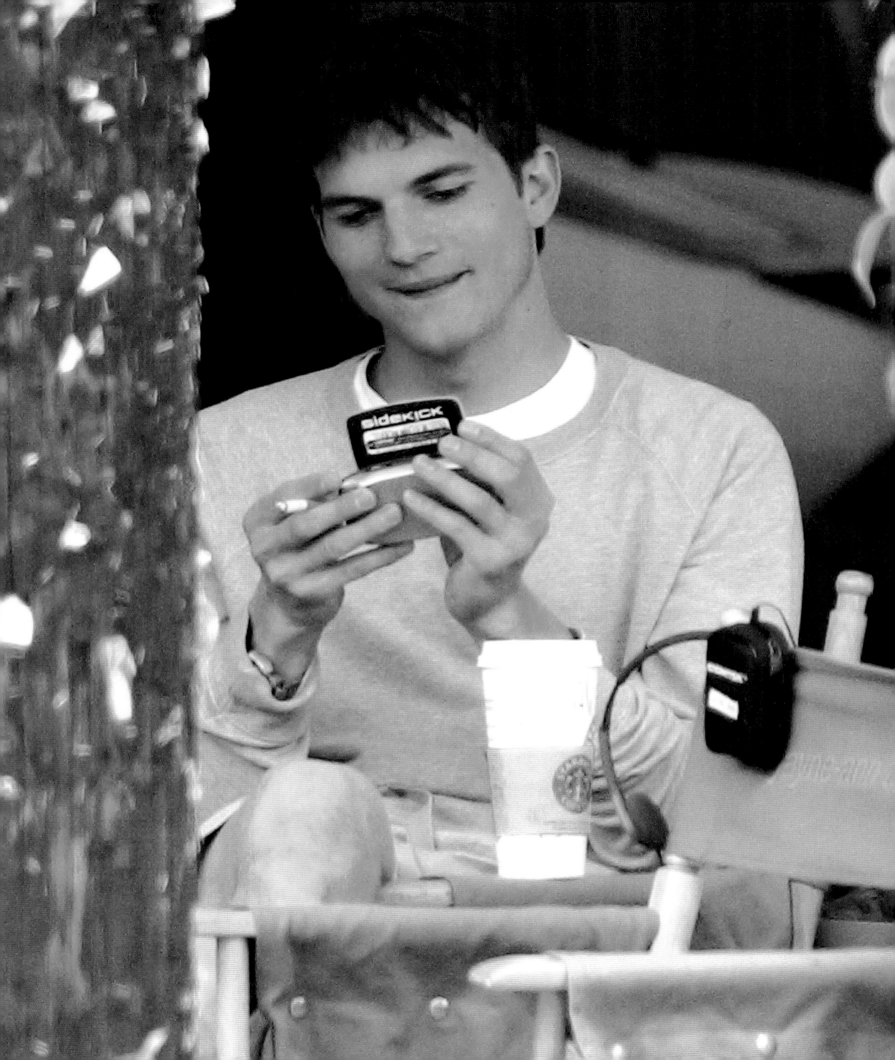

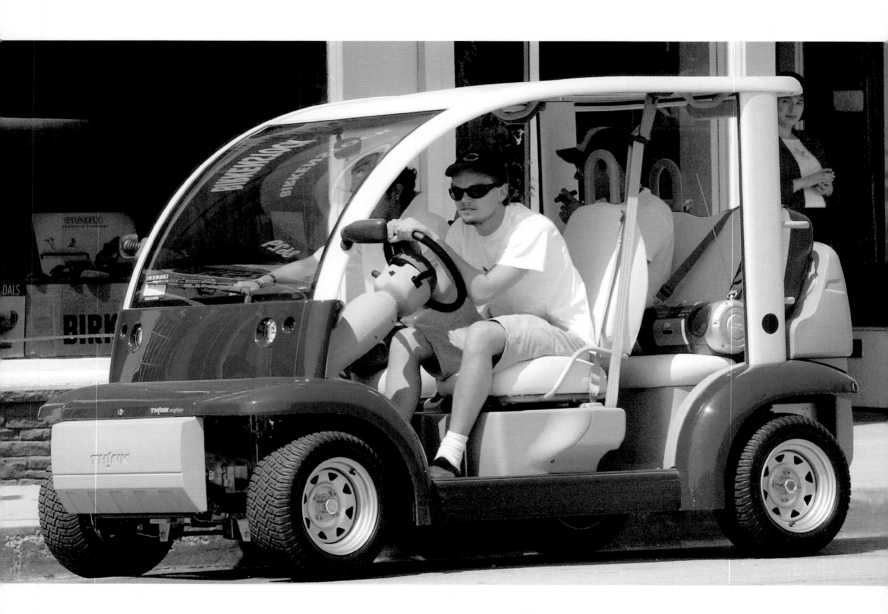

They're Eco-Friendly!
Leonardo DiCaprio chauffeured
pals in his electric car to West
Hollywood's trendy Fred Segal
store on August 13, 2002.

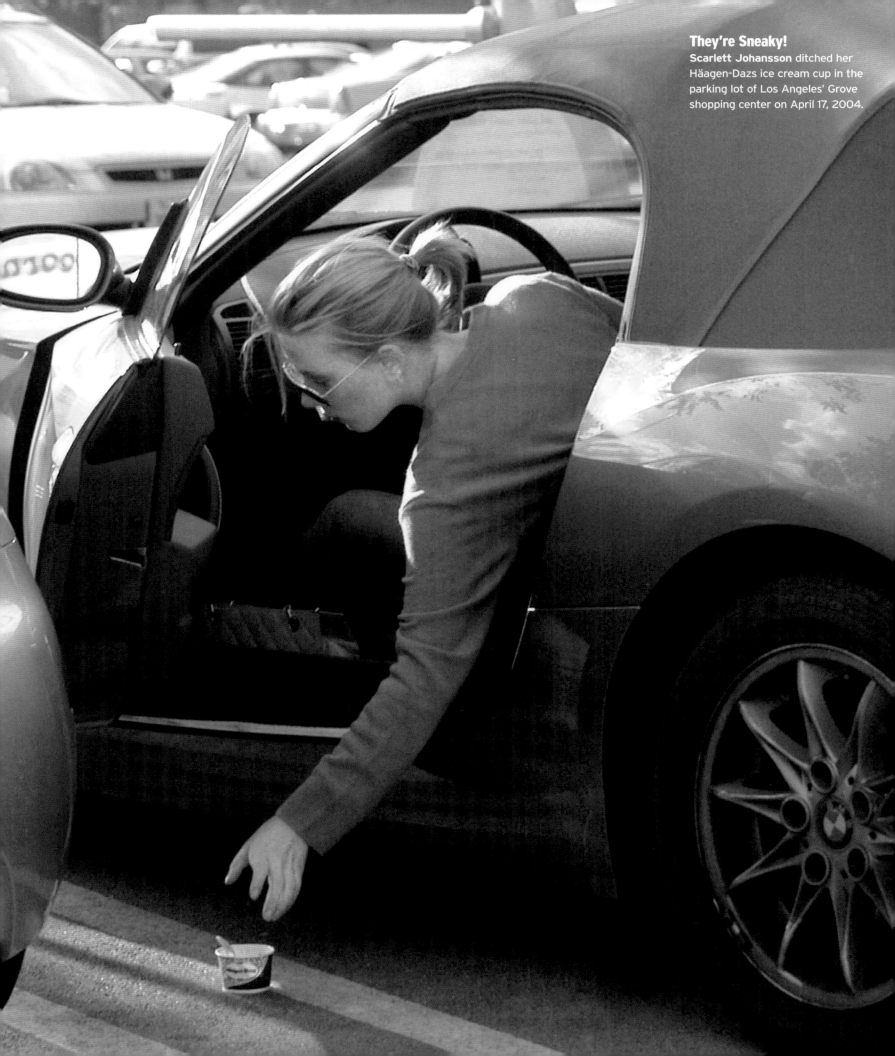

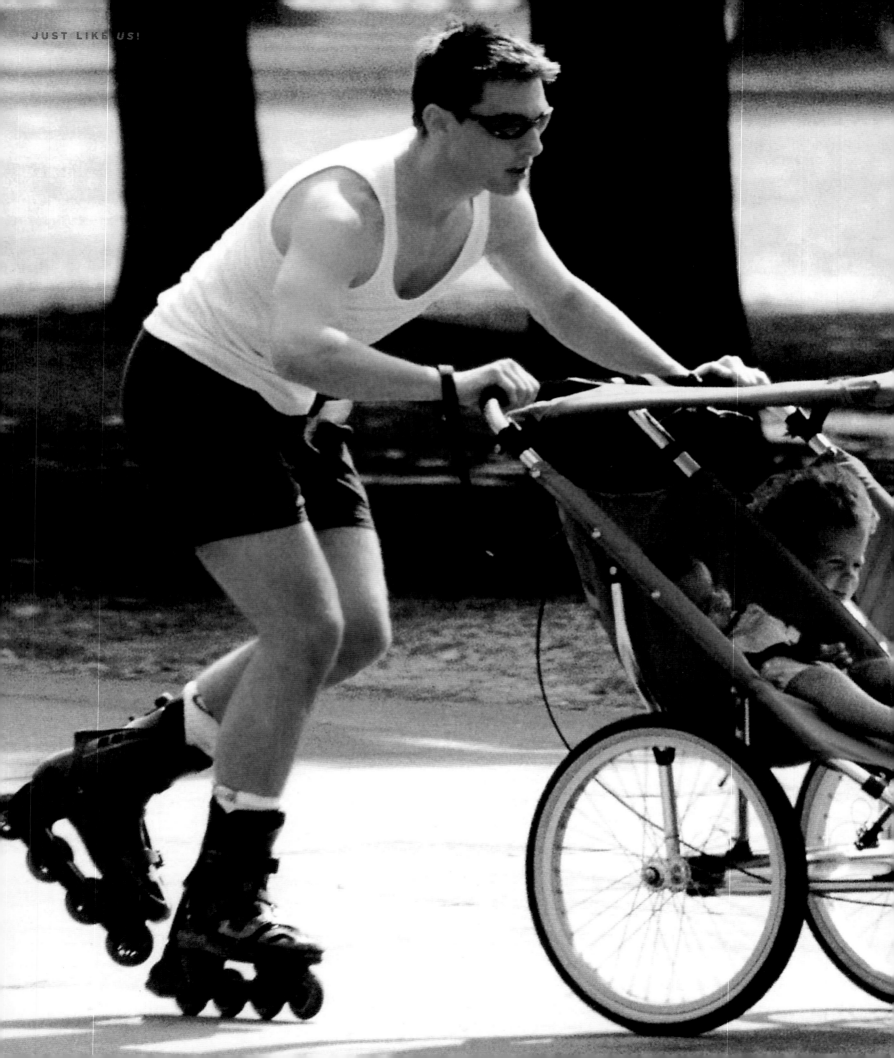

They Power-Stroll!

Tom Cruise felt the need for speed in 1995, strapping on his in-line skates to take kids Isabella, then about 2½, and baby Connor for a trip near their home.

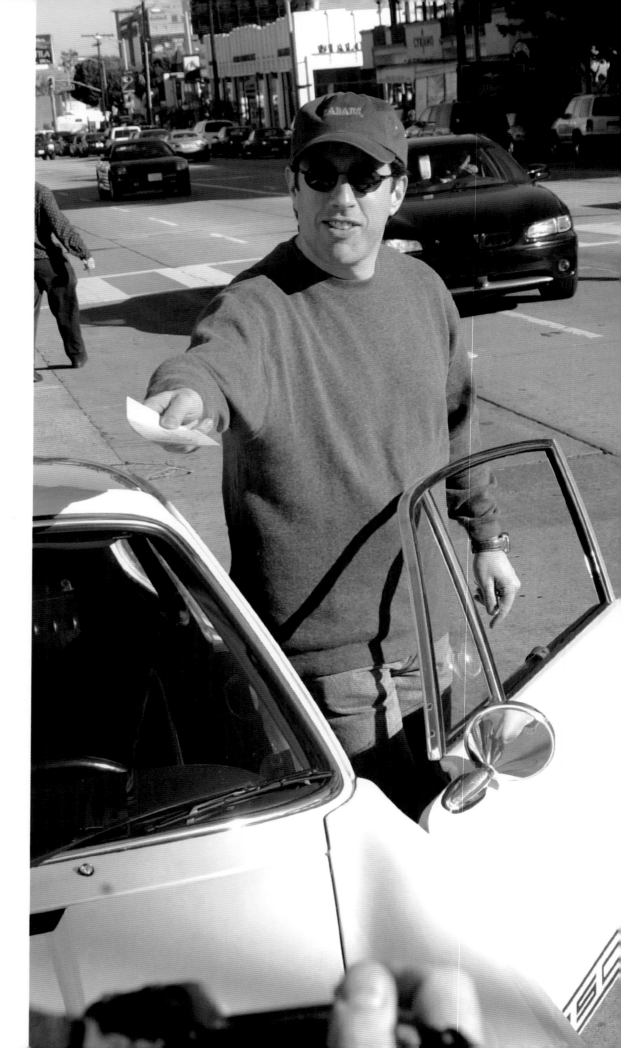

They Get Parking Tickets!

THIS PAGE: On January 18, 2001, **Jerry Seinfeld** parked his Porsche on a Beverly Hills street, had lunch with pal **James Spader** and – yada, yada, yada – found a ticket when he returned.

OPPOSITE, TOP: She smiled sweetly, but **Jennifer Love Hewitt** still got a ticket for a moving violation on November 5, 2000, in L.A.

OPPOSITE, BOTTOM: Supermodel **Gisele Bündchen** cringed on April 11, 2004, as she got a ticket while driving around Malibu – with boyfriend **Leonardo DiCaprio**'s mom!

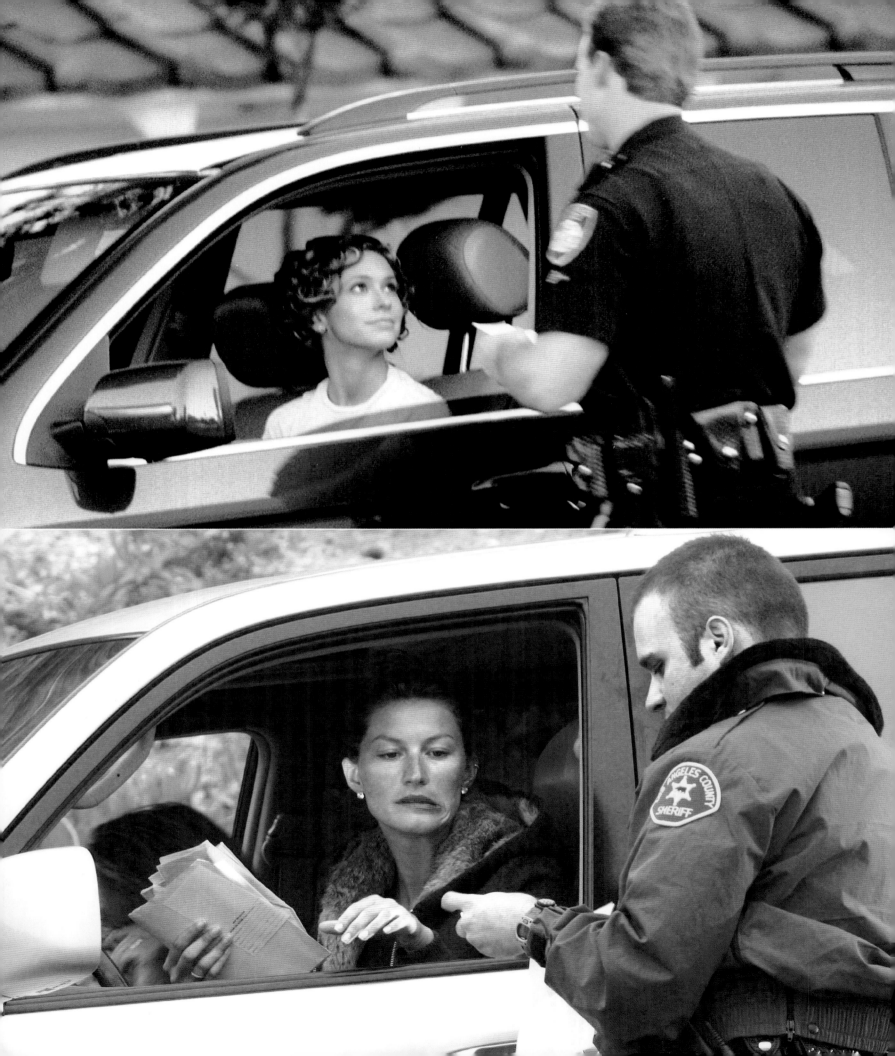

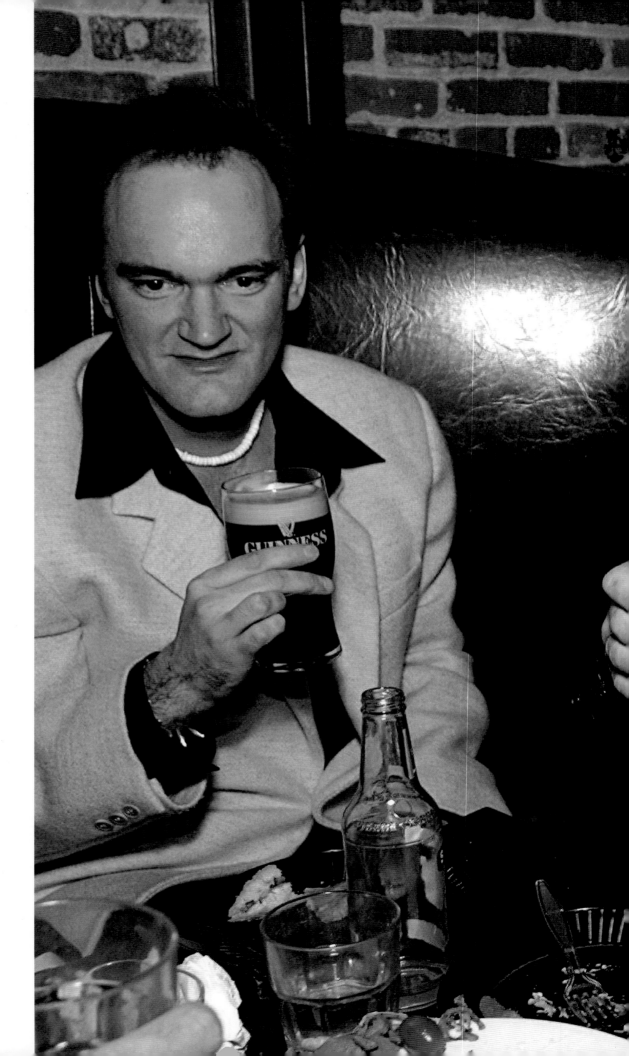

They Go Drinking With Friends!
Quentin Tarantino, with **Guy Ritchie** and his
wife, **Madonna**, hoisted a Guinness after the
Hollywood premiere of Ritchie's heist comedy
Snatch on January 18, 2001.

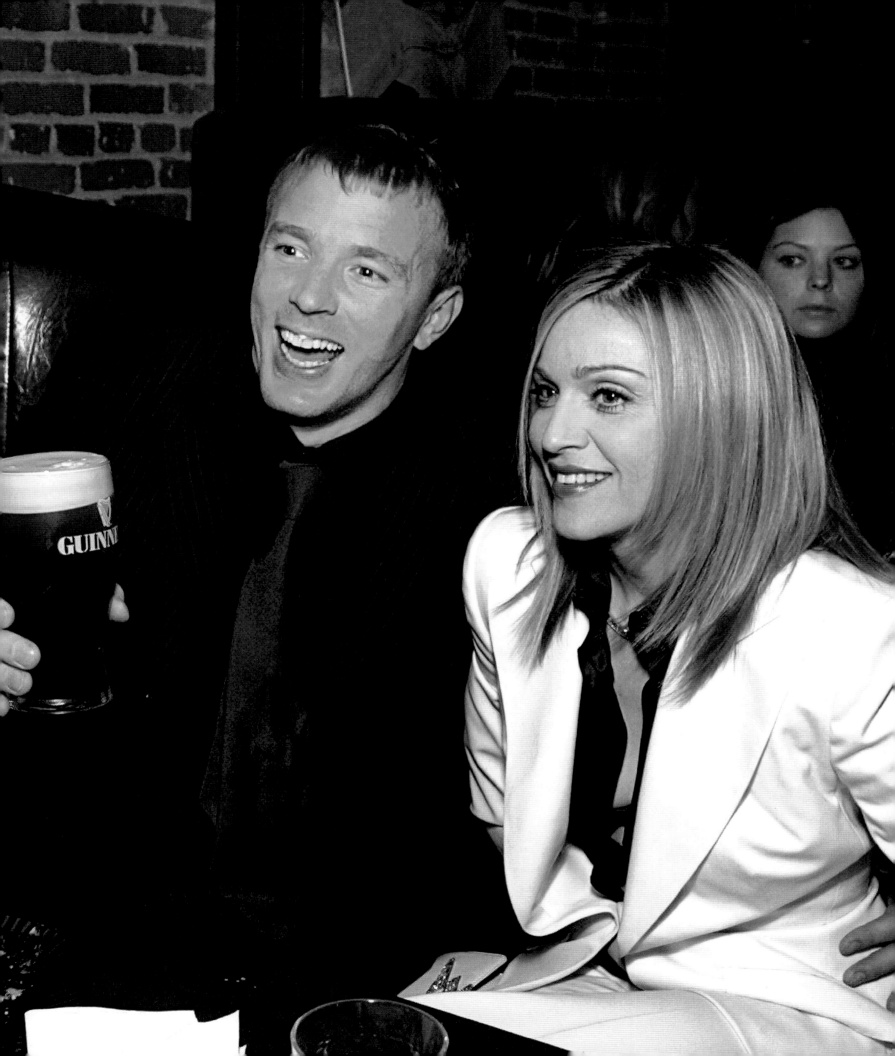

How Stars

Say "*I Do*"

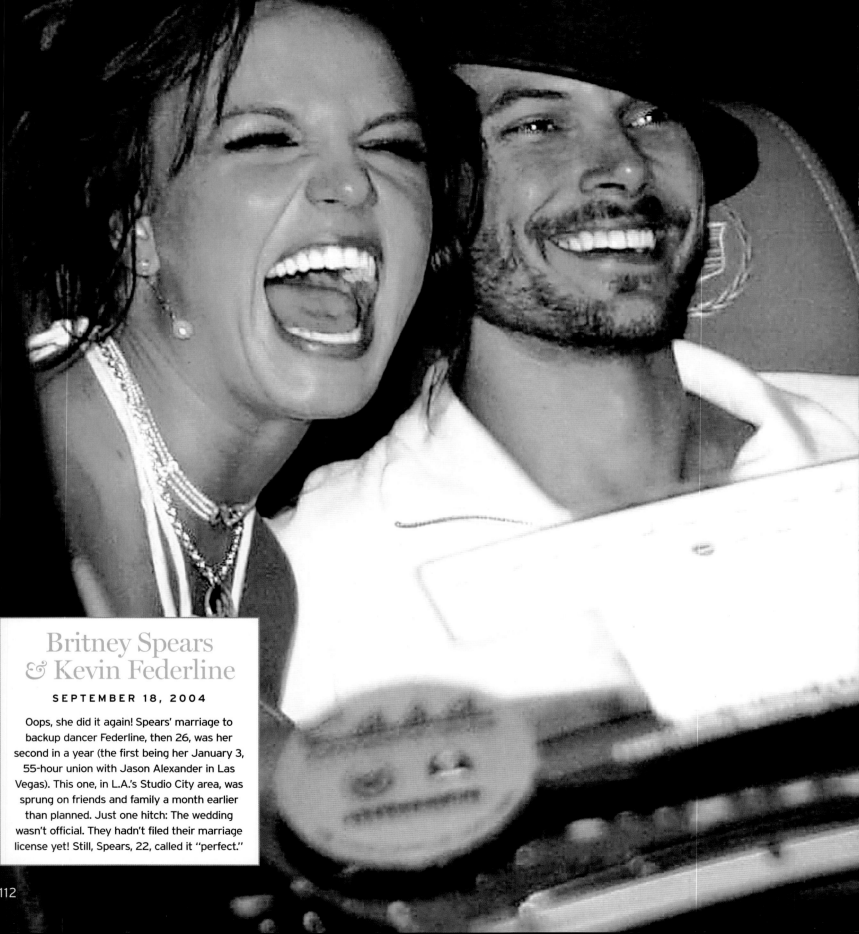

Britney Spears & Kevin Federline

SEPTEMBER 18, 2004

Oops, she did it again! Spears' marriage to backup dancer Federline, then 26, was her second in a year (the first being her January 3, 55-hour union with Jason Alexander in Las Vegas). This one, in L.A.'s Studio City area, was sprung on friends and family a month earlier than planned. Just one hitch: The wedding wasn't official. They hadn't filed their marriage license yet! Still, Spears, 22, called it "perfect."

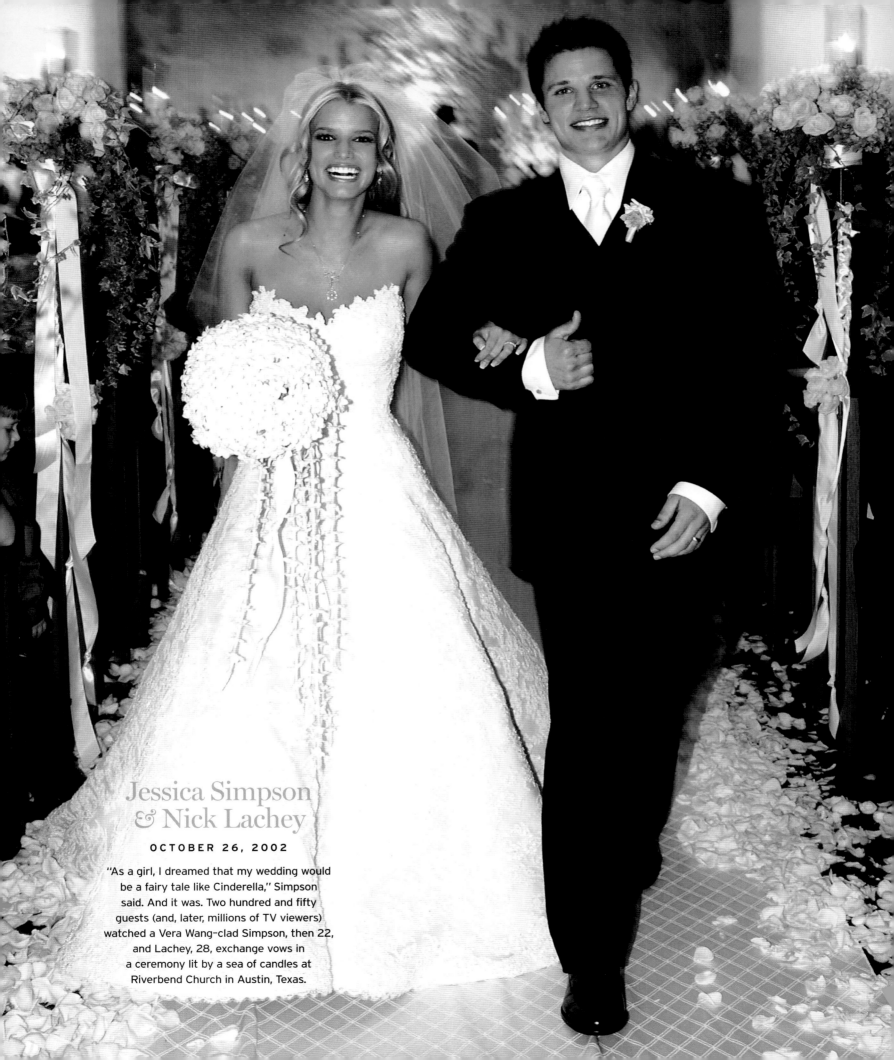

Jessica Simpson
& Nick Lachey

OCTOBER 26, 2002

"As a girl, I dreamed that my wedding would
be a fairy tale like Cinderella," Simpson
said. And it was. Two hundred and fifty
guests (and, later, millions of TV viewers)
watched a Vera Wang–clad Simpson, then 22,
and Lachey, 28, exchange vows in
a ceremony lit by a sea of candles at
Riverbend Church in Austin, Texas.

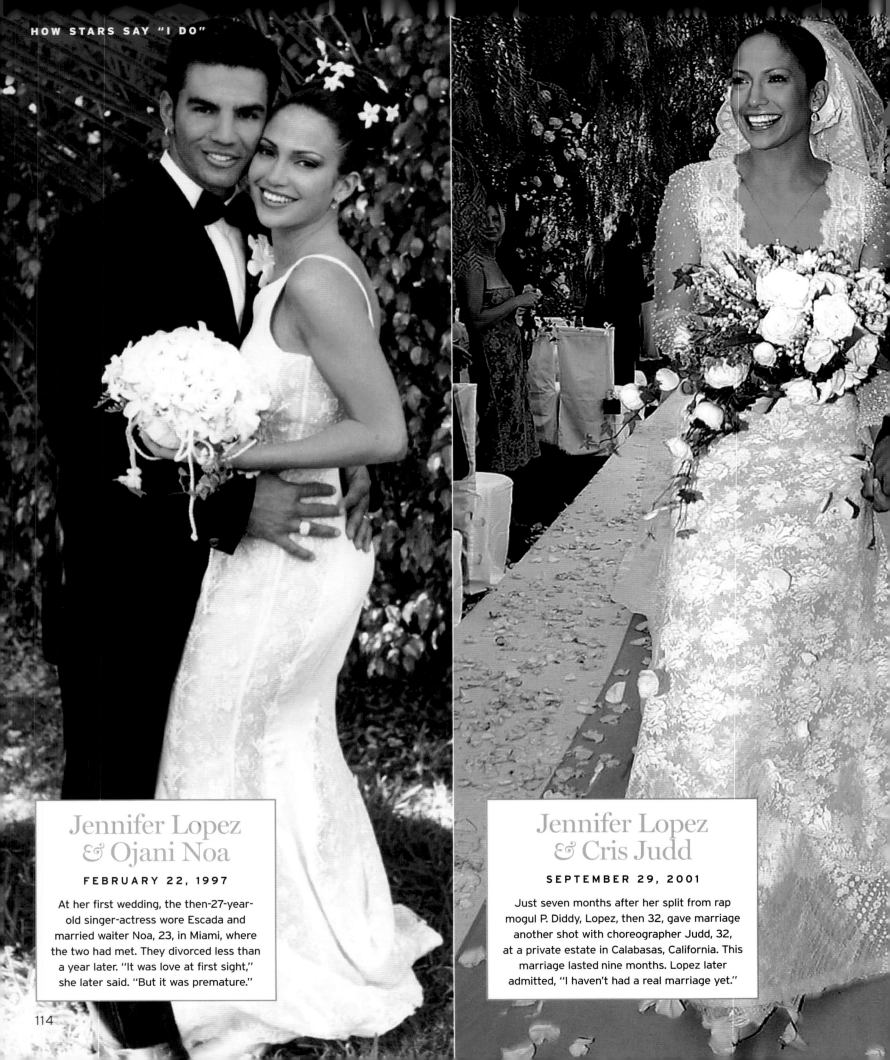

Jennifer Lopez & Ojani Noa

FEBRUARY 22, 1997

At her first wedding, the then-27-year-old singer-actress wore Escada and married waiter Noa, 23, in Miami, where the two had met. They divorced less than a year later. "It was love at first sight," she later said. "But it was premature."

Jennifer Lopez & Cris Judd

SEPTEMBER 29, 2001

Just seven months after her split from rap mogul P. Diddy, Lopez, then 32, gave marriage another shot with choreographer Judd, 32, at a private estate in Calabasas, California. This marriage lasted nine months. Lopez later admitted, "I haven't had a real marriage yet."

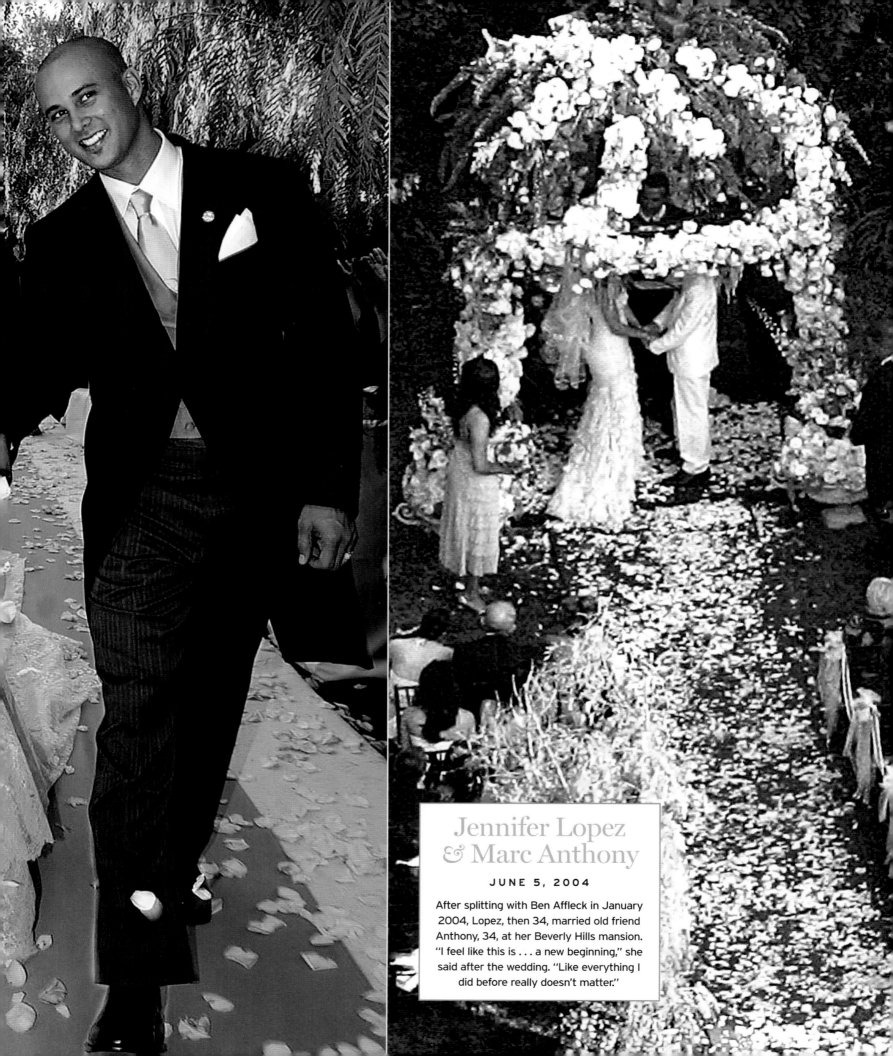

Jennifer Lopez
& Marc Anthony

JUNE 5, 2004

After splitting with Ben Affleck in January 2004, Lopez, then 34, married old friend Anthony, 34, at her Beverly Hills mansion. "I feel like this is . . . a new beginning," she said after the wedding. "Like everything I did before really doesn't matter."

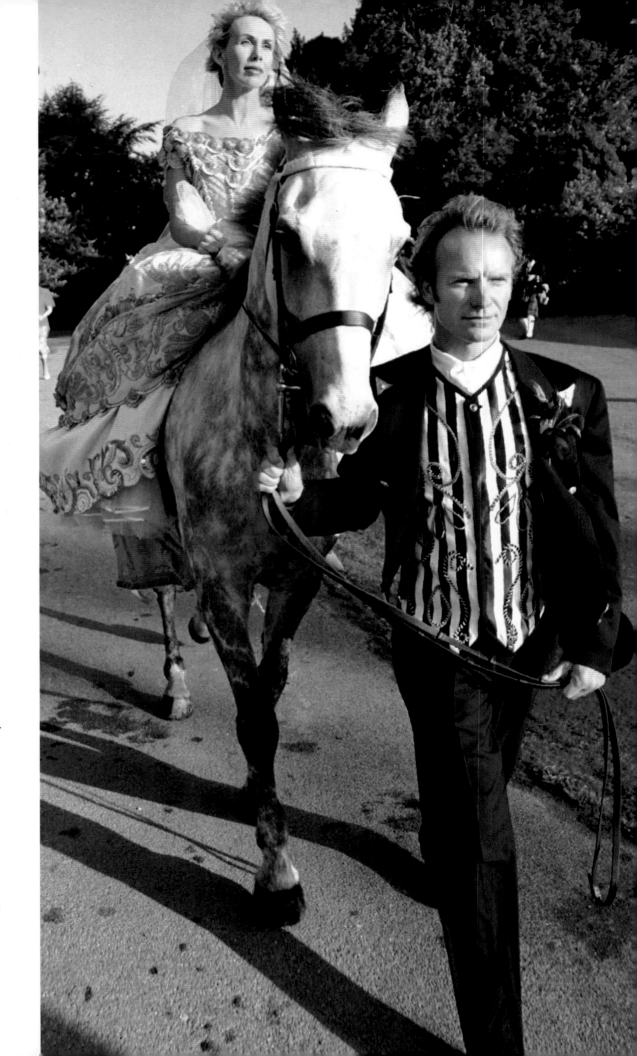

Trudie Styler & Sting

AUGUST 20, 1992

THIS PAGE: The rock icon, then 40, made sure his lady love, 37, arrived in style at their reception: He led Styler, dressed in a $40,000 Versace gown, on horseback from an English country church in Great Dunford (where they were blessed) to his multimillion-dollar house in the nearby village of Lake.

Kevin Costner & Christine Baumgartner

SEPTEMBER 25, 2004

OPPOSITE: Costner, then 49, turned his 165-acre Aspen, Colorado, estate into a field of dreams for his $1 million wedding to Baumgartner, 30. The couple entertained 320 guests with a weekend of barbecues, baseball and horse-riding before enjoying a private canoe ride. "It was so romantic," she said.

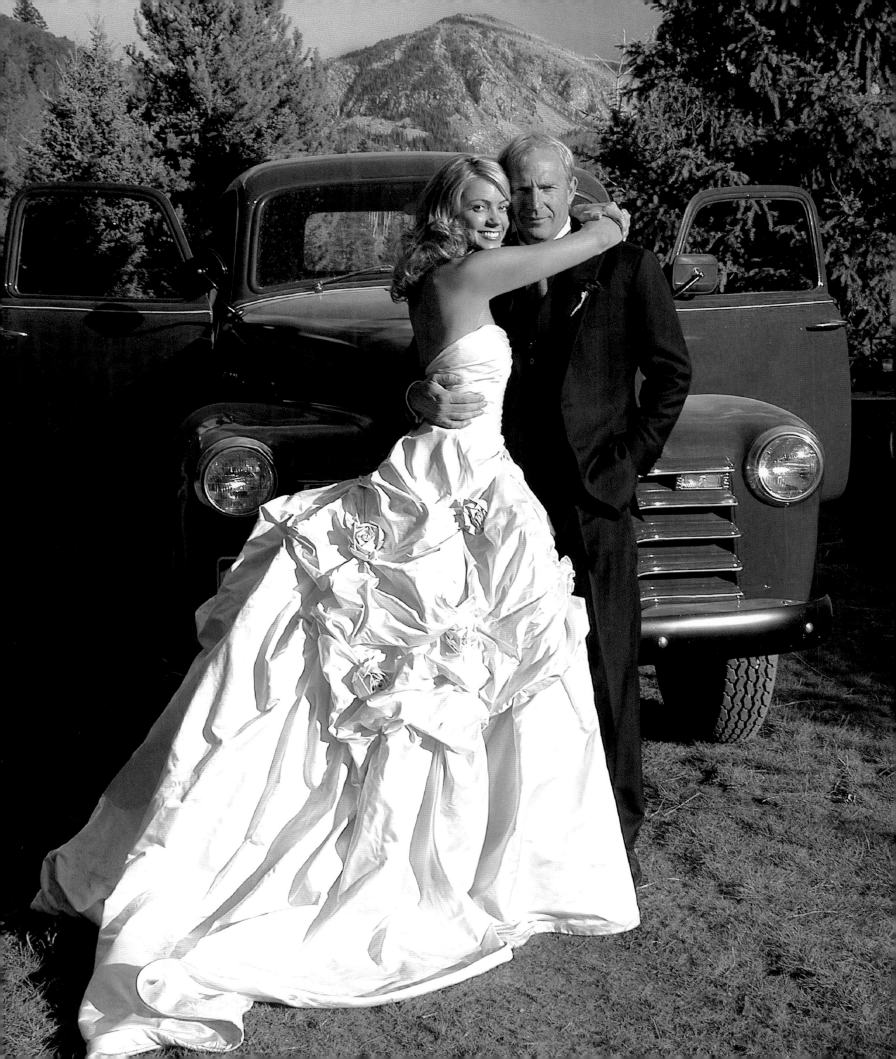

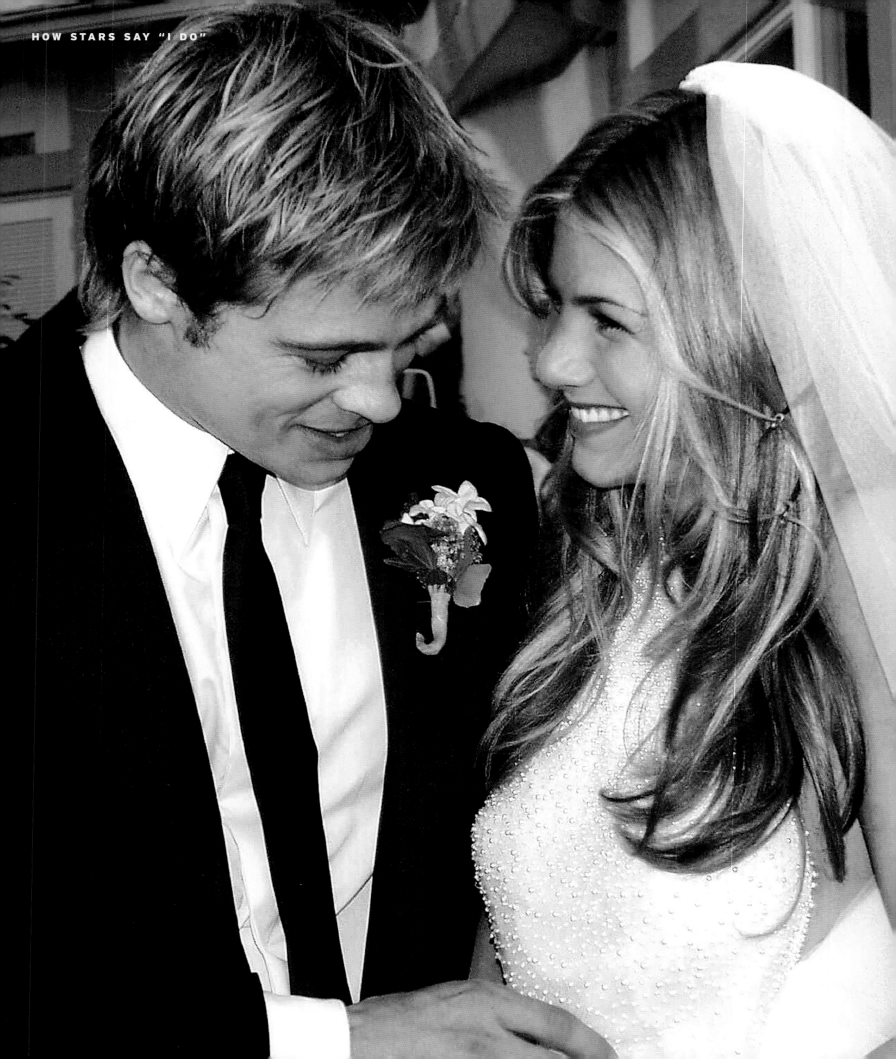

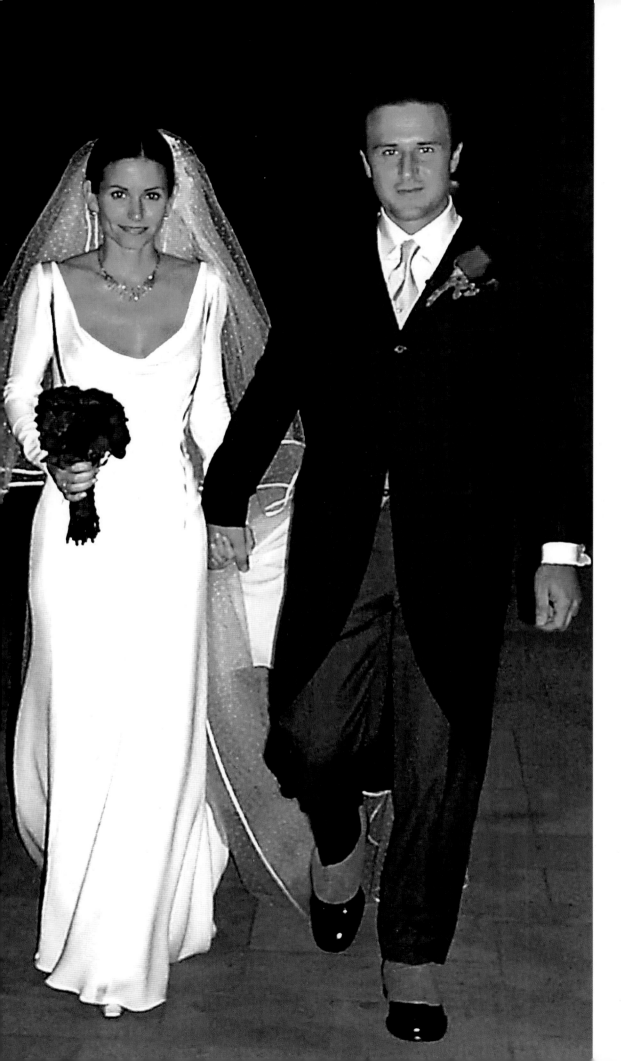

Jennifer Aniston
& Brad Pitt

JULY 29, 2000

OPPOSITE: The ultimate Hollywood couple wed at an estimated $1 million Malibu, California, extravaganza, complete with fireworks and four bands. The bride, then 31, and Pitt, 36, even wrote their own I do's, with Aniston vowing to make Pitt's "favorite banana milkshake" and Pitt agreeing to "split the difference on the thermostat."

Courteney Cox
& David Arquette

JUNE 12, 1999

THIS PAGE: At San Francisco's Grace Cathedral, the bride, then 35, wore silk crepe Valentino and an antique choker. Cox and Arquette, 27, and their 250 guests – including all five Friends – then hit Bimbo's 365 Club near Fisherman's Wharf for lobster, steak and dancing till 1 A.M.

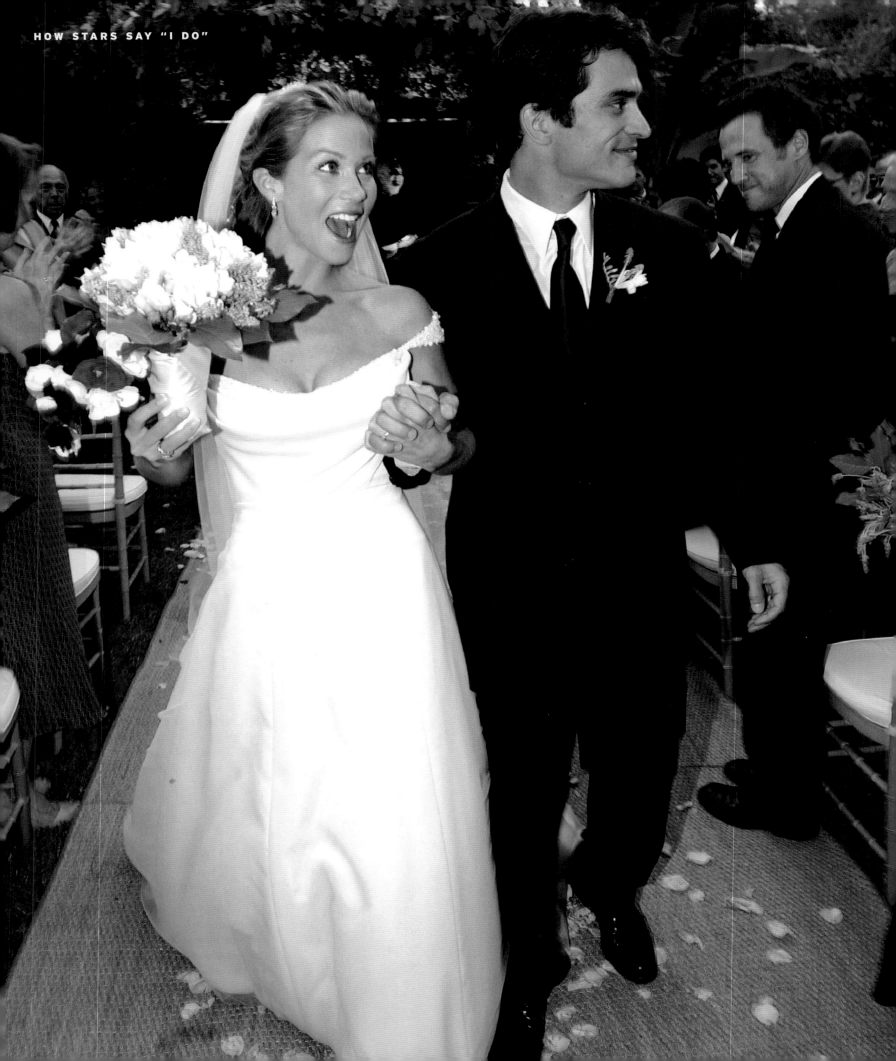

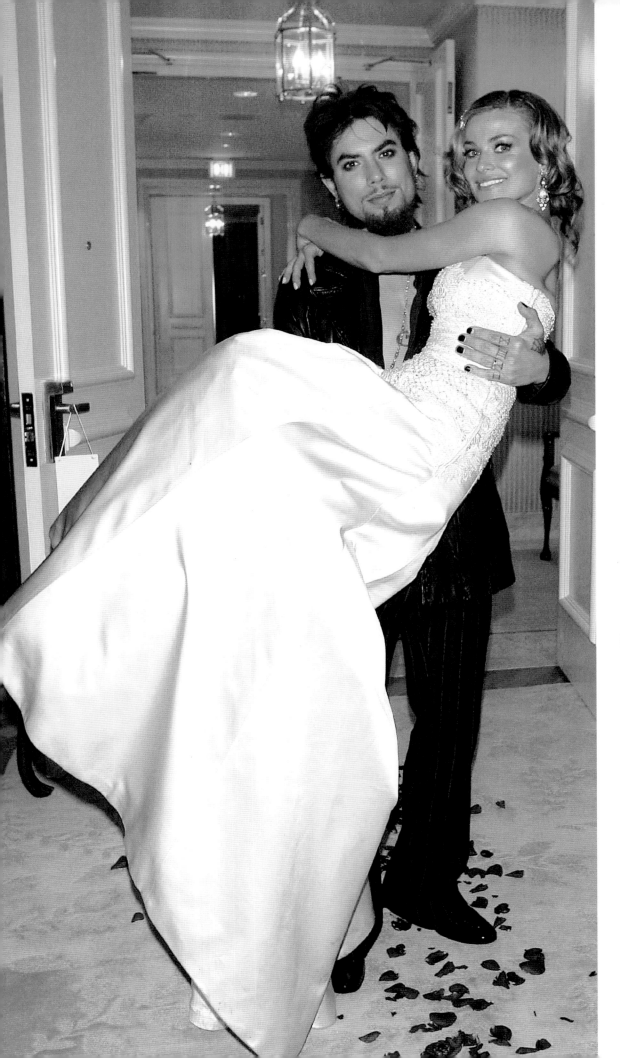

Christina Applegate & Johnathan Schaech

OCTOBER 20, 2001

OPPOSITE: Applegate, then 29, and Schaech, 32, got hitched in a romantic Palm Springs, California, ceremony in front of 130 guests. "When we danced in front of all those people I loved, I felt so proud that I was her husband," Schaech has said.

Carmen Electra & Dave Navarro

NOVEMBER 22, 2003

THIS PAGE: The couple, who documented their wedding preparations in the MTV show *'Til Death Do Us Part: Carmen & Dave*, wed at L.A.'s St. Regis Hotel. Electra, then 31, described the wedding as "the most beautiful day of my life." Navarro, 36, has said, "The only thing I noticed was the sparkle of Carmen's eyes."

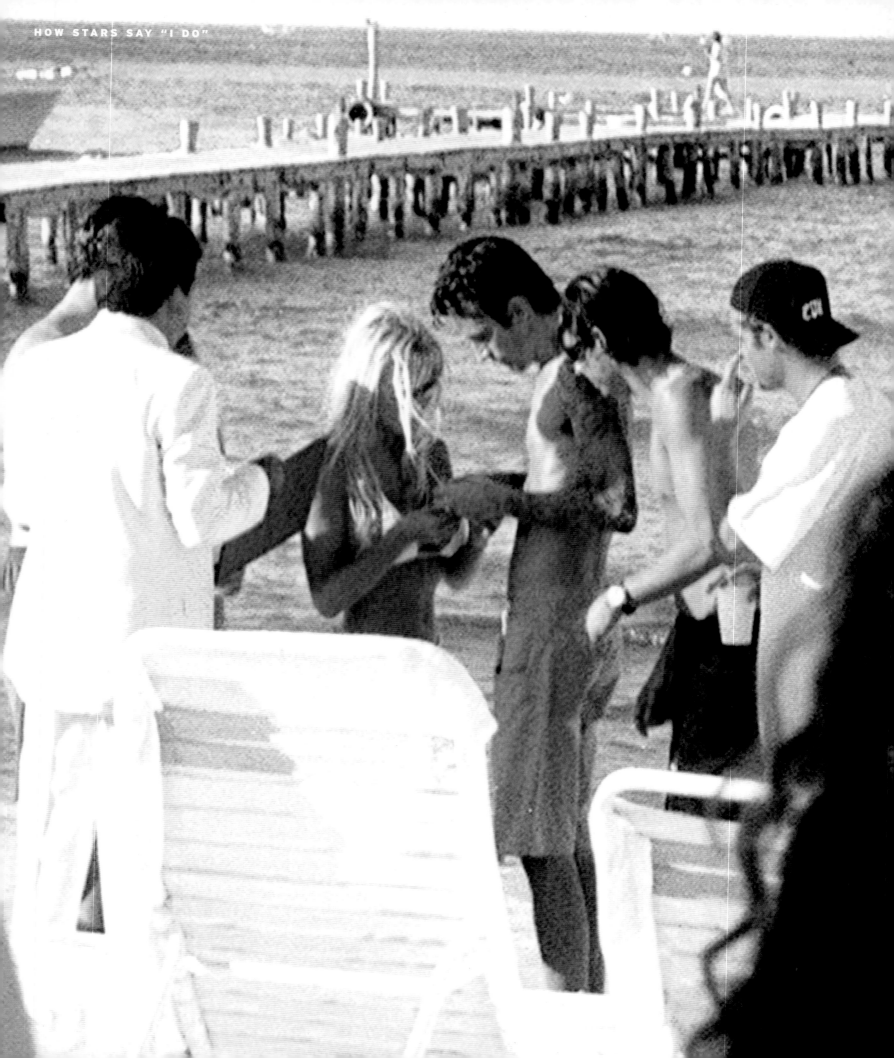

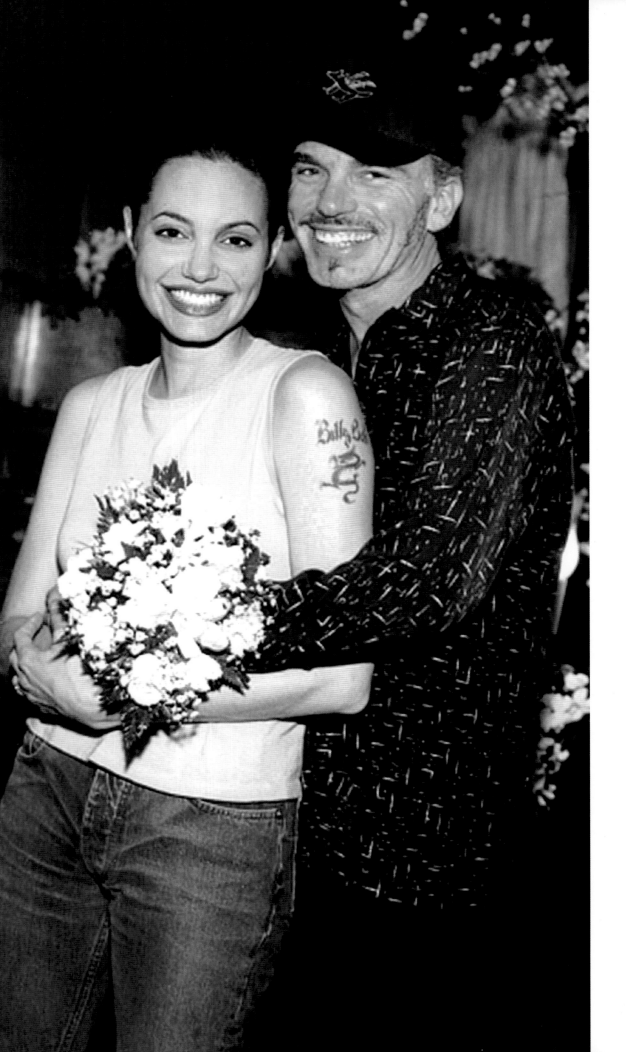

Pamela Anderson & Tommy Lee

FEBRUARY 19, 1995

OPPOSITE: Anderson, then 27, had dated Lee, 32, less than a week when she put on her best white string bikini for a beach wedding in Cancún, Mexico. In the years that followed, they made a sex tape that went public, had two sons and filed for divorce — twice!

Angelina Jolie & Billy Bob Thornton

MAY 5, 2000

THIS PAGE: When Jolie, then 24, and Thornton, 44, married at the Little Church of the West in Las Vegas for a bargain $189, everyone was in for a wild ride. During their wacky marriage (Thornton's fifth!), they wore vials of each other's blood and bought cemetery plots as gifts for each other. "I'm madly in love with this man and will be till I die," Jolie said then. Turns out, it lasted two years.

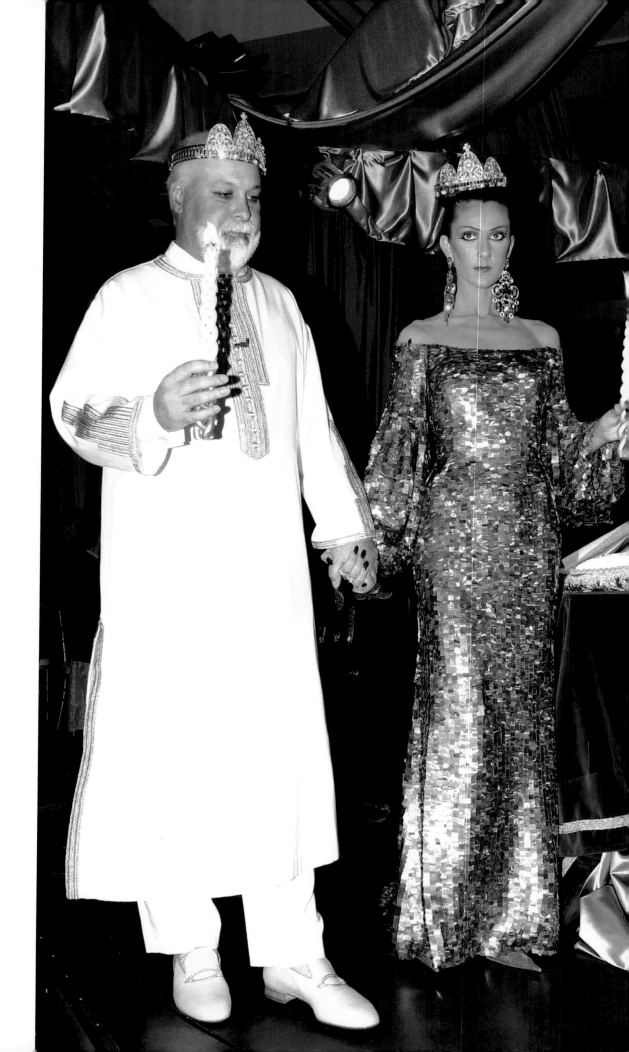

Celine Dion & René Angélil

JANUARY 5, 2000

THIS PAGE: When Dion, then 31, and Angélil, 57, renewed their vows — first taken five years earlier — at Caesars Palace in Las Vegas, the spectacle, which included snake charmers and belly dancers, put the shows on the Strip to shame!

Sir Paul McCartney & Heather Mills

JUNE 11, 2002

OPPOSITE: Four years after the death of his first wife, Linda, Sir Paul, then 59, spared no expense in his marriage to former model and activist Mills, 34. Their big day at St. Salvator's Church at Castle Leslie in Glaslough, Ireland, cost $3.2 million and culminated in a vegetarian Indian banquet.

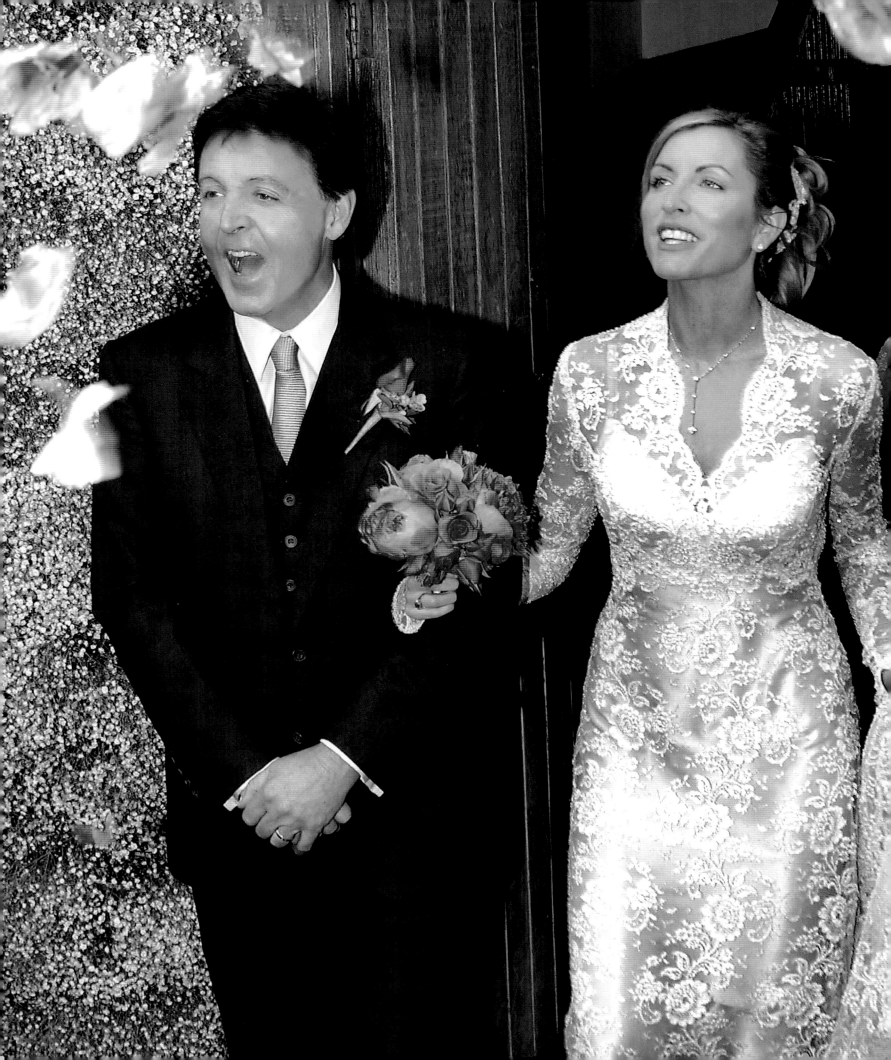

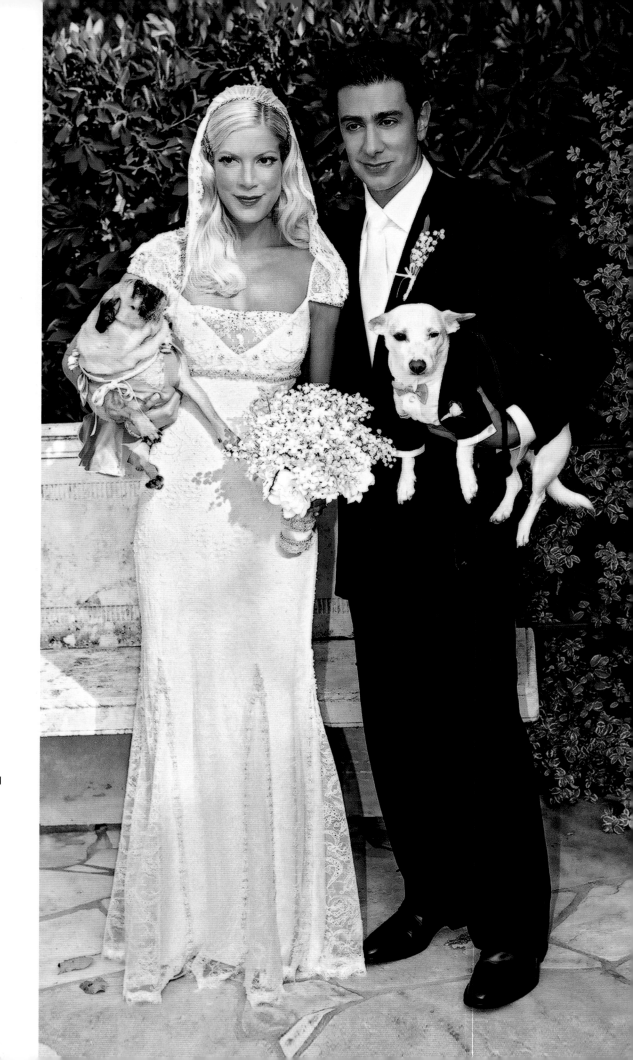

Tori Spelling
& Charlie Shanian

JULY 3, 2004

THIS PAGE: When the *Beverly Hills, 90210* star, then 31, wed actor-writer Shanian, 35, at her parents' estate in L.A.'s Holmby Hills area, she paired her $50,000 beaded Badgely Mischka gown with two very special accessories: her prized pups — pug Mimi La Rue and Jack Russell Chihuahua, Ferris!

Adam Sandler
& Jackie Titone

JUNE 22, 2003

OPPOSITE: Sandler, then 36, got hitched in Malibu, California, to girlfriend of four years Titone, 28. Sandler's bulldog, Meatball (who sadly passed away in 2004), dressed to impress in a tux and yarmulke (*inset*).

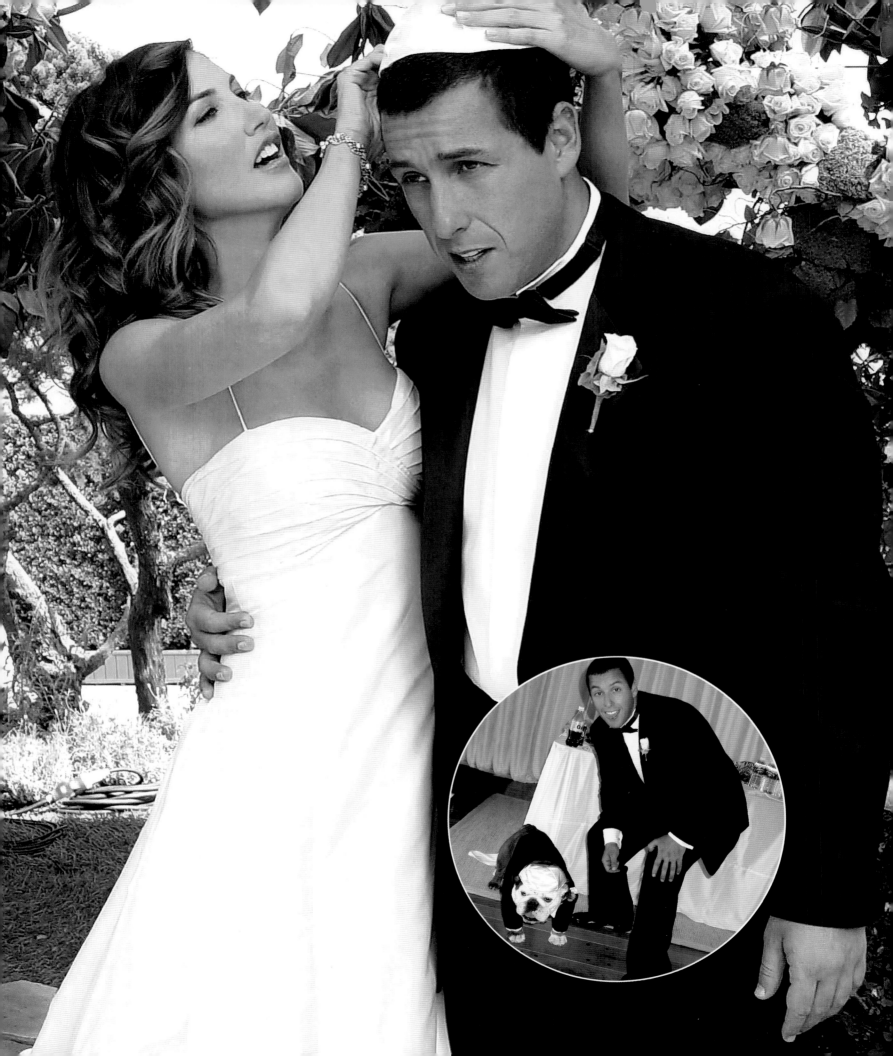

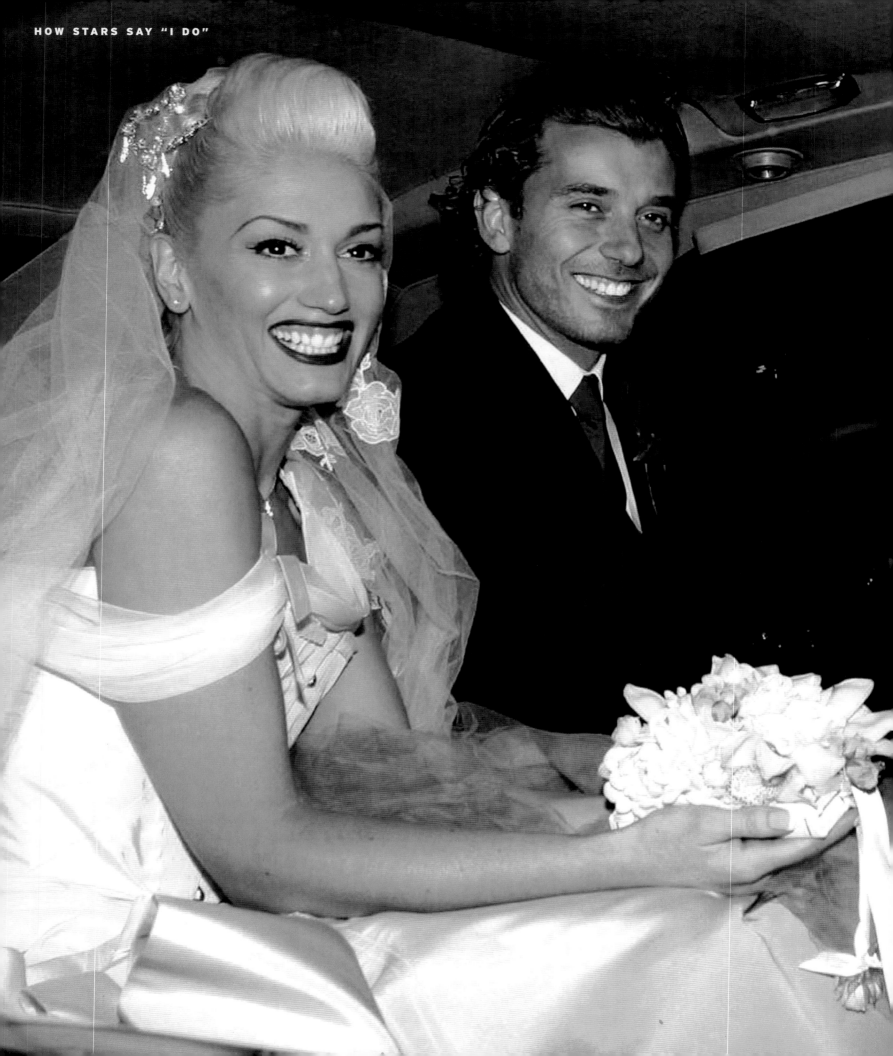

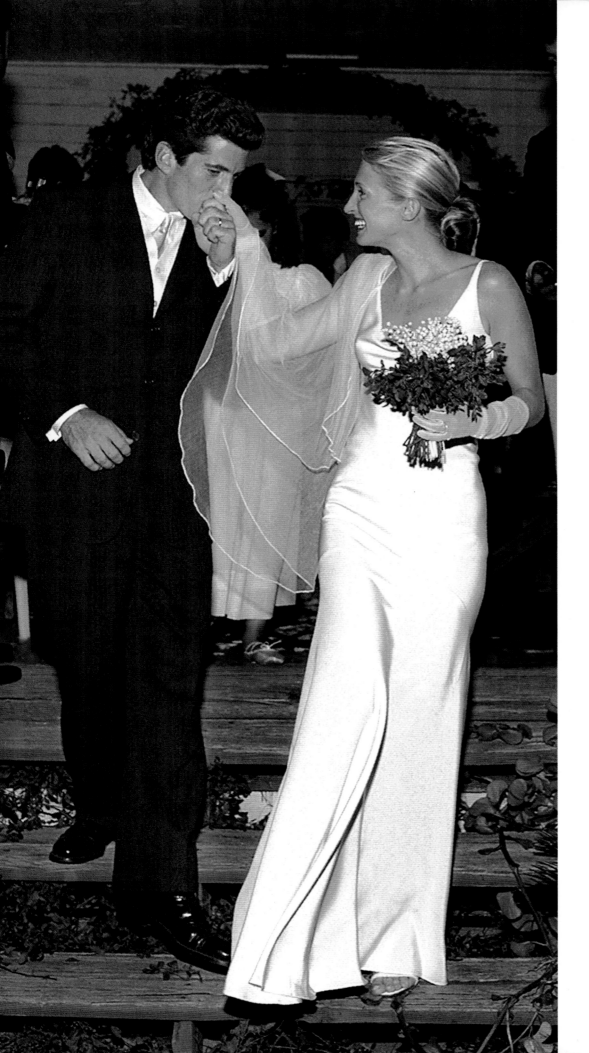

Gwen Stefani & Gavin Rossdale

SEPTEMBER 14, 2002

OPPOSITE: Why have just one wedding when you can have two? Galliano-clad Stefani, then 32, wed Rossdale, 34, during an Anglican service with 150 guests in St. Paul's church in London. The couple then did it all over again in a Catholic ceremony in L.A. on September 28 in front of Jennifer Aniston, Brad Pitt and Ben Stiller.

John F. Kennedy Jr. & Carolyn Bessette

SEPTEMBER 21, 1996

THIS PAGE: Against the odds, Kennedy, then 35, managed to keep his wedding to Calvin Klein publicist Bessette, 30, secret. Guests were ferried to a wooden chapel on Cumberland Island, Georgia, where the bride stunned in a Narciso Rodriguez gown. Tragically, the couple were killed in a plane crash three years later.

129

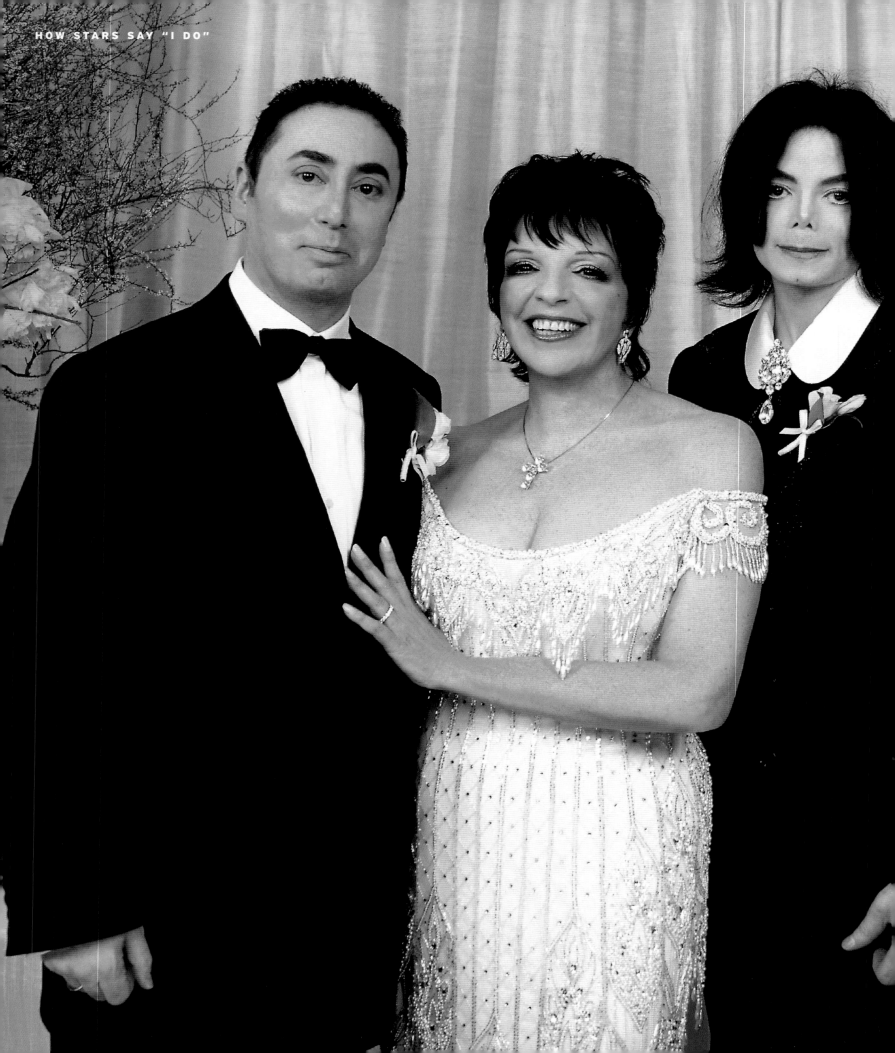

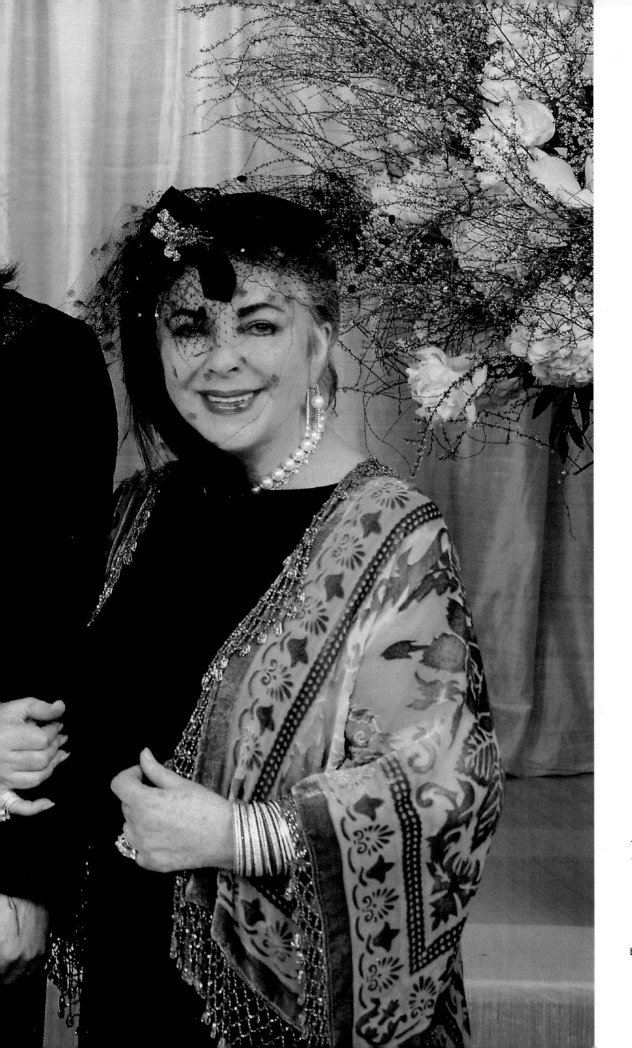

Liza Minnelli & David Gest

MARCH 16, 2002

Michael Jackson was best man. Elizabeth Taylor (who arrived at the church in slippers) was matron of honor. In fact, the 850-strong guest list at the Minnelli-Gest union (at New York City's Marble Collegiate Church) was a virtual who's who that included Donald Trump, Diana Ross, Martha Stewart and David Hasselhoff. The reported $2.7 million bash even featured a 12-tier, six-foot-tall cake and cookies printed with the likenesses of Minnelli, then 56, and Gest, 48. The pair split up just 16 months later.

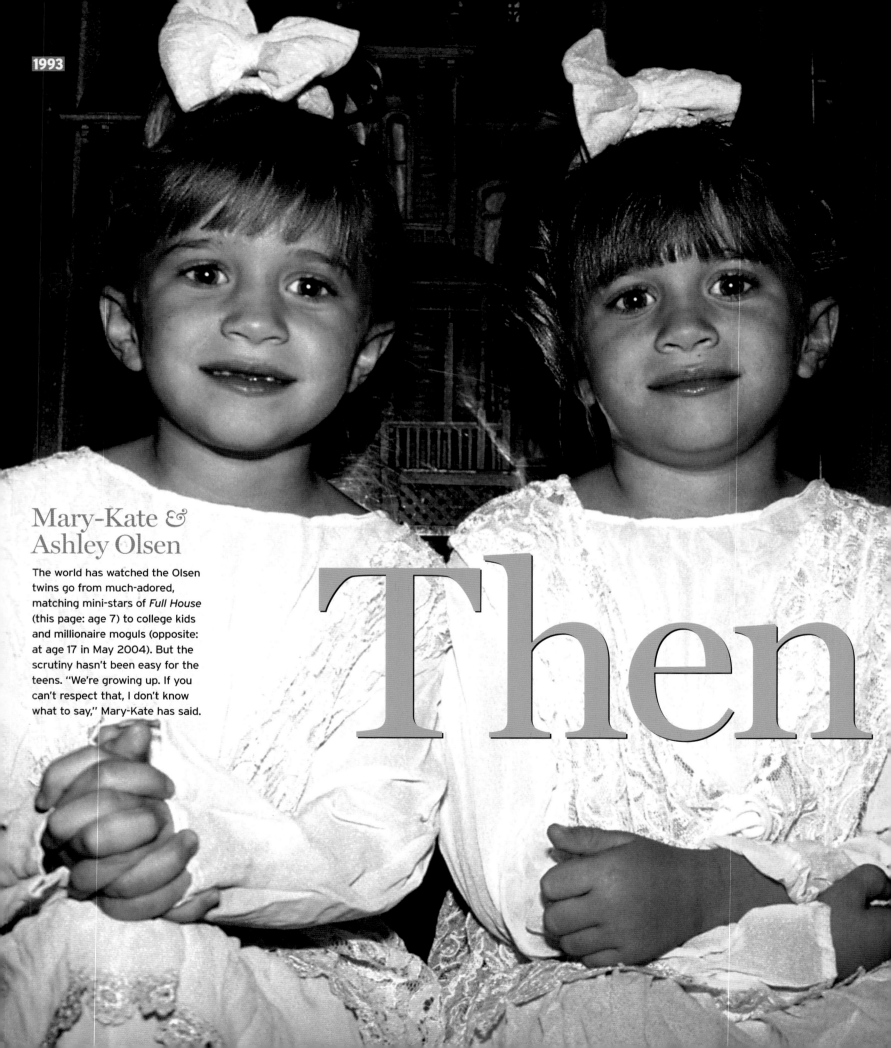

Mary-Kate & Ashley Olsen

The world has watched the Olsen twins go from much-adored, matching mini-stars of *Full House* (this page: age 7) to college kids and millionaire moguls (opposite: at age 17 in May 2004). But the scrutiny hasn't been easy for the teens. "We're growing up. If you can't respect that, I don't know what to say," Mary-Kate has said.

Then

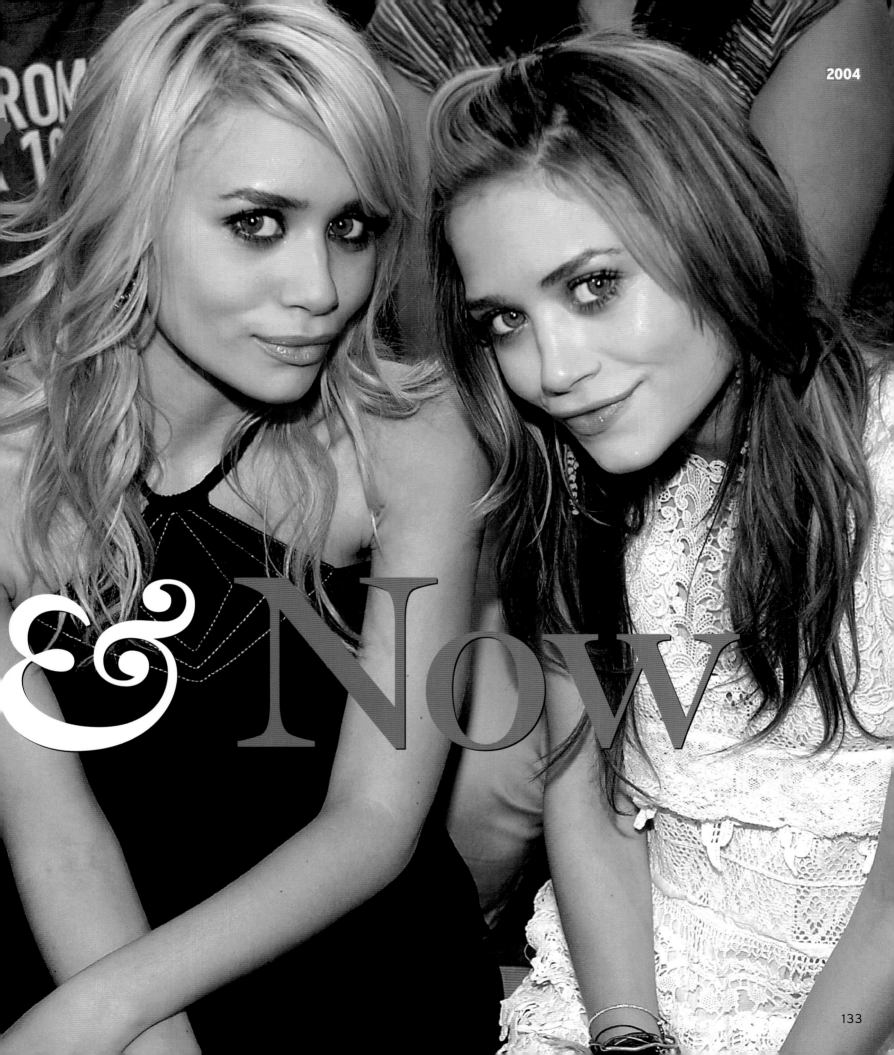

2004

& Now

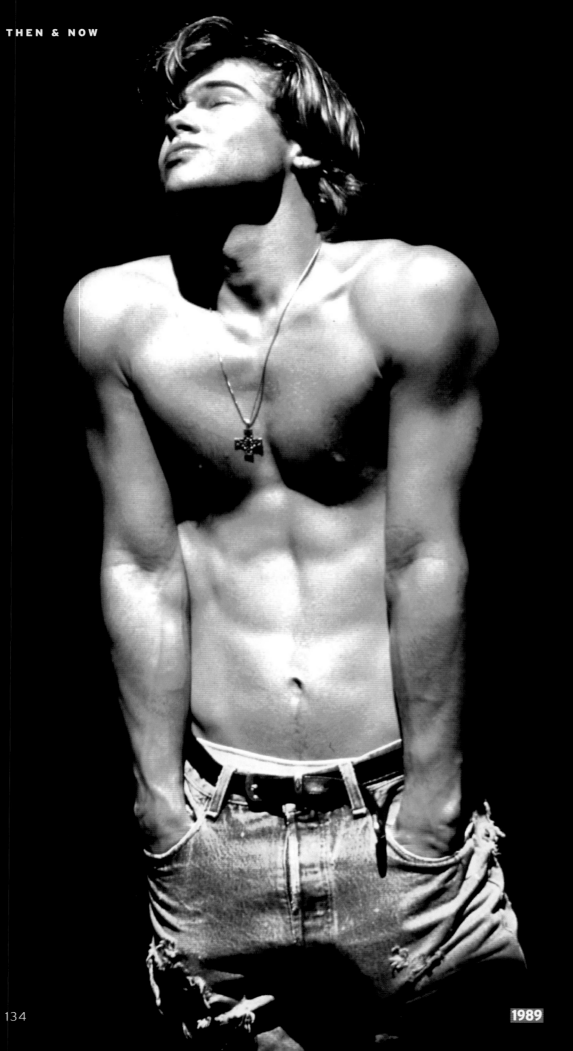

1989

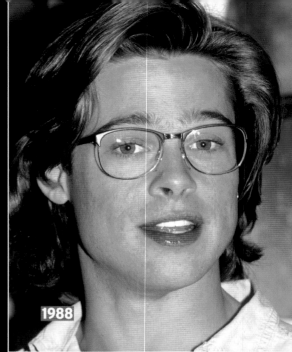

1988

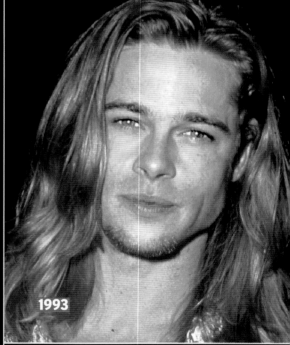

1993

1997

2000

2001

2002

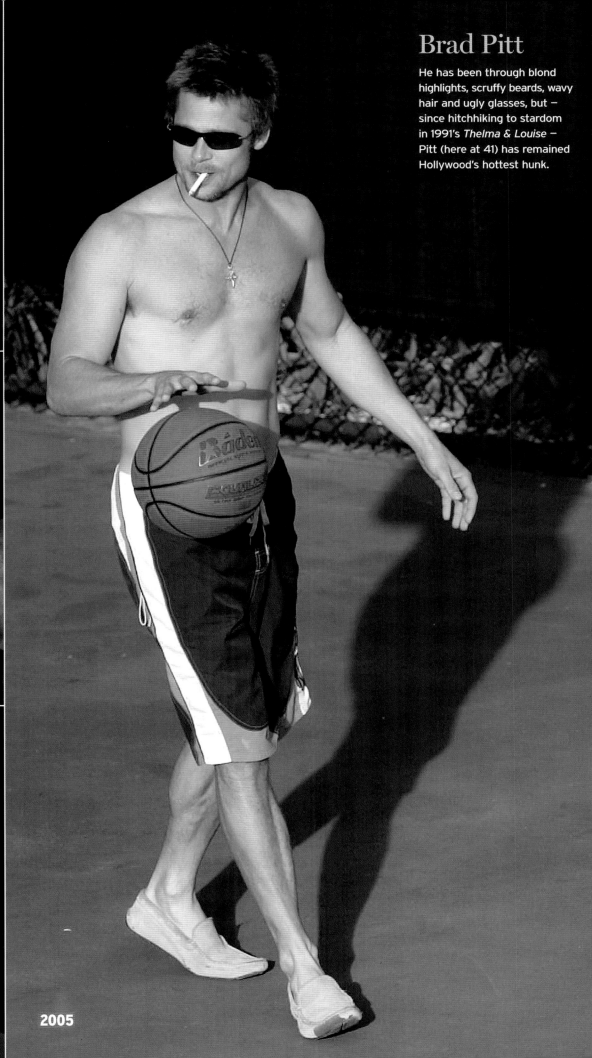

2005

Brad Pitt

He has been through blond highlights, scruffy beards, wavy hair and ugly glasses, but — since hitchhiking to stardom in 1991's *Thelma & Louise* — Pitt (here at 41) has remained Hollywood's hottest hunk.

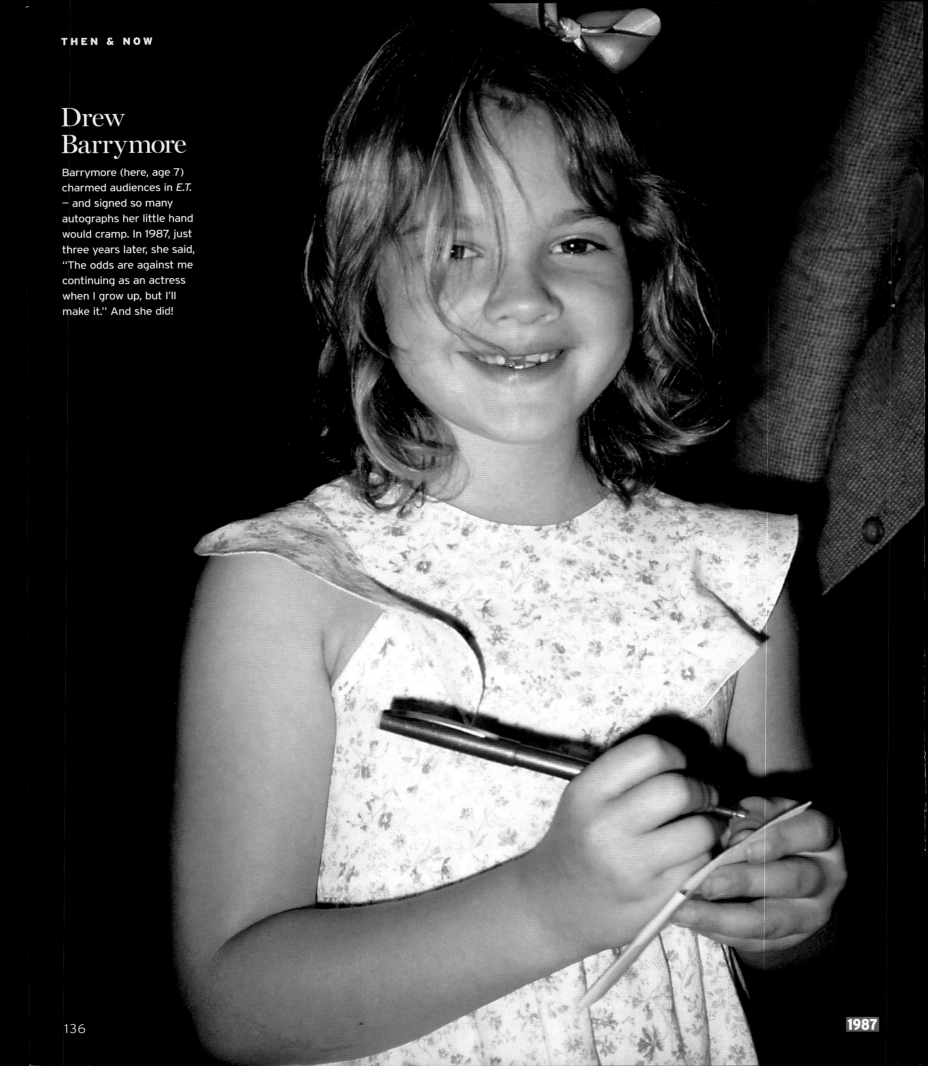

Drew Barrymore

Barrymore (here, age 7) charmed audiences in *E.T.* — and signed so many autographs her little hand would cramp. In 1987, just three years later, she said, "The odds are against me continuing as an actress when I grow up, but I'll make it." And she did!

1987

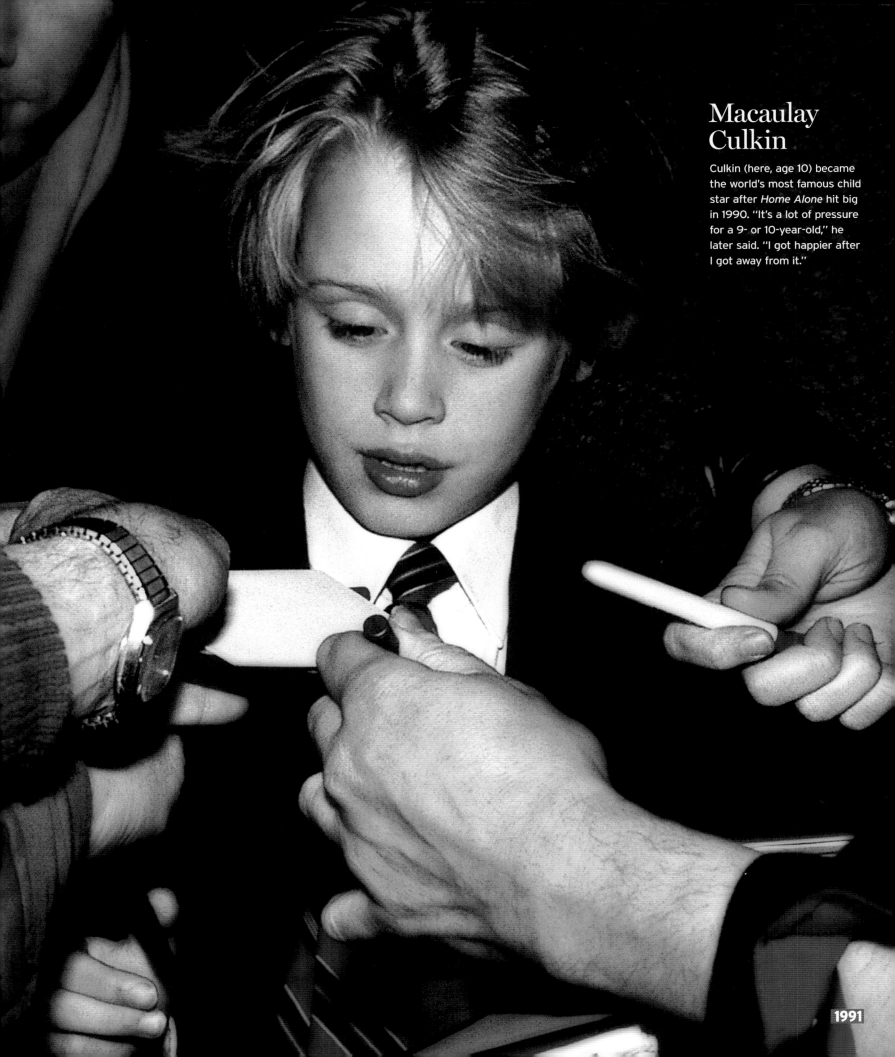

Macaulay Culkin

Culkin (here, age 10) became the world's most famous child star after *Home Alone* hit big in 1990. "It's a lot of pressure for a 9- or 10-year-old," he later said. "I got happier after I got away from it."

1991

TOP ROW, FROM LEFT:
Jennifer Love Hewitt
Christina Aguilera
Kelly Ripa

MIDDLE ROW, FROM LEFT:
Justin Timberlake
Jamie-Lynn DiScala
Ashton Kutcher

BOTTOM ROW, FROM LEFT:
Noah Wyle
Keanu Reeves

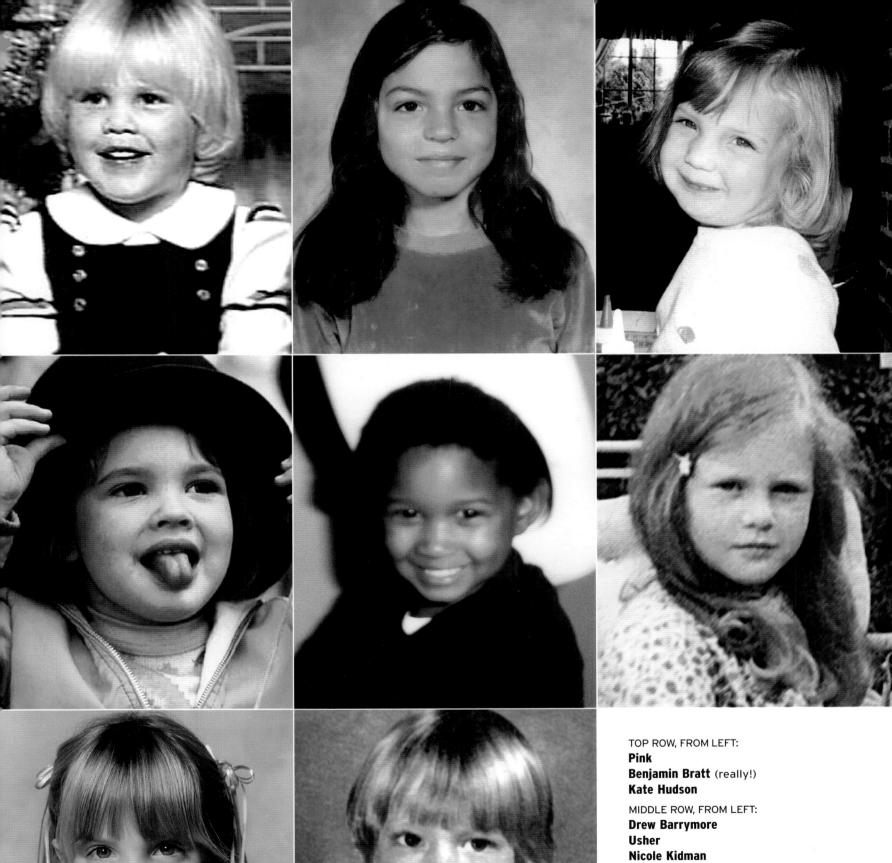

TOP ROW, FROM LEFT:
Pink
Benjamin Bratt (really!)
Kate Hudson

MIDDLE ROW, FROM LEFT:
Drew Barrymore
Usher
Nicole Kidman

BOTTOM ROW, FROM LEFT:
Mena Suvari
Eminem

139

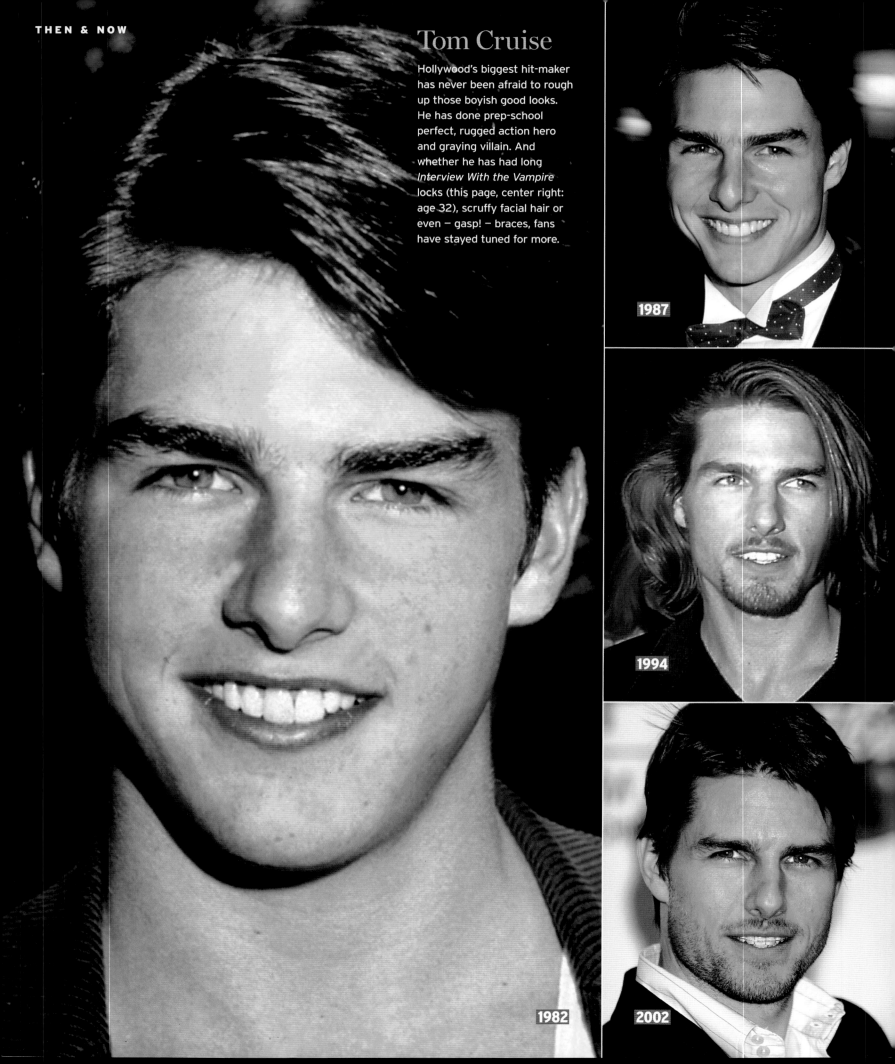

Tom Cruise

Hollywood's biggest hit-maker has never been afraid to rough up those boyish good looks. He has done prep-school perfect, rugged action hero and graying villain. And whether he has had long *Interview With the Vampire* locks (this page, center right: age 32), scruffy facial hair or even – gasp! – braces, fans have stayed tuned for more.

1987

1994

1982

2002

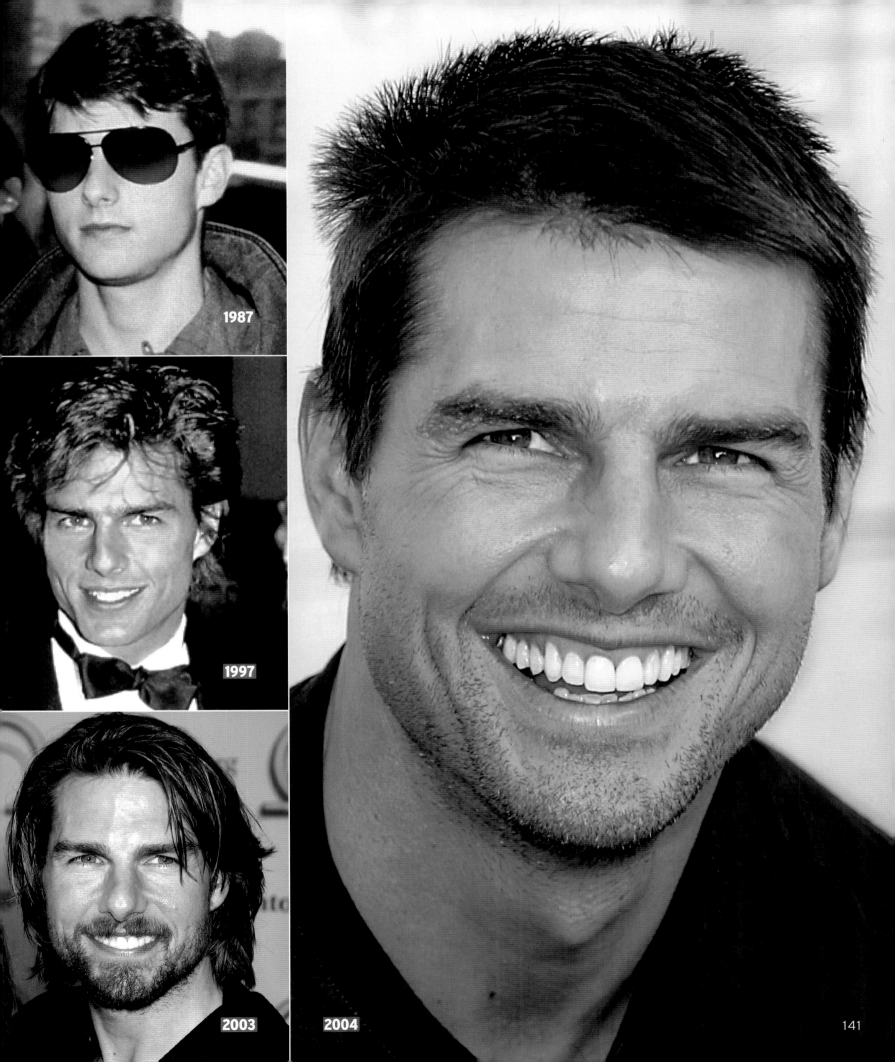

1987

1997

2003

2004

141

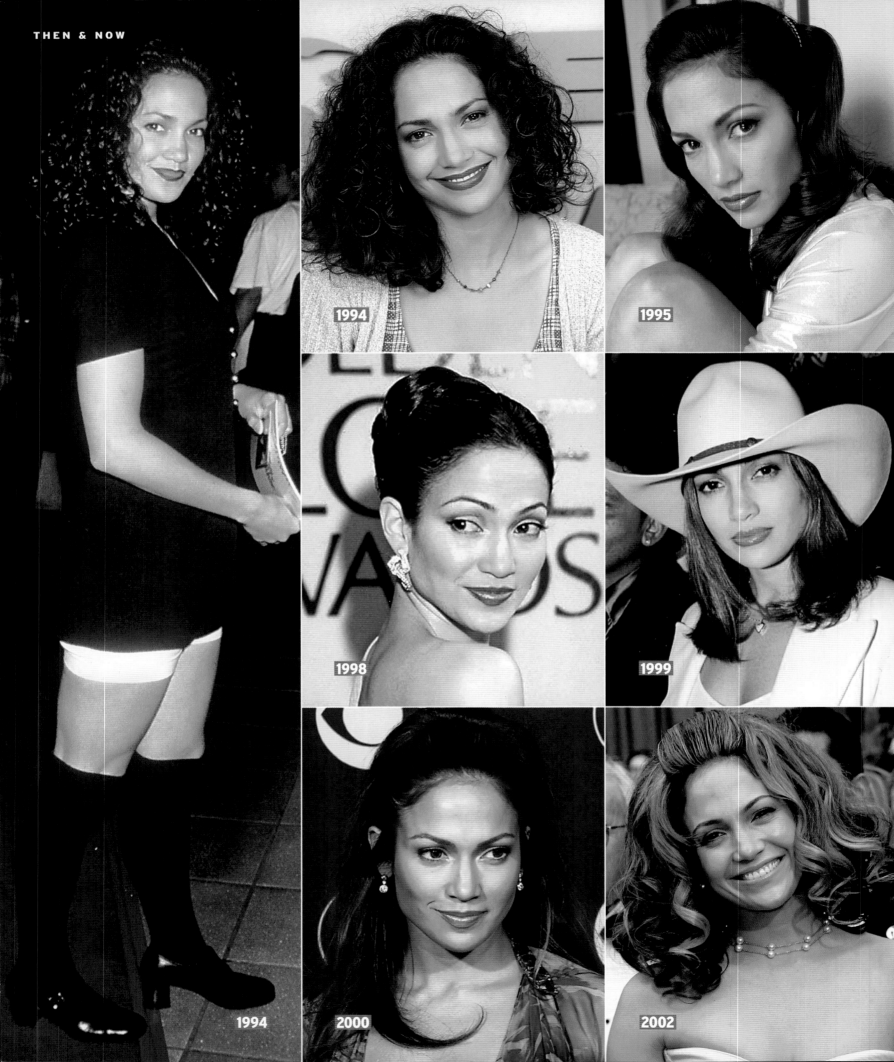

1994

1995

1998

1999

1994

2000

2002

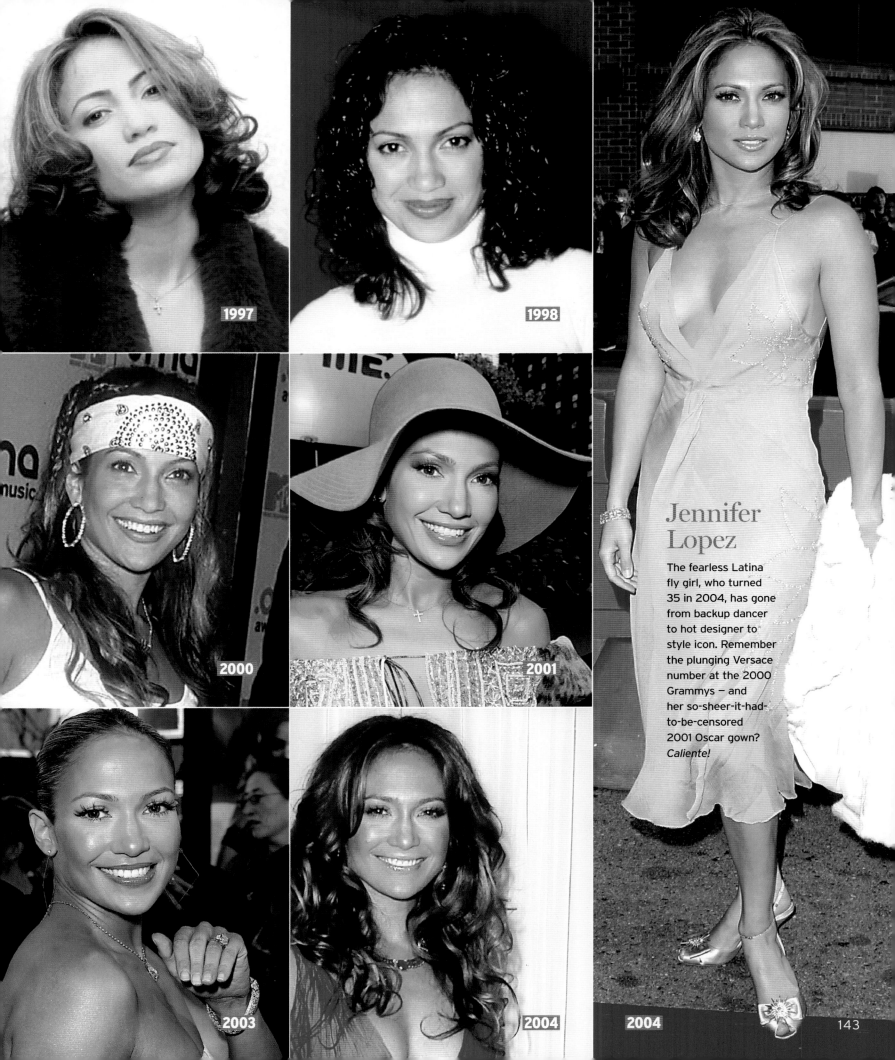

1997

1998

2000

2001

Jennifer Lopez

The fearless Latina fly girl, who turned 35 in 2004, has gone from backup dancer to hot designer to style icon. Remember the plunging Versace number at the 2000 Grammys — and her so-sheer-it-had-to-be-censored 2001 Oscar gown? *Caliente!*

2003

2004

2004

143

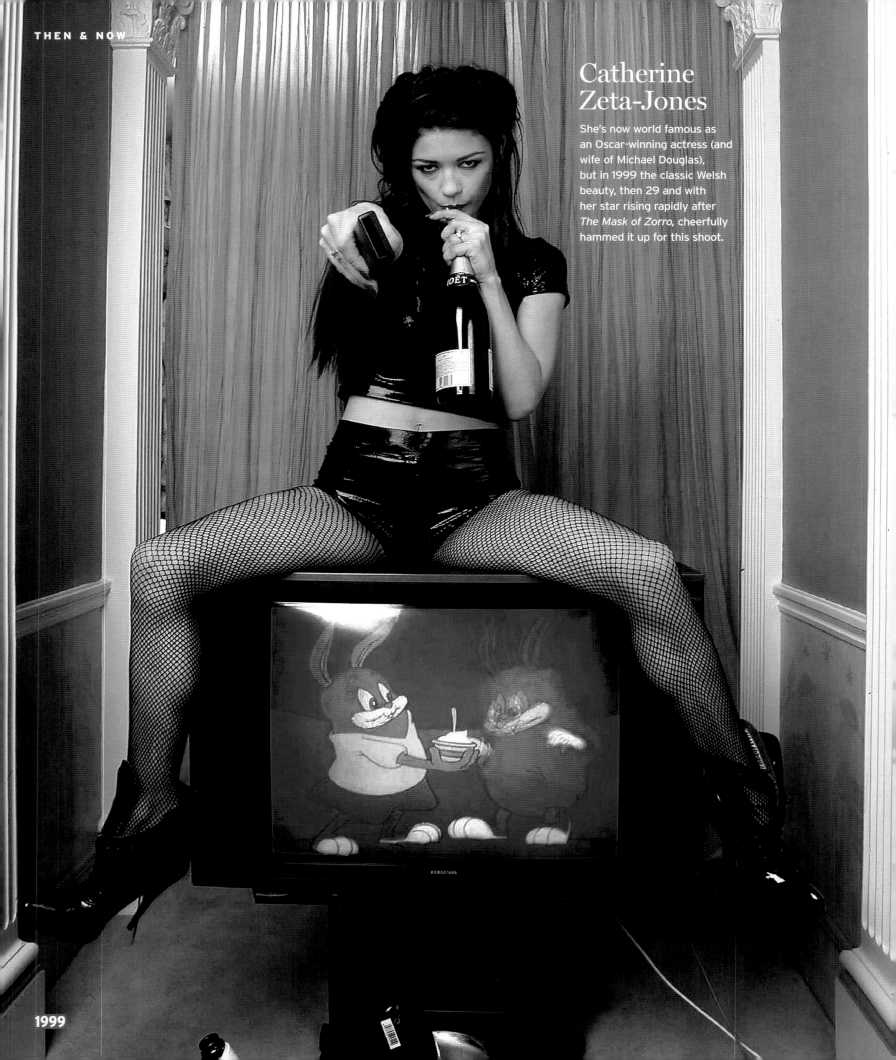

Catherine Zeta-Jones

She's now world famous as an Oscar-winning actress (and wife of Michael Douglas), but in 1999 the classic Welsh beauty, then 29 and with her star rising rapidly after *The Mask of Zorro*, cheerfully hammed it up for this shoot.

1999

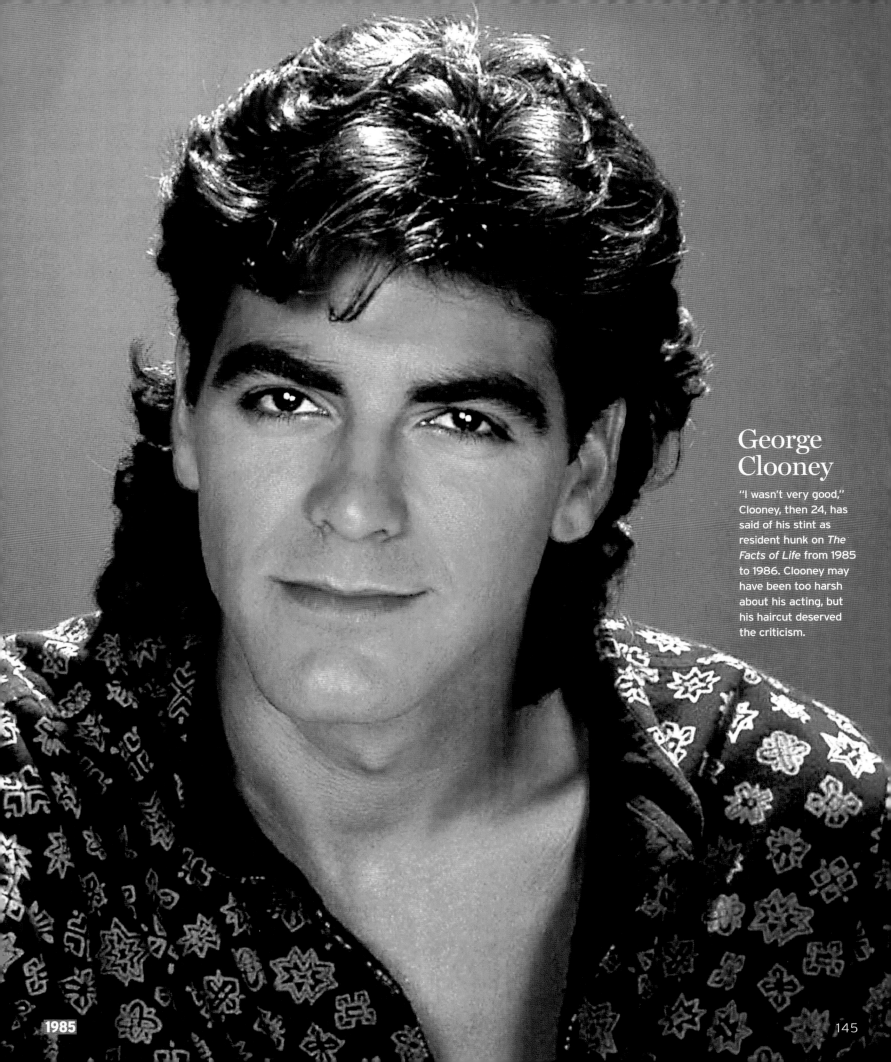

George Clooney

"I wasn't very good," Clooney, then 24, has said of his stint as resident hunk on *The Facts of Life* from 1985 to 1986. Clooney may have been too harsh about his acting, but his haircut deserved the criticism.

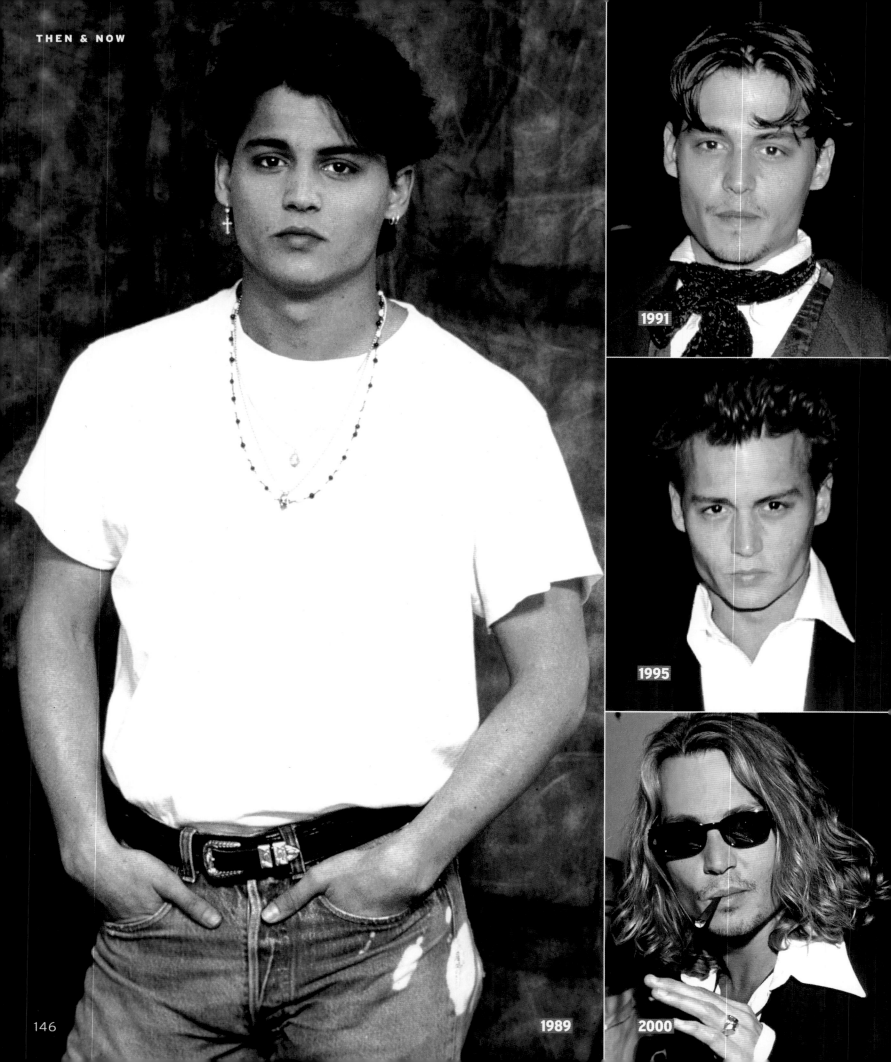

146

1989

1991

1995

2000

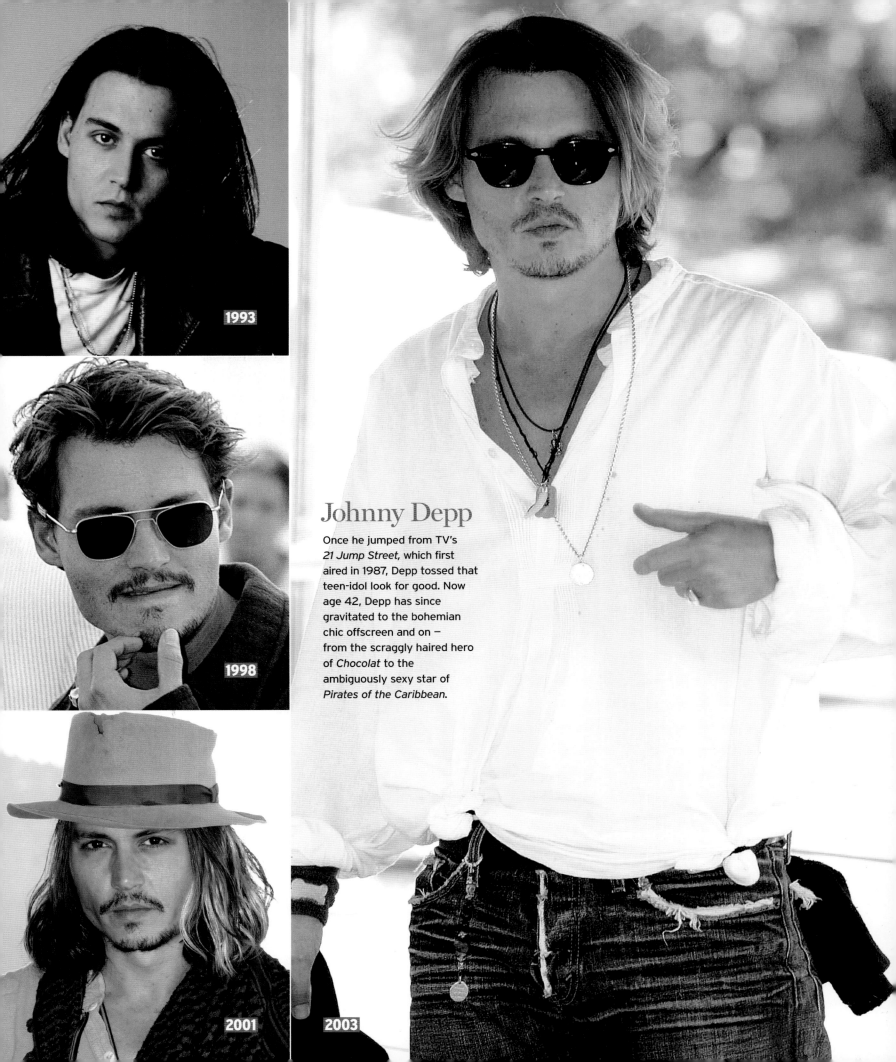

1993

1998

2001

2003

Johnny Depp

Once he jumped from TV's
21 Jump Street, which first
aired in 1987, Depp tossed that
teen-idol look for good. Now
age 42, Depp has since
gravitated to the bohemian
chic offscreen and on –
from the scraggly haired hero
of *Chocolat* to the
ambiguously sexy star of
Pirates of the Caribbean.

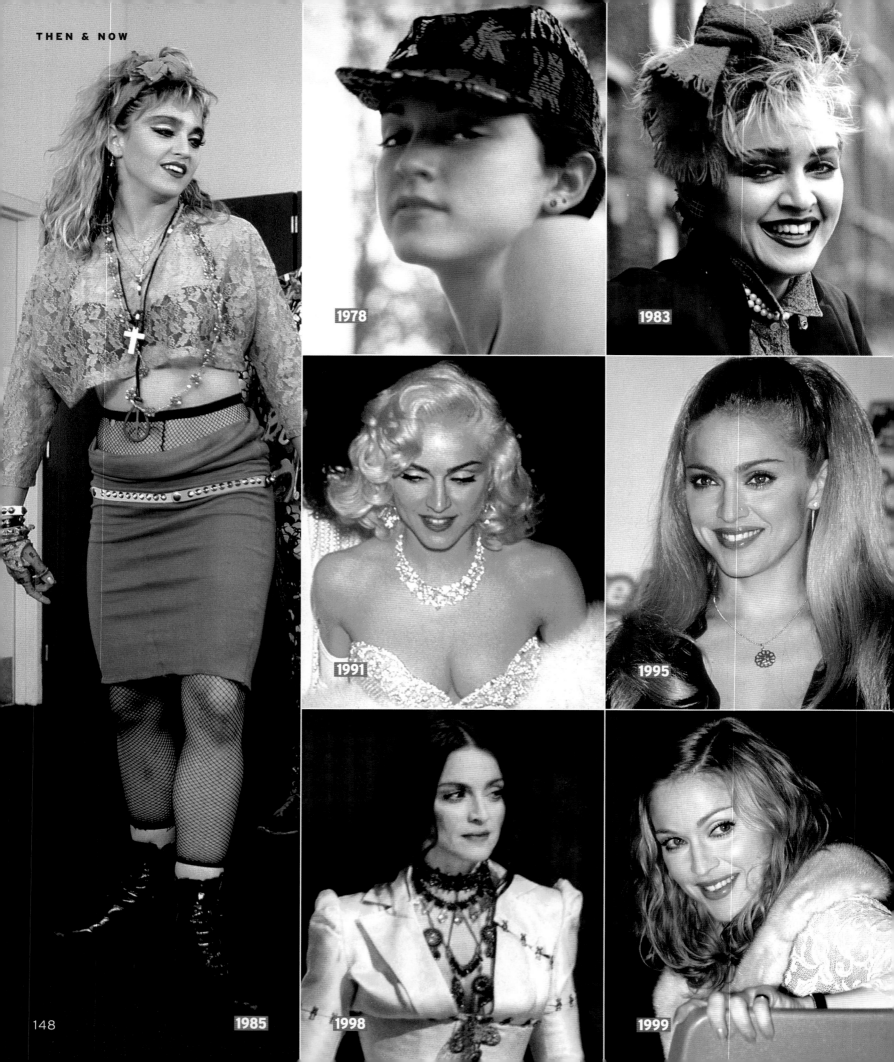

1978

1983

1991

1995

1998

1999

1985

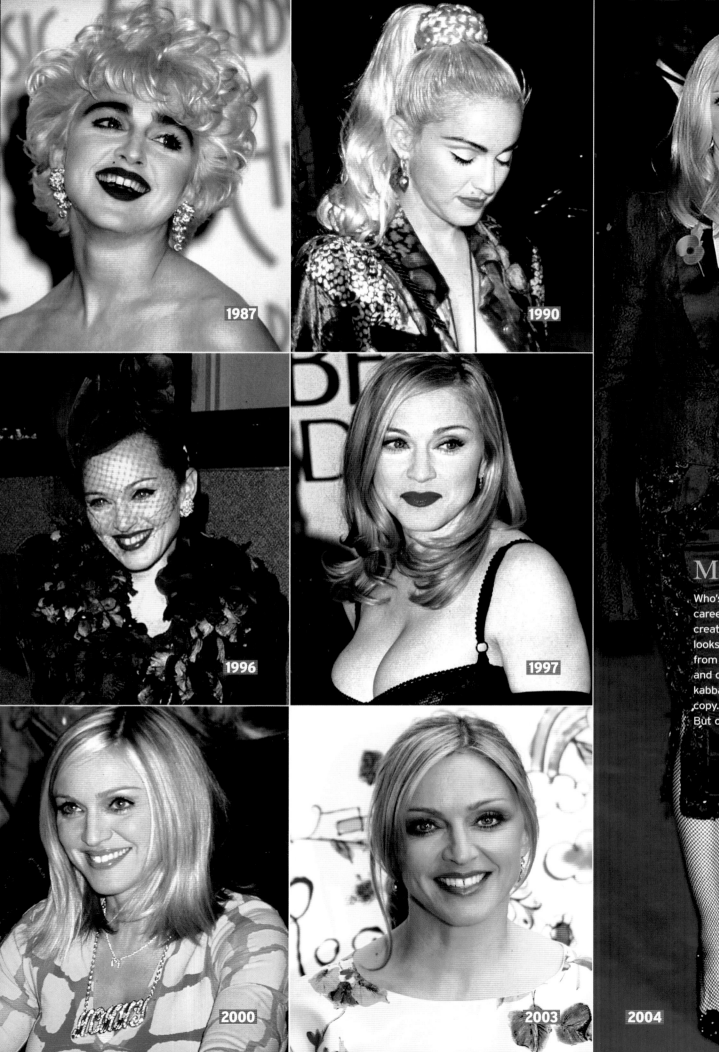

1987

1990

1996

1997

2000

2003

2004

Madonna

Who's that girl?! In her 20-year career, the Material Girl has created a million different looks. She has made everything from accessory overkill, corsets and cone bras to yoga and kabbalah seem cool enough to copy. And her one constant? But of course — fishnet tights!

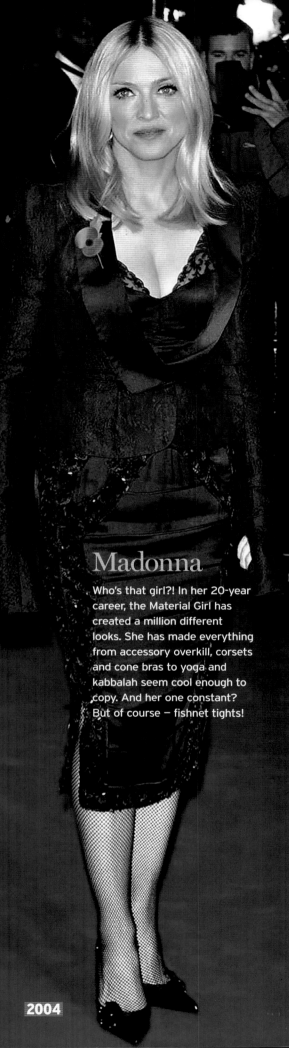

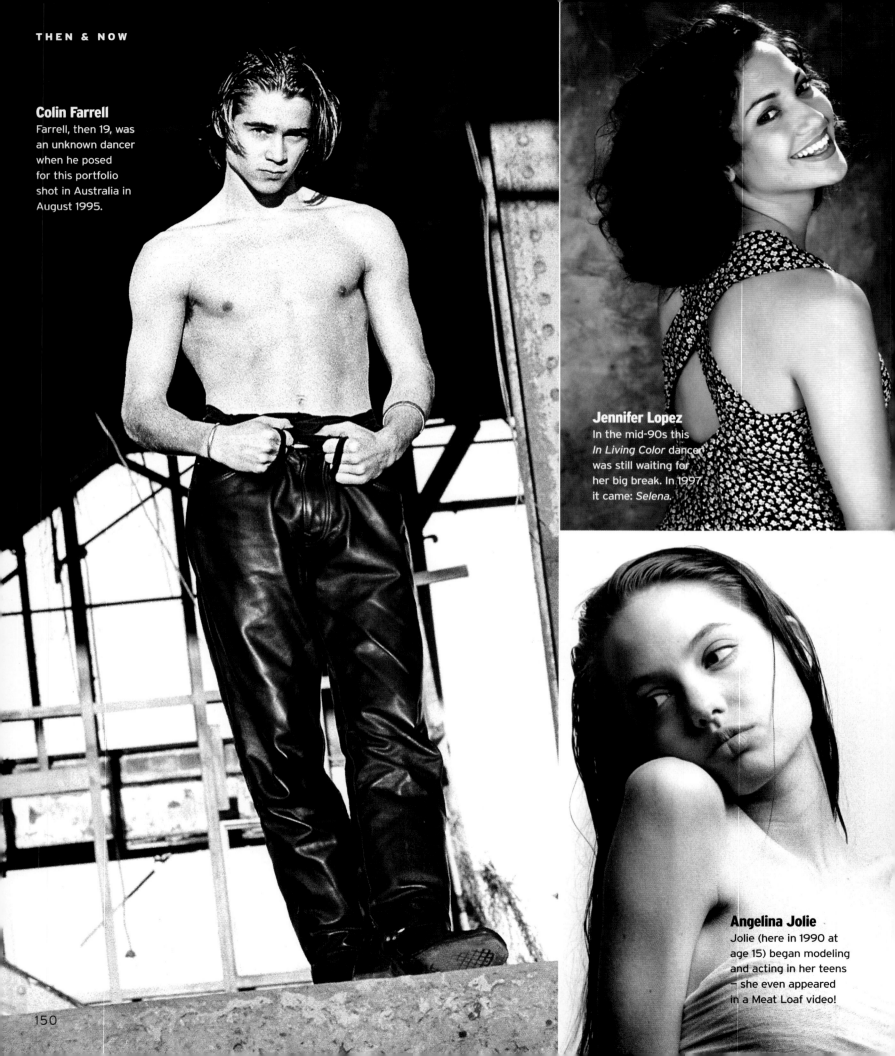

Colin Farrell
Farrell, then 19, was an unknown dancer when he posed for this portfolio shot in Australia in August 1995.

Jennifer Lopez
In the mid-90s this *In Living Color* dancer was still waiting for her big break. In 1997, it came: *Selena*.

Angelina Jolie
Jolie (here in 1990 at age 15) began modeling and acting in her teens — she even appeared in a Meat Loaf video!

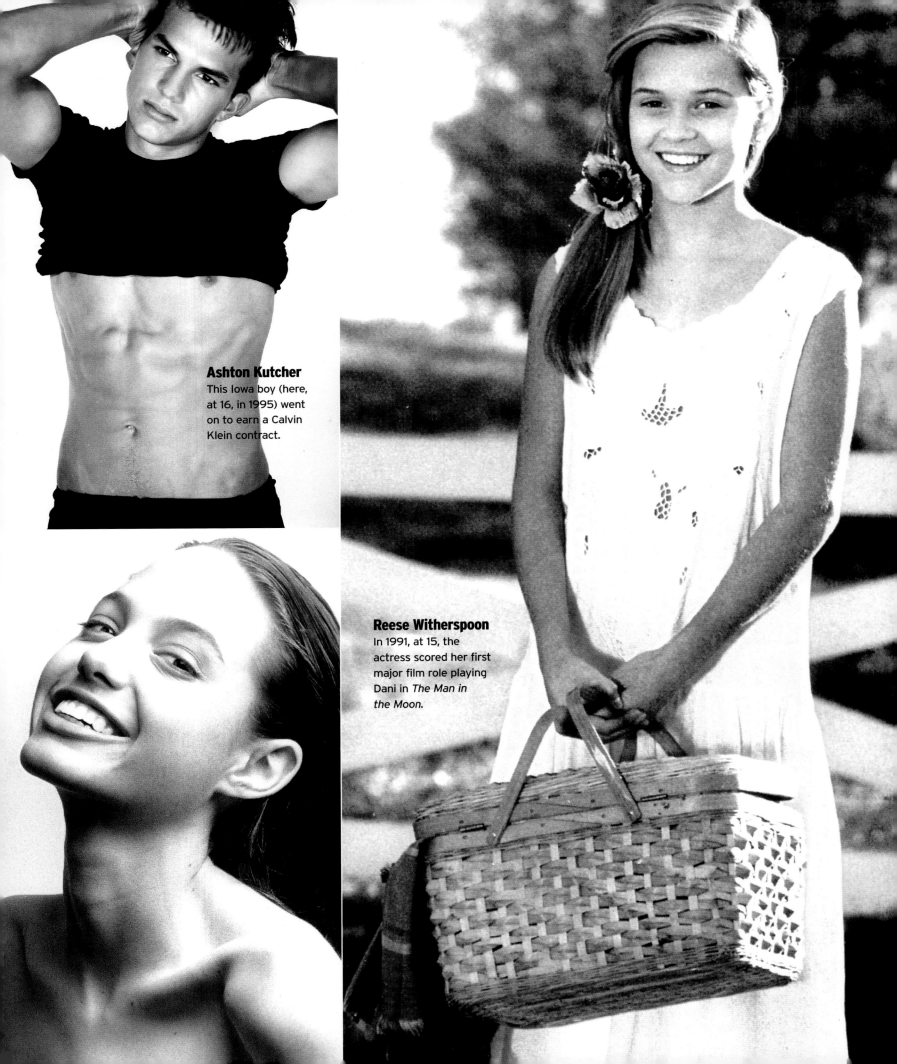

Ashton Kutcher
This Iowa boy (here, at 16, in 1995) went on to earn a Calvin Klein contract.

Reese Witherspoon
In 1991, at 15, the actress scored her first major film role playing Dani in *The Man in the Moon*.

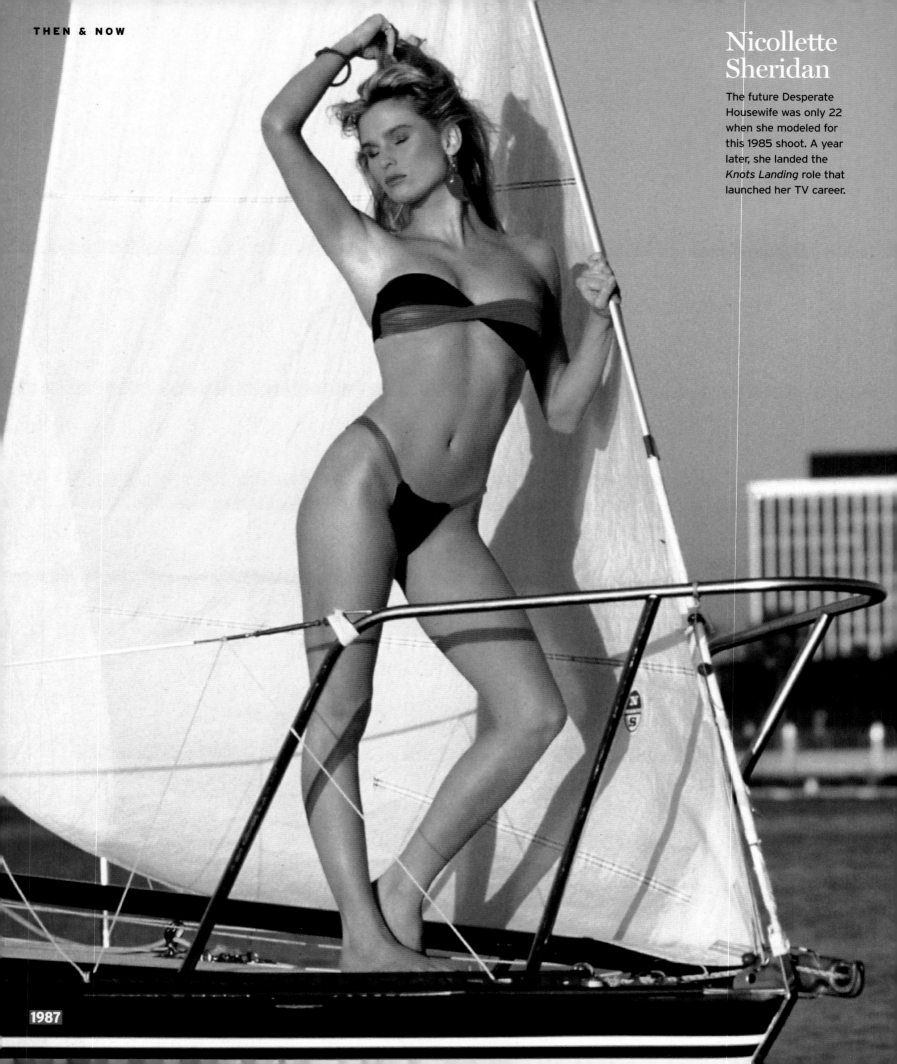

Nicollette Sheridan

The future Desperate Housewife was only 22 when she modeled for this 1985 shoot. A year later, she landed the *Knots Landing* role that launched her TV career.

1987

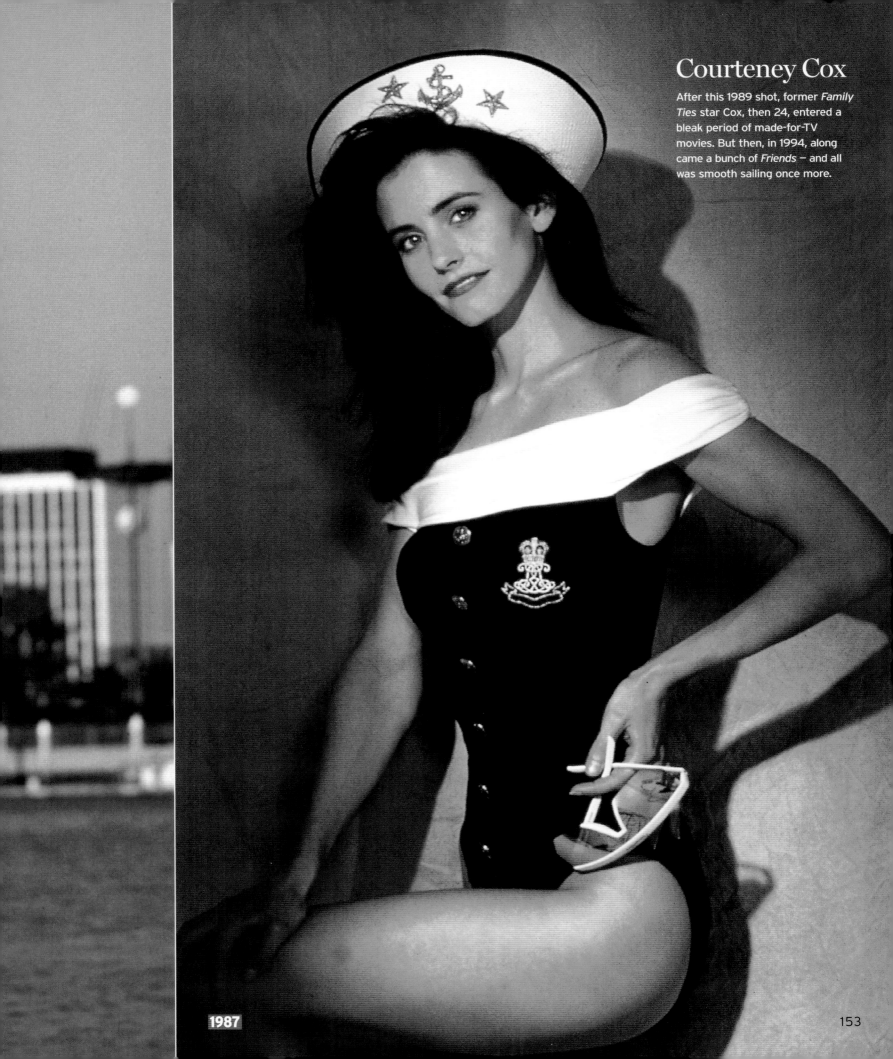

Courteney Cox

After this 1989 shot, former *Family Ties* star Cox, then 24, entered a bleak period of made-for-TV movies. But then, in 1994, along came a bunch of *Friends* — and all was smooth sailing once more.

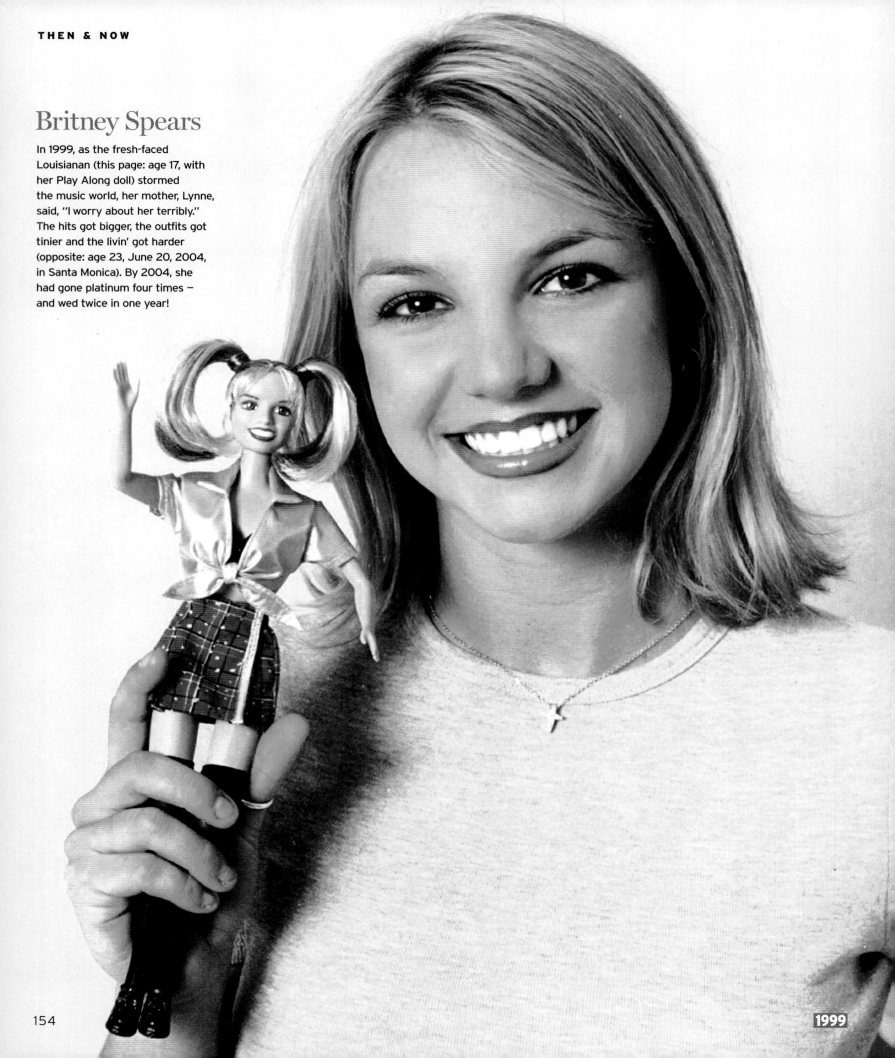

Britney Spears

In 1999, as the fresh-faced
Louisianan (this page: age 17, with
her Play Along doll) stormed
the music world, her mother, Lynne,
said, "I worry about her terribly."
The hits got bigger, the outfits got
tinier and the livin' got harder
(opposite: age 23, June 20, 2004,
in Santa Monica). By 2004, she
had gone platinum four times –
and wed twice in one year!

1999

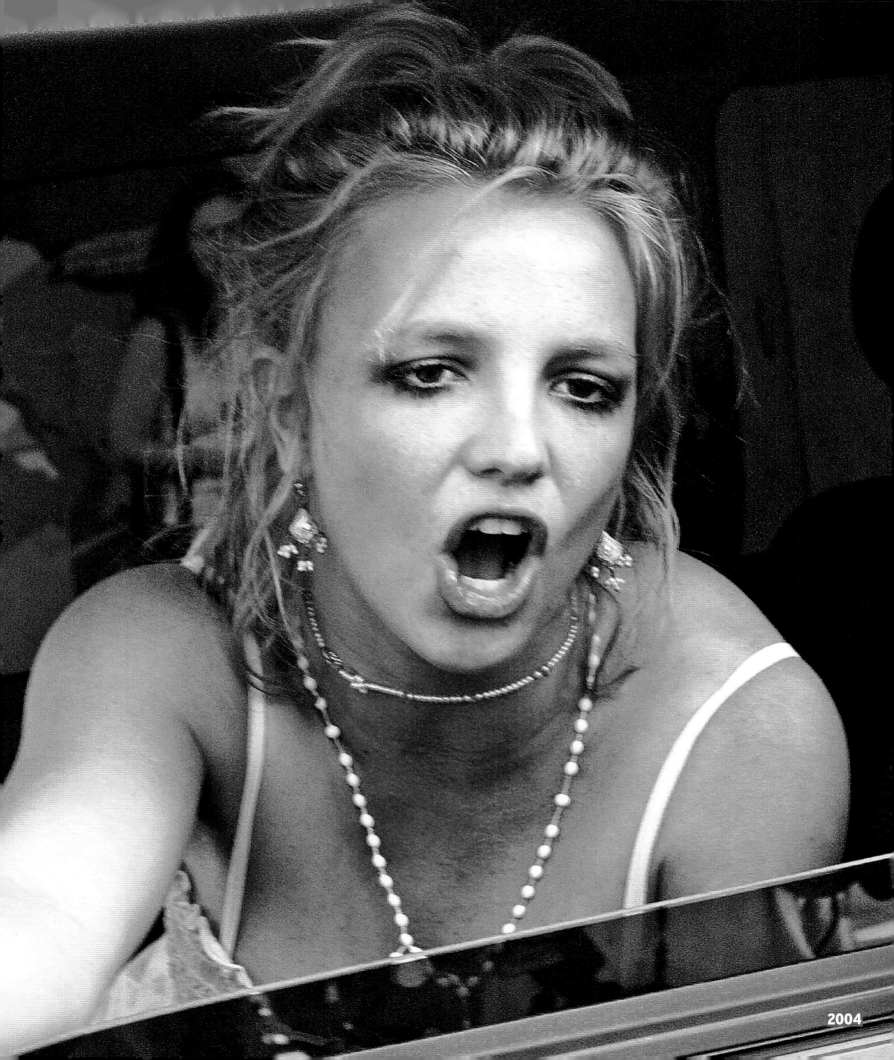

2004

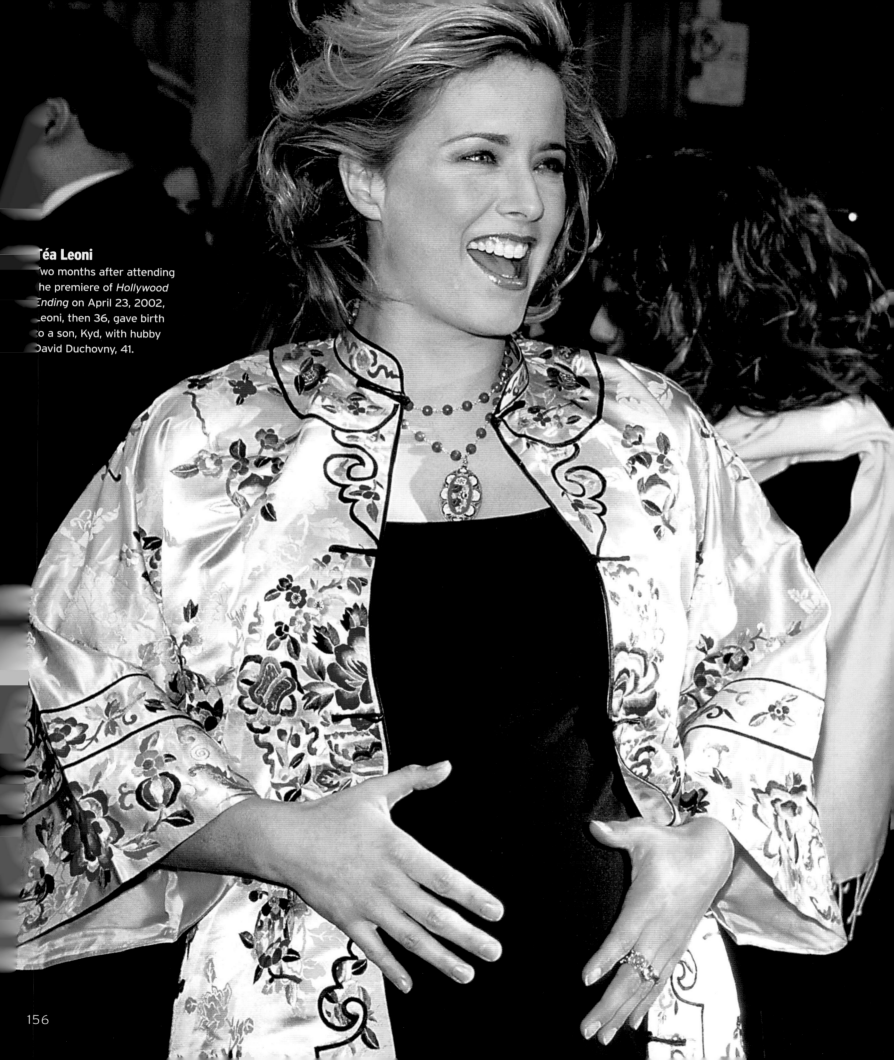

Téa Leoni
Two months after attending the premiere of *Hollywood Ending* on April 23, 2002, Leoni, then 36, gave birth to a son, Kyd, with hubby David Duchovny, 41.

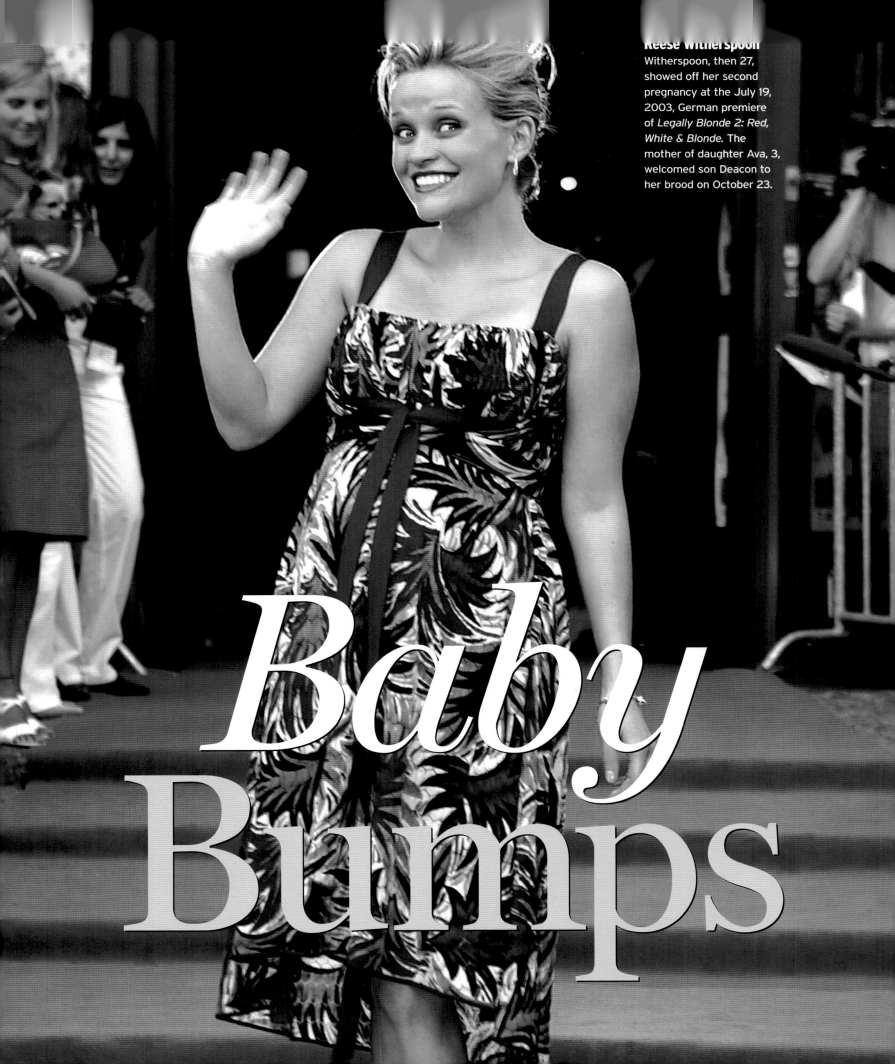

Reese Witherspoon
Witherspoon, then 27, showed off her second pregnancy at the July 19, 2003, German premiere of *Legally Blonde 2: Red, White & Blonde*. The mother of daughter Ava, 3, welcomed son Deacon to her brood on October 23.

Baby Bumps

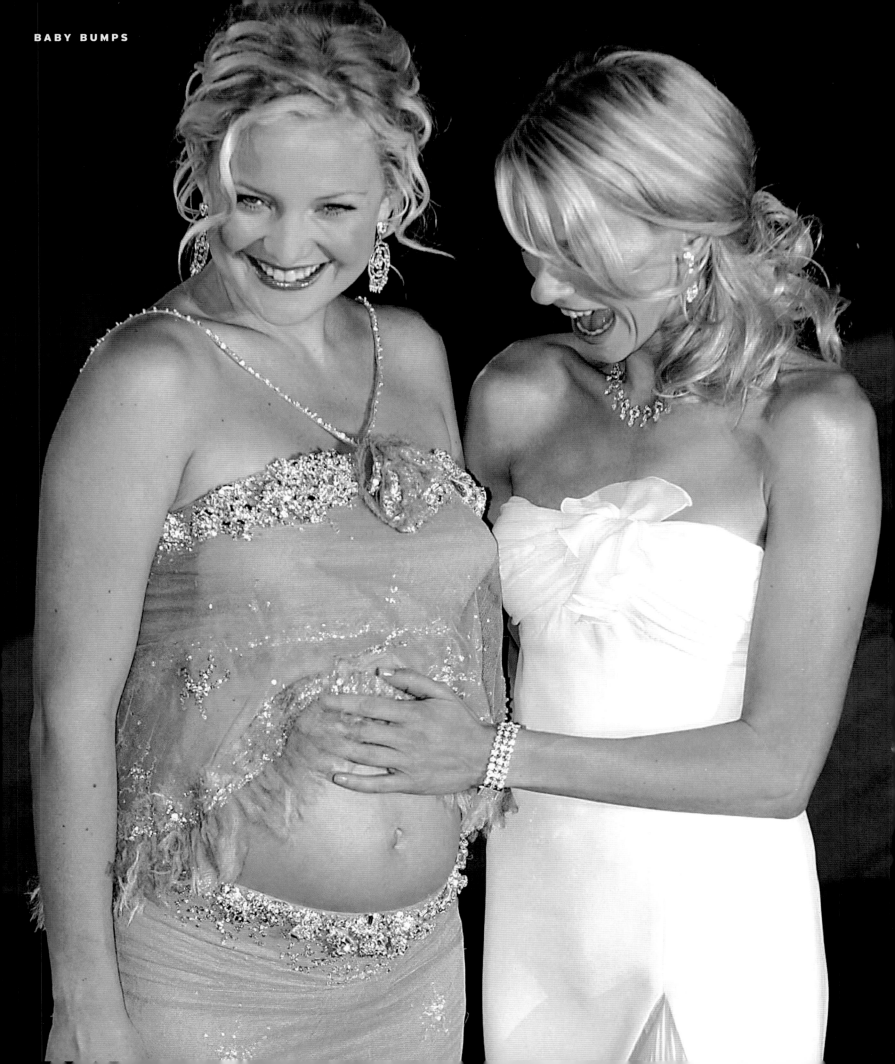

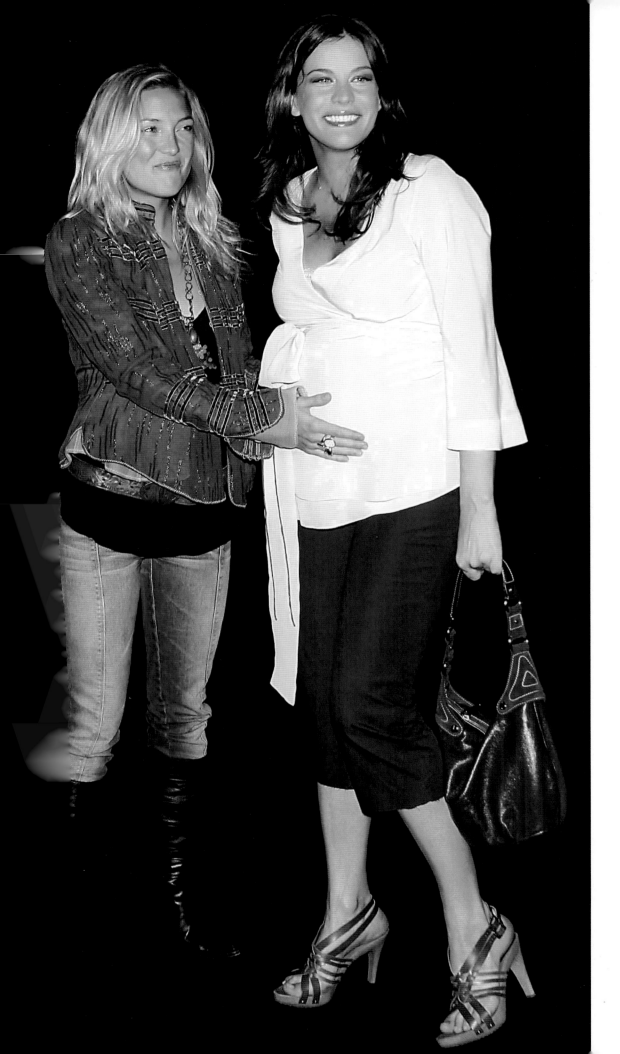

Kate Hudson & Naomi Watts

OPPOSITE: At the premiere of their film *Le Divorce* in Venice, Italy, on August 31, 2003, costars Hudson, then 24 and due in January, and Watts, 34, just wanted to talk *bébé*!

Kate Hudson & Liv Tyler

THIS PAGE: New mom Hudson and mommy-to-be Tyler, then 27 and due in December, bonded during New York City's Fashion Week on September 13, 2004.

159

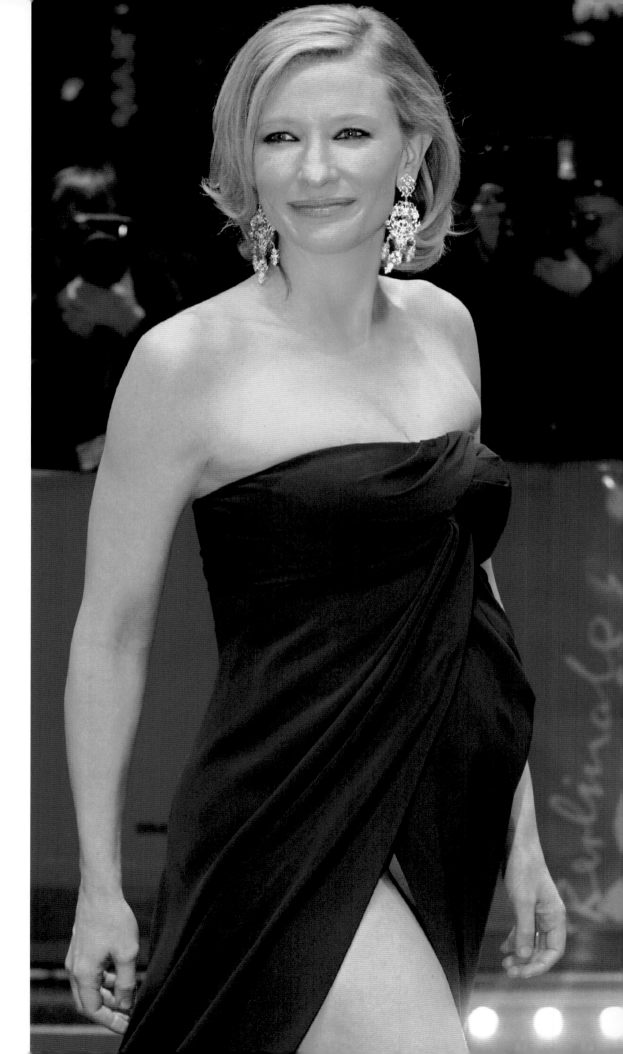

Cate Blanchett

THIS PAGE: At the screening of her thriller *The Missing* at the Berlin Film Festival on February 7, 2004, Blanchett, then 34 and seven months pregnant with her second child, showed it off – in style.

Cyndi Lauper

OPPOSITE: Even at 44 and eight months gone, girls just wanna have fun. So '80s pop icon Lauper let it all hang out as a belly dancer at an NYC Halloween bash in 1997. On November 19, she gave birth to son Declyn.

160

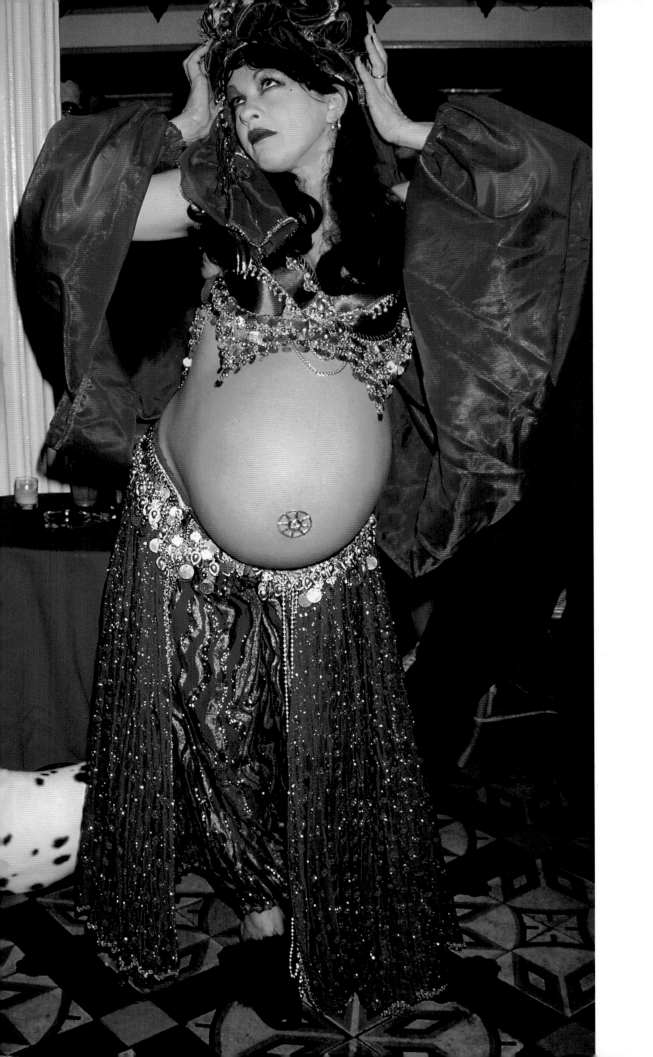

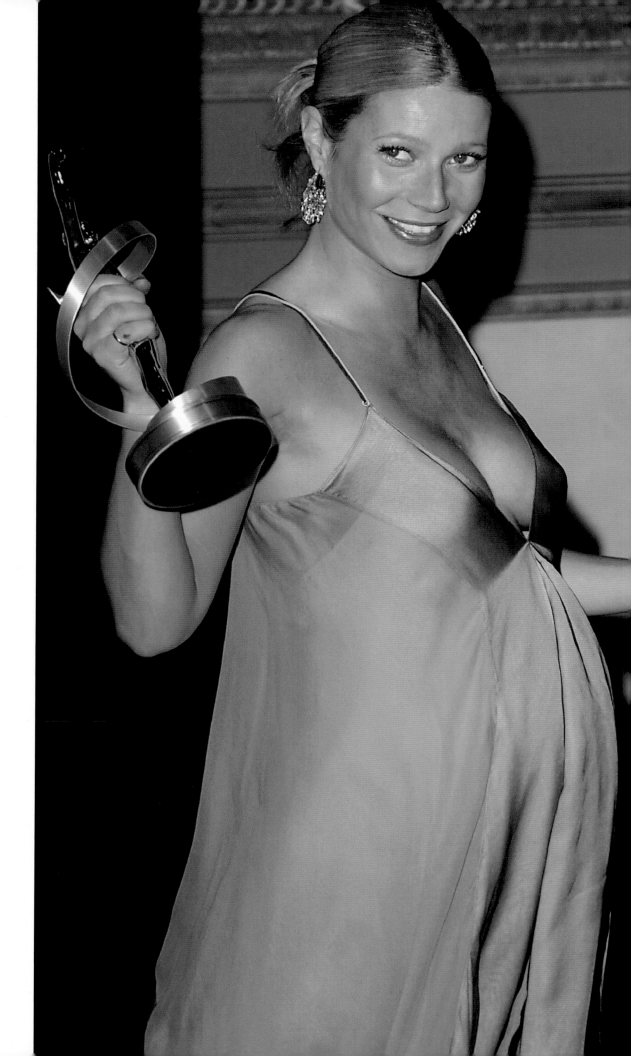

Gwyneth Paltrow

THIS PAGE: A very pregnant Paltrow, then 31, scored the Distinguished Decade of Achievement in Film award at ShoWest in Las Vegas on March 25, 2004, then returned to London to prepare for her most important role – as Apple's mom.

Catherine Zeta-Jones

OPPOSITE: When you're good to mama . . . The *Chicago* star, then 33, brought home an Oscar from the Academy Awards on March 23, 2003. Almost one month later, she brought home a baby daughter – Carys.

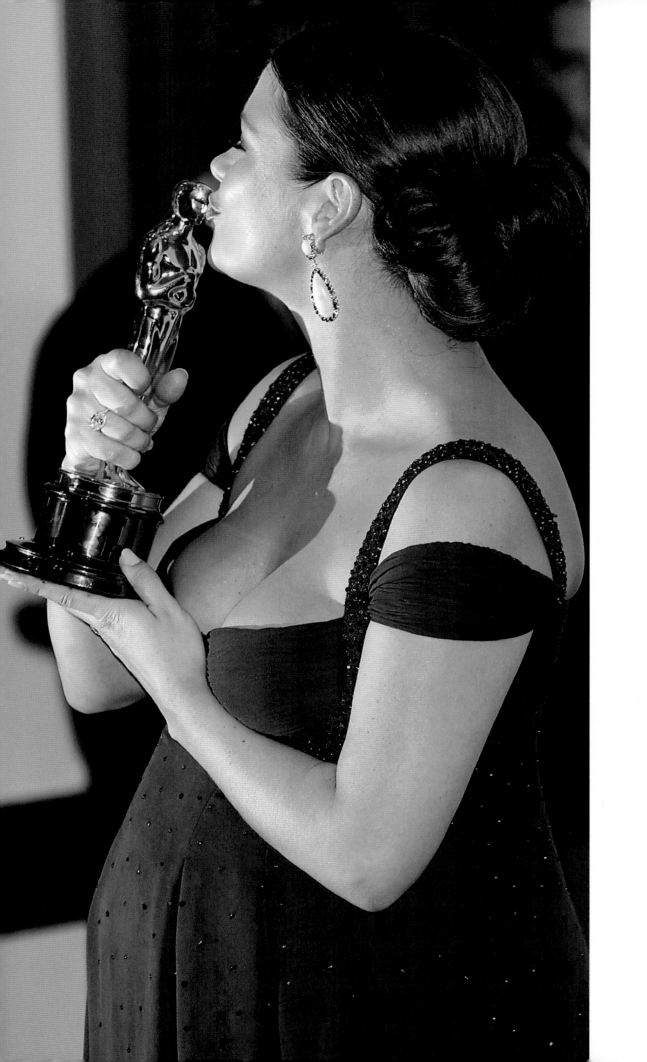

*Kid*sp

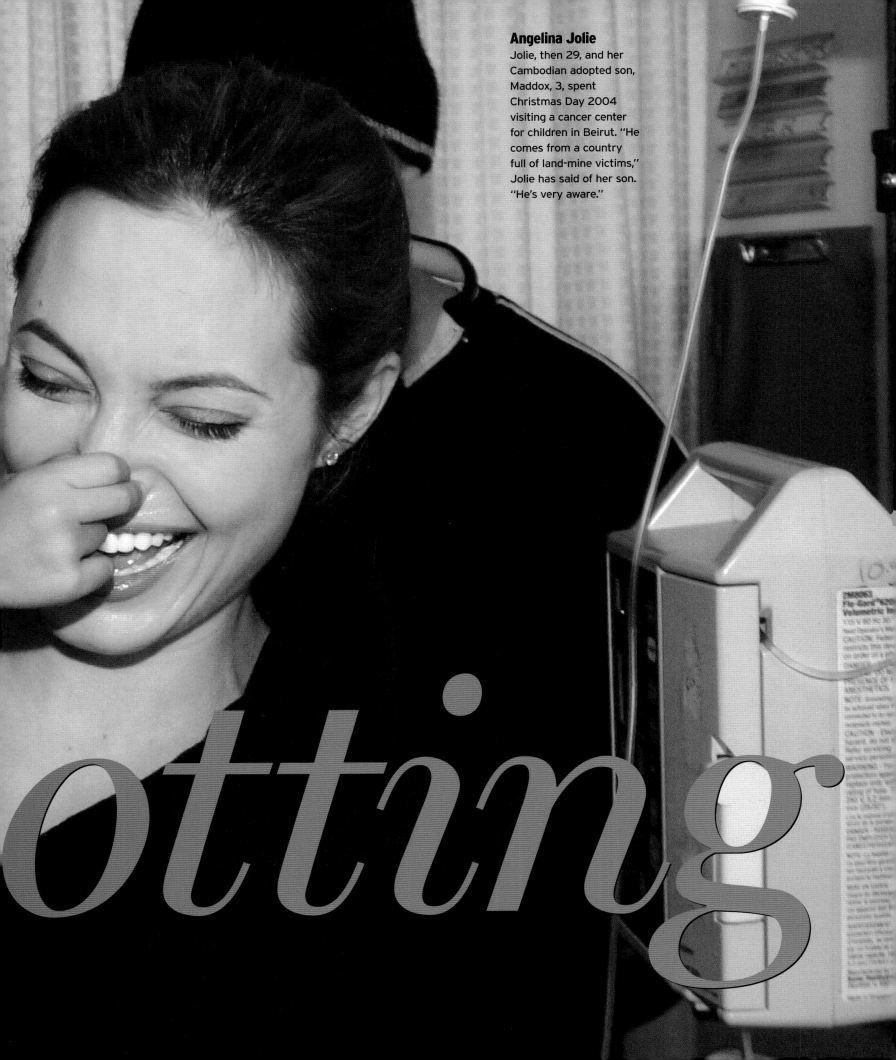

Angelina Jolie
Jolie, then 29, and her Cambodian adopted son, Maddox, 3, spent Christmas Day 2004 visiting a cancer center for children in Beirut. "He comes from a country full of land-mine victims," Jolie has said of her son. "He's very aware."

otting

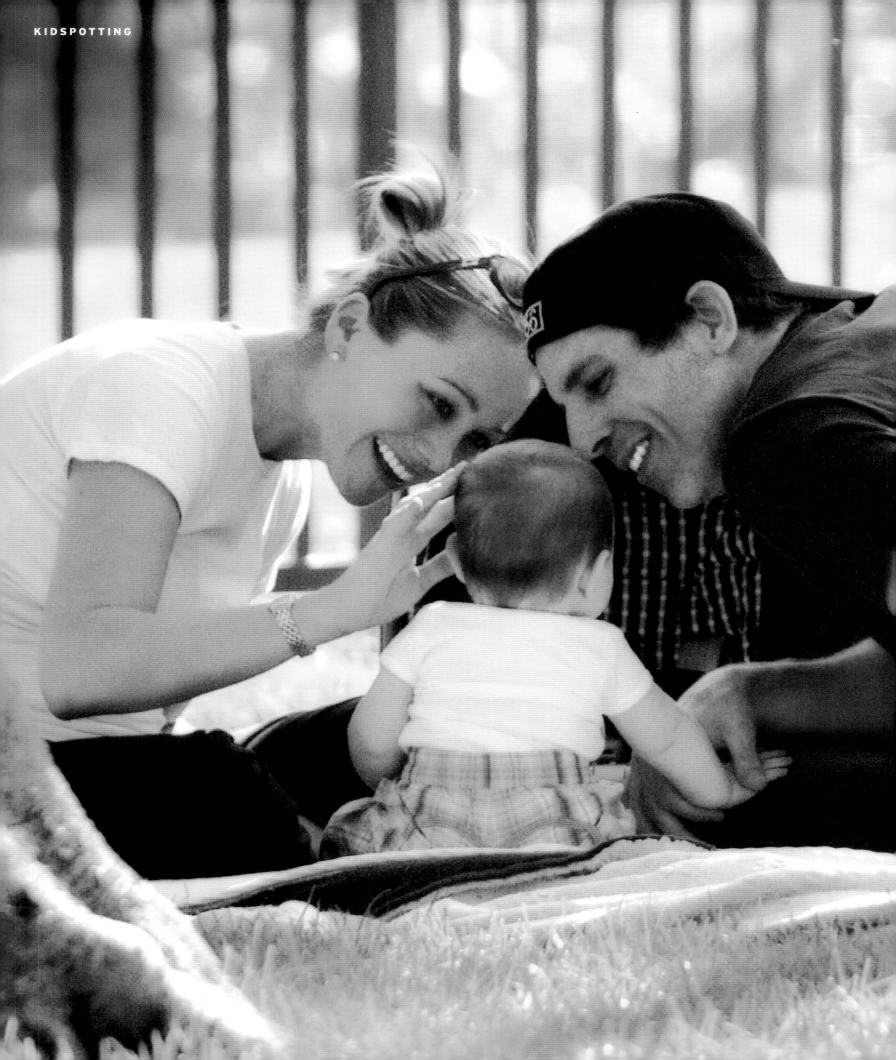

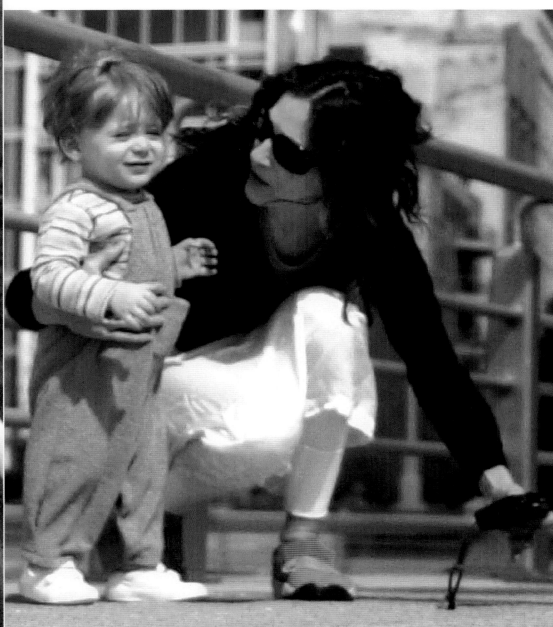

Christine Taylor & Ben Stiller

OPPOSITE: Meet the Parents! The new mom and dad took baby Ella, then 6 months, to a Beverly Hills park on October 8, 2002.

Sarah Jessica Parker

TOP: On April 10, 2004, the *Sex and the City* star and baby James, then 18 months, played at a park near their New York City home.

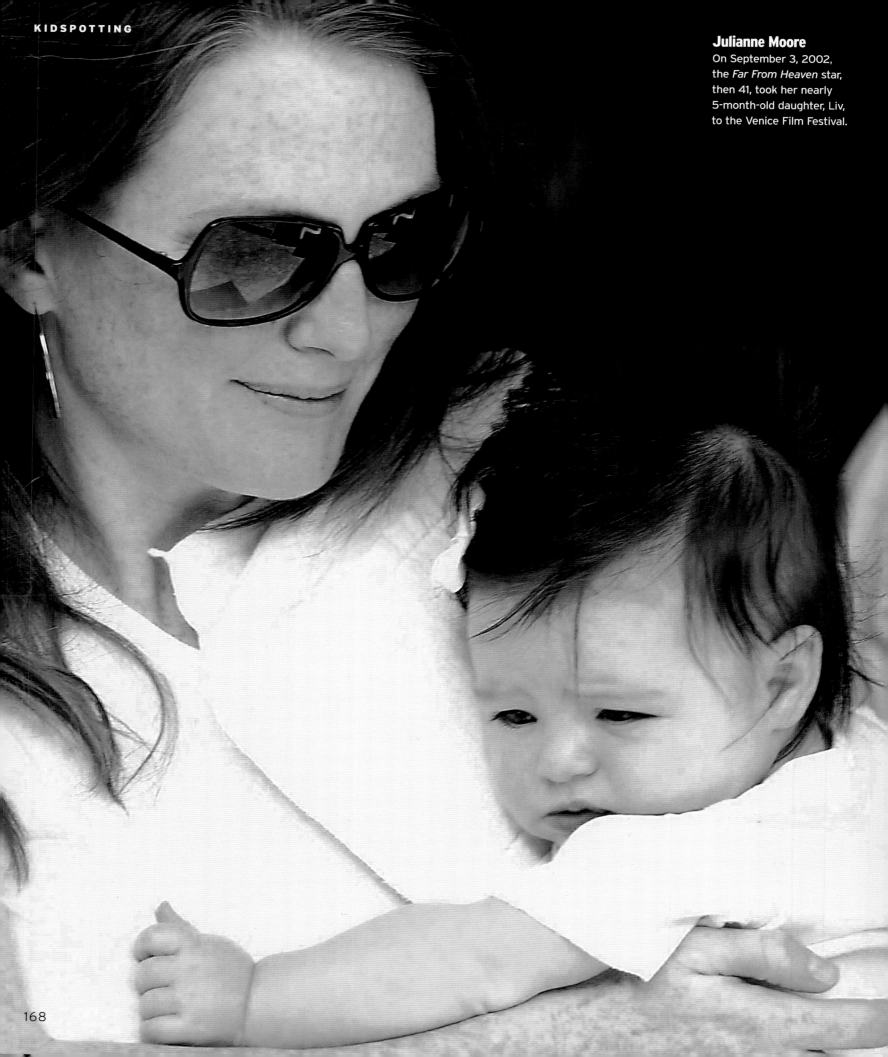

Julianne Moore
On September 3, 2002, the *Far From Heaven* star, then 41, took her nearly 5-month-old daughter, Liv, to the Venice Film Festival.

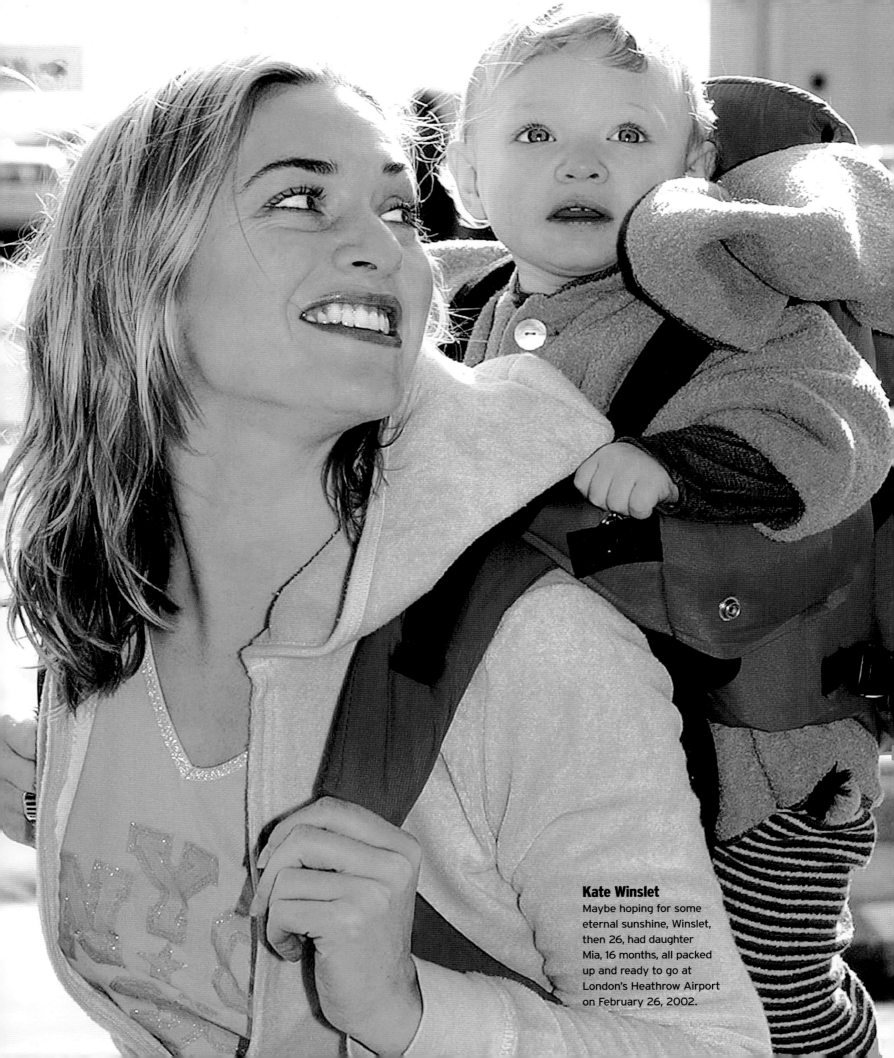

Kate Winslet
Maybe hoping for some eternal sunshine, Winslet, then 26, had daughter Mia, 16 months, all packed up and ready to go at London's Heathrow Airport on February 26, 2002.

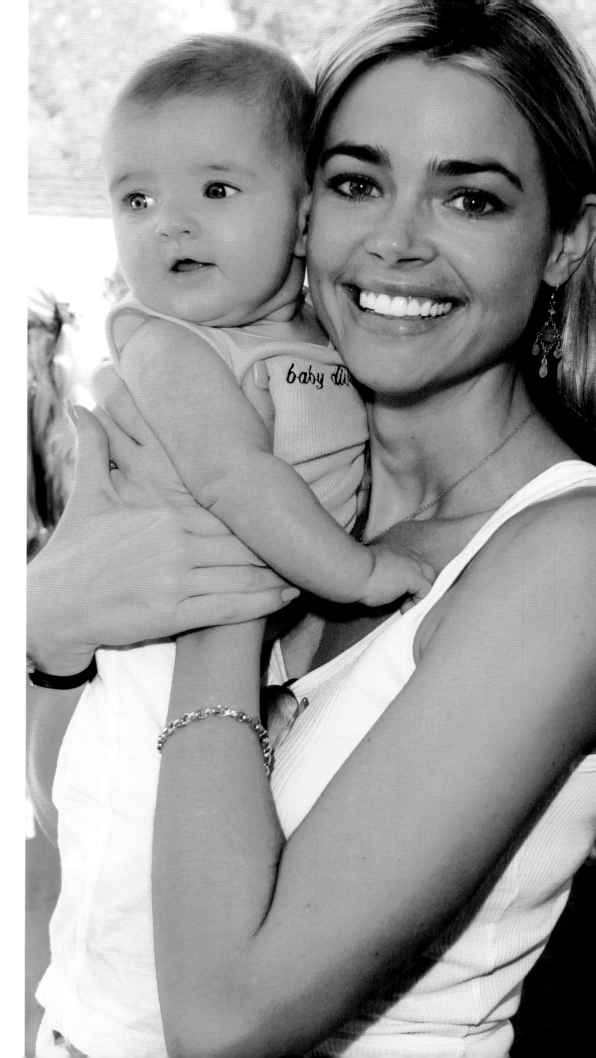

Denise Richards
THIS PAGE: "She looks just like Charlie [Sheen, her dad]," Richards, then 33, once said of Sam, here at 4 months on July 31, 2004. Just eight months later, after almost three years of marriage, a six-months-pregnant Richards filed for divorce.

Gwyneth Paltrow
OPPOSITE: Baby Apple, then 3 months, hit the Big Apple on August 27, 2004, for a press event with her mom, 31. Apple's dad, Coldplay frontman Chris Martin, married mom in December 2003.

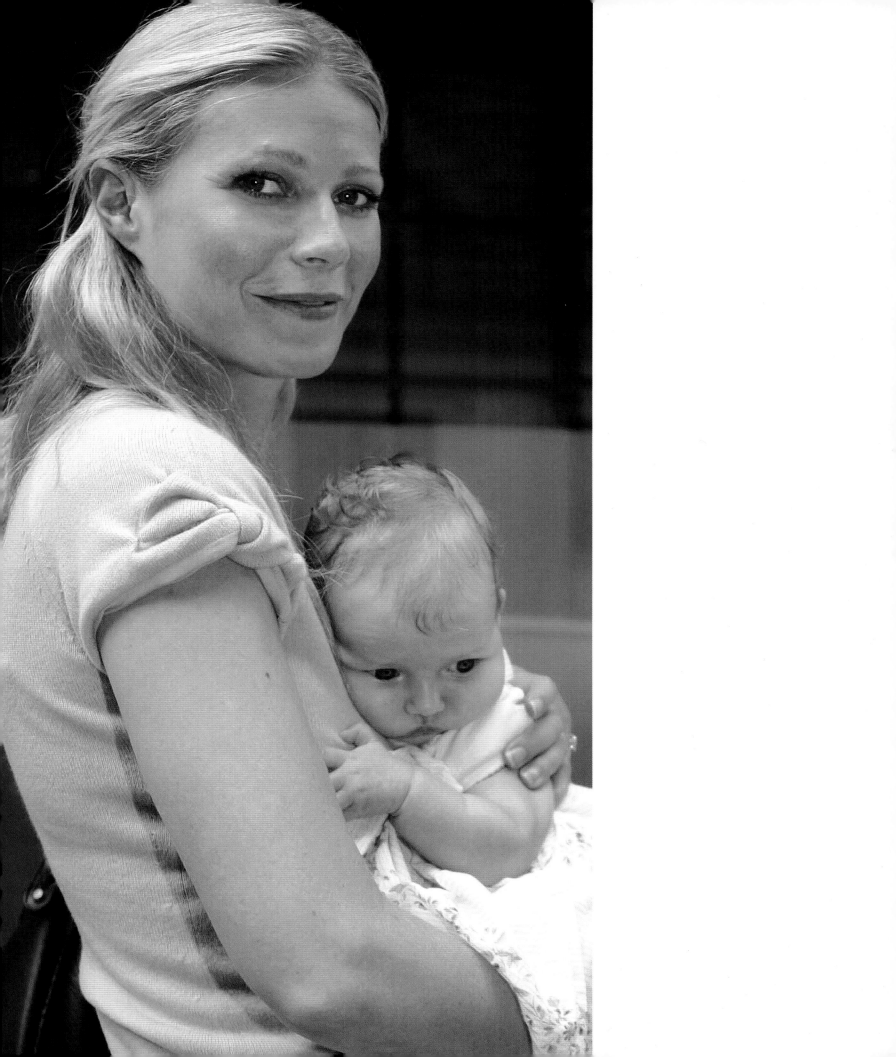

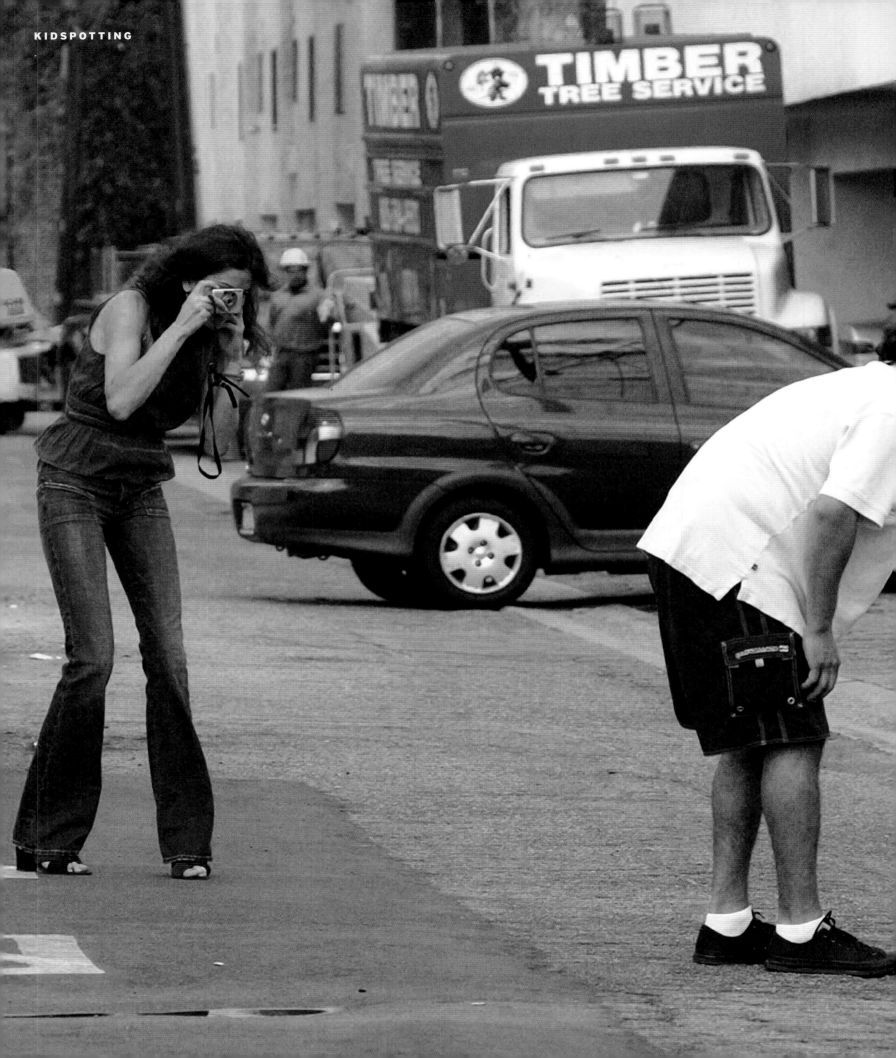

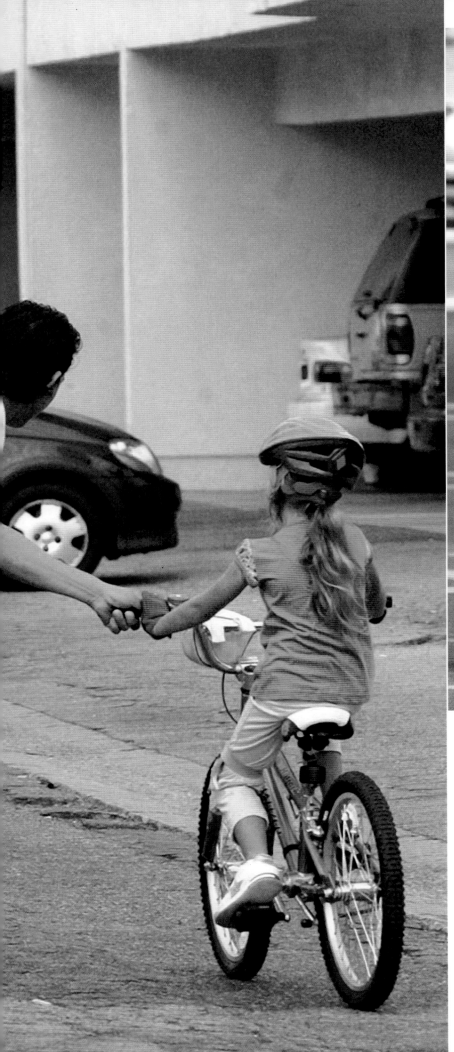

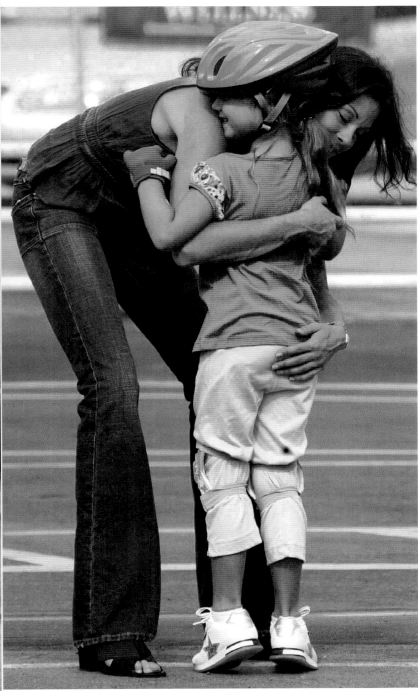

Teri Hatcher
The Desperate Housewife, then 38, was just a proud mommy on August 21, 2003, as she taught daughter Emerson, 5, to ride her two-wheeler outside L.A.

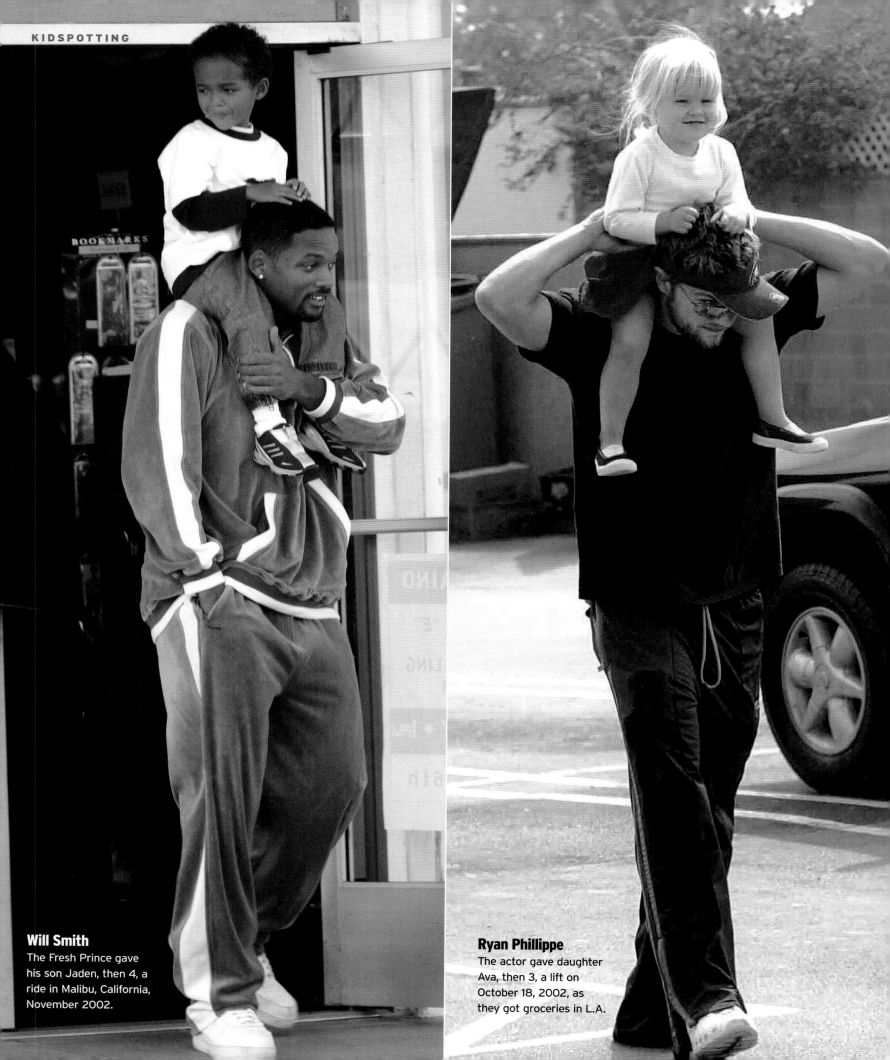

BOOKMARKS

Will Smith
The Fresh Prince gave
his son Jaden, then 4, a
ride in Malibu, California,
November 2002.

Ryan Phillippe
The actor gave daughter
Ava, then 3, a lift on
October 18, 2002, as
they got groceries in L.A.

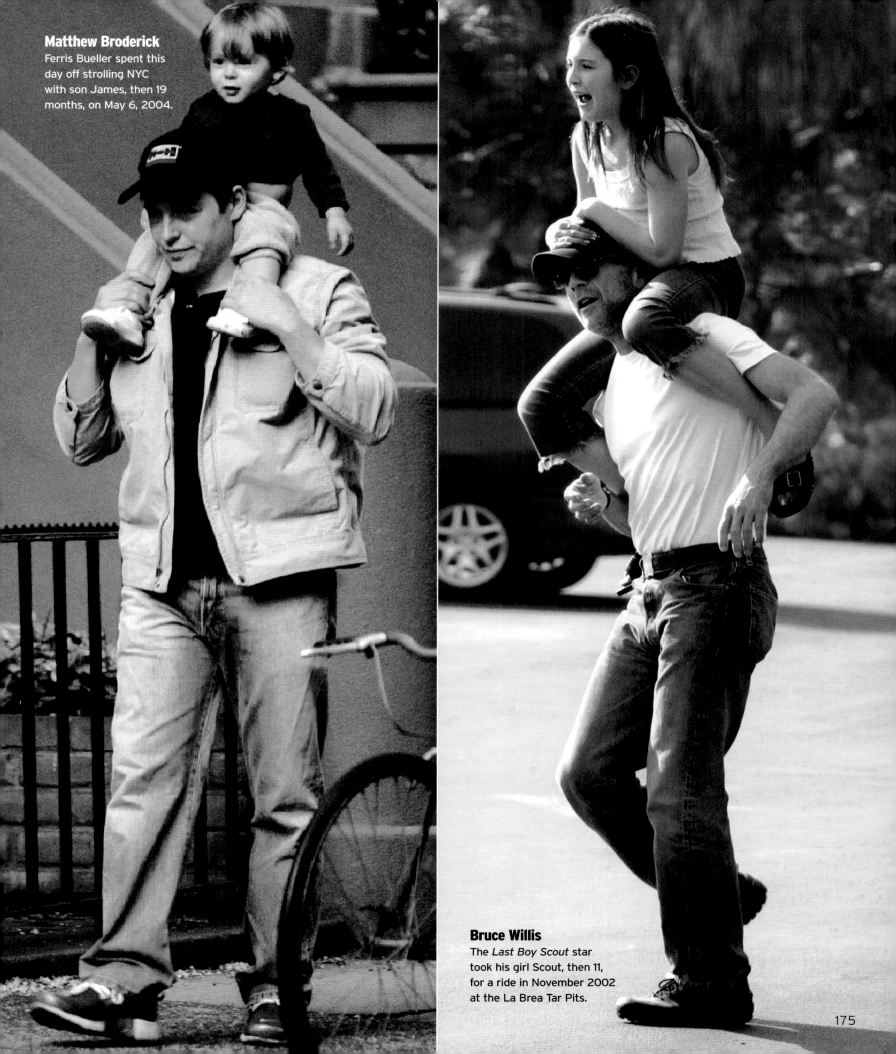

Matthew Broderick
Ferris Bueller spent this day off strolling NYC with son James, then 19 months, on May 6, 2004.

Bruce Willis
The *Last Boy Scout* star took his girl Scout, then 11, for a ride in November 2002 at the La Brea Tar Pits.

175

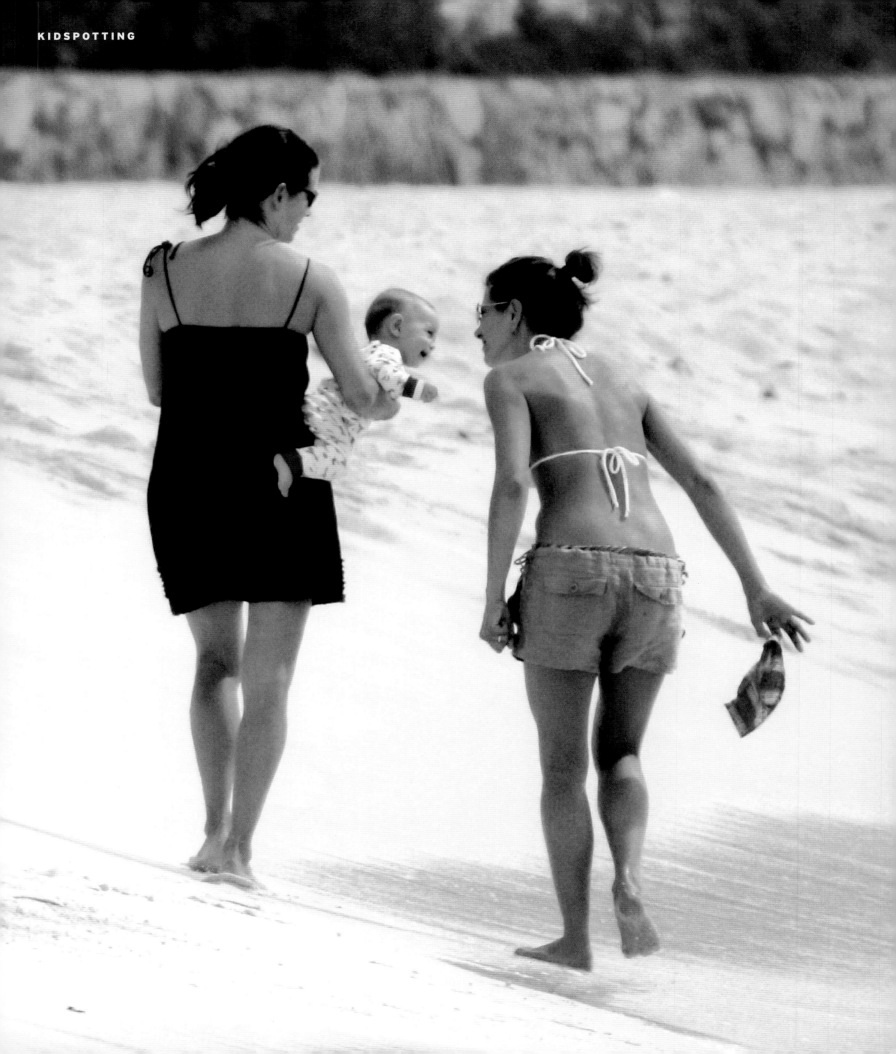

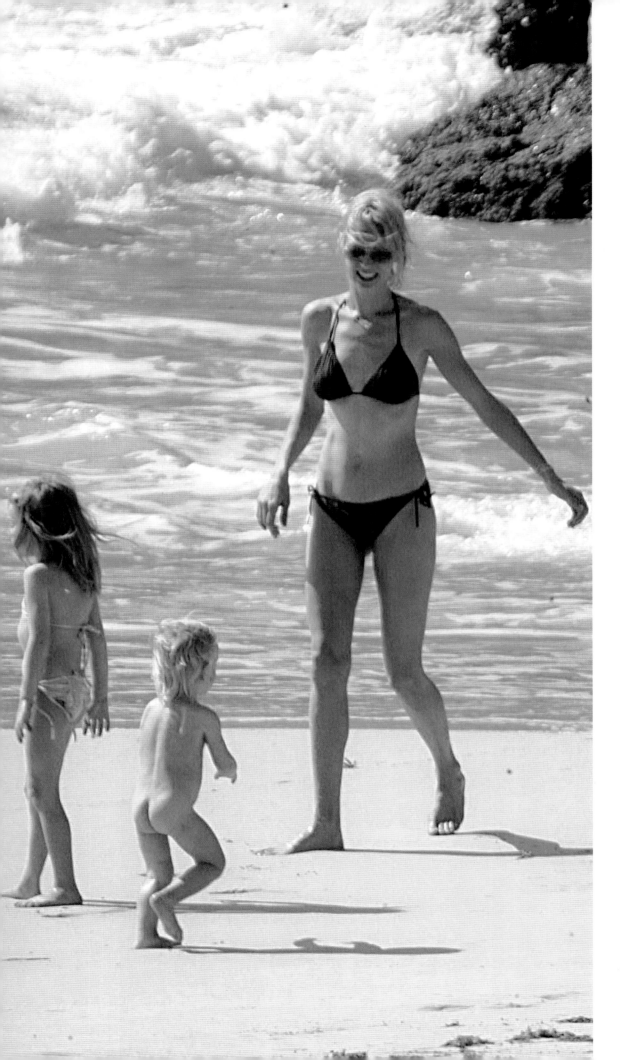

Courteney Cox & Jennifer Aniston

OPPOSITE: The two Friends strolled the beach in Anguilla, cooing to Cox's baby, Coco, then 7 months, on January 7, 2005. Later that same day, Aniston, then 35, and husband Brad Pitt, 41, announced their separation.

Uma Thurman

THIS PAGE: Thurman, then 33, and kids Roan (here almost 2 years old) and Maya, 5, hit St. Bart's with Thurman's hotelier boyfriend, Andre Balazs, on December 27, 2003.

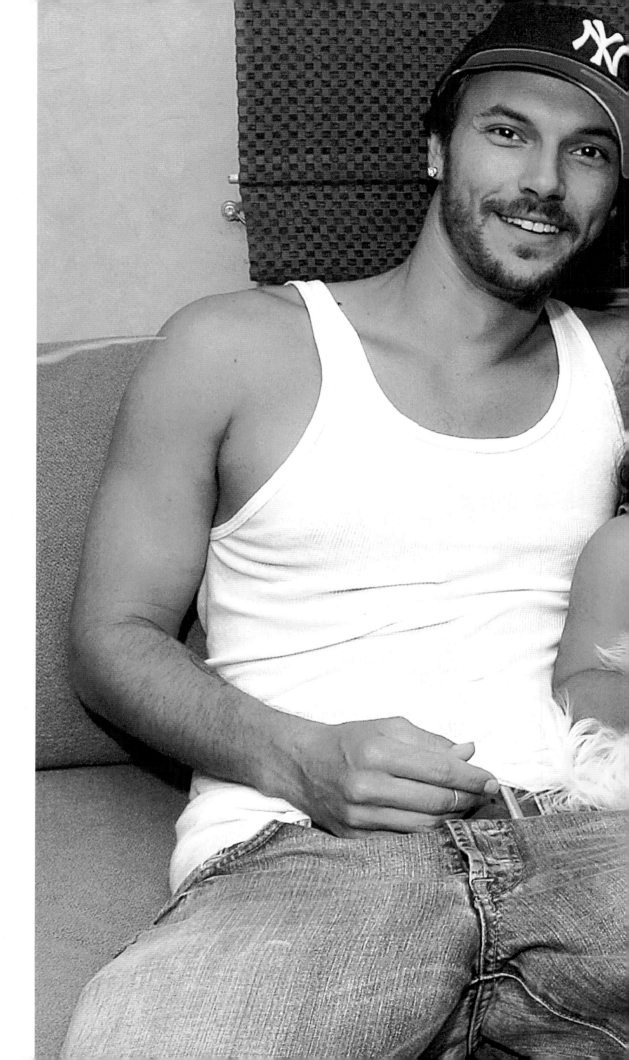

Kevin Federline & Britney Spears
Yummy stepmummy! Spears, then 22,
cozied up to fiancé Federline's daughter,
Kori, 2, on August 5, 2004, while shooting
a perfume ad. Being around kids agreed with
her: "You end up remembering what makes
you happy," she once said. And, in April
2005, Spears announced her own pregnancy.

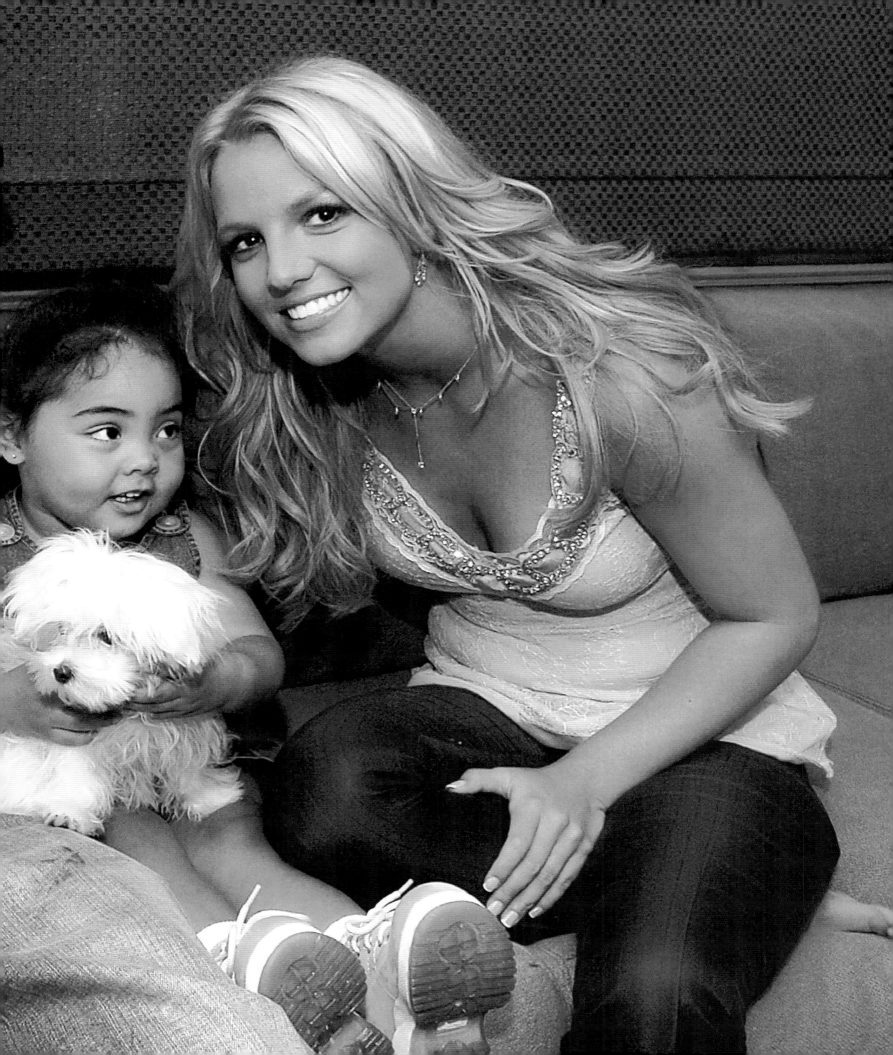

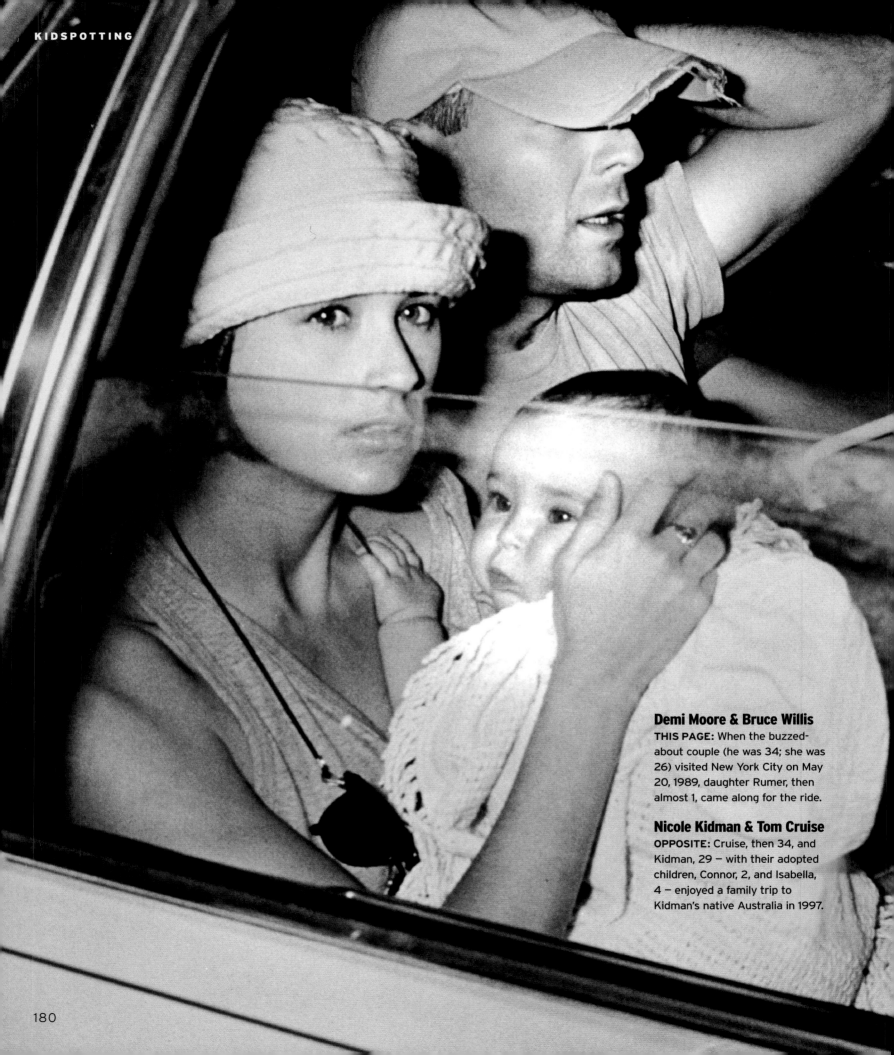

Demi Moore & Bruce Willis
THIS PAGE: When the buzzed-about couple (he was 34; she was 26) visited New York City on May 20, 1989, daughter Rumer, then almost 1, came along for the ride.

Nicole Kidman & Tom Cruise
OPPOSITE: Cruise, then 34, and Kidman, 29 — with their adopted children, Connor, 2, and Isabella, 4 — enjoyed a family trip to Kidman's native Australia in 1997.

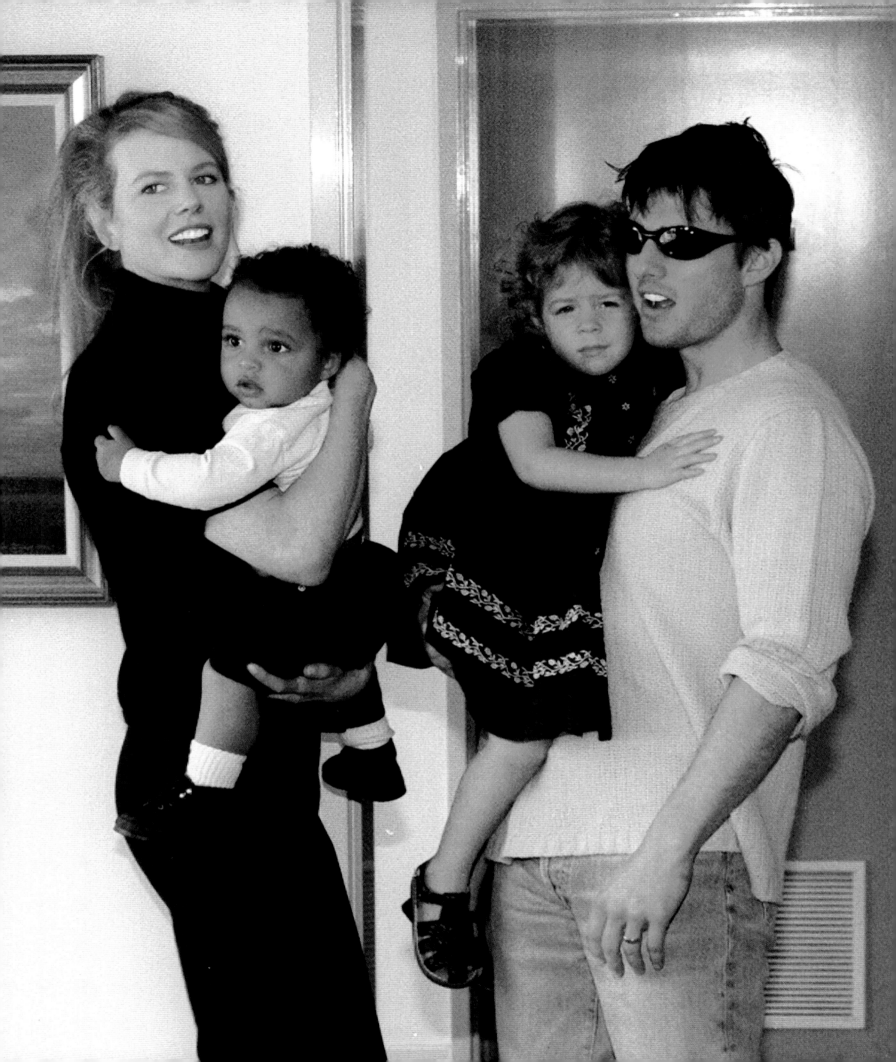

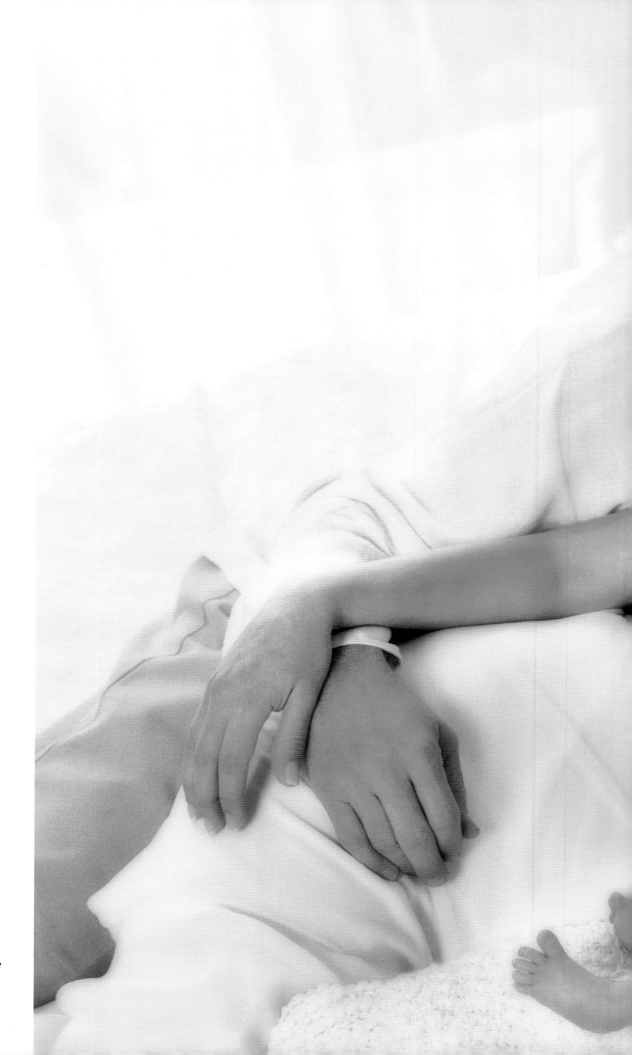

Michael Douglas & Catherine Zeta-Jones

On August 8, 2000, Zeta-Jones, then 30, and Douglas, 55, welcomed their first child, son Dylan. Just two weeks later, the threesome posed for a family portrait in their home in L.A.'s Pacific Palisades area.

Reese Witherspoon
She has always aimed for top of the class, going from straight A's at Nashville's Harpeth Hall School (here as a senior in 1994) to Type A Films (her production company). "I went to an all-girls school. It was very competitive and ambitious," she has said. "I was driven and competitive in another arena: trying to become a movie actress."

Hollywood
High

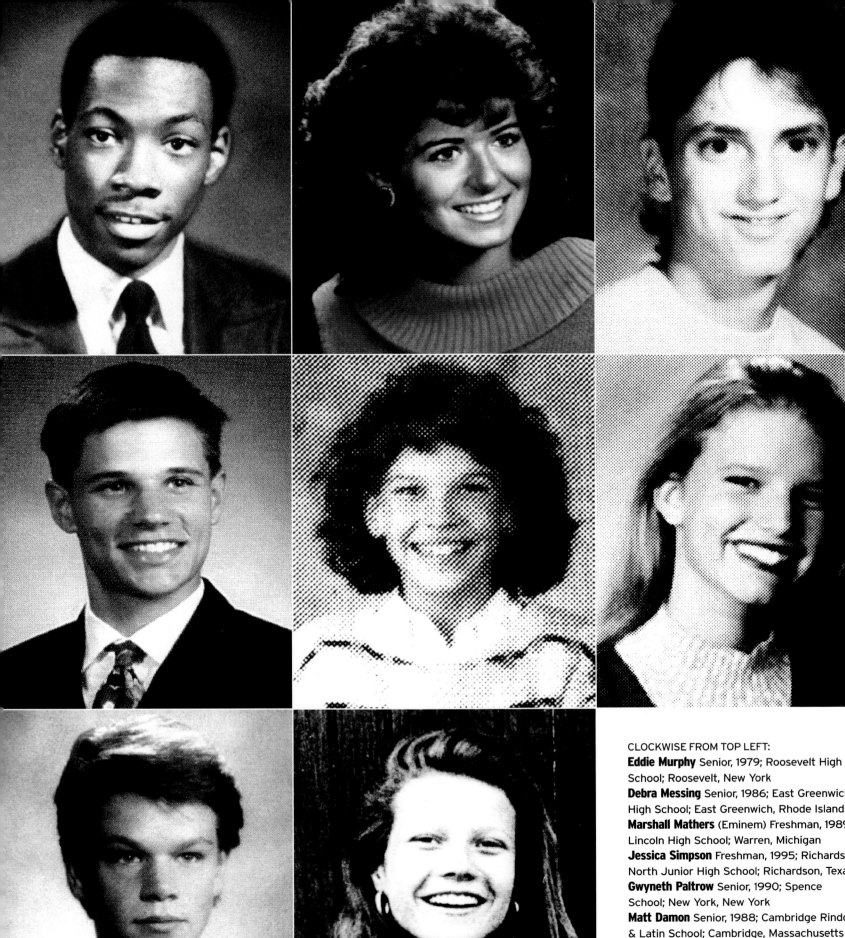

CLOCKWISE FROM TOP LEFT:
Eddie Murphy Senior, 1979; Roosevelt High School; Roosevelt, New York
Debra Messing Senior, 1986; East Greenwich High School; East Greenwich, Rhode Island
Marshall Mathers (Eminem) Freshman, 1989; Lincoln High School; Warren, Michigan
Jessica Simpson Freshman, 1995; Richardson North Junior High School; Richardson, Texas
Gwyneth Paltrow Senior, 1990; Spence School; New York, New York
Matt Damon Senior, 1988; Cambridge Rindge & Latin School; Cambridge, Massachusetts
Nick Lachey Senior, 1992; School for Creative and Performing Arts; Cincinnati, Ohio
Hilary Swank 7th grade, 1987; Fairhaven Middle School; Bellingham, Washington

185

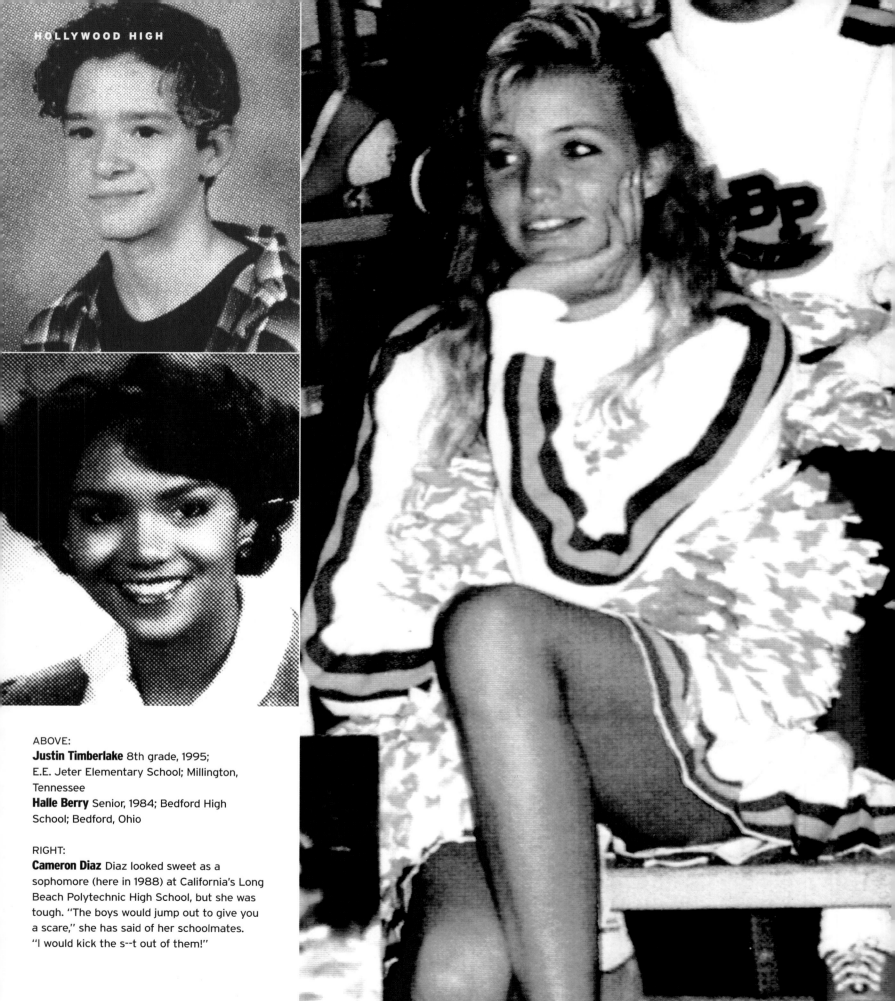

ABOVE:
Justin Timberlake 8th grade, 1995;
E.E. Jeter Elementary School; Millington,
Tennessee
Halle Berry Senior, 1984; Bedford High
School; Bedford, Ohio

RIGHT:
Cameron Diaz Diaz looked sweet as a
sophomore (here in 1988) at California's Long
Beach Polytechnic High School, but she was
tough. "The boys would jump out to give you
a scare," she has said of her schoolmates.
"I would kick the s--t out of them!"

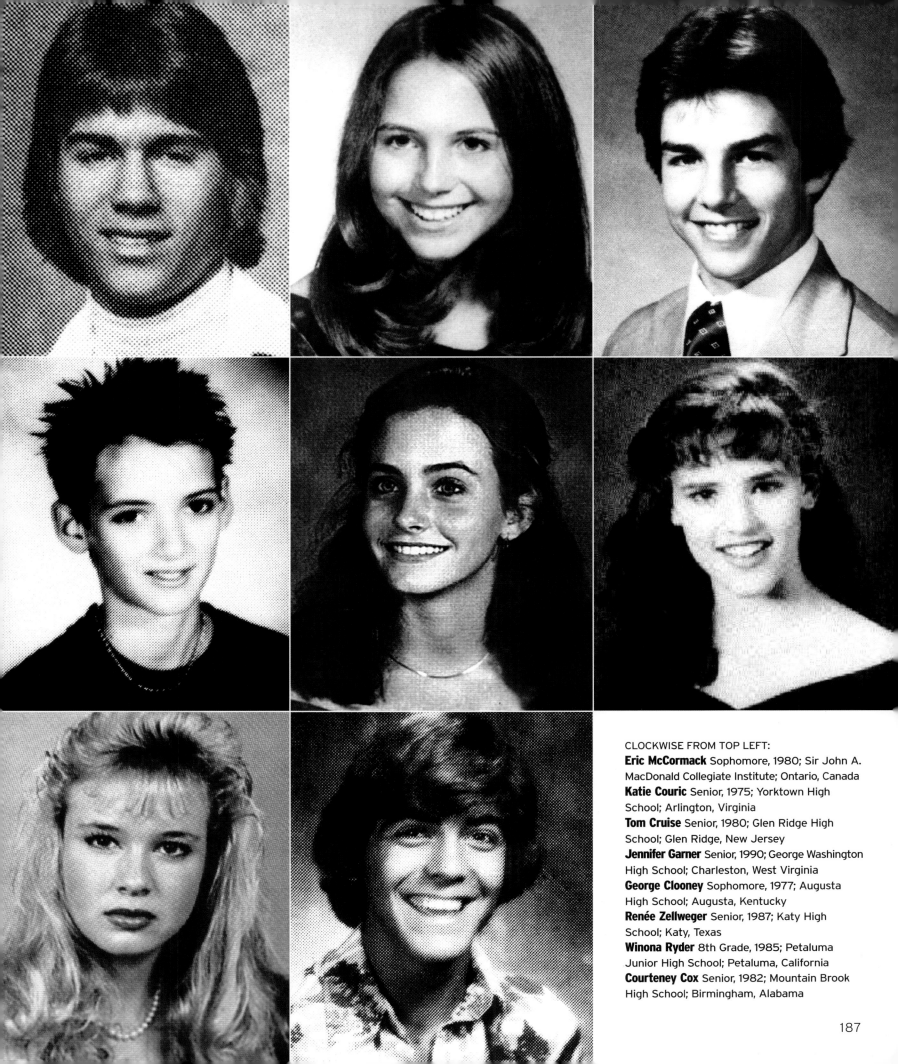

CLOCKWISE FROM TOP LEFT:

Eric McCormack Sophomore, 1980; Sir John A. MacDonald Collegiate Institute; Ontario, Canada

Katie Couric Senior, 1975; Yorktown High School; Arlington, Virginia

Tom Cruise Senior, 1980; Glen Ridge High School; Glen Ridge, New Jersey

Jennifer Garner Senior, 1990; George Washington High School; Charleston, West Virginia

George Clooney Sophomore, 1977; Augusta High School; Augusta, Kentucky

Renée Zellweger Senior, 1987; Katy High School; Katy, Texas

Winona Ryder 8th Grade, 1985; Petaluma Junior High School; Petaluma, California

Courteney Cox Senior, 1982; Mountain Brook High School; Birmingham, Alabama

187

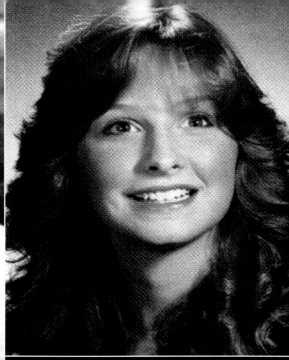
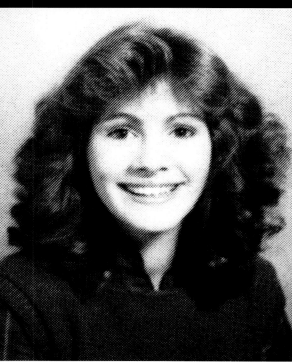

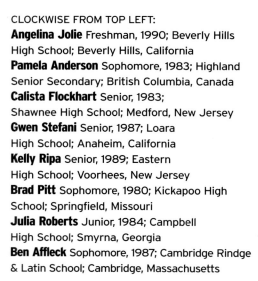
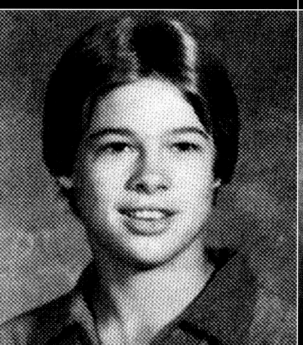
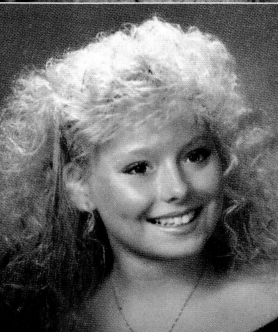

CLOCKWISE FROM TOP LEFT:
Angelina Jolie Freshman, 1990; Beverly Hills
High School; Beverly Hills, California
Pamela Anderson Sophomore, 1983; Highland
Senior Secondary; British Columbia, Canada
Calista Flockhart Senior, 1983;
Shawnee High School; Medford, New Jersey
Gwen Stefani Senior, 1987; Loara
High School; Anaheim, California
Kelly Ripa Senior, 1989; Eastern
High School; Voorhees, New Jersey
Brad Pitt Sophomore, 1980; Kickapoo High
School; Springfield, Missouri
Julia Roberts Junior, 1984; Campbell
High School; Smyrna, Georgia
Ben Affleck Sophomore, 1987; Cambridge Rindge
& Latin School; Cambridge, Massachusetts

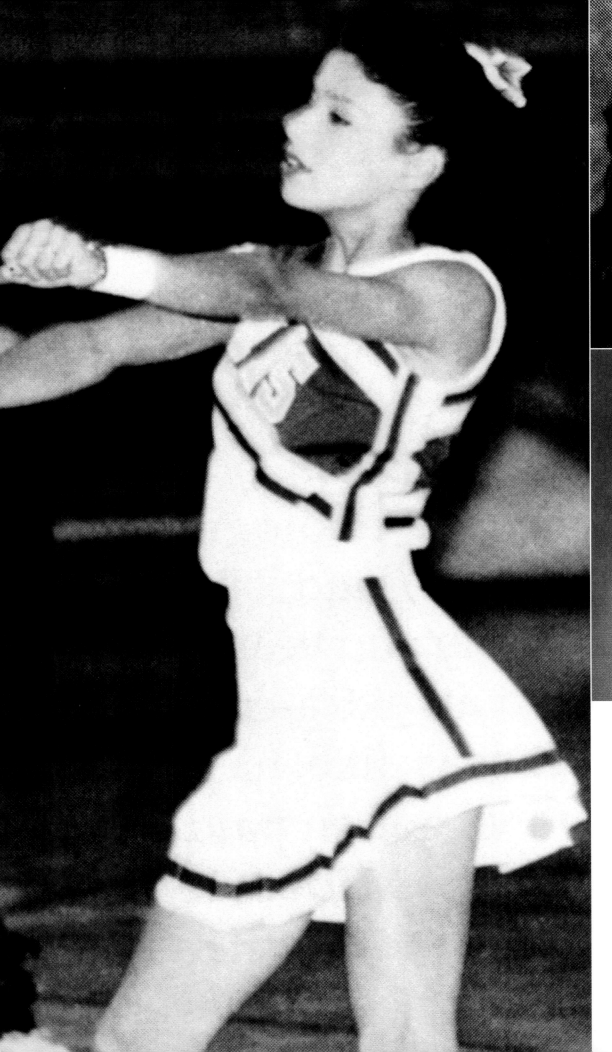

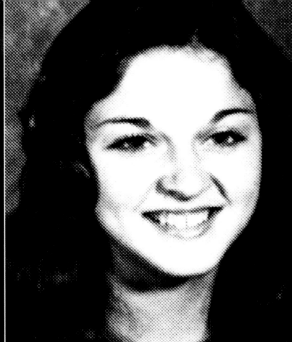

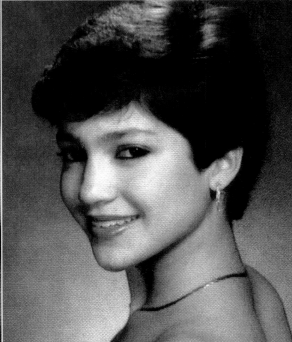

ABOVE:
Madonna Sophomore, 1974; Adams High School; Rochester, Michigan
Jennifer Lopez Senior, 1987; Preston High School; the Bronx, New York City

LEFT:
Eva Longoria As a senior in 1993, the hot, gardener-loving Gabrielle of *Desperate Housewives* was a cheerleader at Roy Miller High School in Corpus Christi, Texas. She wasn't always as popular as her show, though. "Girls used to call me Skinny Minnie," the petite star has said.

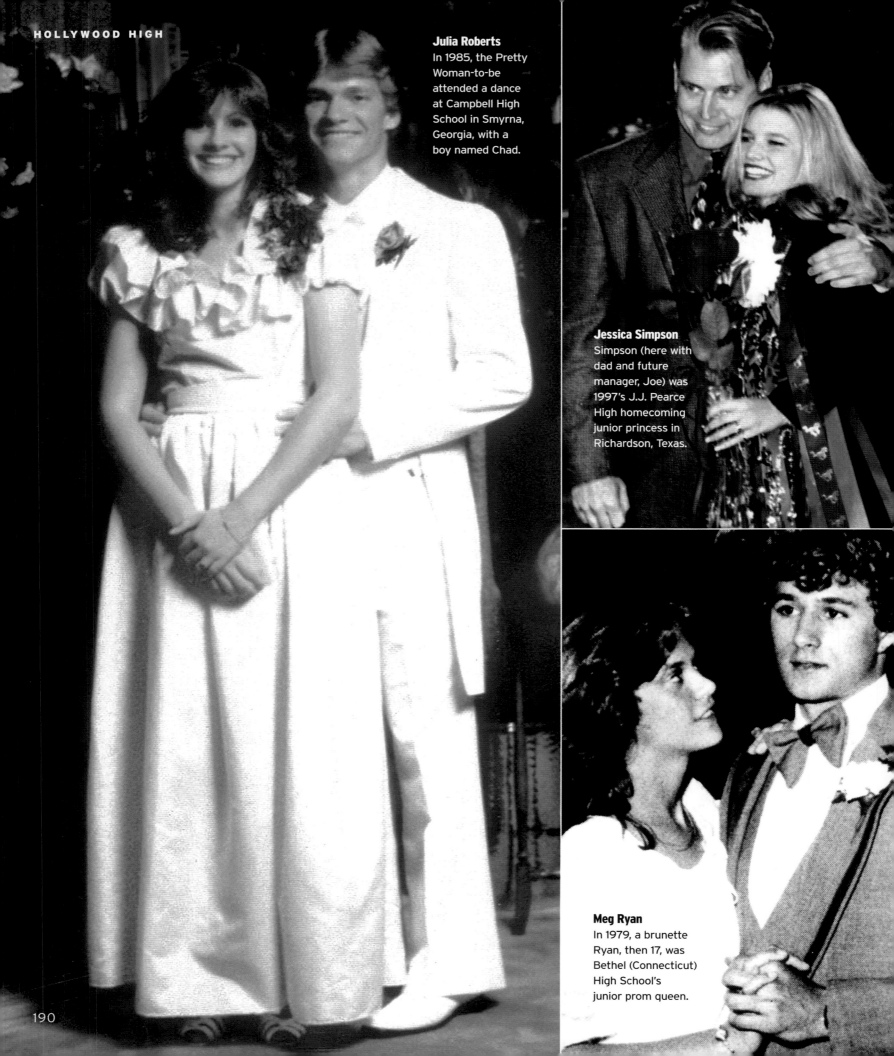

Julia Roberts
In 1985, the Pretty Woman-to-be attended a dance at Campbell High School in Smyrna, Georgia, with a boy named Chad.

Jessica Simpson
Simpson (here with dad and future manager, Joe) was 1997's J.J. Pearce High homecoming junior princess in Richardson, Texas.

Meg Ryan
In 1979, a brunette Ryan, then 17, was Bethel (Connecticut) High School's junior prom queen.

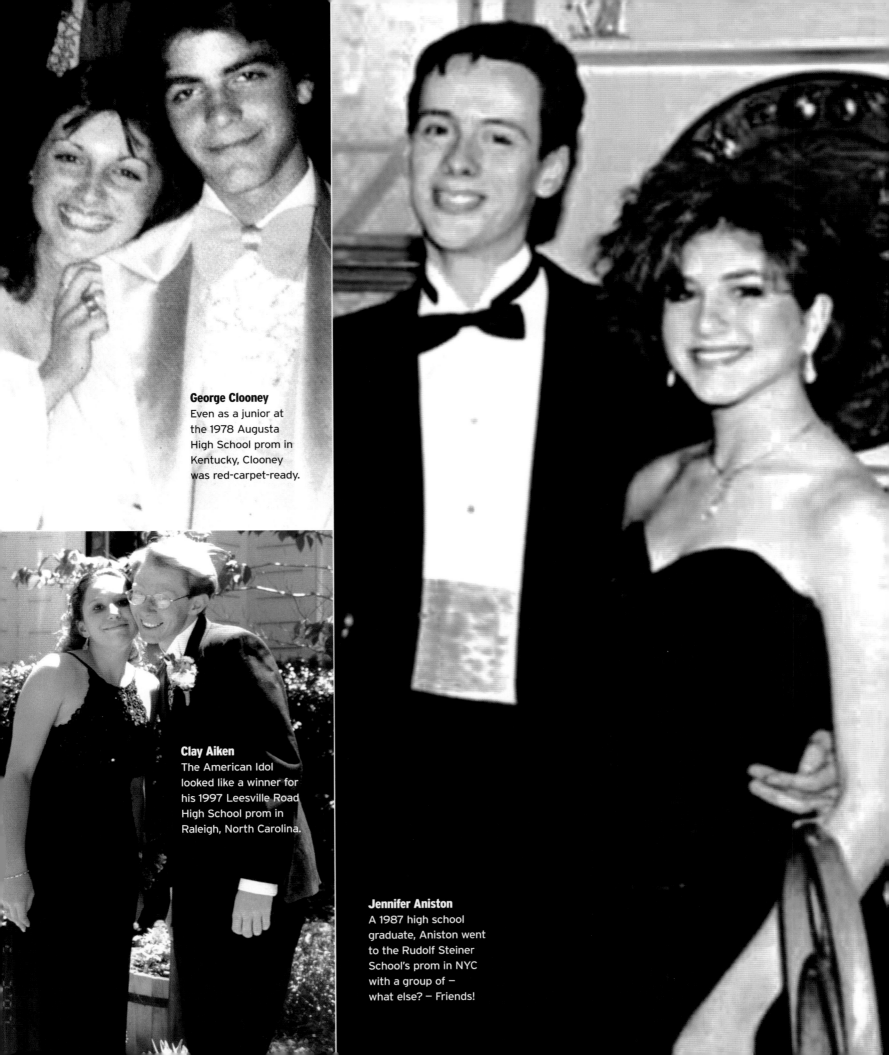

George Clooney
Even as a junior at the 1978 Augusta High School prom in Kentucky, Clooney was red-carpet-ready.

Clay Aiken
The American Idol looked like a winner for his 1997 Leesville Road High School prom in Raleigh, North Carolina.

Jennifer Aniston
A 1987 high school graduate, Aniston went to the Rudolf Steiner School's prom in NYC with a group of — what else? — Friends!

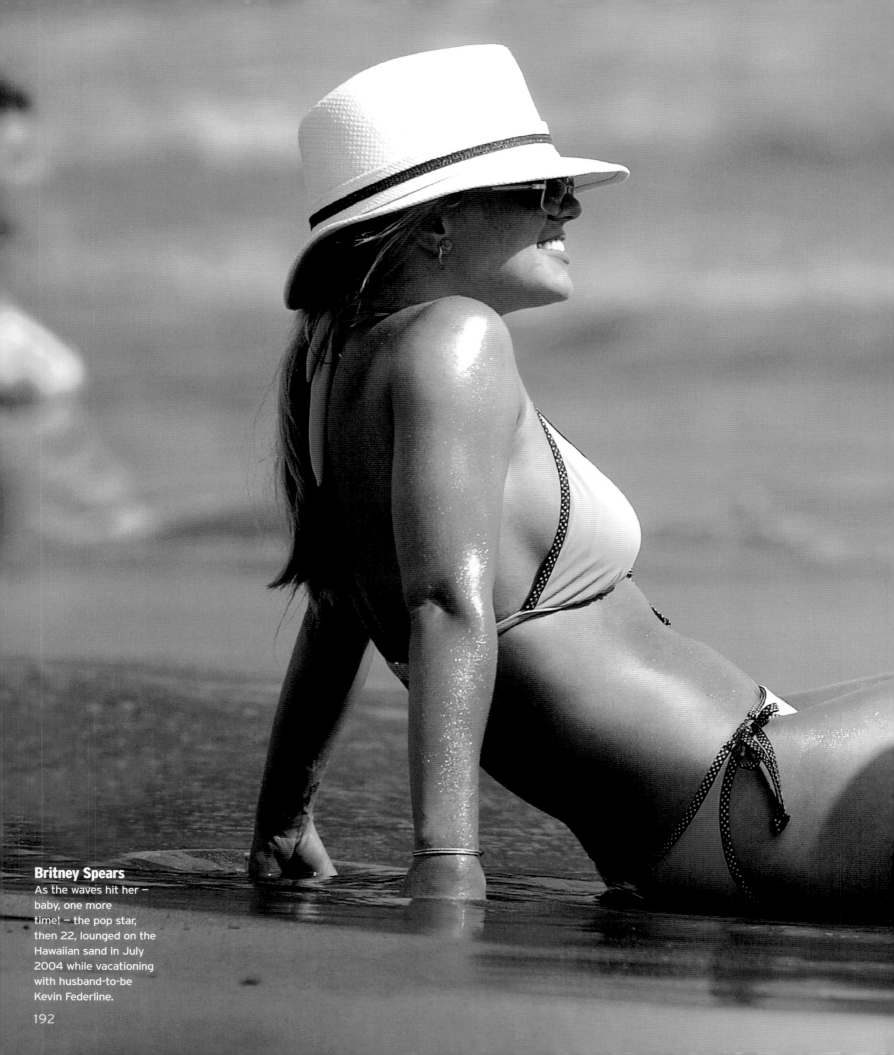

Britney Spears
As the waves hit her — baby, one more time! — the pop star, then 22, lounged on the Hawaiian sand in July 2004 while vacationing with husband-to-be Kevin Federline.

192

Life's a
Beach

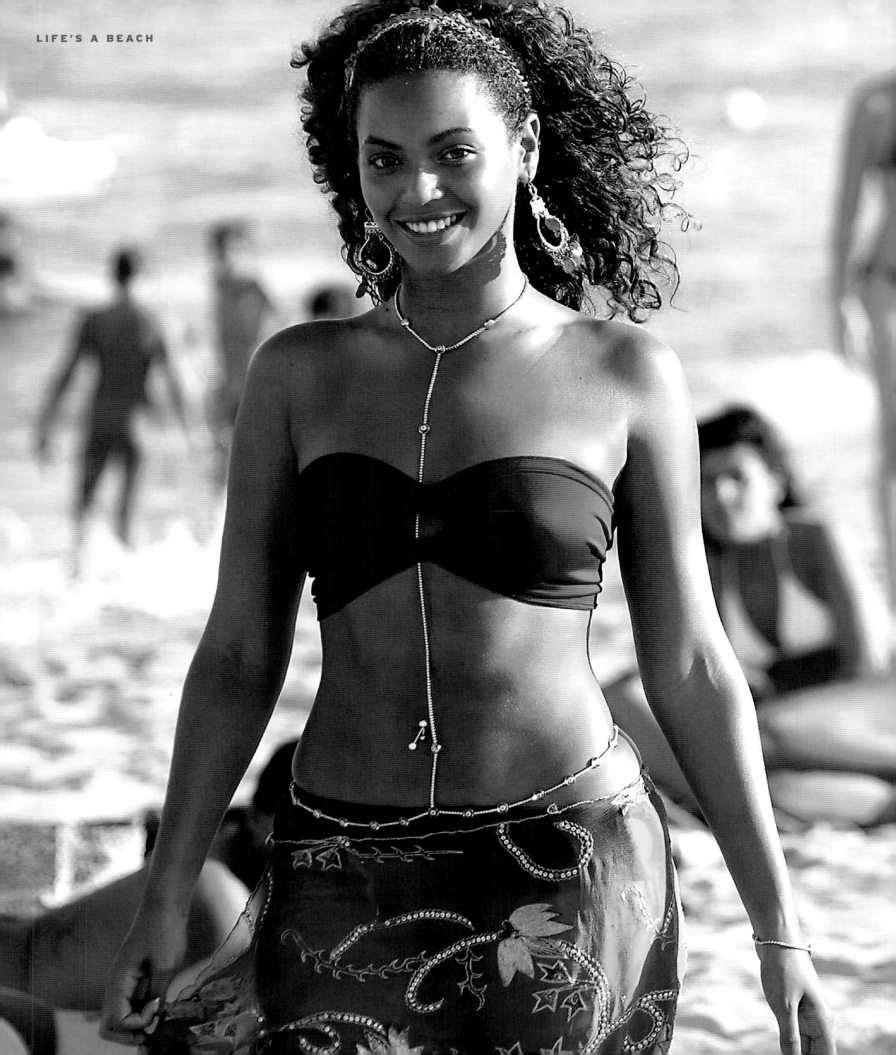

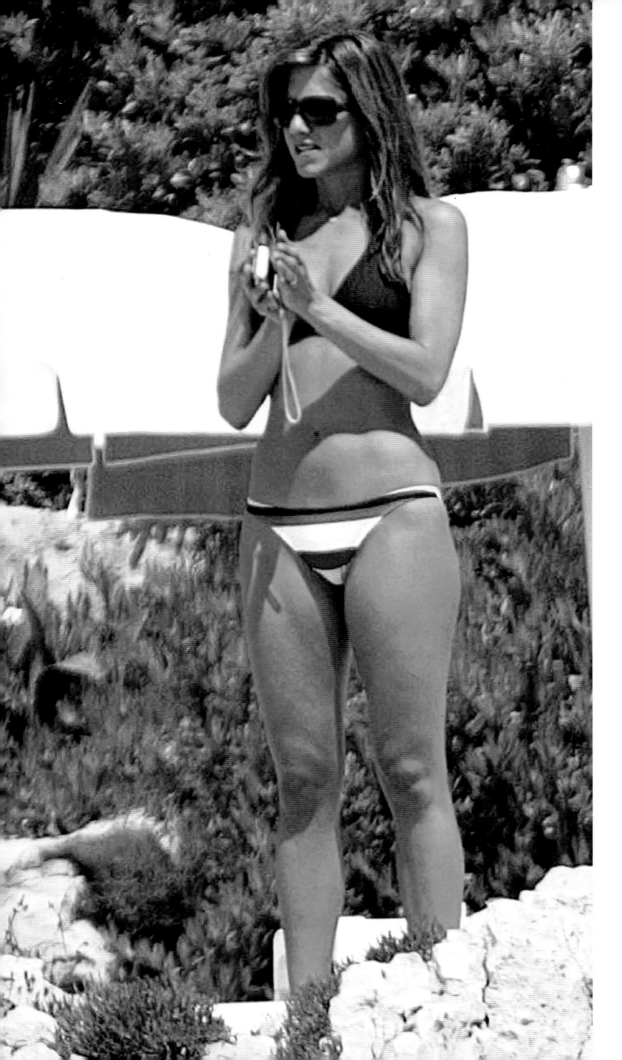

Beyoncé Knowles

OPPOSITE: On August 19, 2003, the singer, then 21, enjoyed beach walks in St-Tropez with rapper boyfriend Jay-Z, 33. The pair later met up with fellow vacationers – model Helena Christensen and U2's Bono – for lunch.

Jennifer Aniston

THIS PAGE: Ooh la la! Aniston, then 35, accompanied hubby Brad Pitt to the Cannes Film Festival. While he was off promoting *Troy,* she caught some rays on May 13, 2004, at the luxe Hôtel du Cap Eden Roc.

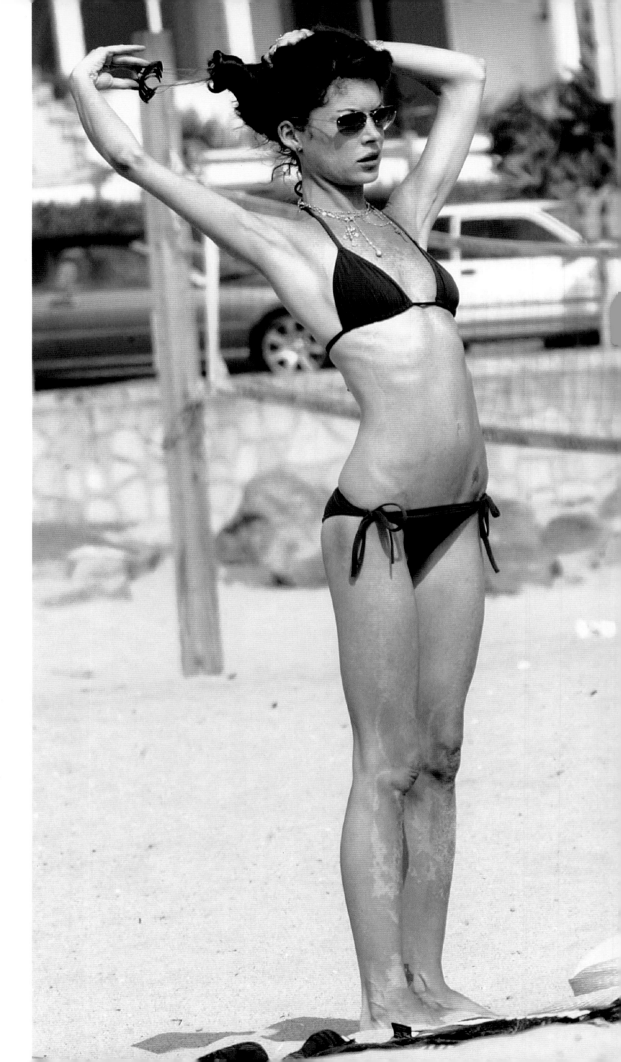

Lara Flynn Boyle

THIS PAGE: To think, the camera's supposed to *add* pounds! On July 20, 2003, Boyle, then 33, was all skin and bones (and skinned knees) in L.A.'s Venice area. She shrugged it off: "I eat pizza, I eat cookies. I'm fine."

Pamela Anderson

OPPOSITE: Anderson, then 37, made a stab at a cover-up in Malibu, California, on October 10, 2004, while swimming with her two sons. "Everything is always popping off me," she has said. "Clothes and I are like two magnets opposing each other."

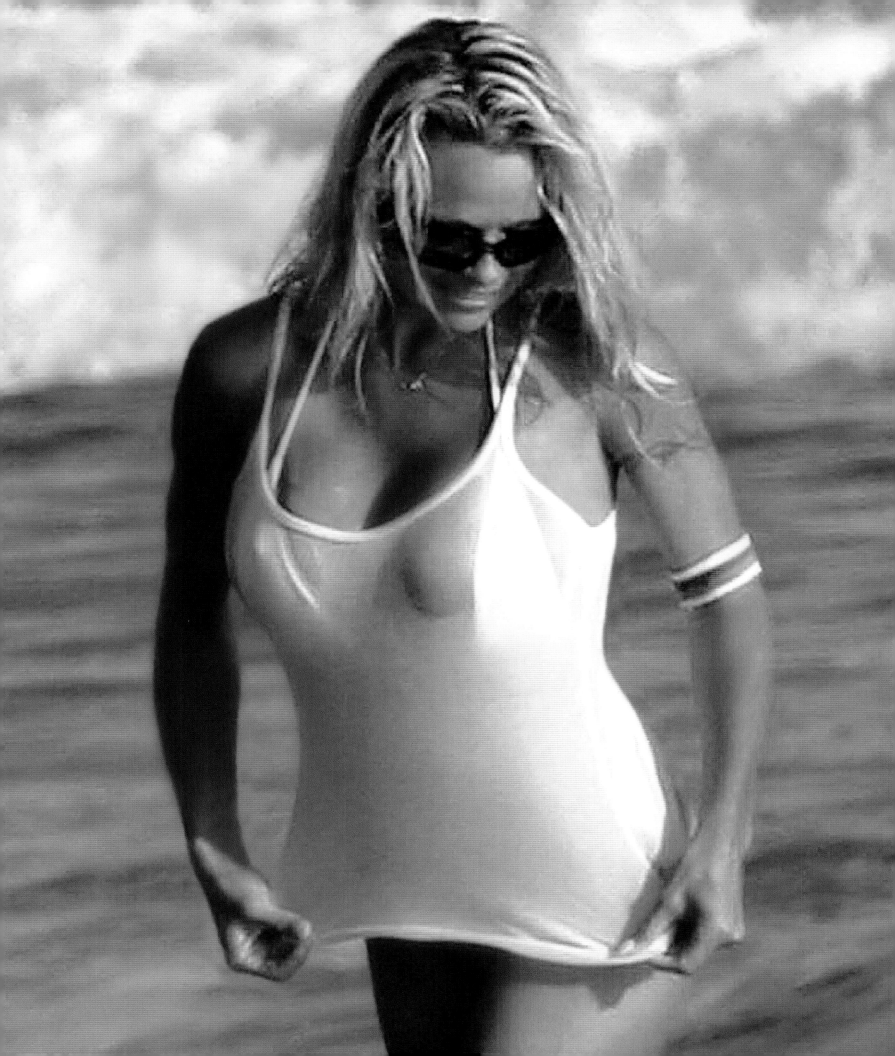

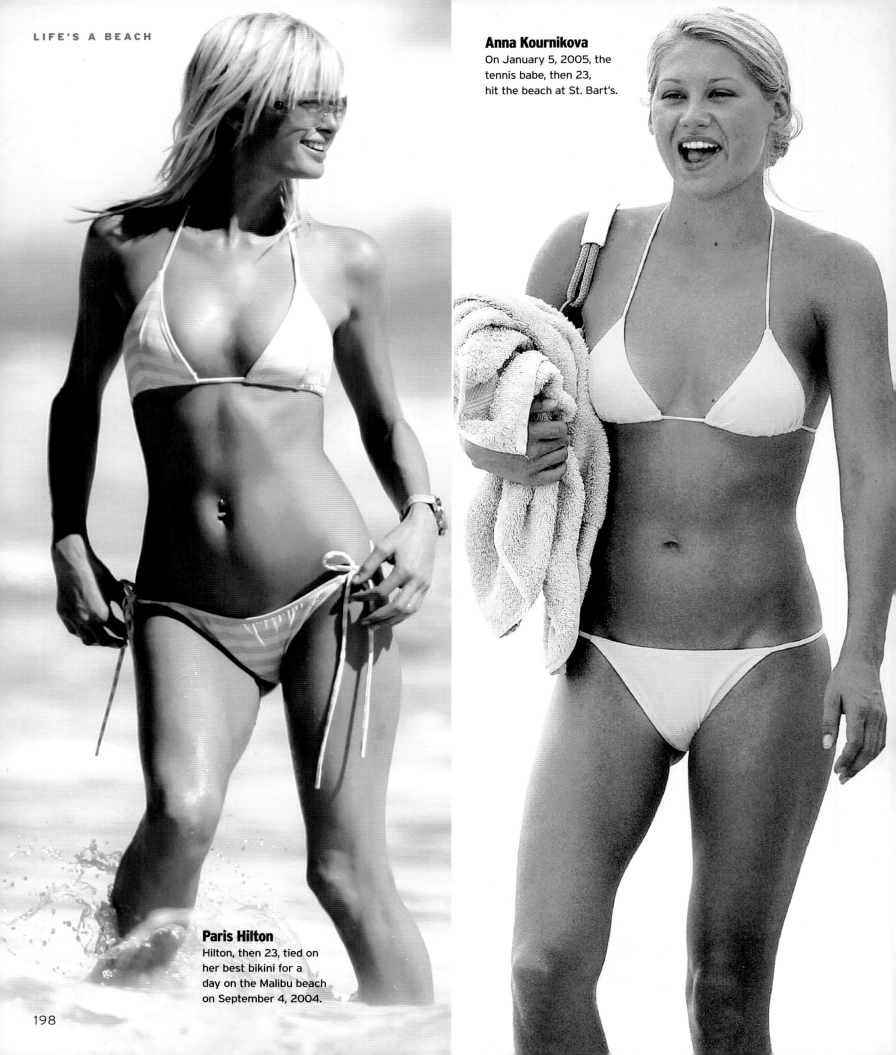

Anna Kournikova
On January 5, 2005, the tennis babe, then 23, hit the beach at St. Bart's.

Paris Hilton
Hilton, then 23, tied on her best bikini for a day on the Malibu beach on September 4, 2004.

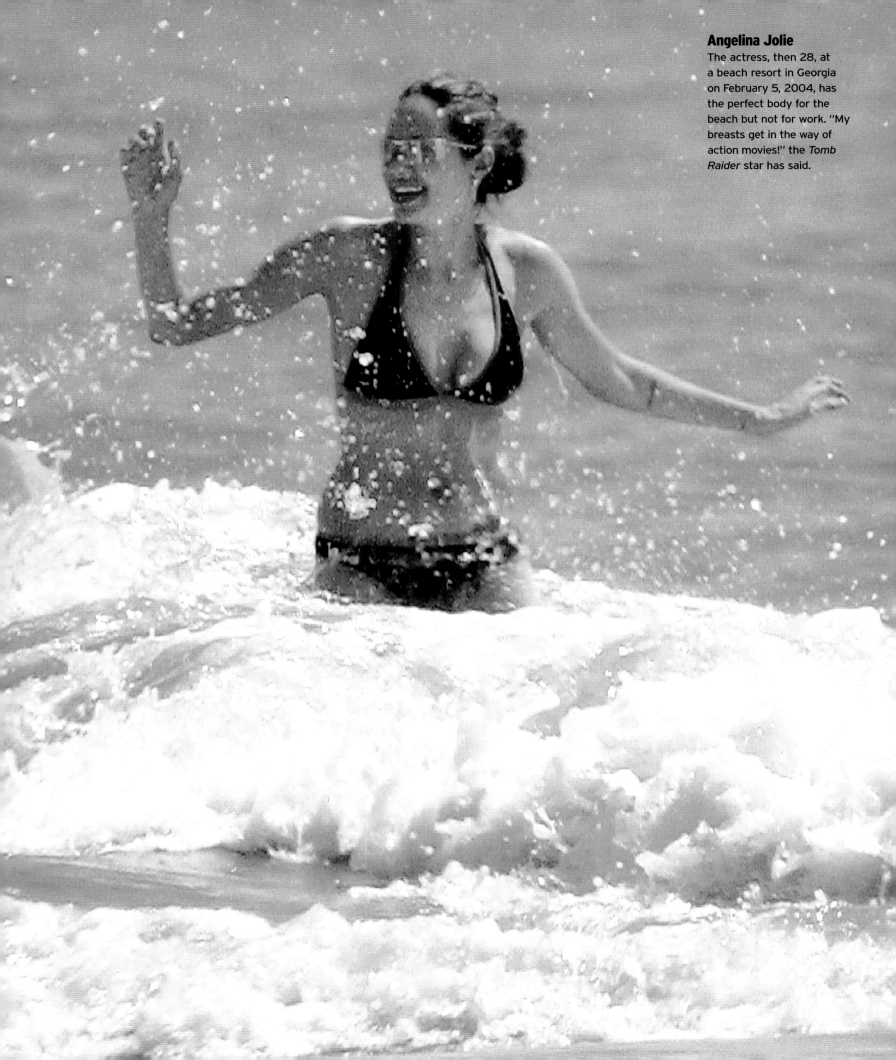

Angelina Jolie
The actress, then 28, at a beach resort in Georgia on February 5, 2004, has the perfect body for the beach but not for work. "My breasts get in the way of action movies!" the *Tomb Raider* star has said.

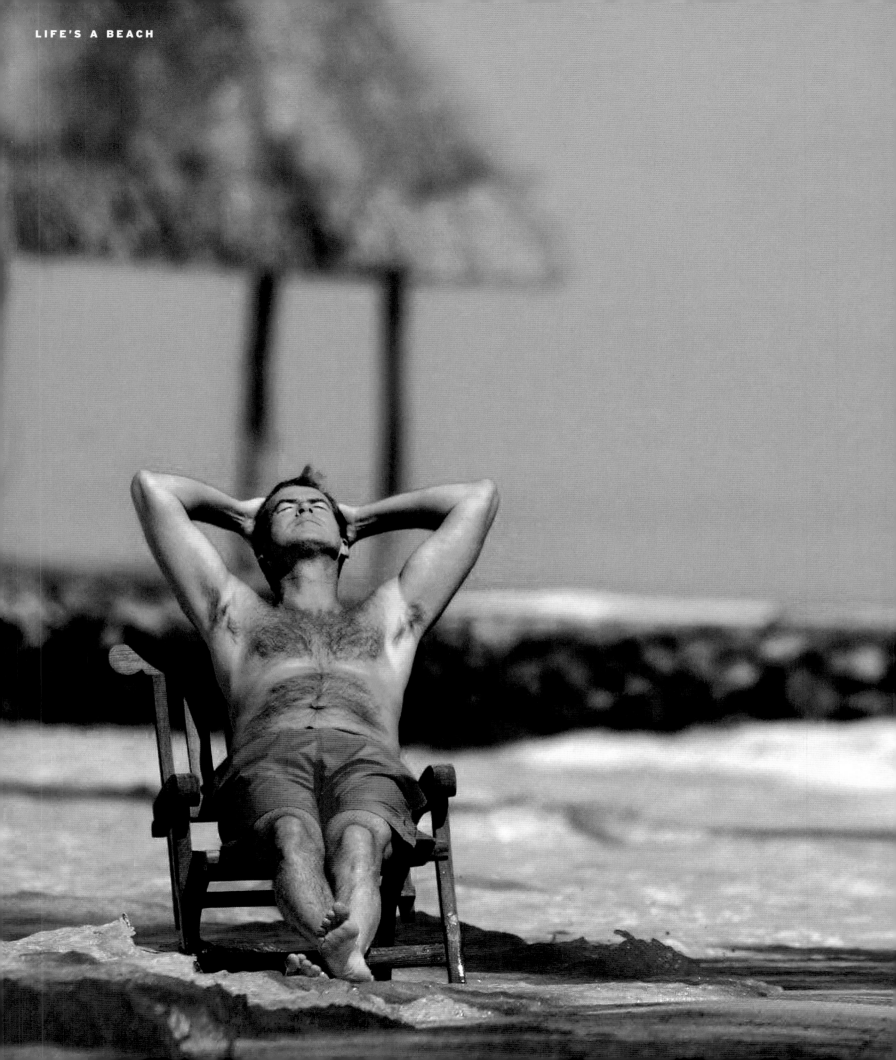

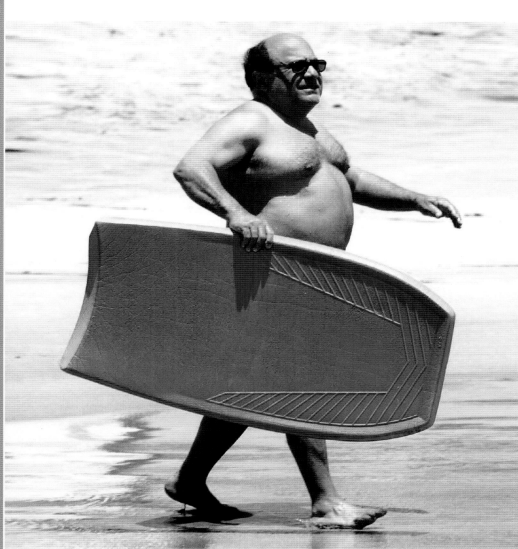

Pierce Brosnan
OPPOSITE: Double Oh-heaven! Even James Bond needs a holiday. Brosnan, then 49, relaxed in Bora Bora, Tahiti, in August 2002 with wife Keely Shaye Smith and 18-month-old son Paris.

Danny DeVito
TOP: Boogie down! DeVito, then 58, rode the Maui surf on June 18, 2003, while enjoying a Hawaiian vacation with wife/actress Rhea Perlman and their kids, Lucy, 20, Grace, 18, and Jacob, 14.

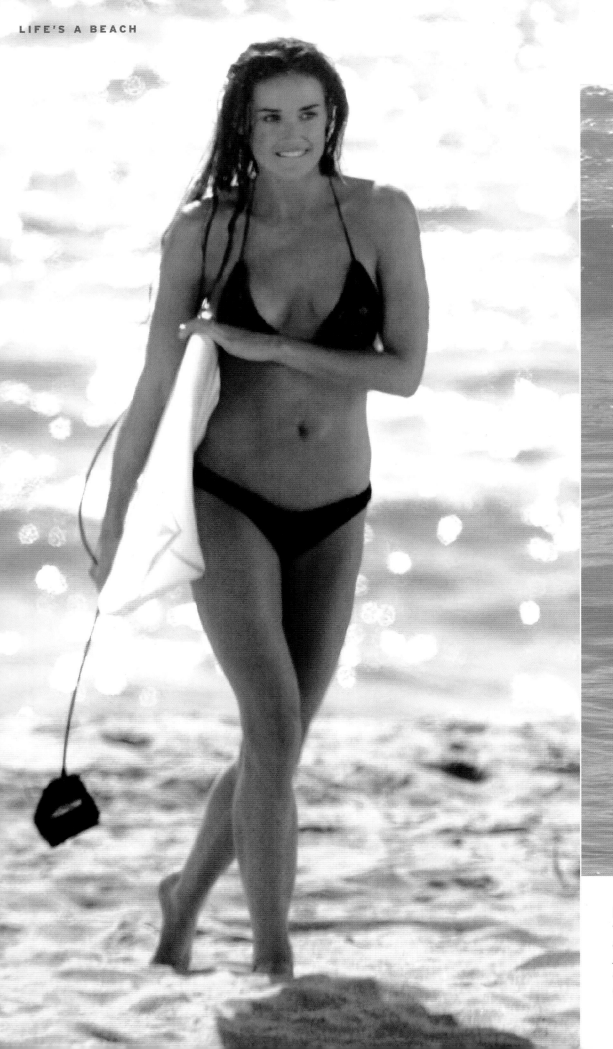

Demi Moore

The actress, then 39, staged a sizzling comeback in 2002, vamping it up in *Charlie's Angels: Full Throttle.* "How many opportunities do you get to kick ass and look good, where good hair and lip gloss are key?" she has joked.

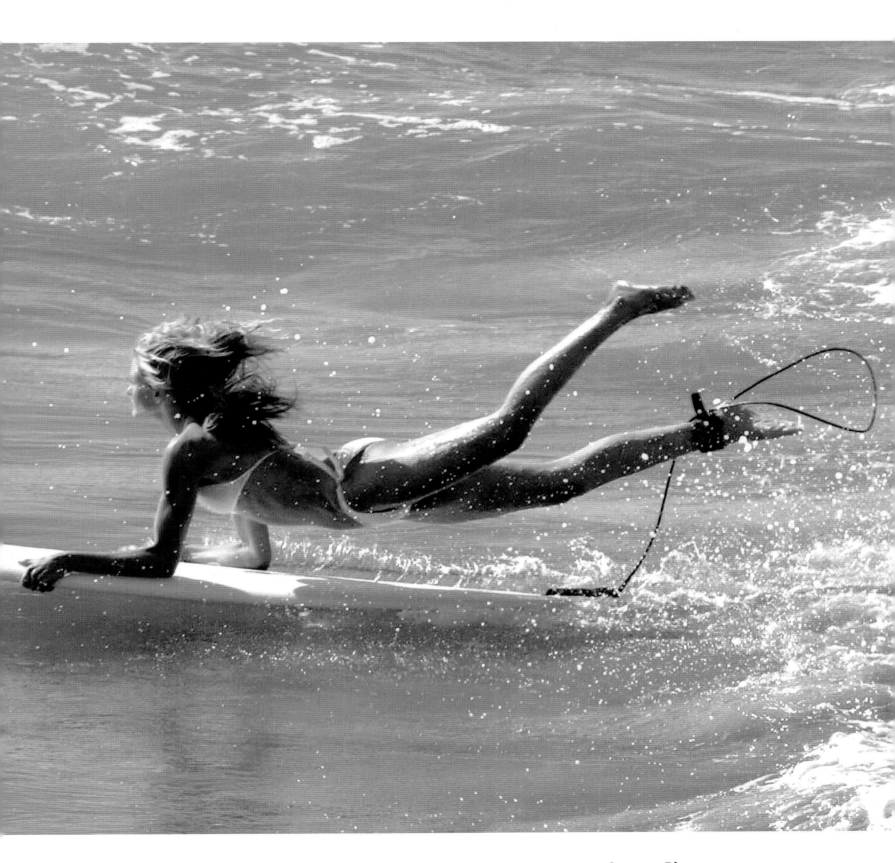

Cameron Diaz
The California girl, then 30, learned to surf for the
Charlie's Angels sequel, shot in October 2002
at Malibu's Westward Beach. Diaz's instructor, Mike
Justus, considered her a natural. "She did unreal,
like she had been surfing for years," he said.

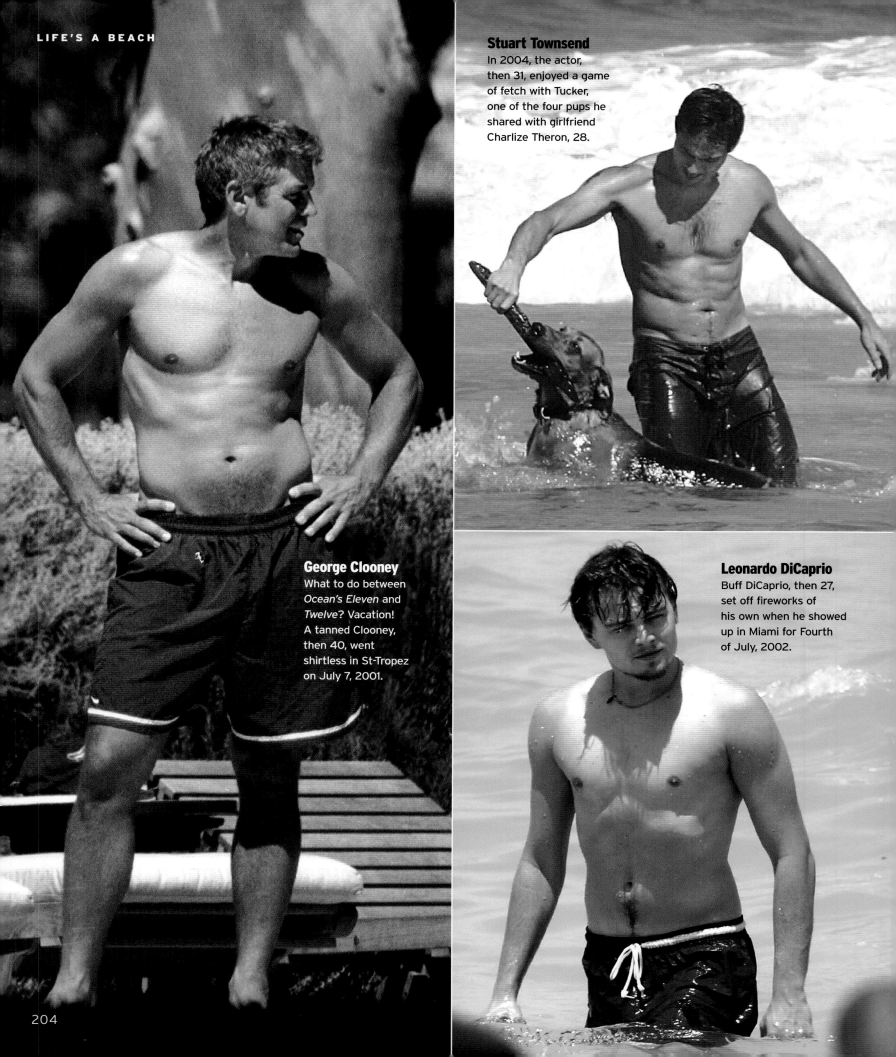

George Clooney
What to do between *Ocean's Eleven* and *Twelve*? Vacation! A tanned Clooney, then 40, went shirtless in St-Tropez on July 7, 2001.

Stuart Townsend
In 2004, the actor, then 31, enjoyed a game of fetch with Tucker, one of the four pups he shared with girlfriend Charlize Theron, 28.

Leonardo DiCaprio
Buff DiCaprio, then 27, set off fireworks of his own when he showed up in Miami for Fourth of July, 2002.

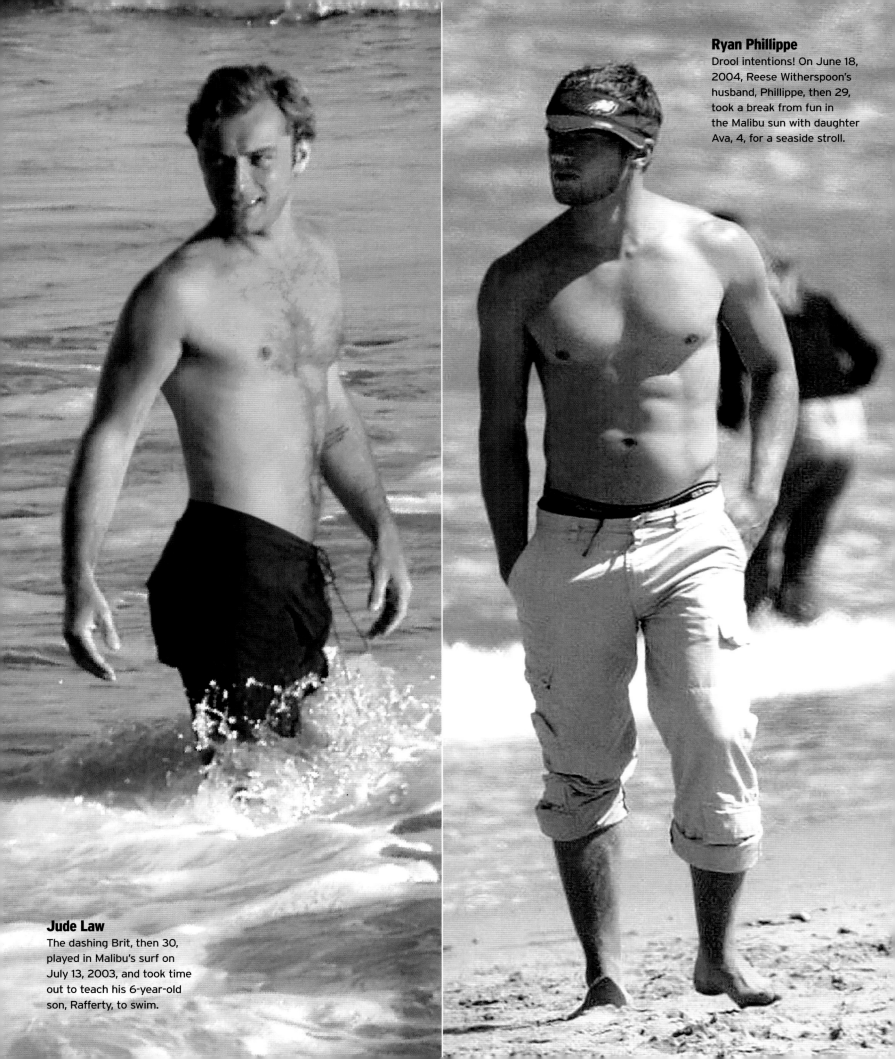

Ryan Phillippe
Drool intentions! On June 18, 2004, Reese Witherspoon's husband, Phillippe, then 29, took a break from fun in the Malibu sun with daughter Ava, 4, for a seaside stroll.

Jude Law
The dashing Brit, then 30, played in Malibu's surf on July 13, 2003, and took time out to teach his 6-year-old son, Rafferty, to swim.

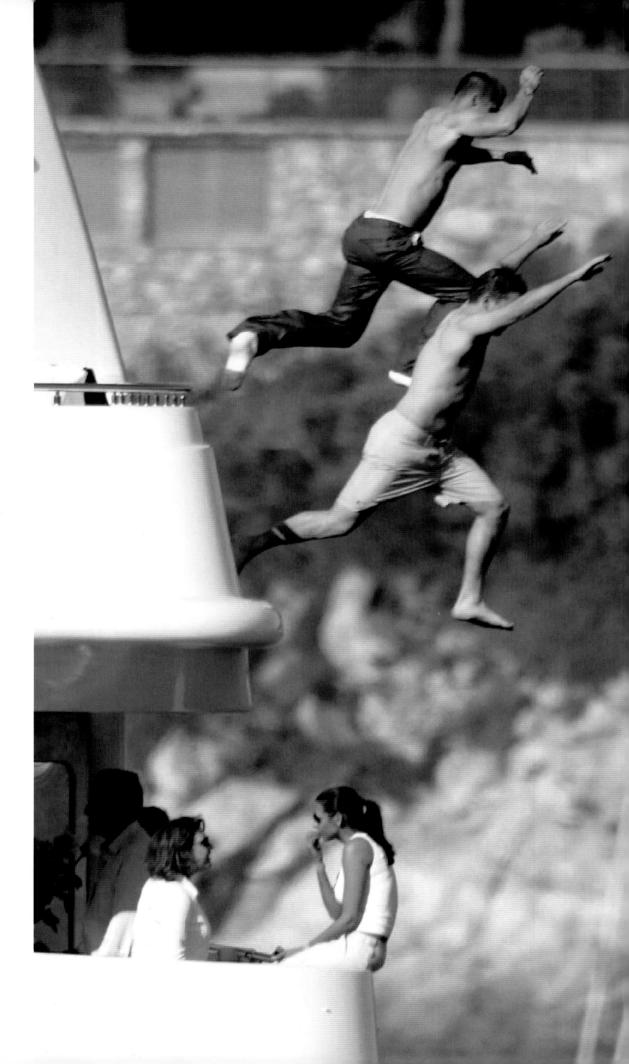

Brad Pitt & Matt Damon

THIS PAGE: And if Brad jumped off a bridge, would you do it too, Matt? Pitt, then 40, and Damon, 33, spent a day in May 2004 yachting (and jumping) in Villefranche, France.

Bruce & Rumer Willis

OPPOSITE: Demi's former hubby, Willis, then 48, joined daughter Rumer, 15, for a dip while vacationing in Sardinia in August 2003.

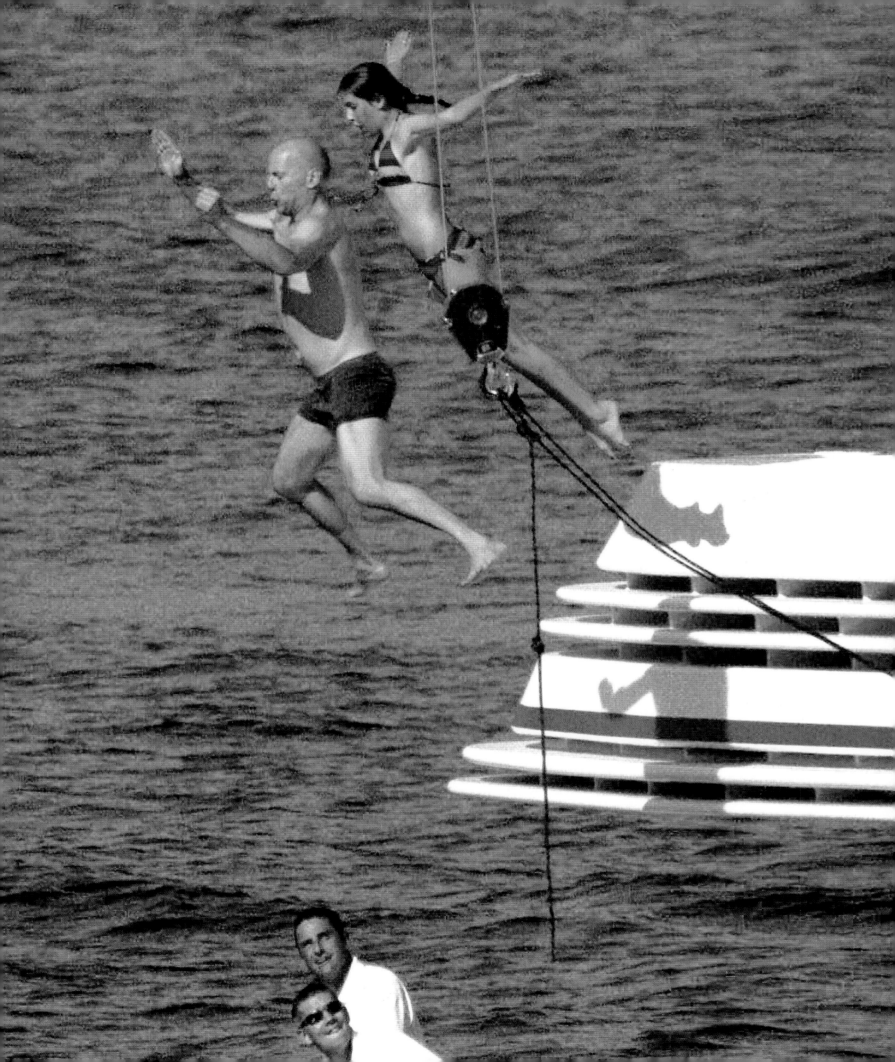

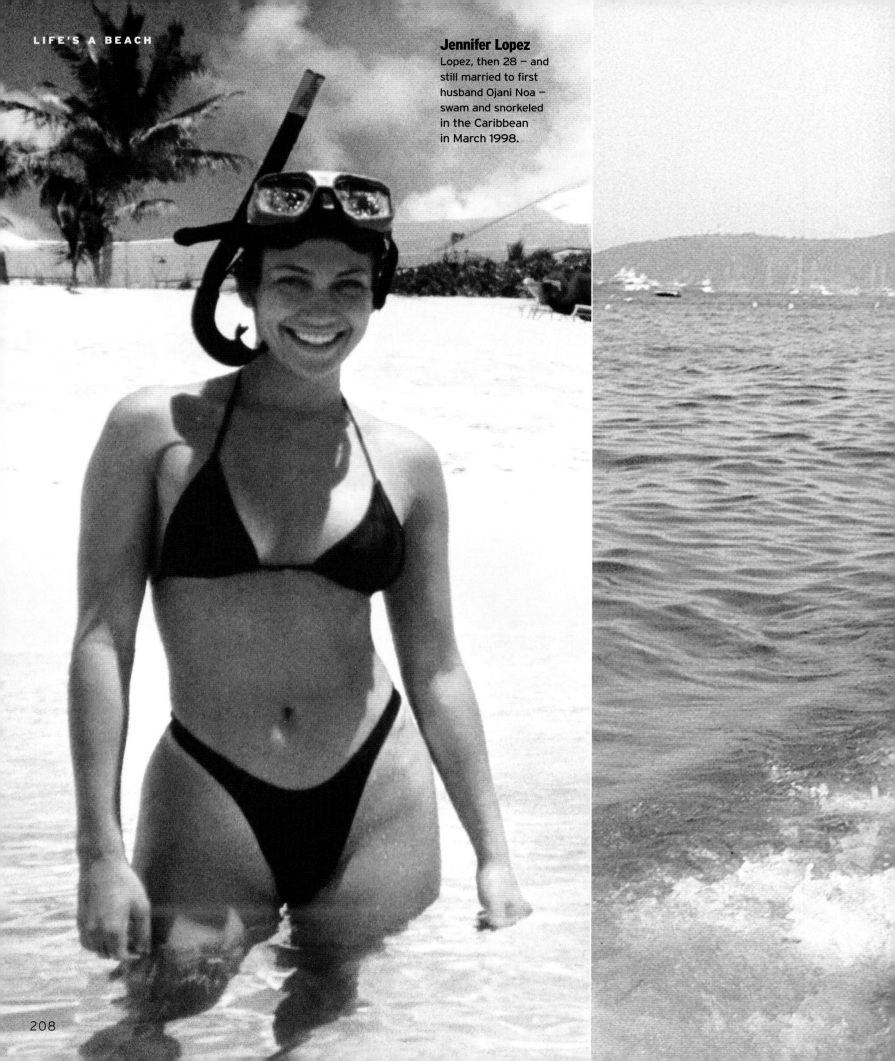

Jennifer Lopez
Lopez, then 28 – and still married to first husband Ojani Noa – swam and snorkeled in the Caribbean in March 1998.

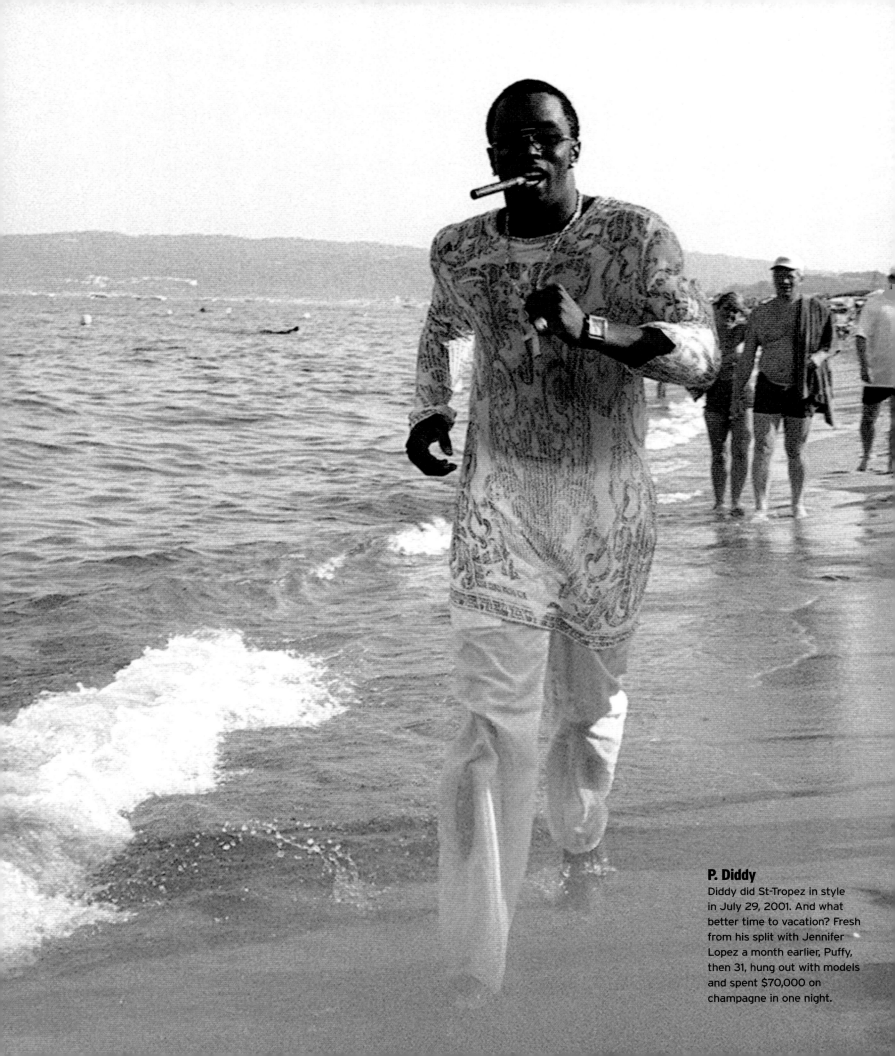

P. Diddy

Diddy did St-Tropez in style in July 29, 2001. And what better time to vacation? Fresh from his split with Jennifer Lopez a month earlier, Puffy, then 31, hung out with models and spent $70,000 on champagne in one night.

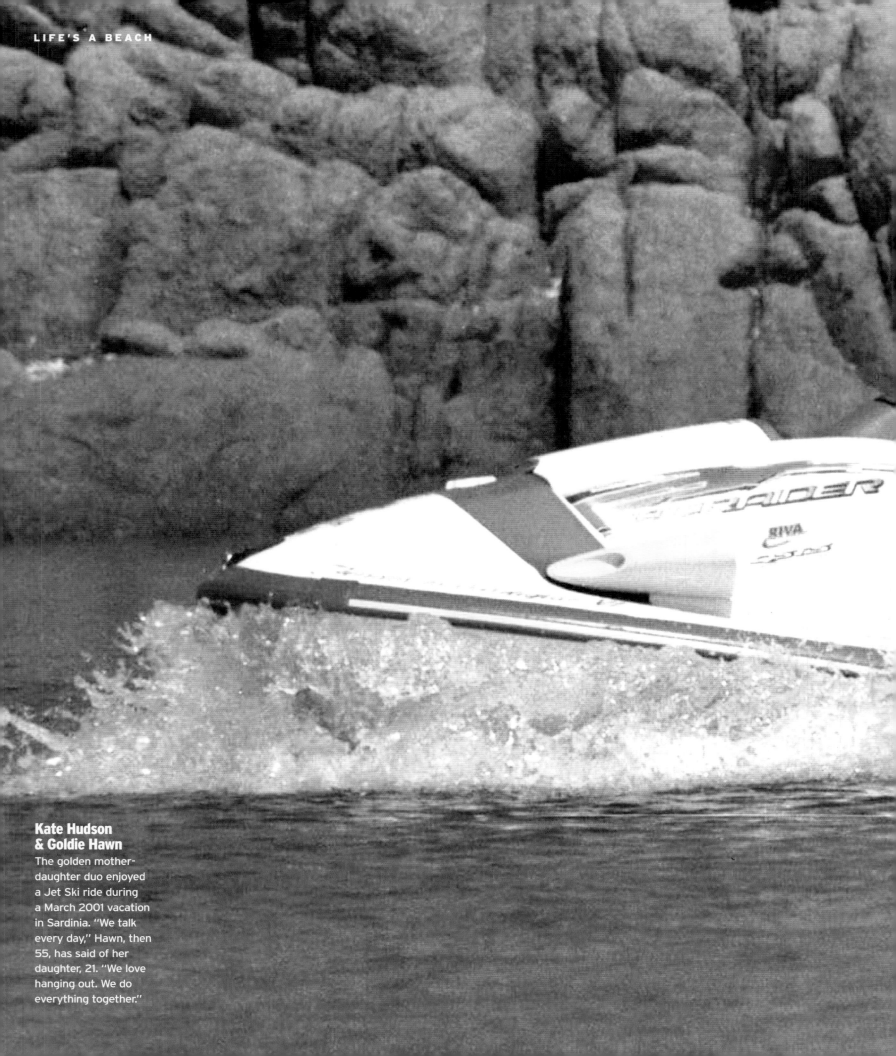

Kate Hudson & Goldie Hawn
The golden mother-daughter duo enjoyed a Jet Ski ride during a March 2001 vacation in Sardinia. "We talk every day," Hawn, then 55, has said of her daughter, 21. "We love hanging out. We do everything together."

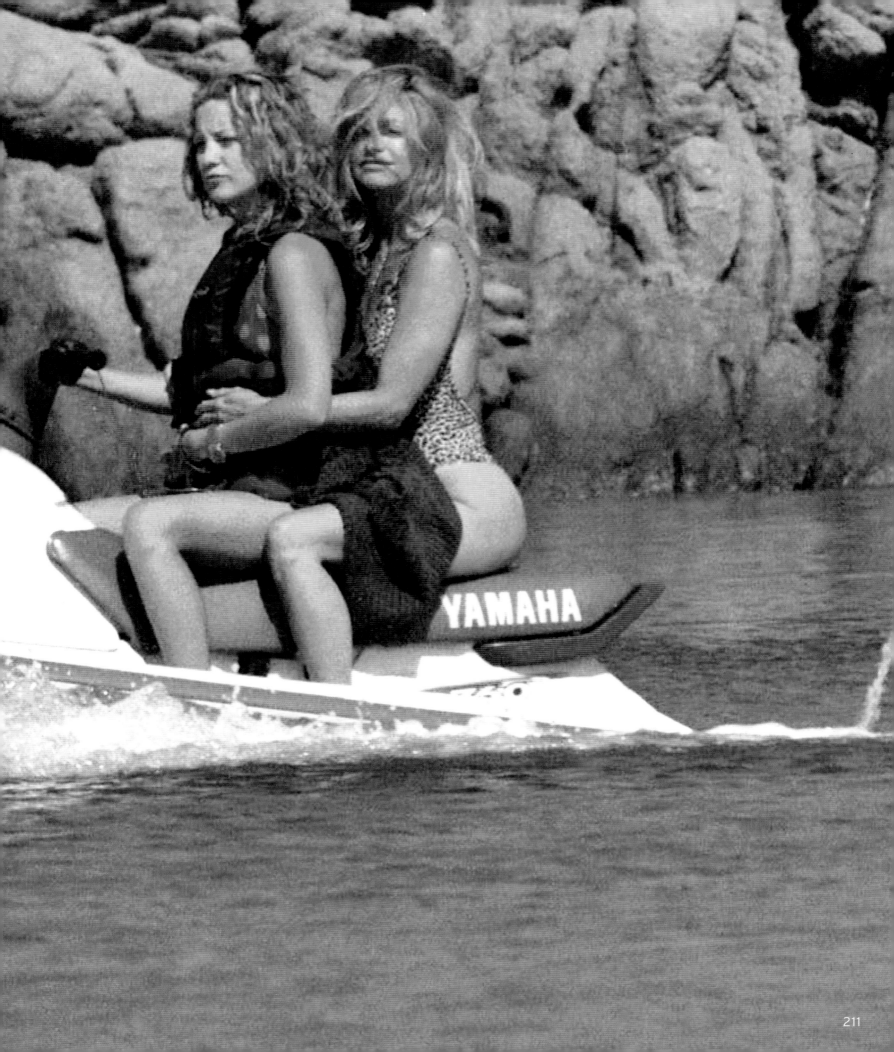

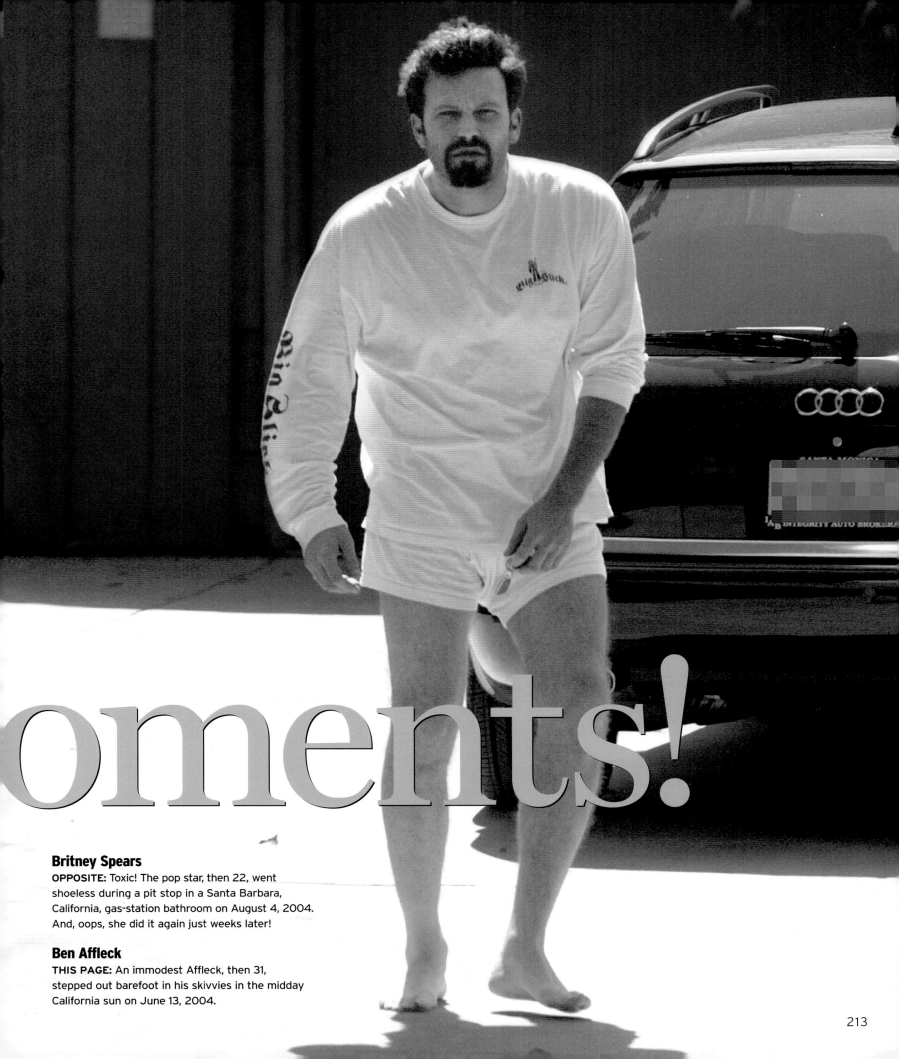

oments!

Britney Spears

OPPOSITE: Toxic! The pop star, then 22, went shoeless during a pit stop in a Santa Barbara, California, gas-station bathroom on August 4, 2004. And, oops, she did it again just weeks later!

Ben Affleck

THIS PAGE: An immodest Affleck, then 31, stepped out barefoot in his skivvies in the midday California sun on June 13, 2004.

213

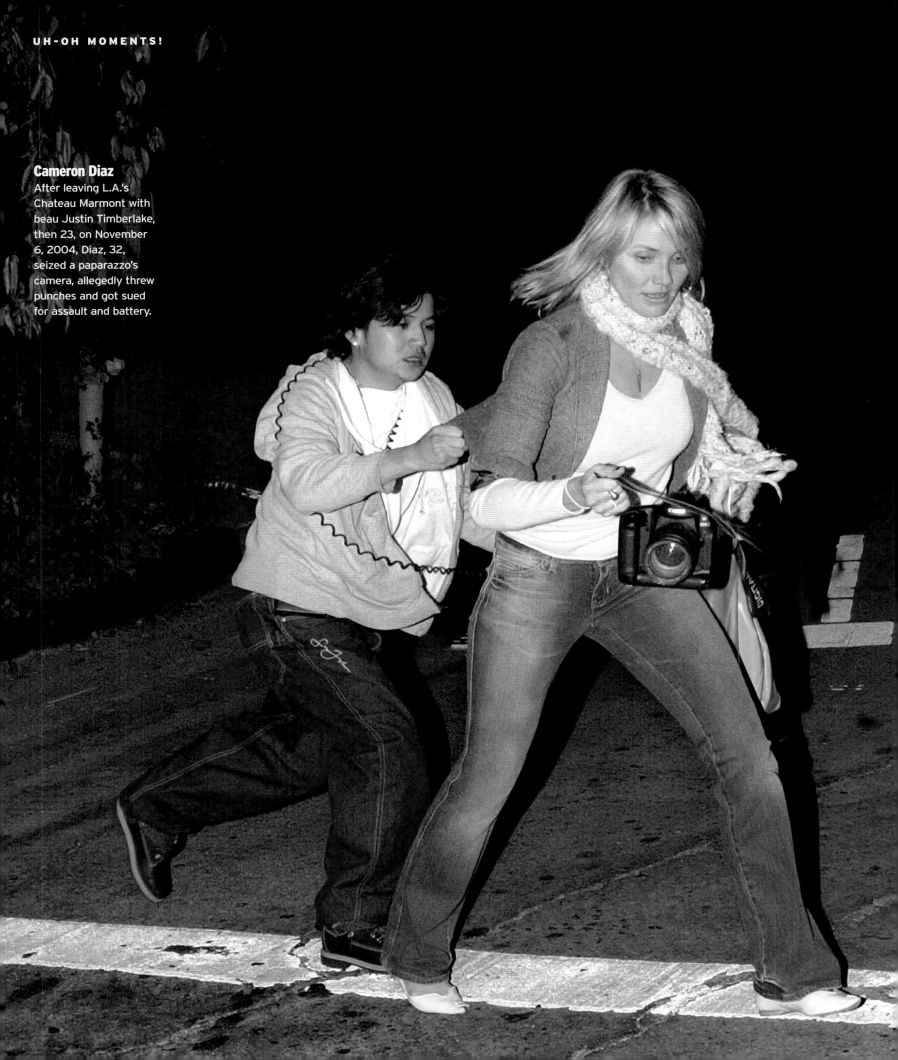

Cameron Diaz
After leaving L.A.'s Chateau Marmont with beau Justin Timberlake, then 23, on November 6, 2004, Diaz, 32, seized a paparazzo's camera, allegedly threw punches and got sued for assault and battery.

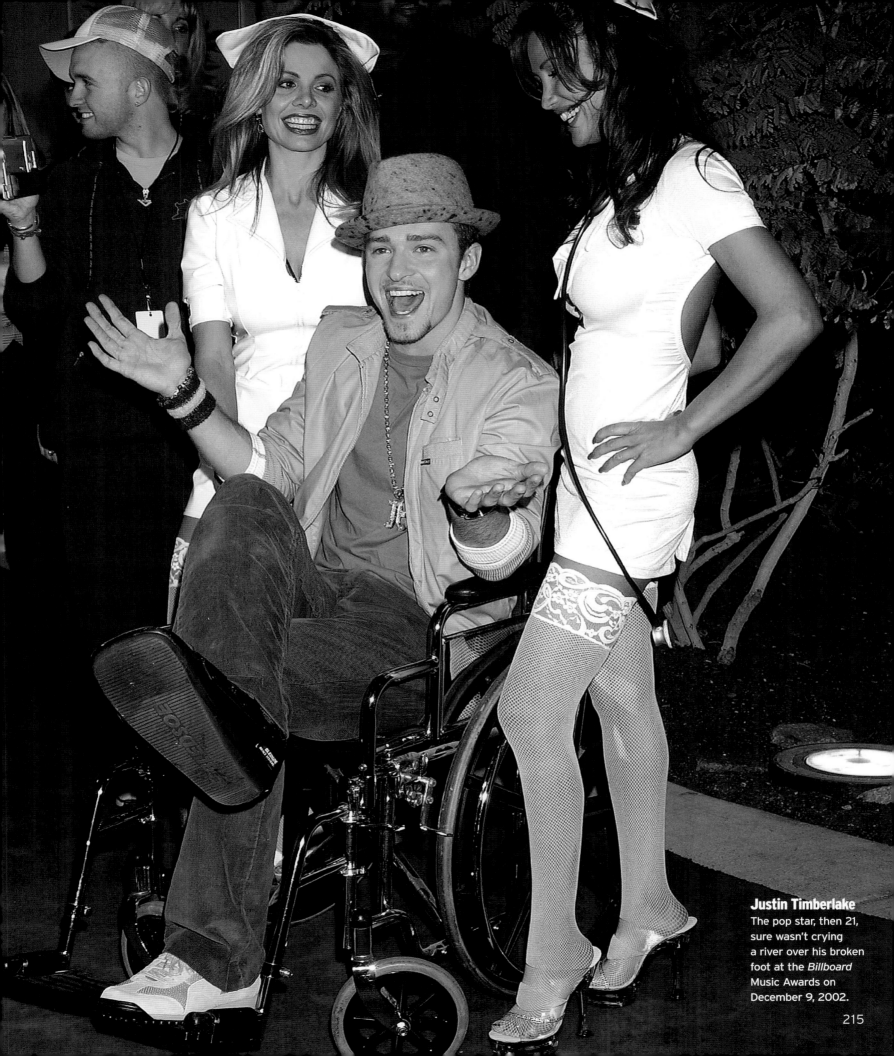

Justin Timberlake
The pop star, then 21, sure wasn't crying a river over his broken foot at the *Billboard* Music Awards on December 9, 2002.

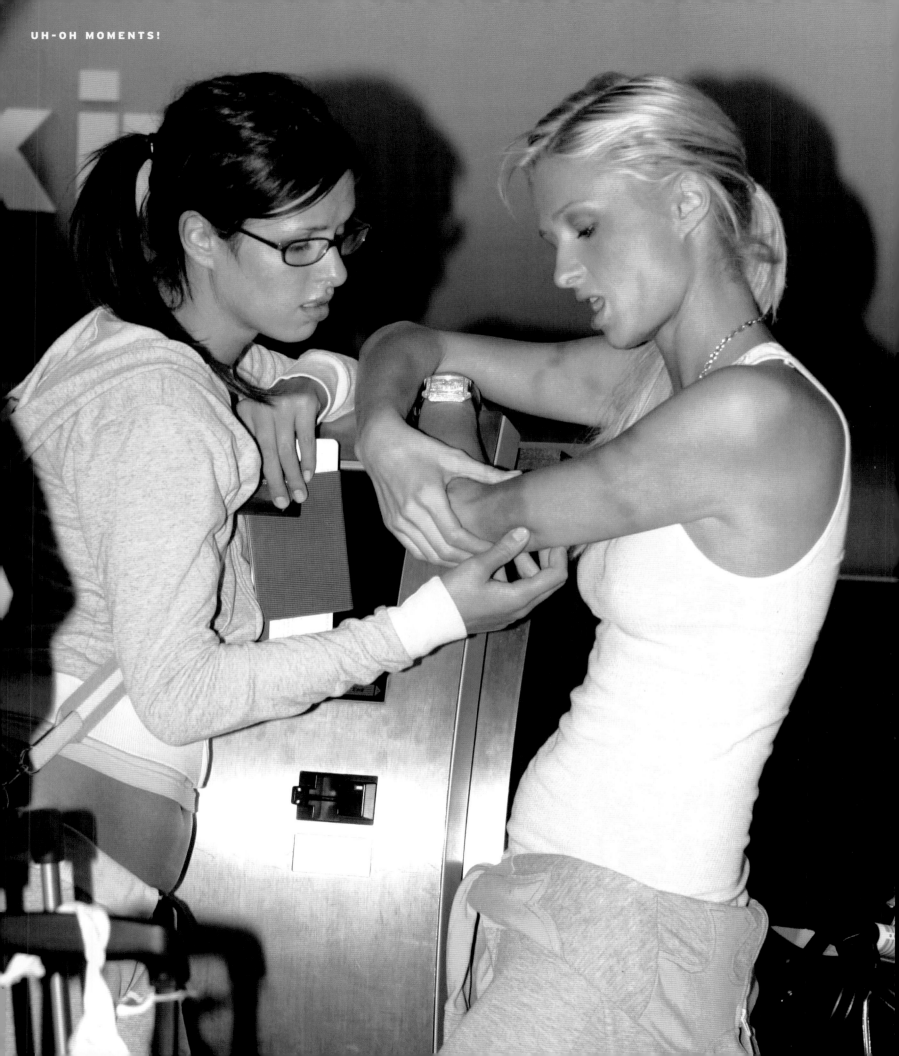

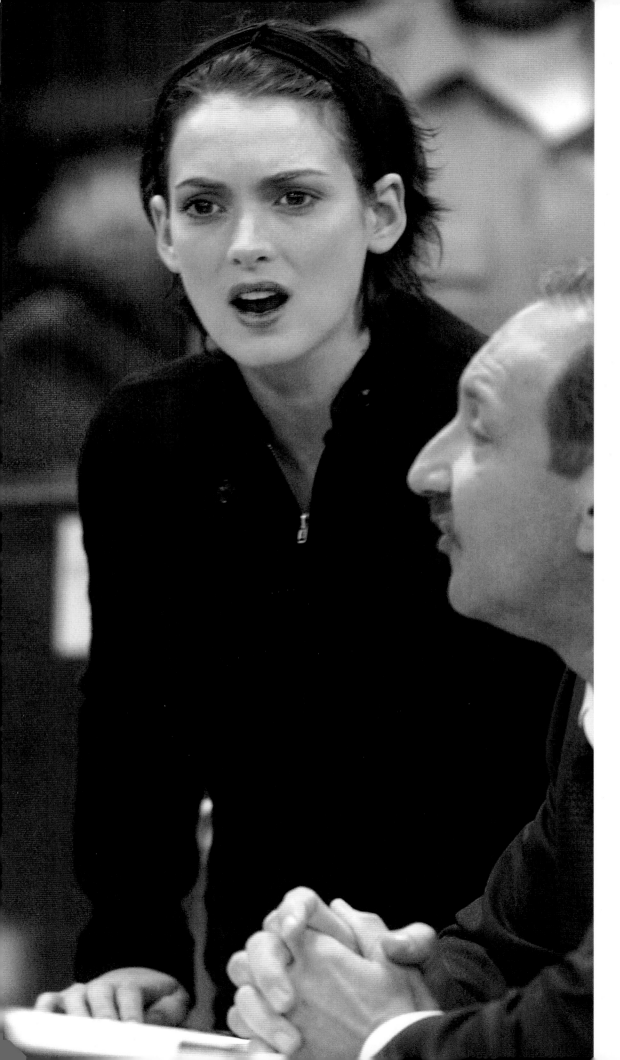

Nicky & Paris Hilton
OPPOSITE: Paris, then 23, showed sister Nicky, 20, her bruised arm in L.A. on July 29, 2004. Rumors flew that then-boyfriend Nick Carter, 24, was to blame — but he denied it.

Winona Ryder
THIS PAGE: Reality bit at the Beverly Hills Municipal Courthouse on December 6, 2002, when the actress, then 31, was found guilty of shoplifting $6,355 worth of merchandise from Saks Fifth Avenue.

217

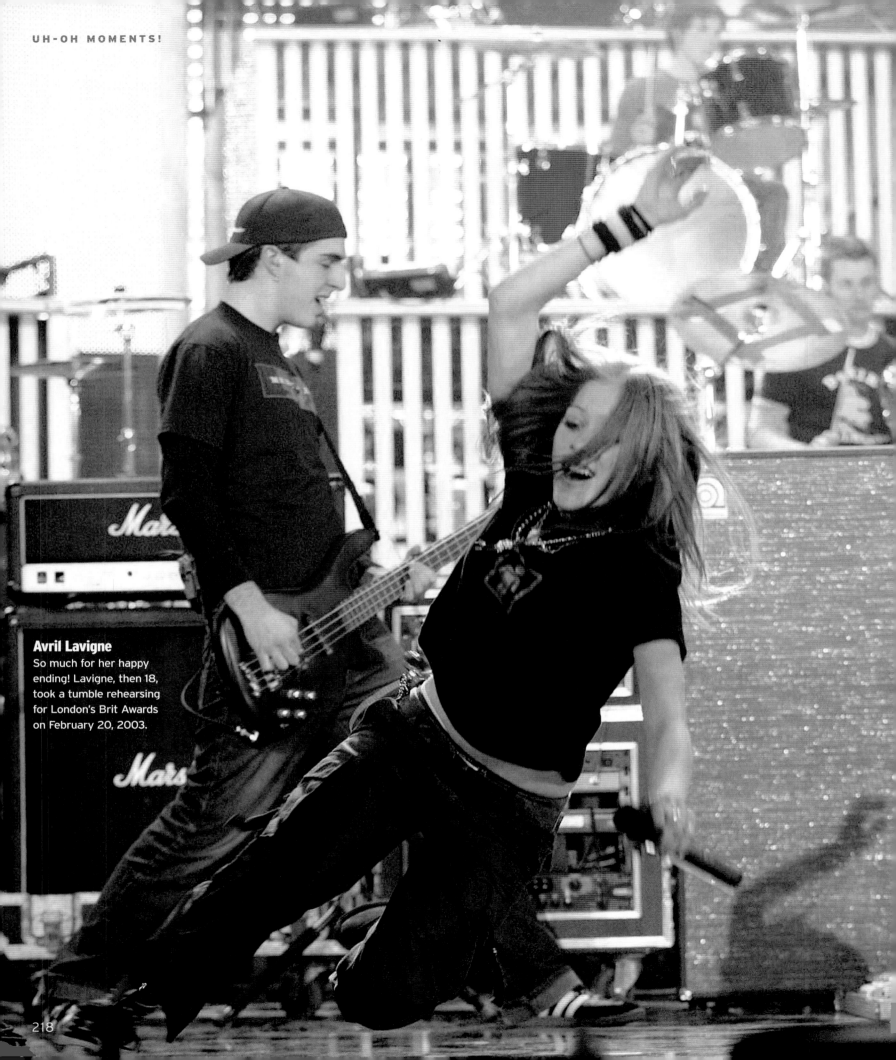

Avril Lavigne
So much for her happy ending! Lavigne, then 18, took a tumble rehearsing for London's Brit Awards on February 20, 2003.

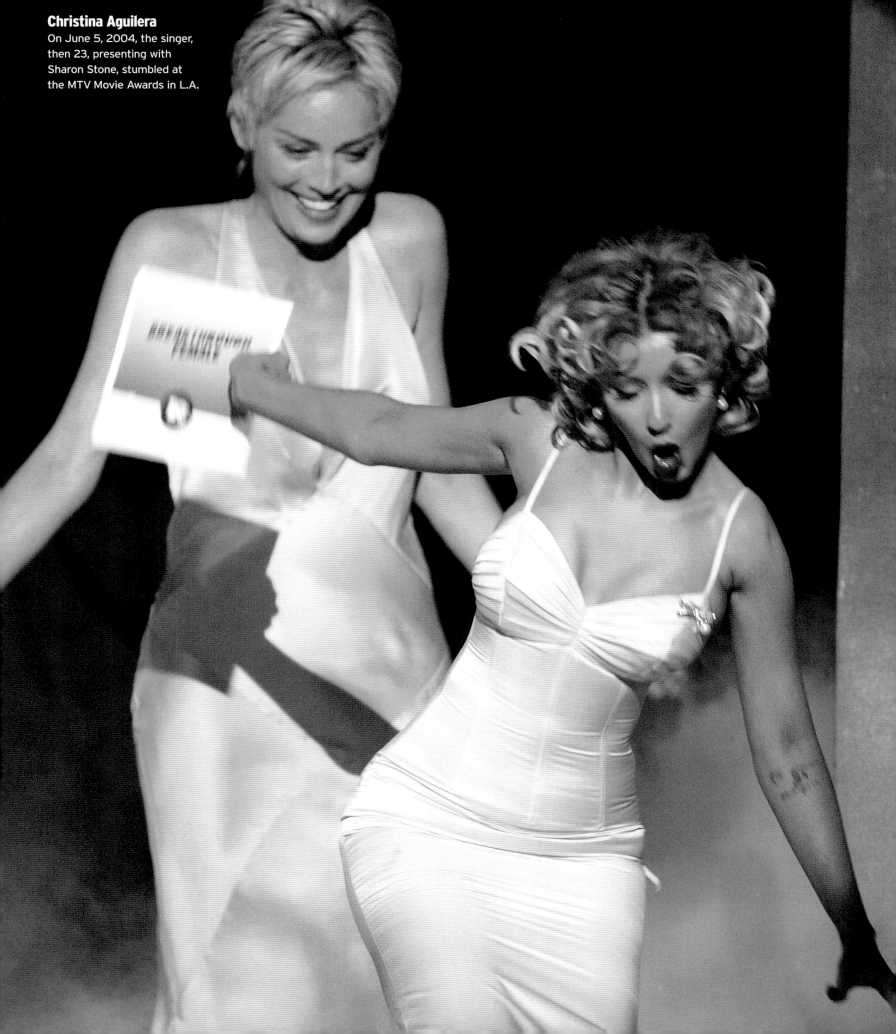

Christina Aguilera
On June 5, 2004, the singer, then 23, presenting with Sharon Stone, stumbled at the MTV Movie Awards in L.A.

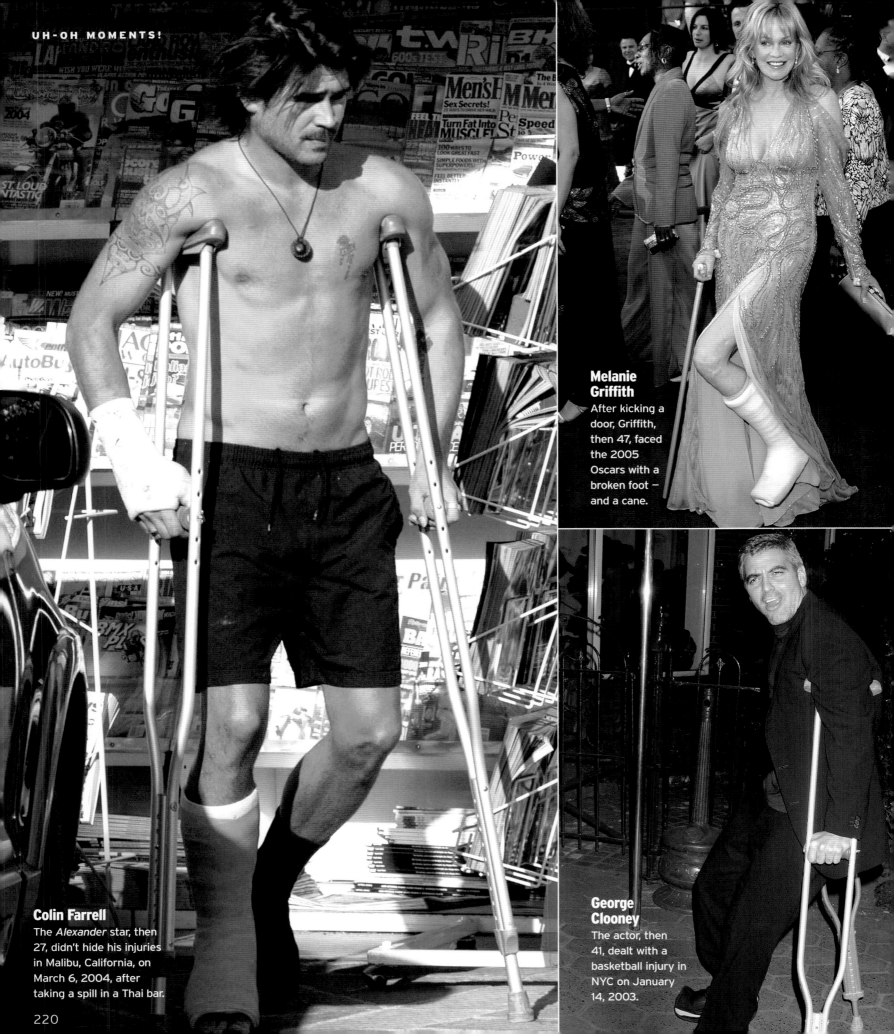

Colin Farrell
The *Alexander* star, then 27, didn't hide his injuries in Malibu, California, on March 6, 2004, after taking a spill in a Thai bar.

Melanie Griffith
After kicking a door, Griffith, then 47, faced the 2005 Oscars with a broken foot — and a cane.

George Clooney
The actor, then 41, dealt with a basketball injury in NYC on January 14, 2003.

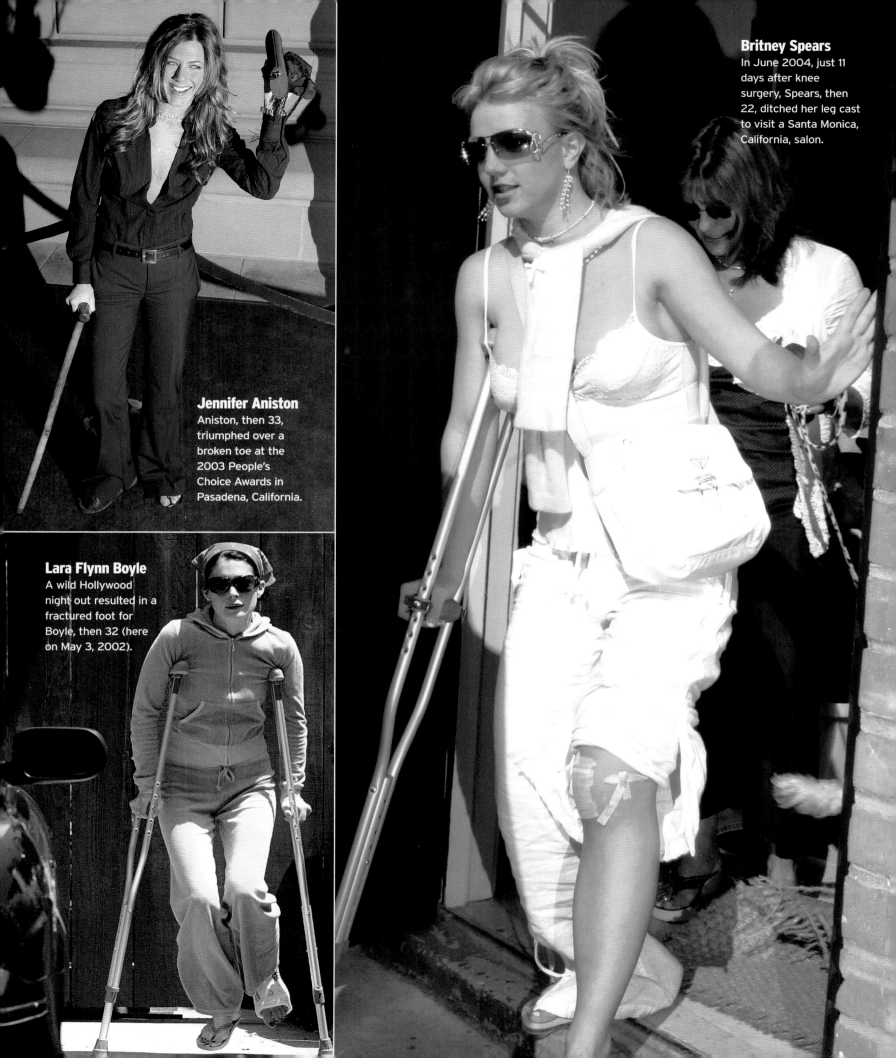

Jennifer Aniston
Aniston, then 33, triumphed over a broken toe at the 2003 People's Choice Awards in Pasadena, California.

Lara Flynn Boyle
A wild Hollywood night out resulted in a fractured foot for Boyle, then 32 (here on May 3, 2002).

Britney Spears
In June 2004, just 11 days after knee surgery, Spears, then 22, ditched her leg cast to visit a Santa Monica, California, salon.

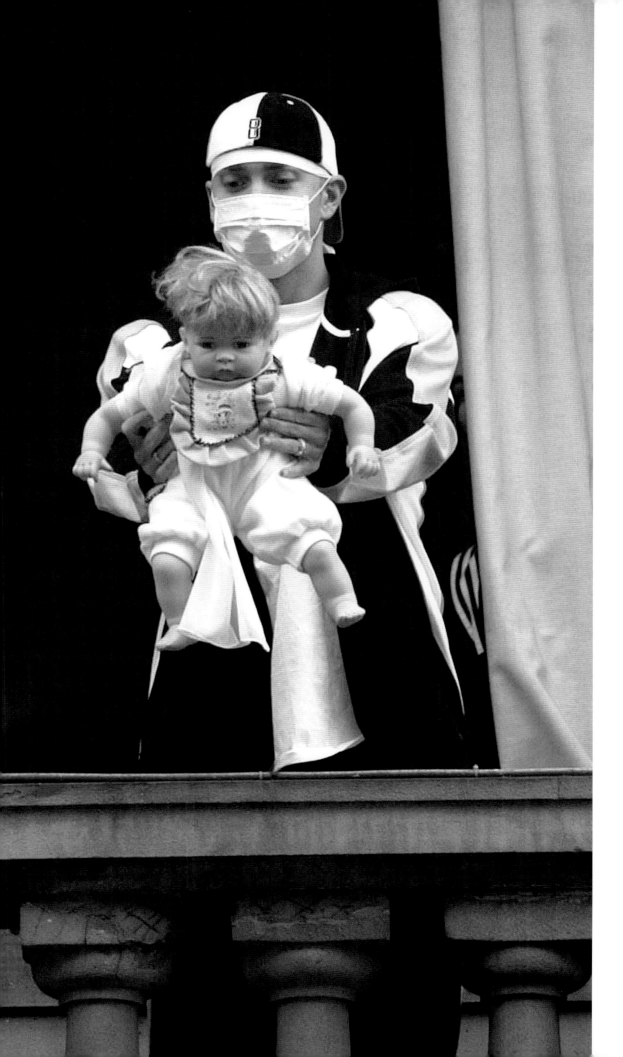

Michael Jackson
OPPOSITE: "[The fans] were chanting they wanted to see the baby," Jackson, then 44, has said of dangling 9-month-old son Prince Michael II from his Berlin hotel balcony on November 19, 2002.

Eminem
THIS PAGE: On tour in Glasgow, Scotland, the rapper, then 30, spoofed Jackson's baby-dangling scandal with a doll on June 24, 2003.

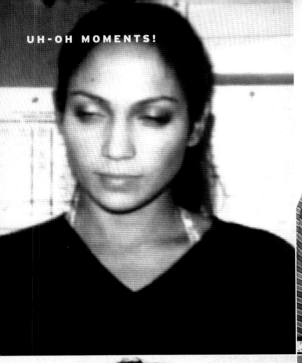

UH-OH MOMENTS!

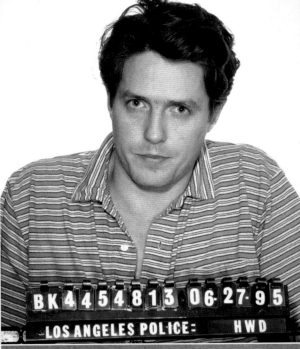

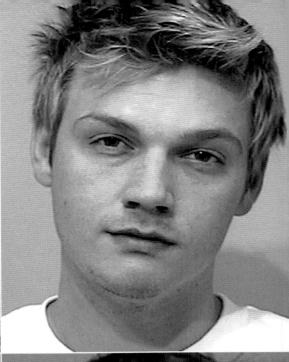

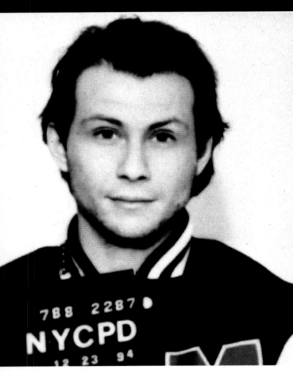

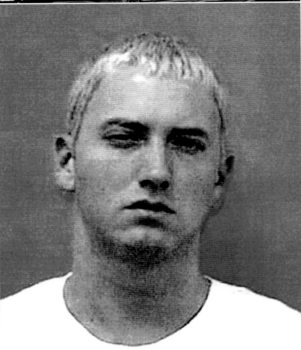

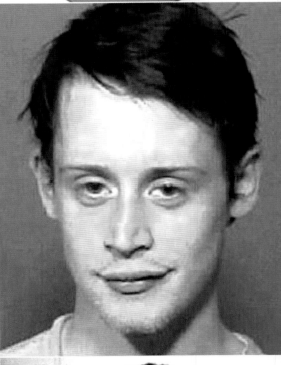

BK4454813 06-27-95
LOS ANGELES POLICE: HWD

788 2287
NYCPD
12 23 94

CLOCKWISE FROM TOP LEFT:
Jennifer Lopez, 1999: Arrested for criminal possession of a gun in connection with nightclub shooting; no charges brought
Hugh Grant, 1995: Lewd conduct; no contest
Nick Carter, 2005: Arrested for DWI; charges pending at press time
Macaulay Culkin, 2004: Charged with drug possession; pleaded not guilty, charges pending at press time
Paul Reubens (Pee-wee Herman), 1991: Charged with indecent exposure; no contest
Yasmine Bleeth, 2001: Cocaine possession; pleaded guilty
Christian Slater, 1994: Unlawful weapons possession; spent a night in jail
Eminem, 2000: Gun possession; sentenced to community service and a year's probation

SARASOTA COUNTY
SHERIFF'S DEPARTMENT

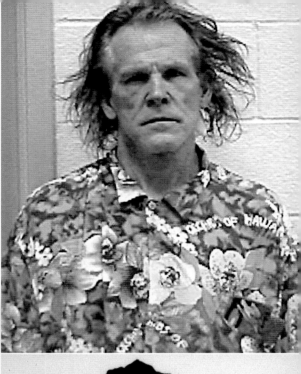
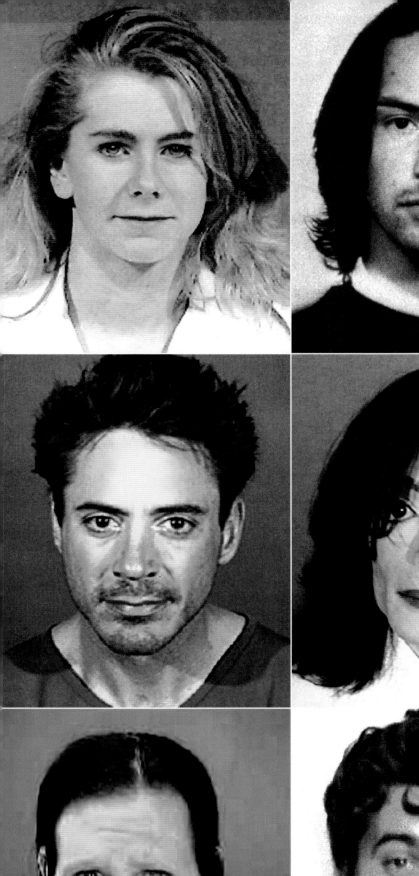
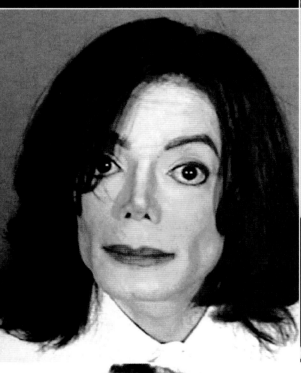
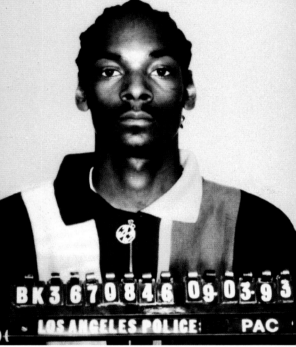

CLOCKWISE FROM TOP LEFT:

Tonya Harding, 1994: Conspiring to hinder prosecution; pleaded guilty

Keanu Reeves, 1993: Reckless driving; found guilty

Nick Nolte, 2002: DUI; no contest

Snoop Doggy Dogg, 1993: Accomplice to murder; acquitted

Joshua Jackson, 2002: Drunk and disruptive conduct; entered alcohol-abuse program

Marilyn Manson, 2001: Criminal sexual misconduct; no contest

Robert Downey Jr., 2001: Suspicion of being under influence of drugs; sentenced to rehab

Michael Jackson, 2003: Child molestation; pleaded not guilty, to trial in 2005

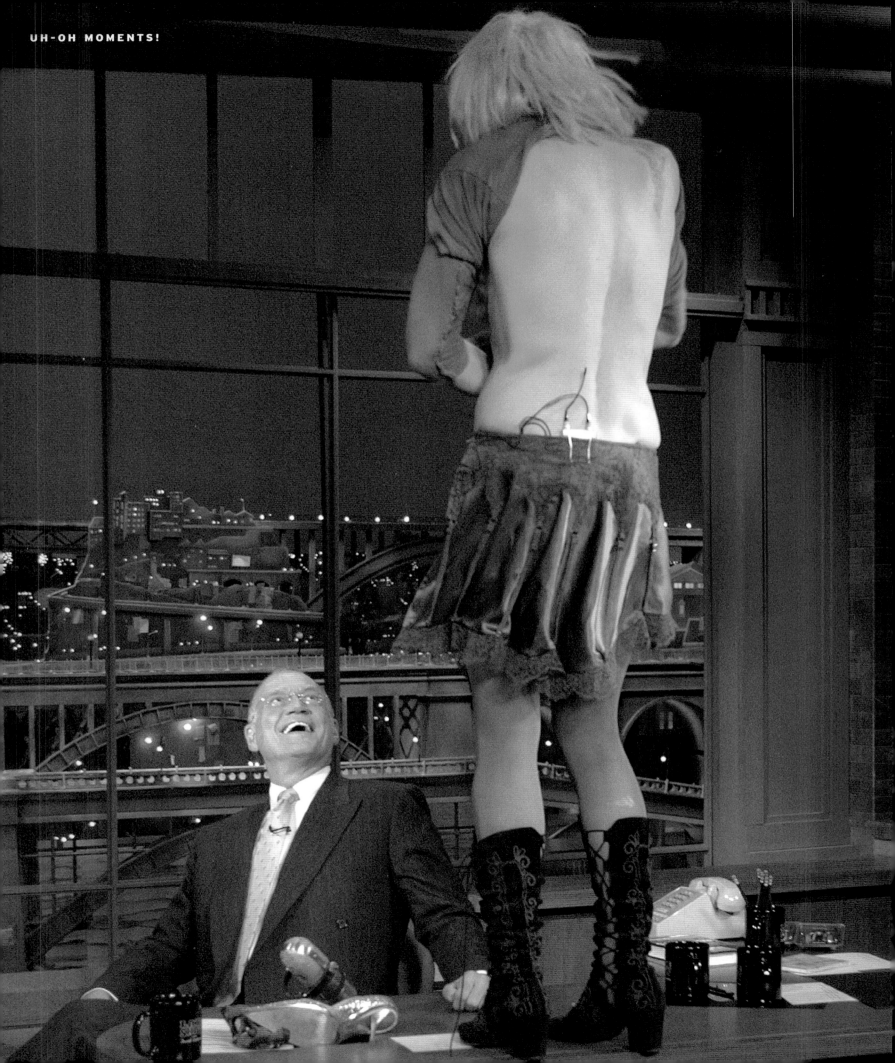

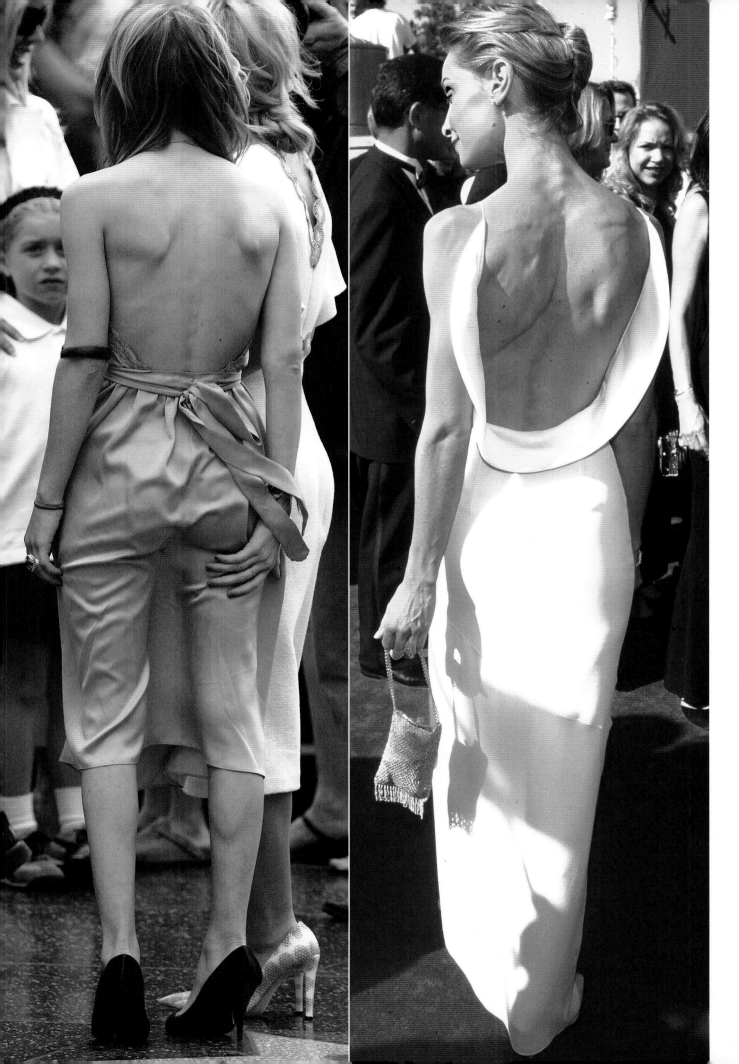

Courtney Love

OPPOSITE: David Letterman got a full-frontal view when Love, then 39, flashed him during her March 17, 2004, *Late Show* appearance.

Mary-Kate Olsen

THIS PAGE, LEFT: The actress, then 17, was alarmingly thin on April 29, 2004, when she and twin Ashley received a star on the Hollywood Walk of Fame. Less than two months later, she began treatment for anorexia.

Calista Flockhart

THIS PAGE, RIGHT: A shockingly skinny Flockhart, then 33, appeared in a backless Richard Tyler gown at the Emmy Awards on September 13, 1998.

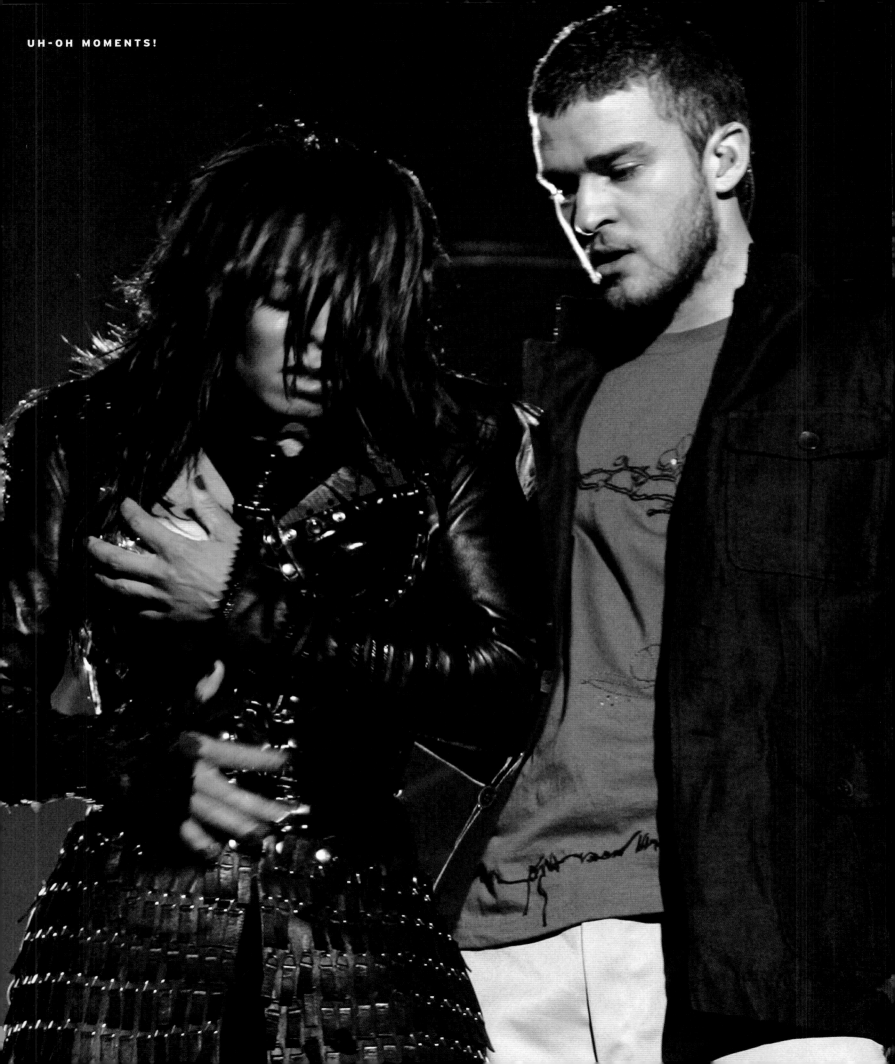

CENSORED BY *US*

Janet Jackson & Justin Timberlake
OPPOSITE: The world's most-watched "wardrobe malfunction" aired during the February 1, 2004, Super Bowl halftime show. Timberlake later apologized, and Jackson issued a statement of regret.

Tara Reid
THIS PAGE: Reid, then 28, set flashbulbs aflutter when she unknowingly exposed her breast at P. Diddy's birthday bash in New York City on November 4, 2004.

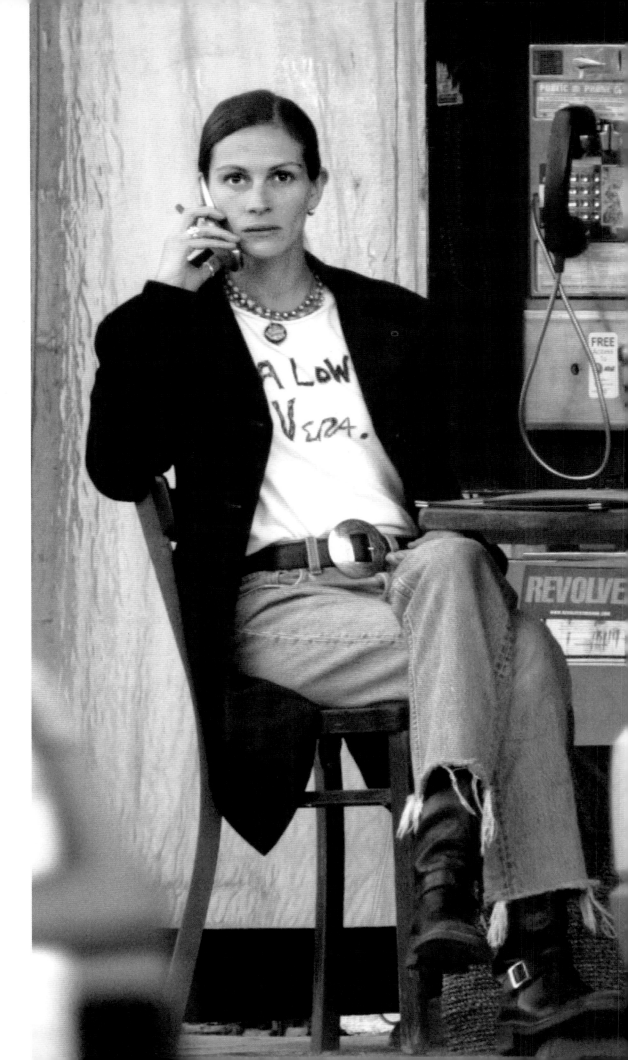

Julia Roberts
THIS PAGE: Sipping coffee at a cafe in West Hollywood on March 22, 2002, Roberts, then 34, sent a message to then-boyfriend Danny Moder's soon-to-be ex-wife, Vera Steimberg.

Britney Spears
OPPOSITE, TOP LEFT: In London on March 2, 2003, after her split from Justin Timberlake, Spears, then 21, had a suggestion for his new love, Alyssa Milano.

Lindsay Lohan
OPPOSITE, TOP RIGHT: In L.A. on December 19, 2004, Lohan, then 18, poked fun at reports of her drastic weight loss.

Naomi Campbell
OPPOSITE, BOTTOM LEFT: Campbell, then 34, proved she could take a joke about her fiery reputation in New York on February 11, 2005. The back of the shirt read: . . . AND I LIKED IT!

Madonna
OPPOSITE, BOTTOM RIGHT: Leaving L.A.'s Kabbalah Centre on May 15, 2004, the movement's best-known enthusiast, then 45, had a giggle at her own expense.

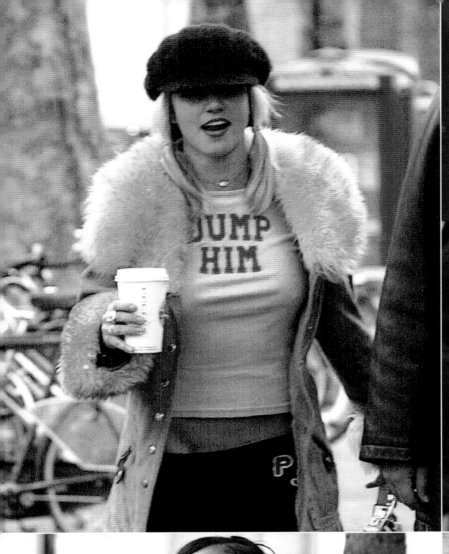

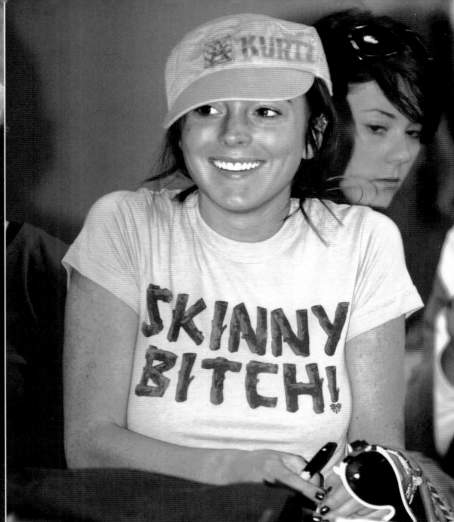

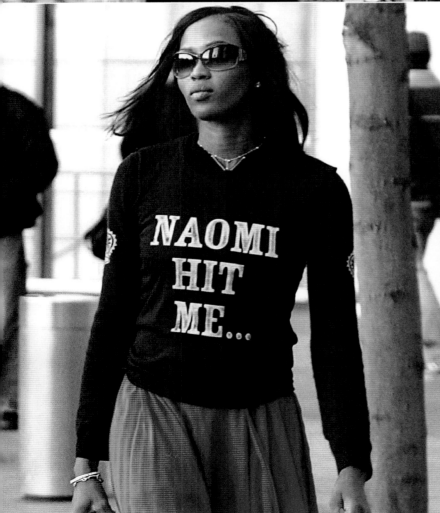

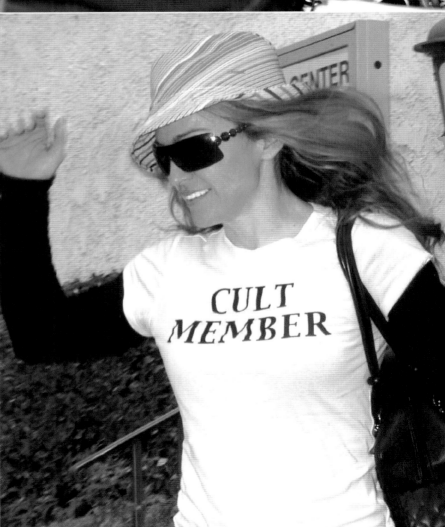

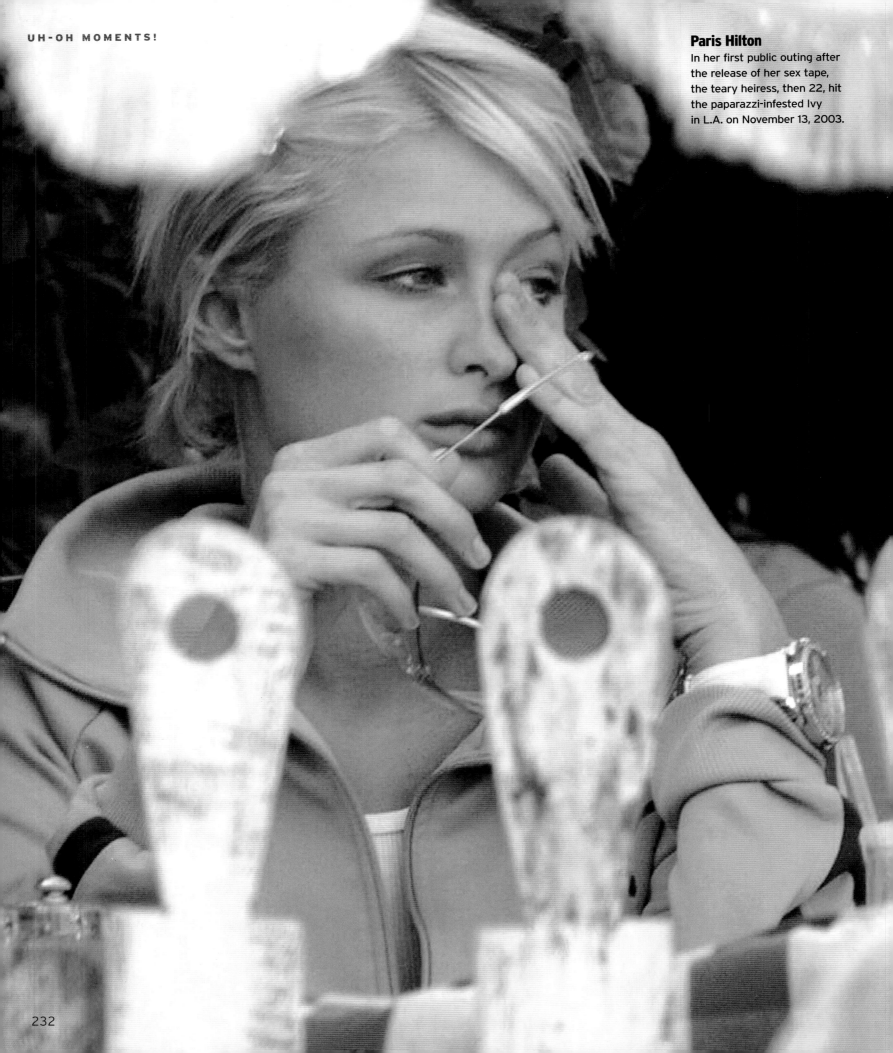

Paris Hilton
In her first public outing after the release of her sex tape, the teary heiress, then 22, hit the paparazzi-infested Ivy in L.A. on November 13, 2003.

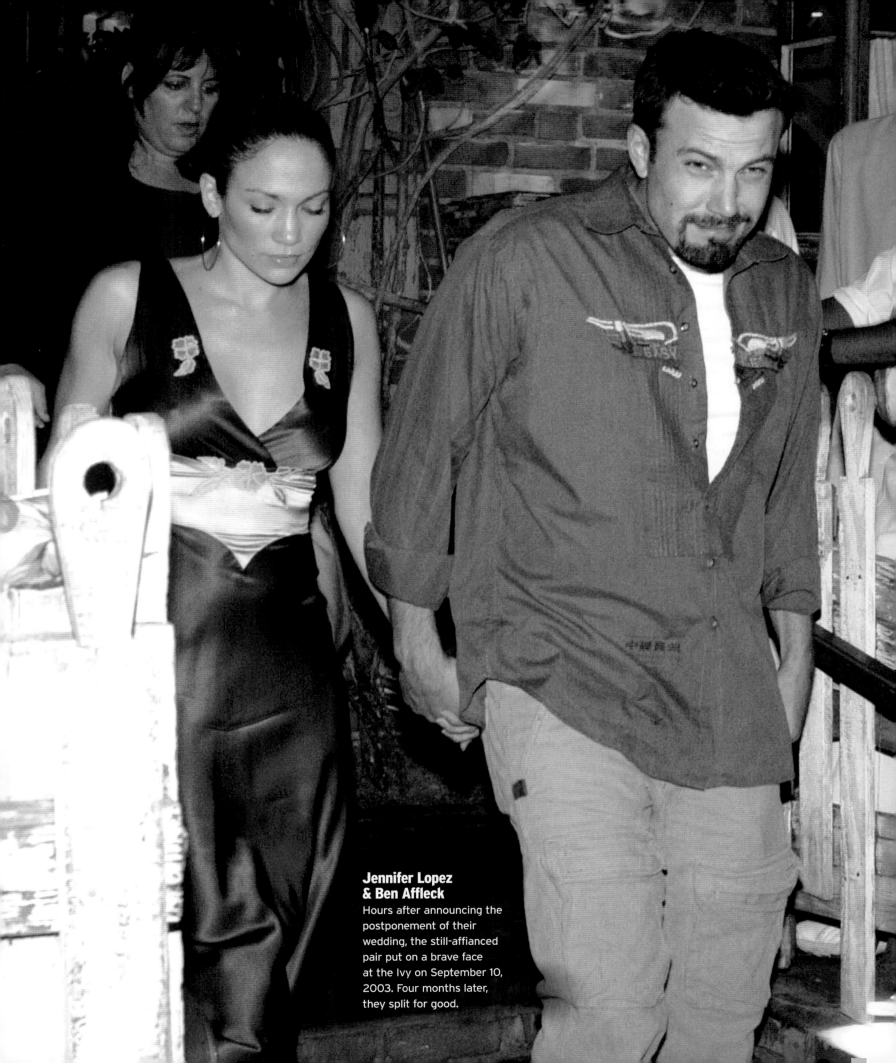

Jennifer Lopez & Ben Affleck
Hours after announcing the postponement of their wedding, the still-affianced pair put on a brave face at the Ivy on September 10, 2003. Four months later, they split for good.

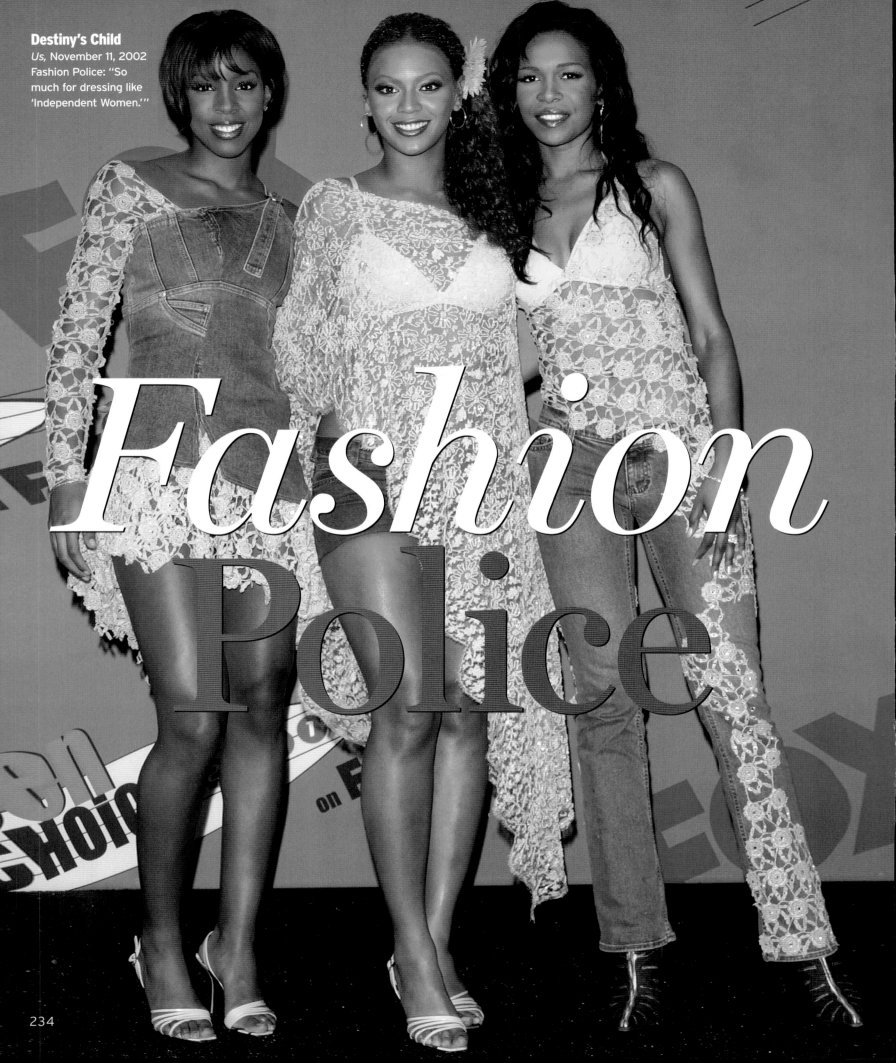

Destiny's Child
Us, November 11, 2002
Fashion Police: "So much for dressing like 'Independent Women.'"

Fashion Police

234

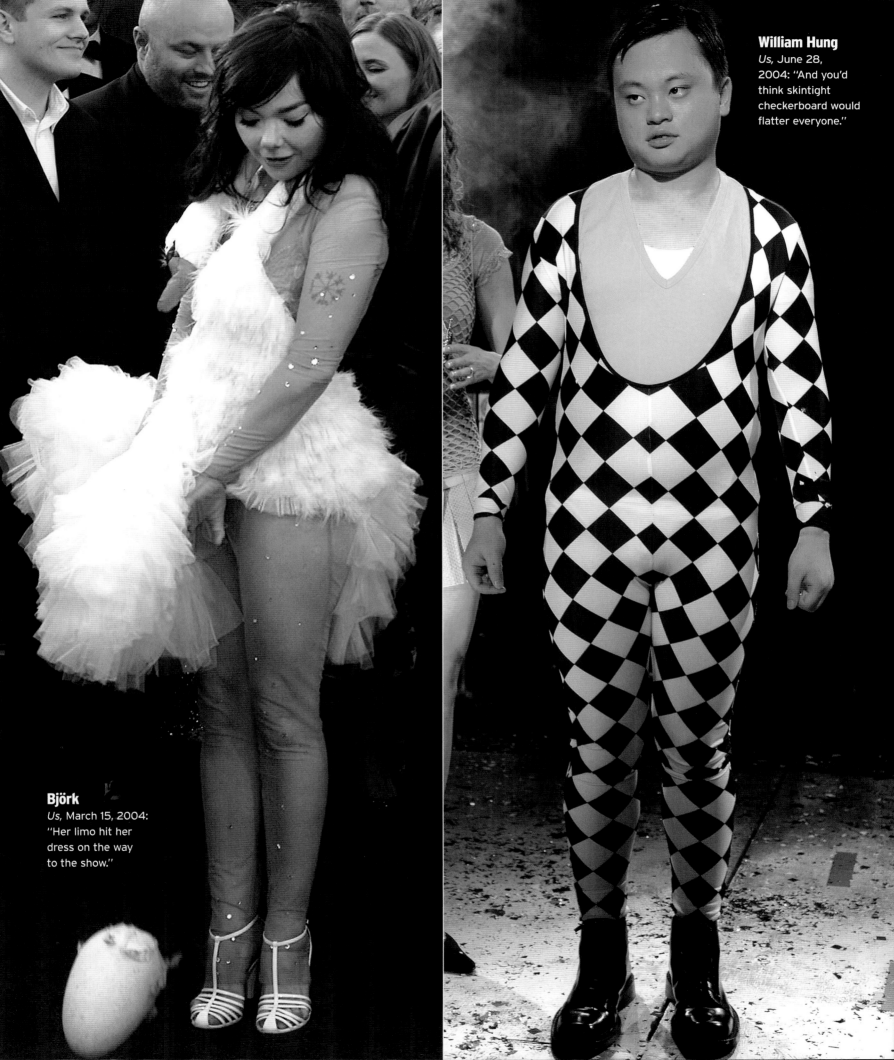

Björk
Us, March 15, 2004: "Her limo hit her dress on the way to the show."

William Hung
Us, June 28, 2004: "And you'd think skintight checkerboard would flatter everyone."

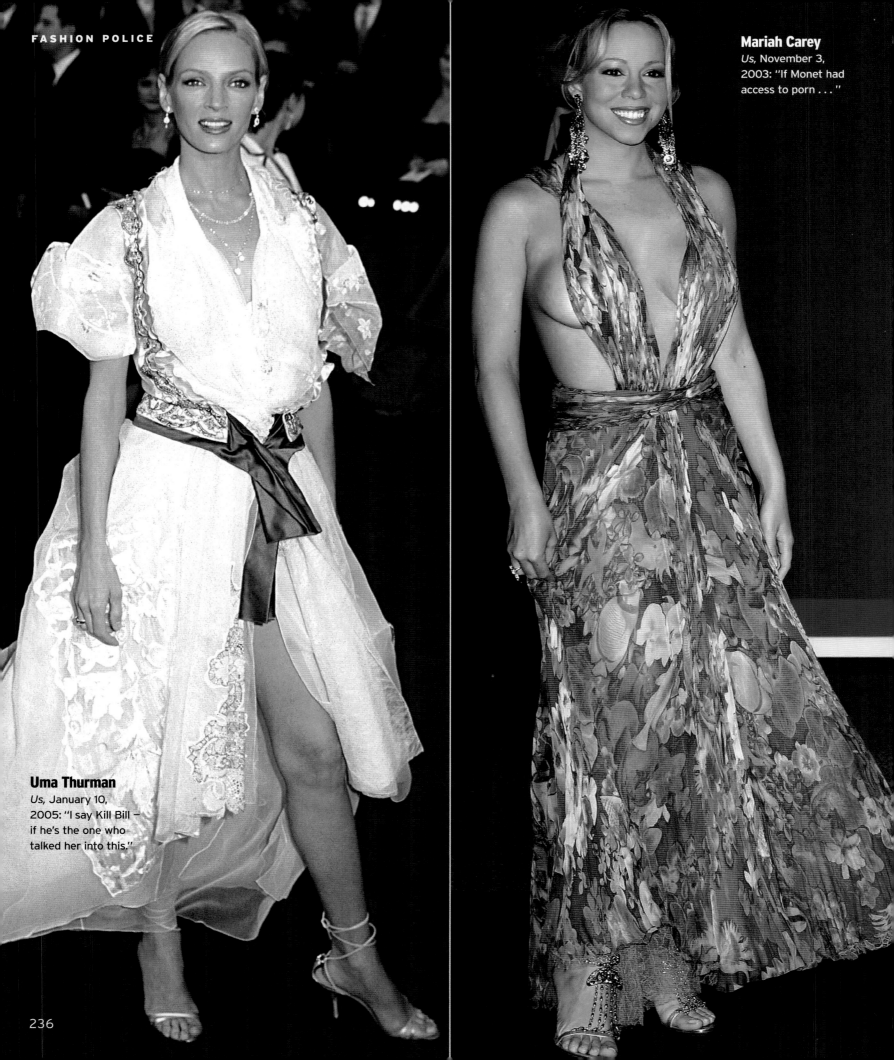

Mariah Carey
Us, November 3, 2003: "If Monet had access to porn . . ."

Uma Thurman
Us, January 10, 2005: "I say Kill Bill — if he's the one who talked her into this."

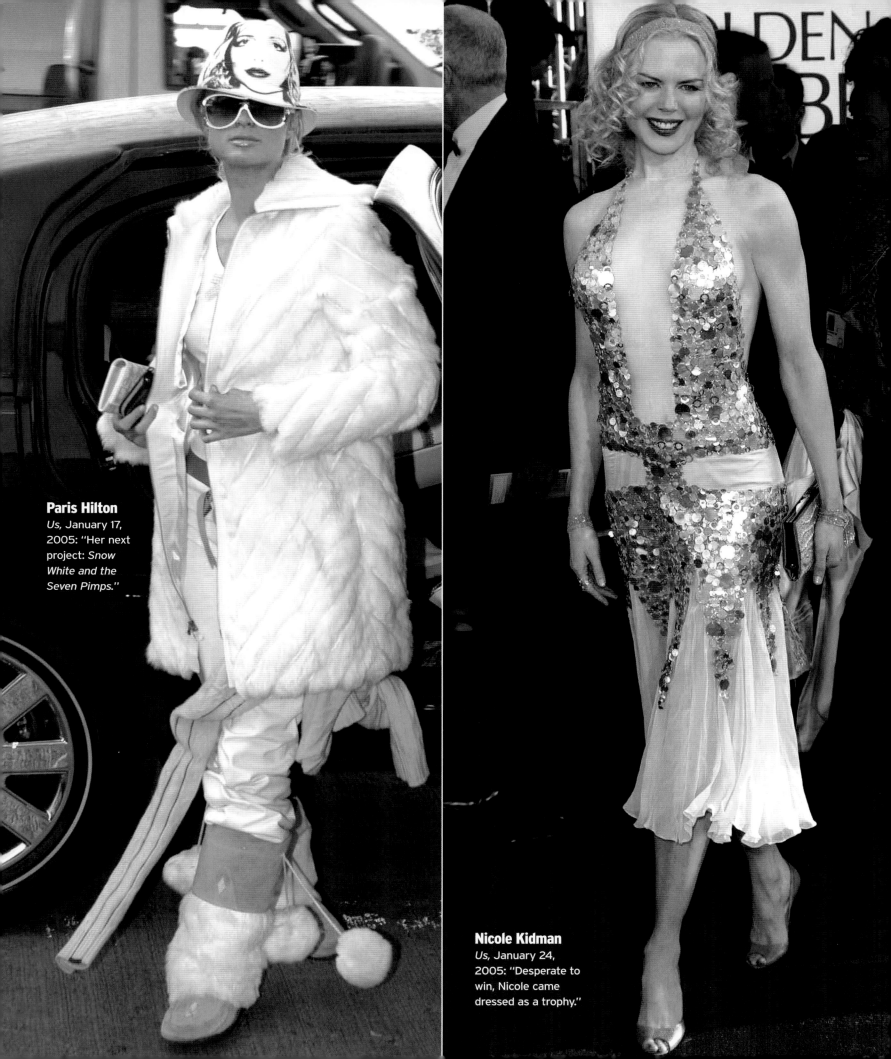

Paris Hilton
Us, January 17, 2005: "Her next project: *Snow White and the Seven Pimps.*"

Nicole Kidman
Us, January 24, 2005: "Desperate to win, Nicole came dressed as a trophy."

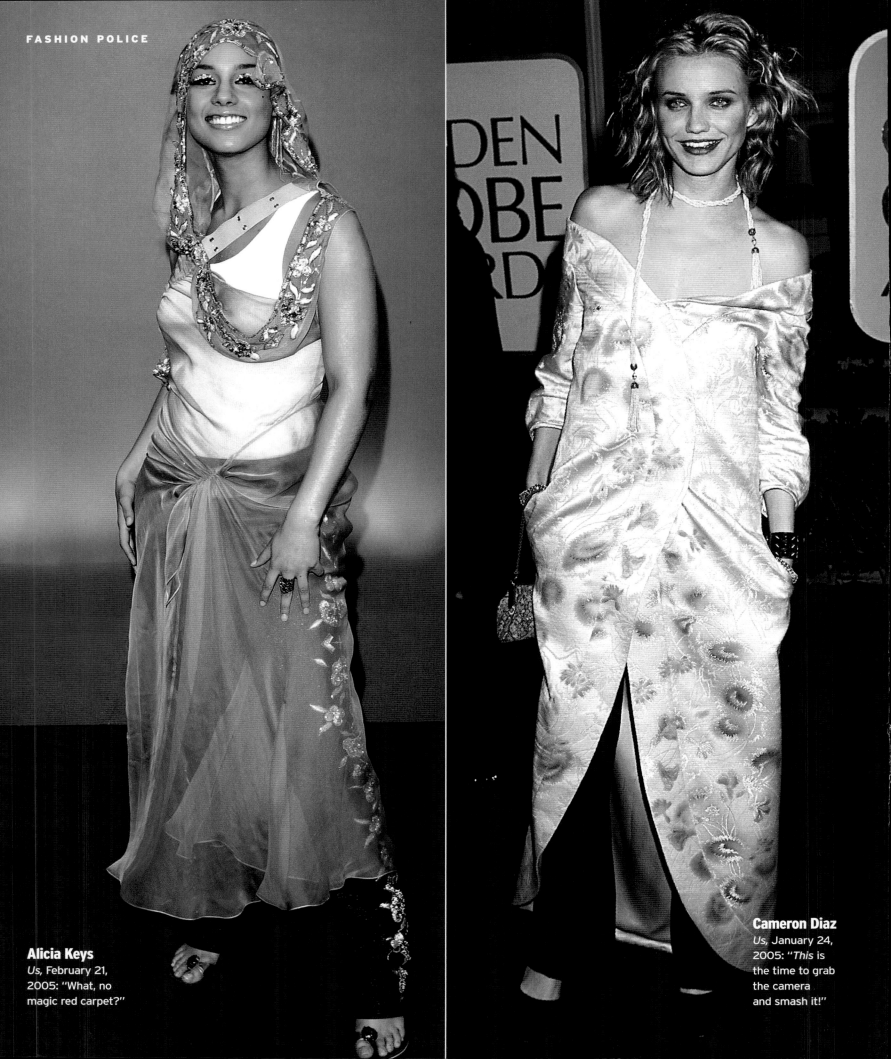

Alicia Keys
Us, Februion 21, 2005: "What, no magic red carpet?"

Cameron Diaz
Us, January 24, 2005: "*This* is the time to grab the camera and smash it!"

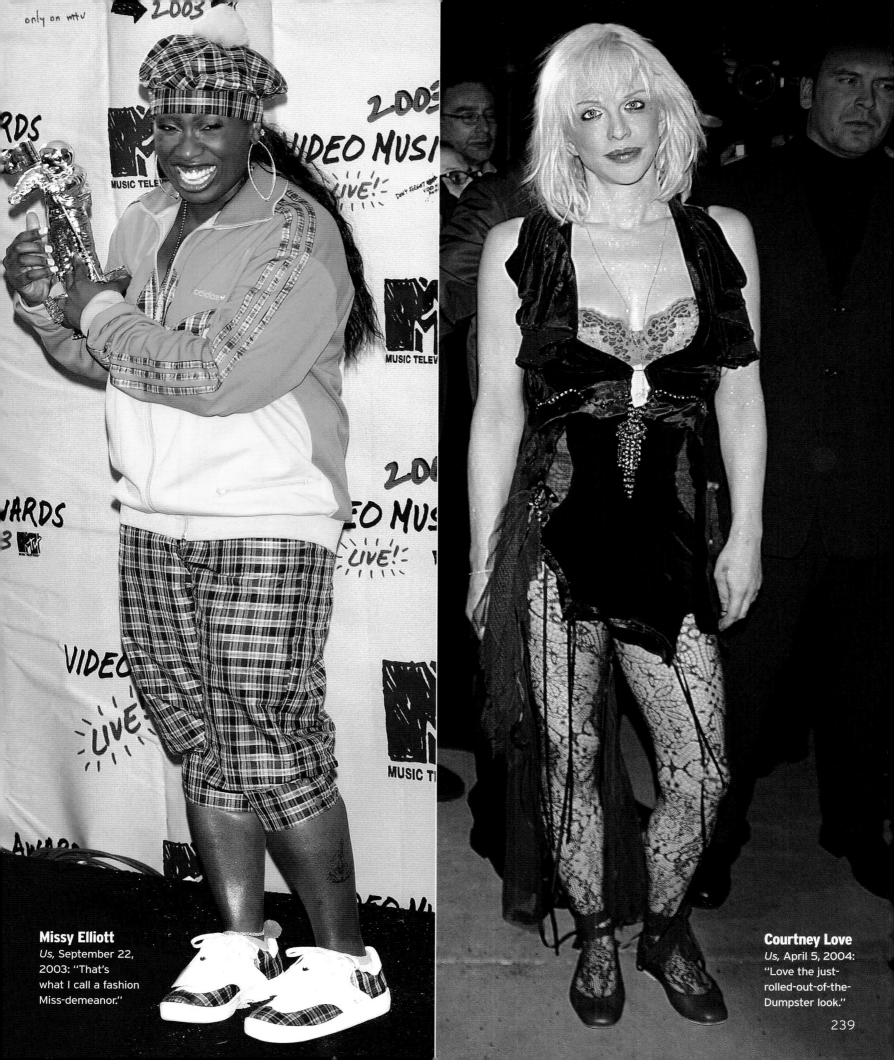

Missy Elliott
Us, September 22, 2003: "That's what I call a fashion Miss-demeanor."

Courtney Love
Us, April 5, 2004: "Love the just-rolled-out-of-the-Dumpster look."

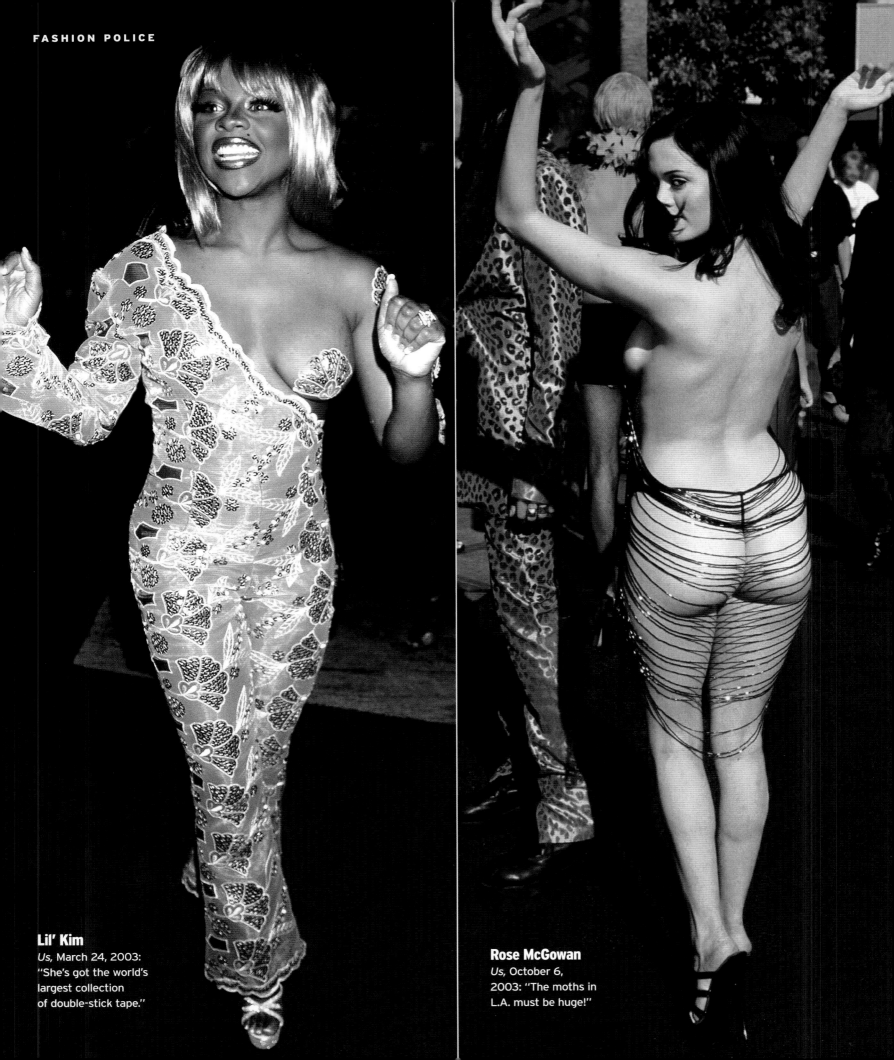

Lil' Kim
Us, March 24, 2003:
"She's got the world's
largest collection
of double-stick tape."

Rose McGowan
Us, October 6,
2003: "The moths in
L.A. must be huge!"

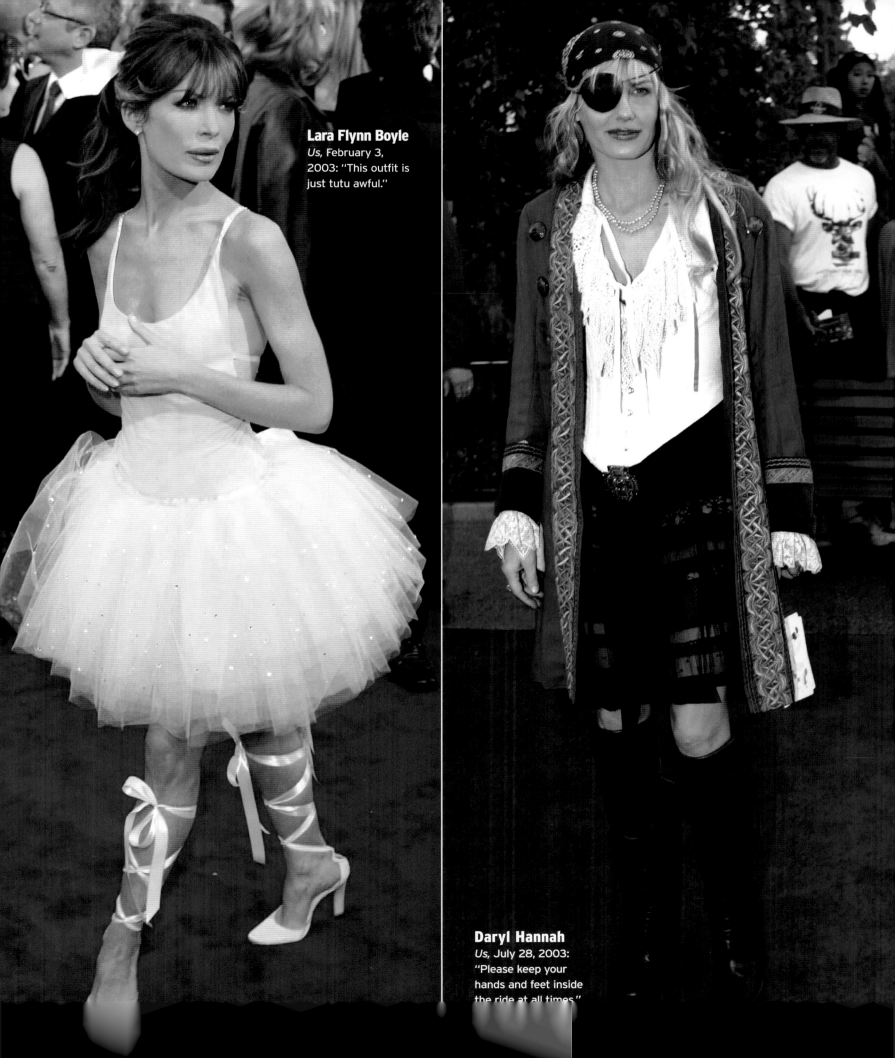

Lara Flynn Boyle
Us, February 3, 2003: "This outfit is just tutu awful."

Daryl Hannah
Us, July 28, 2003: "Please keep your hands and feet inside the ride at all times."

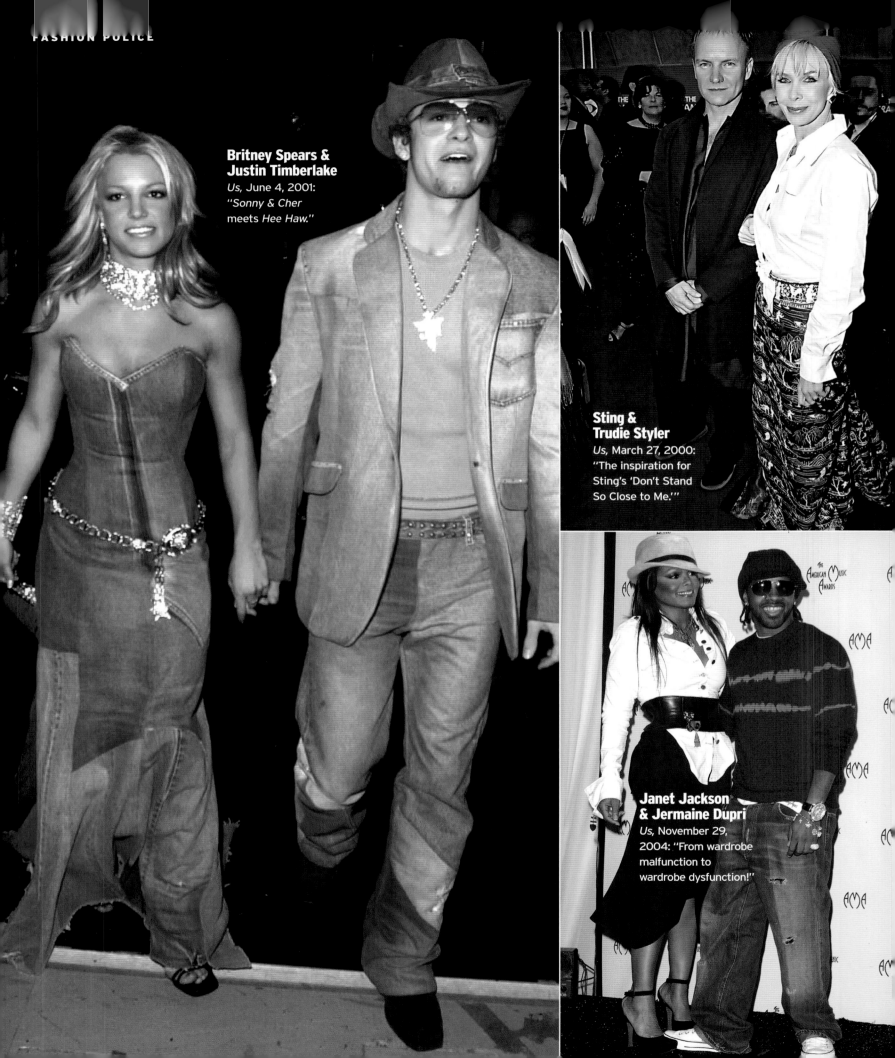

**Britney Spears &
Justin Timberlake**
Us, June 4, 2001:
"Sonny & Cher
meets *Hee Haw*."

**Sting &
Trudie Styler**
Us, March 27, 2000:
"The inspiration for
Sting's 'Don't Stand
So Close to Me.'"

**Janet Jackson
& Jermaine Dupri**
Us, November 29,
2004: "From wardrobe
malfunction to
wardrobe dysfunction!"

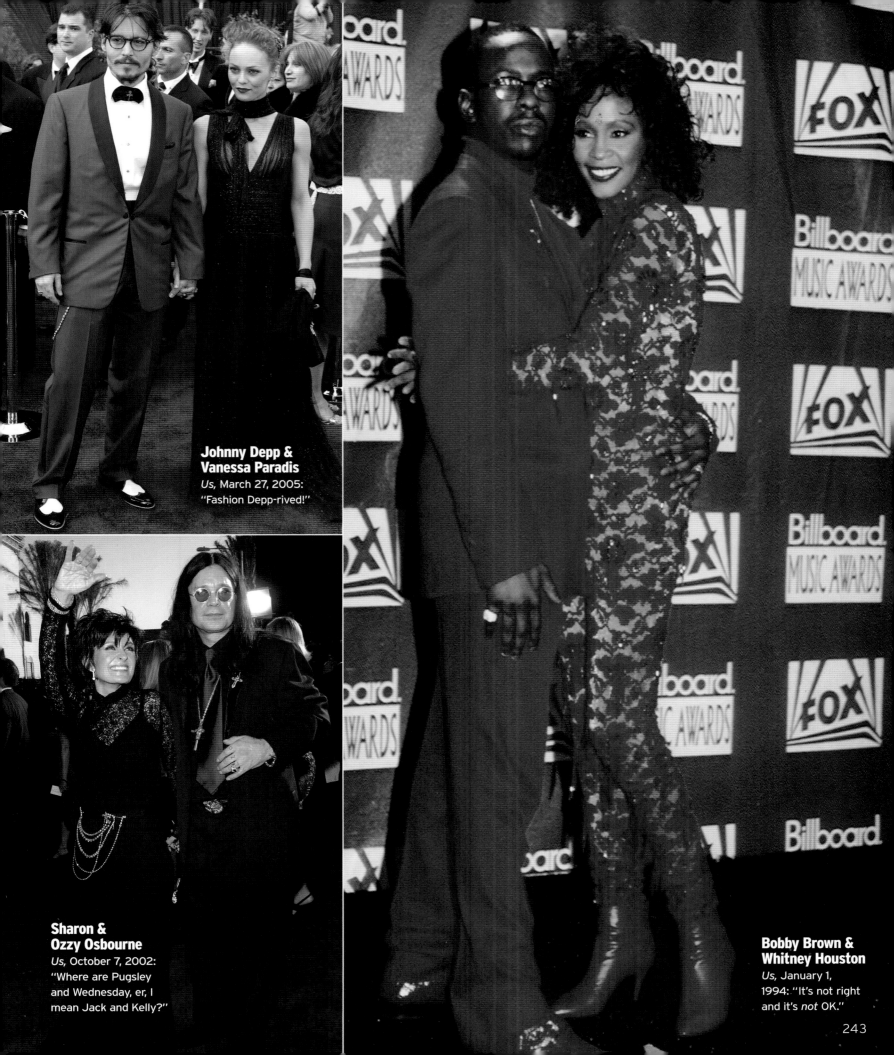

**Johnny Depp &
Vanessa Paradis**
Us, March 27, 2005:
"Fashion Depp-rived!"

**Sharon &
Ozzy Osbourne**
Us, October 7, 2002:
"Where are Pugsley
and Wednesday, er, I
mean Jack and Kelly?"

**Bobby Brown &
Whitney Houston**
Us, January 1,
1994: "It's not right
and it's *not* OK."

243

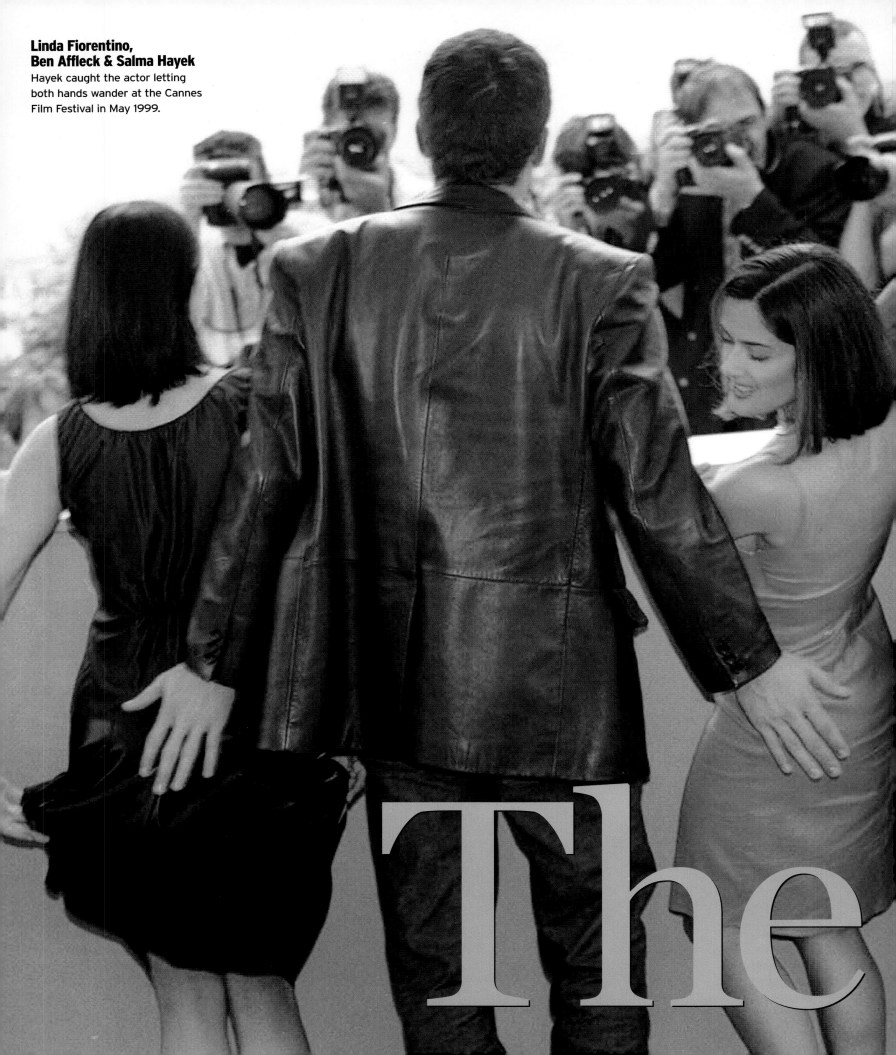

**Linda Fiorentino,
Ben Affleck & Salma Hayek**
Hayek caught the actor letting
both hands wander at the Cannes
Film Festival in May 1999.

The

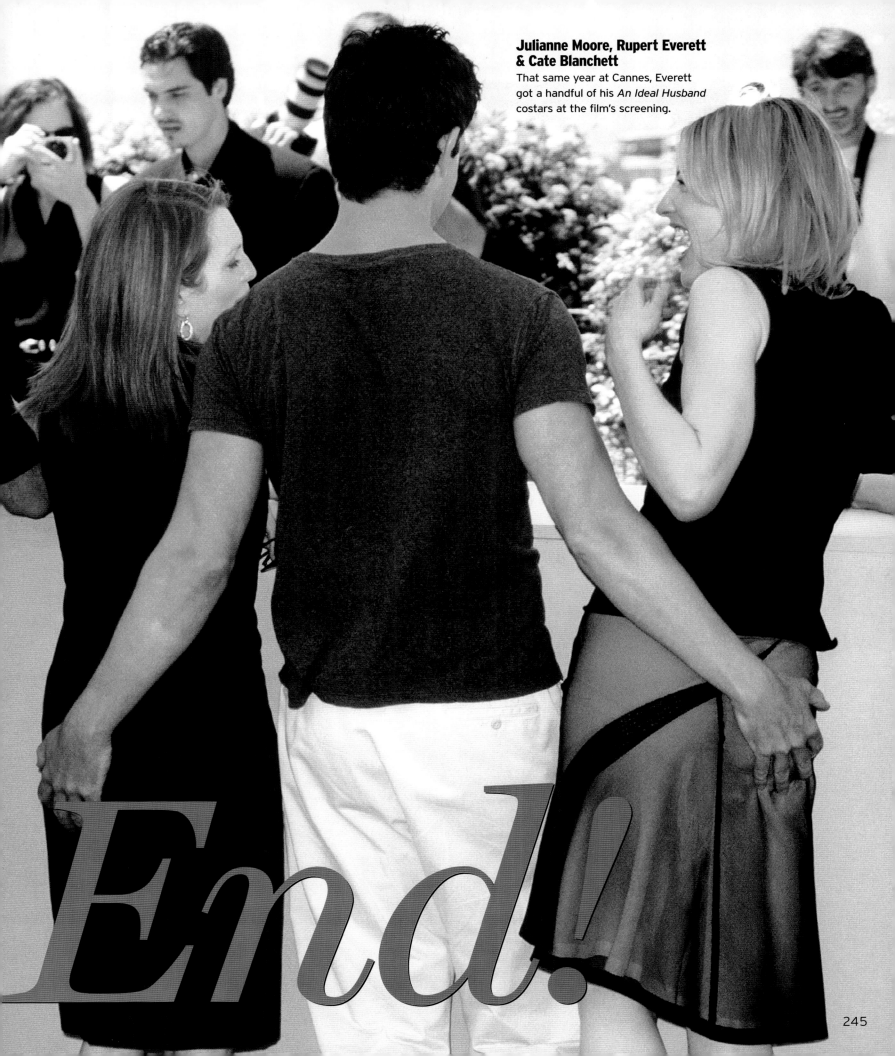

Julianne Moore, Rupert Everett & Cate Blanchett
That same year at Cannes, Everett got a handful of his *An Ideal Husband* costars at the film's screening.

End!

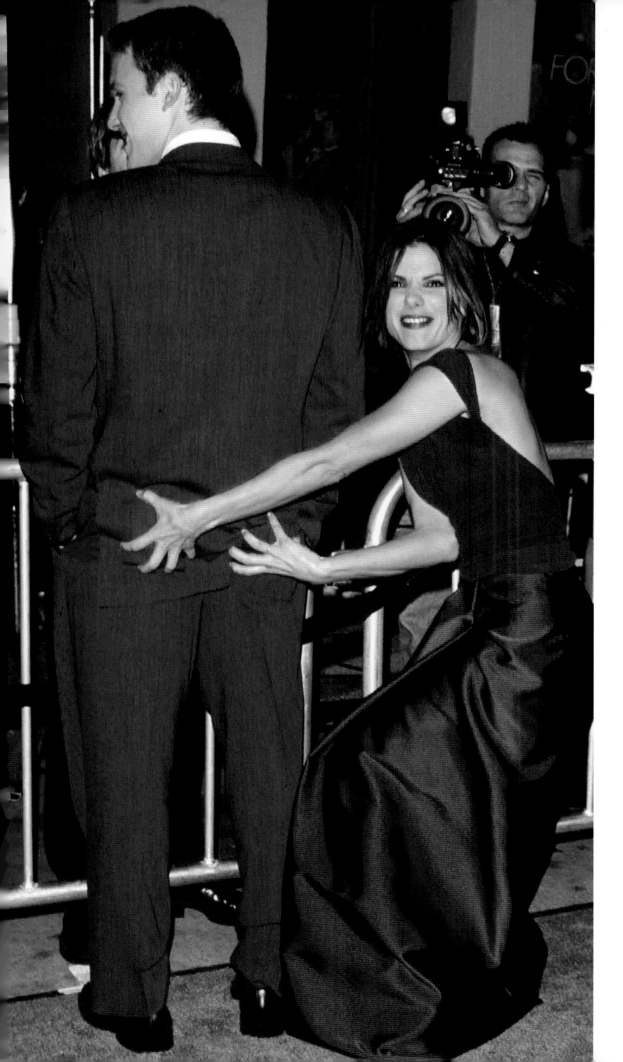

Ben Affleck & Jennifer Lopez

OPPOSITE: Affleck, 30 at the time, made the most of his then-girlfriend's famous asset on August 6, 2003, in Vancouver. Maybe he was making amends after an ill-advised trip to a strip club three weeks earlier!

Ben Affleck & Sandra Bullock

THIS PAGE: Funny lady Bullock, then 34, forced herself on her costar Affleck, 26, at a March 12, 1999, screening of *Forces of Nature* in Los Angeles.

247

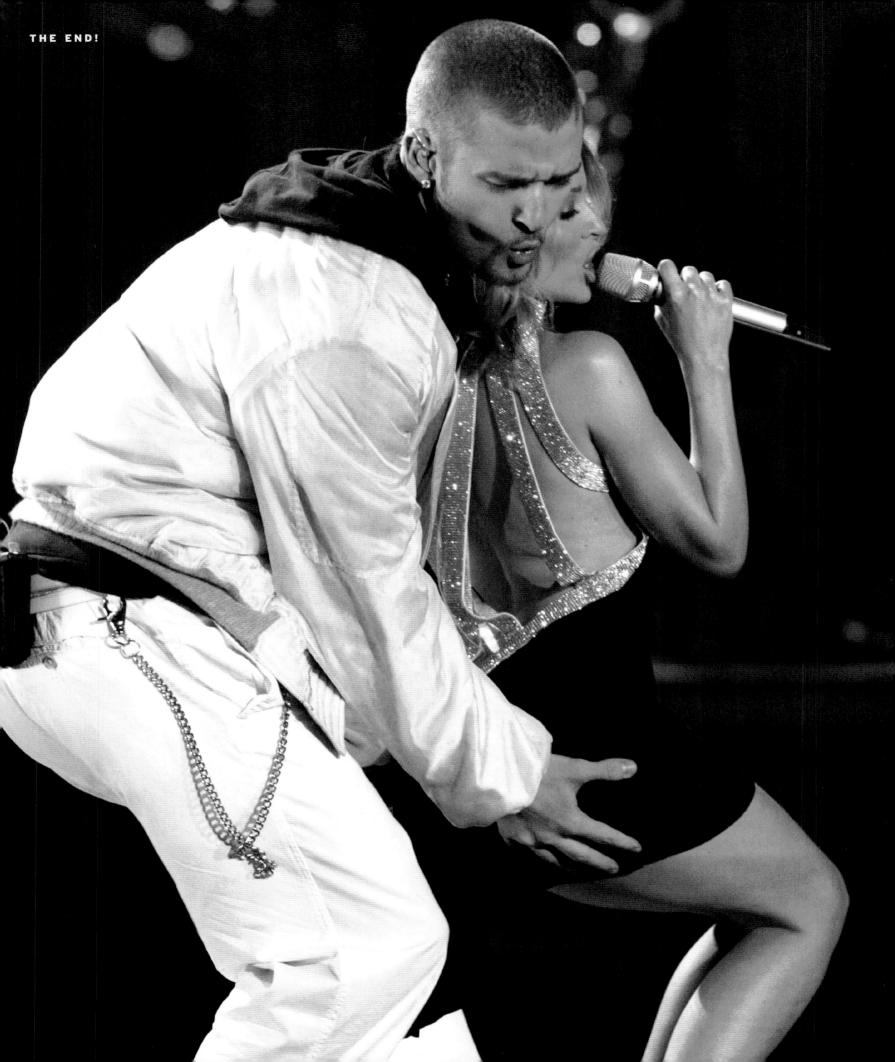

Justin Timberlake & Kylie Minogue

OPPOSITE: He can't get her out of his head! Following their duet at London's Brit Awards on February 20, 2003, Timberlake was still lovin' Minogue's booty. "On a scale of 1 to 10, it's a 58," he said.

Enrique Iglesias

THIS PAGE: He can run, but he won't "Escape" those hands. Iglesias, then 28, got a little extra feeling when he serenaded a fan onstage at a December 14, 2003, concert near Ft. Lauderdale, Florida.

249

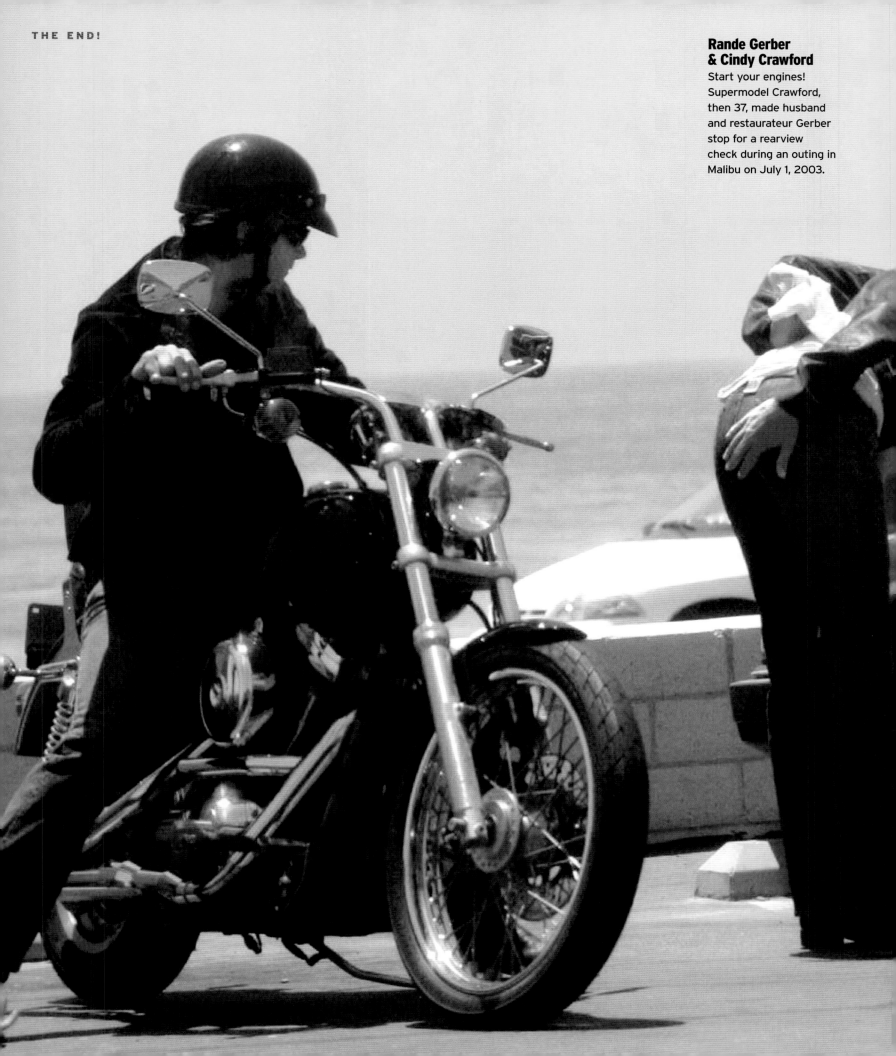

Rande Gerber & Cindy Crawford
Start your engines! Supermodel Crawford, then 37, made husband and restaurateur Gerber stop for a rearview check during an outing in Malibu on July 1, 2003.

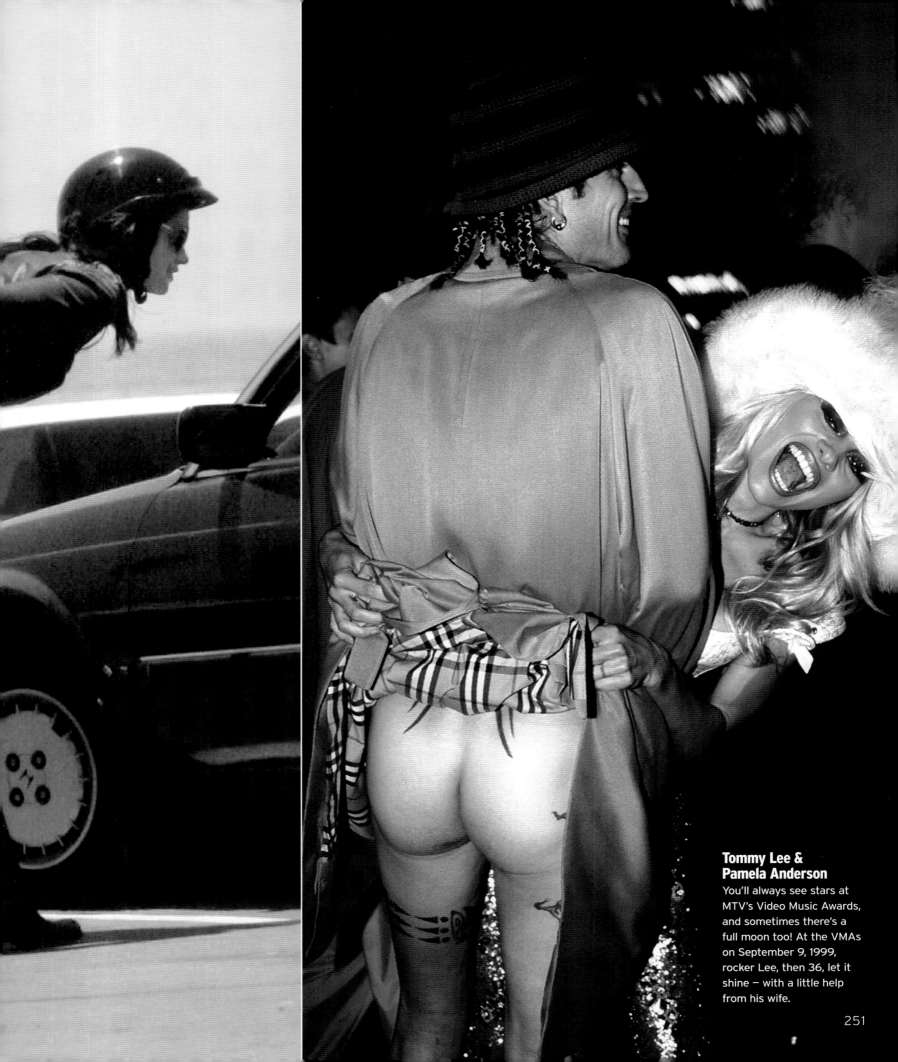

**Tommy Lee &
Pamela Anderson**
You'll always see stars at
MTV's Video Music Awards,
and sometimes there's a
full moon too! At the VMAs
on September 9, 1999,
rocker Lee, then 36, let it
shine — with a little help
from his wife.

251

Jennifer Lopez
At the London premiere of *Maid in Manhattan* on February 26, 2003, the then-33-year-old star gave photographers a shot of her world-famous derrière.

PHOTO CREDITS

COVER
Benainous/Catarina/Debroubaix/Gamma

BACK COVER
Mary-Kate & Ashley Olsen: Mark Mainz/Getty Images, **Brad Pitt & Jennifer Aniston:** Eric Gaillard/Reuters/Landov, **Jessica Simpson & Nick Lachey:** Joe Buissink/WireImage.com, **Gwyneth Paltrow:** Steve Sands/Bauer-Griffin.com, **Paris Hilton:** Lawrence Schwartzwald/Splash News, **Britney Spears:** Ramey Photo Agency, **Justin Timberlake:** Janet Gough/Celebrityphoto.com, **Oprah Winfrey:** Walter McBride/Retna, **Demi Moore:** Ramey Photo Agency, **Cameron Diaz:** Classmates Media Inc., **Nicole Kidman & Tom Cruise:** Alex Berliner/Berliner Studio/BEImages, **Angelina Jolie:** Tawil/Annahar/Balkis Press/Abaca, **Jennifer Lopez & Ben Affleck:** Camera Press/Retna, **Jennifer Garner:** Andrea Renault/Globe Photos, **Sean Combs:** Zuma Press, **Trista & Ryan Sutter:** Craig Sjodin/ABC, **Pamela Anderson:** Nancy Kaszerman/Zuma Press, **Jennifer Garner:** Eric Charbonneau/Berliner Studios/BEImages

INSIDE FRONT COVER
Uma Thurman: Alan Davidson/WireImage.com

CONTENTS
3 CLOCKWISE FROM TOP LEFT: Sara Jaye/Abaca, Todd Plitt/Getty Images, Fame Pictures, Pacific Coast News, Fame Pictures, Jeff Vespa/WireImage.com, Riquet/Bauer-Griffin.com

INTRODUCTION
4-5 Jeff Kravitz/FilmMagic.com

WELCOME TO HOLLYWOOD!
6-7 AP/Wide World Photos, **8-9** Splash News, **10-11** Kevin Mazur/WireImage.com, **12** Alex Berliner/Berliner Studio/BEImages, **13** JFX Direct/Bauer-Griffin.com, **14-15** Guerci-Gros/X17agency.com, **16-17** Mark Mainz/Getty Images, **18-19** John Barrett/Globe Photos, **20** Zuma Press, **21** Jean Baptiste Lacroix/WireImage.com, **22-23** Martha Noble/Globe Photos, **24-25** Alex Berliner/Berliner Studio/BEImages, **26-27** Splash News, **28** Berliner Studio/BEImages, **29** Berliner Studio/BEImages, **30** Monique Bunn/Retna, **31** Walter McBride/Retna, **32-33** Eric Charbonneau/BEImages, **34-35** Celebrity Pictures LA, **36** Pacific Coast News, **37** Furio Agiman/Lucky Mat, **38-39** X17agency.com

KISS, KISS!
40-41 Splash News, **42** Richard Young/Rex USA, **43** FROM TOP: Fame Pictures, Ramey Photo Agency, **44** Flynet Pictures, **45** Sipa, **46** AFP/Gamma, **47** Giboux-Mingasson/Gamma, **48-49** Fame Pictures, **50** FROM TOP: Matrix/Bauer-Griffin.com, N/C, **51** FROM TOP: Jen Lowery/London Features, Ace/Zuma Press **52** CLOCKWISE FROM TOP LEFT: Gary Boas/Retna, Lapresse/Getty Images, Everett Collection, Mitchell Gerber/Corbis, **53** Steve Granitz/WireImage.com, **54** Ronnie Taylor/WireImage.com, **55** RJ Capak/WireImage.com, **56** FROM LEFT: Riquet/Bauer-Griffin.com, London Entertainment/Splash News, **57** Bauer-Griffin.com, **58** Win Mcnamee/Reuters/Corbis (2), **59** AP/Wide World Photos, **60** Richard Young/Rex USA, **61** Patrick Davy/Prestige/Getty Images

ON THE SET
62-63 Tony Alexander/Globe Photos, **64** Globe Photos, **65** Pacific Coast News, **66-67** FROM LEFT: INFGoff.com, Pacific Coast News, **68** Lawrence Schwartzwald/Splash News, **69** Lawrence Schwartzwald/Splash News, **70** Pacific Coast News, **71** Chris Doherty/INF/Starmaxinc.com, **72** FROM LEFT: INFGoff.com, HenryLamb/Photowire/BEImages, **73** Ramey Photo Agency, **74** Startraksphoto.com, **75** Andrea Renault/Globe Photos, **76-77** Anthony Dixon/London Features (2)

CAN YOU BELIEVE THEY DATED?
78-79 Ron Wolfson/London Features, **80** Reuters/Landov, **81** Jeff Kravitz/FilmMagic.com, **82** Neal Preston/Corbis, **83** John Barrett/Globe Photos, **84** John Barrett/Globe Photos, **85** Roger Karnbad/Globe Photos, **86** Robert Hepler/Everett Collection, **87** Frank Trapper/Corbis, **88** Barry King/WireImage.com, **89** Jeff Kravitz/FilmMagic.com, **90** Albert Ferreira/Startraksphoto.com, **91** Lisa Rose/Globe Photos

JUST LIKE *US*!
92-93 Eric Charbonneau/Berliner Studio/BEImages, **94** Bill Davila/Startraksphoto.com, **95** Ramey Photo Agency, **96** CLOCKWISE FROM TOP LEFT: London Entertainment/Splash News, Fame Pictures, Pacific Coast News, Flynet Pictures, **97** Ginsburg-Spaly/X17agency.com, **98** Tom Kingston/WireImage.com, **99** Volpe/X17agency.com, **100** Ramey Photo Agency, **101** Pacific Coast News, **102** Zasi/Bauer-Griffin.com, **103** Thorpe/Bauer-Griffin.com, **104-105** Ramey Photo Agency, **106** Giles Harrison/Splash News, **107** FROM TOP: Mike Carillo/Online USA/Getty Images, Ramey Photo Agency, **108-109** Alex Berliner/Berliner Studio/BEImages

HOW STARS SAY "I DO"
110-11 Craig Sjodin/ABC, **112** Ginsburg-Spaley/X17agency.com, **113** Joe Buissink/WireImage.com, **114-115** FROM LEFT: Ramey Photo Agency, Reuters/Landov, Peter Brandt/Co-Op Image, **116** Rex USA, **117** AP/Wide World Photos, **118** Michael Sanville/WireImage.com, **119** AP/Wide World Photos, **120** Joe Buissink/WireImage.com, **121** Simon/Ferreira/Startraksphoto.com, **122** James Aylott/Getty Images, **123** Ramey Photo Agency, **124** Daniel Auclair/Reuters/Landov, **125** Bill Bernstein/Camera Press/Retna, **126** Simone & Martin Photography, **127** Rex USA, INSET: adamsandler.com, **128** Zandarin and Allen/Rex USA, **129** Dennis Reggie, **130-131** Express Syndication

THEN & NOW
132 Steve Eichner/WireImage.com, **133** Kevin Mazur/WireImage.com, **134** CLOCKWISE FROM LEFT: Barry King/Contour Photos, Lynn McAfee/Retna, Steve Granitz/WireImage.com, Dave Allocca/DMI/Time Life Pictures/Getty Images, **135** CLOCKWISE FROM RIGHT: INFGoff.com, Frank Trapper/Corbis, Fred Prouser/Reuters/Corbis, Lisa O'Connor/Zuma Press, **136** Bettmann/Corbis, **137** Sipa, **138-139** TOP ROW, FROM LEFT: N/C, Getty Images, Classmates Media Inc., Wenn/Landov, N/C, Wenn/Landov; 2ND ROW: Toby Canham/Splash News, Courtesy Jamie-Lynn DiScala, Tom Vickers/ Splash News, Corbis, N/C, Wenn/Landov, 3RD ROW: N/C (3), Splash News, **140** CLOCKWISE FROM LEFT: Retna, Corbis, Barry King/WireImage.com, Rufus F. Folkks/Corbis, **141** CLOCKWISE FROM RIGHT: Jeff Vespa/WireImage.com, Robin Platzer/FilmMagic.com, London Features, Angie Coqueran/London Features, **142** CLOCKWISE FROM LEFT: Michael Ferguson/Globe Photos, Armando Gallo/Retna, CBS/Landov, Jeff Kravitz/FilmMagic.com, Kevin Mazur/WireImage.com, Mike Blake/Reuters/Landov, Ron Wolfson/London Features (CENTER), **143** CLOCKWISE FROM RIGHT: Lee Roth/Starmaxinc.com, Steve Granitz/ WireImage.com, Michael Germana/ UPI/Landov, Stephen Trupp/Starmaxinc.com, Neal Preston/Corbis, Armando Gallo/Retna, Kevin Mazur/WireImage.com (CENTER), **144** Derek Ridgers/London Features, **145** NBC/Globe Photos, **146** CLOCKWISE FROM LEFT: Zuma Press, Jim Smeal/WireImage.com, Jeff Kravitz/FilmMagic.com, Ron Wolfson/London Features, **147** CLOCKWISE FROM RIGHT: Claudio Onorati/EPA/Landov, Tony Barson/WireImage.com, Eric Gaillard/Reuters/Landov, Alex Bailey/Corbis Sygma, **148** CLOCKWISE FROM LEFT: Neal Preston/Corbis, London Features, Joe Bangay/London Features, Retna, Russ Einhorn/Starmaxinc.com, Jeff Christensen/Reuters/Landov, David Mcgough/Time Life Pictures/Getty Images (CENTER), **149** CLOCKWISE FROM RIGHT: Ian West/EPA/Landov, David Wimsett/Uppa/Starmaxinc.com, Russell Einhorn/Starmaxinc.com, Steve Granitz/WireImage.com, Zuma Press, London Features, Reuters/Landov (CENTER), **150** CLOCKWISE FROM LEFT: Stuart Campbell/Austral/Zuma Press, Splash News, Retna, **151** CLOCKWISE FROM RIGHT: AMAX Talent, Retna, Pacific Coast News, **152-153** FROM LEFT: Harry Langdon/Shooting Star, Charles W. Bush/Shooting Star, **154** Getty Images, **155** Bauer-Griffin.com

BABY BUMPS
156 Henry Lamb/Photo Wire/Starmaxinc.com,
157 Stuart Franklin/Getty Images, 158 Matrix/Bauer-Griffin.com, 159 Mitch Gerber/Starmaxinc.com,
160 Tom Maelsa/AFP/Getty Images, 161 Mitchell Gerber/Corbis, 162 Dan Steinberg/BEImages,
163 Capital Pictures/Retna

KIDSPOTTING
164-165 Tawil/Annahar/Balkis Press/Abaca,
166 Fame Pictures, 167 Paul Adao/New York News Service, 168 Alan Davidson/WireImage.com,
169 David Dyson/Camera Press/Retna, 170 Donata Sardella/WireImage.com, 171 Steve Sands/Bauer-Griffin.com, 172-173 Fame Pictures (2), 174 FROM LEFT: Flynet Pictures, Big Pictures/Zuma Press,
175 FROM LEFT: John Connor/Startraksphoto.com, Bauer-Griffin.com, 176 Johnny Island/INFGoff.com,
177 Eliot Press/Bauer-Griffin.com, 178-79 Michael Caulfield/WireImage.com, 180 Ron Galella, 181 Newspix, 182-83 Daniela Federici

HOLLYWOOD HIGH
184 Classmates Media Inc., 185 TOP ROW, FROM LEFT: Classmates Media Inc. (3); 2ND ROW: Classmates Media Inc. (3); 3RD ROW: Boston Herald/Rex USA, Classmates Media Inc., 186 ALL IMAGERY: Classmates Media Inc., 187 ALL IMAGERY: Classmates Media Inc., 188 BEN AFFLECK: Boston Herald/Rex USA, BRAD PITT: Splash News, REMAINING IMAGERY: Classmates Media Inc., 189 CLOCKWISE FROM LEFT: Zuma Press, Classmates Media Inc. (2), 190 CLOCKWISE FROM LEFT: Holly Aguirre/Corbis, Classmates Media Inc. (2), 191 CLOCKWISE FROM RIGHT: Globe Photos, N/C, Classmates Media Inc.

LIFE'S A BEACH
192-193 Splash News, 194 Eliot Press/Bauer-Griffin.com, 195 Zuma Press, 196 Flynet Pictures,
197 Ramey Photo Agency, 198 FROM LEFT: Bauer-Griffin.com, Eliot Press/Bauer-Griffin.com, 199 Kate Lilienthal/Splash News, 200-201 FROM LEFT: Splash News, Flynet Pictures, 202-203 FROM LEFT: Ramey Photo Agency, Splash News, 204 CLOCKWISE FROM LEFT: BEImages, Ramey Photo Agency, Big Pictures USA/Zuma Press, 205 FROM LEFT: The Coqueran Group, Zuma Press, 206 Eliot Press/Bauer-Griffin.com, 207 Splash News, 208-209 FROM LEFT: Abaca/X17, Angeli/ReflexNews, 210-211 Splash News

UH-OH MOMENTS!
212 Fame Pictures, 213 Fame Pictures, 214 Fame Pictures, 215 Janet Gough/Celebrityphoto.com,
216 Blanco/X17agency.com, 217 Reuters/Landov, Dave Hogan/Getty Images, 218 Dave Hogan/Getty Images 219 Kevin Winter/Getty Images, 220 CLOCKWISE FROM LEFT: JFX-Gros/X17agency.com, Chris Polk/FilmMagic.com, Roger Wong/INF/

Starmaxinc.com, 221 CLOCKWISE FROM RIGHT: MB Pictures/Rex USA, Lee Roth/Starmaxinc.com, Fame Pictures, 222 Tobias Schwarz/Reuters/Corbis,
223 Express Syndication, 224-225 TOP ROW, FROM LEFT: Reuters/Landov, Corbis Sygma, Pacific Coast News, Getty Images, Sipa, AP/Wide World Photos; 2ND ROW: G. Seminara Collection/Shooting Star, Splash News, Zuma Press, Corbis Sygma, Frazer Harrison/Getty Images, G. Seminara Collection/Shooting Star; 3RD ROW: Splash News, G. Seminara Collection/Shooting Star, Rex USA, Splash News, 226 CBS, 227 FROM LEFT: Flynet Pictures, Time Life Pictures/Getty Images, 228 Reuters/Landov, 229 DMI, 230 Bauer-Griffin.com,
231 CLOCKWISE FROM TOP LEFT: Zuma Press, X17agency.com, Denis-Volpe/X17agency.com, Lawrence Schwartzwald/Splash News, 232 Abaca, 233 Ramey Photo Agency

FASHION POLICE
234 Chris Delmas/Zuma Press, 235 FROM LEFT: Fred Prouser/Reuters/Corbis, Jeff Kravitz/FilmMagic.com, 236-237 FROM LEFT: Alberto Lowe/Zuma Press, Steve Finn/Getty Images, Splash News, Jen Lowery/London Features,
238-239 FROM LEFT: Hahn-Kahyat/Abaca, Jeff Kravitz/FilmMagic.com, Walter Weissman/Starmaxinc.com, Diane Cohen/Sipa, 240-241 FROM LEFT: Brenda Chase/Online USA/Getty Images, Jane Caine/Zuma Press, Rex USA, Mario Anzuoni/Splash News, 242 CLOCKWISE FROM LEFT: Ron Wolfson/London Features, Jeff Kravitz/FilmMagic.com, Jim Smeal/BEImages,
243 CLOCKWISE FROM RIGHT: Frank Trapper/Corbis Sygma, Jill Johnson/JPI, Fotos International/Zuma Press

THE END!
244 Connan/Beverel/Corbis, 245 Camera Press/Retna, 246 LDP Images, 247 Fitzroy Barrett/Globe Photos, 248 Dave Hogan/Getty Images, 249 Larry Marano/London Features, 250-251 FROM LEFT: X17agency.com, Sonia Moskowitz/Globe Photos, 252 Karwai Tang/Alpha/Globe Photos

INSIDE BACK COVER
Britney Spears & Kevin Federline: Thorpe/Bauer-Griffin.com

CHAIRMAN, WENNER MEDIA Jann S. Wenner

EDITOR IN CHIEF Janice Min

SPECIAL PROJECTS EDITOR Sarah Pyper
CREATIVE DIRECTOR Elizabeth Betts
ART DIRECTOR Trey Speegle
PHOTOGRAPHY DIRECTOR T. Brittain Stone
DEPUTY MANAGING EDITOR Virginia Shannon
EDITOR Tamara Glenny
WRITER Aimee Agresti
DESIGN PRODUCTION MANAGER David Schulz
ART PRODUCTION Roxy Baer-Block
PHOTO RESEARCHERS Sonja Gill, Leyla Sharabi
PHOTO PRODUCTION Keri Pruett
COPY CHIEF Don Jeffrey
DEPUTY RESEARCH CHIEF James Dobbins
DEPUTY COPY CHIEF Michael Quiñones
COPY EDITORS Josh Bernstein, David Delp,
Marla Garfield
RESEARCHERS James Kendall, Justin Sullivan

FASHION POLICE Jeff Ahearn, Steve Altes,
Mario Correa, Anthony DeVito, Susie Felber, Amy
Fenster, Matt Iseman, Cecily Knobler, Lisa Landry,
Stefanie Novik, Jennifer Rade, Wendy Shanker,
Traci Skene, Buck Wolf

PRODUCTION Cliff Cerar, Henry Groskinsky,
Kent Ochjaroen
EDITORIAL OPERATIONS MANAGERS
Steven Pang, Michael Skinner
EDITORIAL OPERATIONS DIRECTOR
John Dragonetti

EDITOR IN CHIEF, WENNER BOOKS
Robert Wallace
ASSISTANT EDITOR, WENNER BOOKS
Kate Rockland

SENIOR VICE PRESIDENT, WENNER MEDIA
Kent Brownridge

WITH SPECIAL THANKS TO
John Kline, Hayley Hill, Albert Lee, Mark Cina,
David Evans, Anne Mellinger, Nick Rhodes,
Rich Garella, Peter Grossman, Sara Levine,
Andrew Sroka, Colleen Stoll, Patti Wilson,
Jane Yeomans, Alex French, Shauna DeGeorge,
Allegra Muzzillo, Jack Savage, Vincent Stanley
and the whole *Us* team for their hard work and
celebrity expertise.

Britney Spears & Kevin Federline

FOLLOWING SPREAD: Spears, then 22, showed off her
brand-new boyfriend, Federline, 26, on the Malibu,
California, beach on April 23, 2004, with an impromptu
photo shoot in front of the world's photographers.

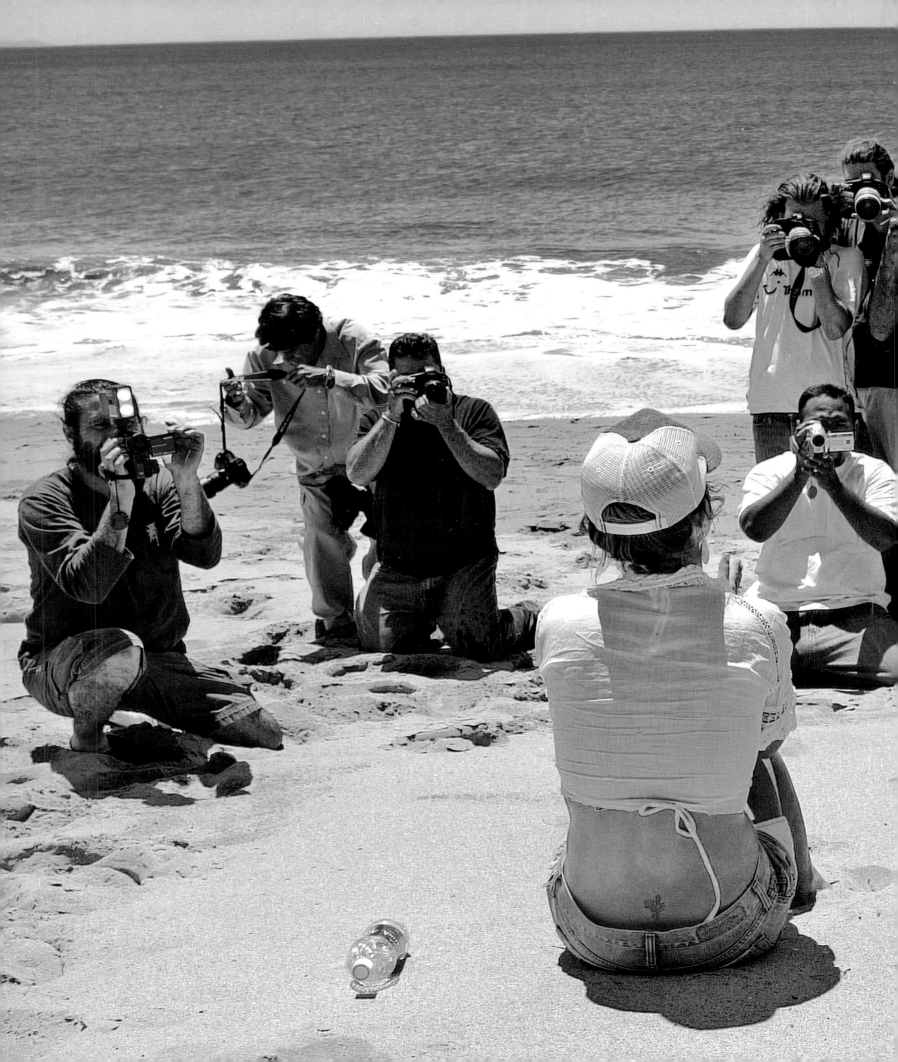